AHMANSON · MURPHY
FINE ARTS IMPRINT

THE PUBLISHER AND THE UNIVERSITY OF CALIFORNIA PRESS
FOUNDATION GRATEFULLY ACKNOWLEDGE THE GENEROUS
SUPPORT OF THE AHMANSON • MURPHY IMPRINT IN FINE ARTS.

RESTLESS ENTERPRISE

The publisher gratefully acknowledges the generous support of the Chairman's Circle of the University of California Press Foundation, whose members are:

Elizabeth and David Birka-White
Linda Carlson Shaw
Harriett Gold
Maria and David Hayes-Bautista
Carolyn Hsu-Balcer and René Balcer
Patricia and Robin Klaus
Susan McClatchy
Lisa See
Rowena and Marc Singer
Peter J. and Chinami S. Stern
Lynne Withey and Michael Hindus

RESTLESS ENTERPRISE

The Art and Life of Eliza Pratt Greatorex

Katherine Manthorne

 UNIVERSITY OF CALIFORNIA PRESS

University of California Press

Oakland, California

© 2020 by Katherine Manthorne

Cataloging-in-Publication Data is on file at the Library of Congress.

ISBN 978-0-520-35550-7 (cloth : alk. paper)

Printed in Turkey

29 28 27 26 25 24 23 22 21 20
10 9 8 7 6 5 4 3 2 1

To

Katherine Farrell

Catherine Fallon

Margaret Ann McElhinney

and all the brave Irish women

who crossed the sea to make a home in America

CONTENTS

ACKNOWLEDGMENTS

WHEN I BEGAN TRACKING Eliza Greatorex decades ago, I had no inkling of the places I would go, the resources I would consult, or the number of people who would provide invaluable assistance along the way. It is with great pleasure that at this point I pause and acknowledge all those who contributed to this book. Research assistants who have been on the front lines in libraries and archives include Chad Alligood, Mary Helen Burnham, Marnie Coleman, Isabel Elson, Bree Lehman, Nicole Simpson, and Jean Resnais. I am grateful to colleagues and students at the City University of New York Graduate Center. I thank the late Colonel Merl Moore, Jr. for his indefatigable research and generosity in sharing it. Colleagues who have supported this project in innumerable ways include Richard Aste, Carolyn Carr, Diane Clifford, Anne Keller Geraci, Jennifer Krieger, Carol Turner, David G. Wright, and Helena Wright. Fellowships from the Smithsonian Institution and the Crystal Bridges Museum of American Art provided time away for research and writing. The Terra Foundation for American Art's professorship in Berlin provided opportunities in Germany. Staffs at libraries and museums across the United States were key to advancing my work, including the Archives of American Art,

Bancroft Library, Cragsmoor Free Library, Denver Public Library Western History Collection, Dibner Library of the Smithsonian Institution, Frick Art Reference Library, Harvard University Library, Jello Museum of LeRoy, NY, Library of Congress, Massachusetts Historical Society, Museum of the City of New York, New-York Historical Society, New York Public Library, Smithsonian American Art Museum, and the Virginia Libraries. Many staff members at the University of California Press gave of their expertise to produce this book, but I especially want to single out the gracious assistance of Archna Patel. Ben Alexander provided skillful editing.

In Ireland, I benefited greatly from the help of John Cunningham, Art Hughes, and Robin P. Roddie of the Methodist Historical Society of Ireland, along with Harold Thompson and the residents of Manorhamilton. In Munich, Christian Fuhrmeister provided critical leads. In Paris, I spoke about Greatorex at the Musee d'Orsay's *Faire Oeuvre* conference and learned much from the members of AWARE (Archives of Women Artists, Research and Exhibitions). In Moret-sur-Loing, enthusiastic support was received from Anne Bourdeau and Gilles de Crick, Hans-Christian Bohlmann, René Roesch, Christian Recoing of Les Amis de Sisley, and Luc Paylot of Les Amis de Moret et de sa Region.

The manuscript received careful readings by Adrienne Baxter Bell and Sylvia Yount, for whose thoughtful comments and wise counsel I am immensely grateful. Family members Jay, Patricia, and Mark Manthorne are unfailingly supportive. Three people have been indispensable in the realization of *Restless Enterprise*. From my first long-ago contact with Ronald Berg, he has been steadfast in his commitment to Greatorex, collecting and safe-keeping her work. He and his wife Carole opened their door for research trips and tasty repasts. Nadine Little's enthusiasm for the book and her guiding hand in navigating its publication with the University of California Press mean more to me than words can express. Following everywhere in Greatorex's steps, studying prints and paintings and reading the manuscript, my husband James Lancel McElhinney has been a partner in this quest from beginning to end.

INTRODUCTION

COMMUTING FROM MY HOME in northern Manhattan to my office in Midtown, I daily encounter buildings shrouded in scaffolding, wrecking balls, construction crews, and holes dug deep into the island's rocky substructure to lay new foundations. It was similar in the 1860s and 1870s when Eliza Pratt Greatorex (1819–97) determined to record the old structures that were being lost to progress in pictures and in her folio volume *Old New York, from the Battery to Bloomingdale* (1875). That book solidified her status as the most famous woman artist of the day, an intrepid Irish-born painter and graphic artist who blazed a pioneering trail for her daughters Kathleen Honora Greatorex (1851–1942) and Eleanor Elizabeth Greatorex (1854–1908) and their generation. She initially painted in the Hudson River mode, but then laid down her brushes to draw in pen and ink in Germany, Colorado, and New York. By 1880 she was reinventing herself for a third and final reincarnation as a leader of the Etching Revival. Hailed as the only female member of the National Academy of Design and the Artists Fund Society and a founding member of important art colonies in Cragsmoor, New York, and in Colorado Springs, Eliza Greatorex was the first American woman to earn an international reputation

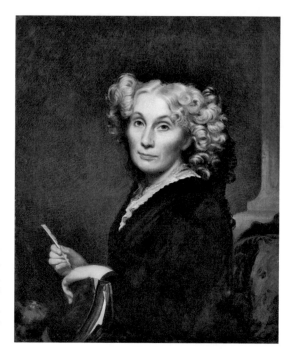

FIGURE O.O1
Ferdinand Thomas Lee Boyle, *Eliza
Pratt Greatorex*, 1869. Oil on canvas,
30 × 25 ¼ in. National Academy of
Design, New York (ANA Diploma
portrait; 145-P.). Courtesy
Bridgeman Images.

as an artist, travel writer, and pioneer of the Etching Revival. A widow of limited financial means who supported her four children through her art, Eliza Greatorex was celebrated as a model for the women's rights movement. And yet today, she has been all but forgotten (fig. o.o1).

In the tradition of accounts of creative women from Megan Marshall's *The Peabody Sisters: Three Women Who Ignited American Romanticism* to Hayden Herrera's *Frida: A Biography of Frida Kahlo, Restless Enterprise* brings Greatorex's life back into focus.[1] She delineated the Hudson River, chronicled the destruction of Old New York's streetscapes and landmarks, traveled across Europe, and made art in Morocco. Drawing in the Colorado Rockies made her the first eastern woman artist to produce artwork in the West. Through close affiliations with suffragist Susan B. Anthony, actress Charlotte Cushman, and founding editor of *Harper's Bazaar* Mary Louise Booth, her art and enterprise blazed a trail for subsequent generations of female artists. All of her creative endeavors were shared with her two unmarried artist-daughters and her sister Matilda Pratt Despard (1827–1915). Exploring

her fierce ambition and creative path, this book reveals how this formidable female and her circle of art women helped to shape American gender politics, visual culture, and urban consciousness.

HER LIFE

To narrate her life, the book unfolds in a series of nine chapters focused on key episodes in a career that starts in Ireland and extends from the antebellum era through the Civil War and Reconstruction to the Gilded Age. Since these same years witnessed the birth of the modern art world, this narrative structure allows the reader to track its development as she negotiated studio space, the pitfalls of a predominantly male art establishment, the new class of art dealers, international travel and exhibition, shifting aesthetic tastes that necessitated successive self-inventions, and a balance between career and child rearing as a widowed single parent. No existing study provides such a panorama of the cultural realm, and certainly not from a woman's perspective. The successes she achieved in these overlapping arenas led one critic writing in the early 1880s to proclaim her the first artist of her sex in America.[2]

The history of nineteenth-century American art is generally divided into two broad periods, demarcated by the Civil War: Antebellum and Gilded Age. As this account demonstrates, however, the years between the Emancipation Proclamation and the Centennial—the high point of Greatorex's career coinciding with political Reconstruction—comprise a distinct and complex moment. It argues, therefore, that these years should be distilled out from the broad and inappropriate heading "Gilded Age" and treated as a discrete period with its own unique character. It was a moment of not only great promise but also dark genius, when women, like African Americans, stepped out from the shadows. The art scene of that moment evidenced diversity and experimentation, played off against the increasingly conservative sensibilities of the 1880s and 1890s. The fulfillment of American social equality seemed possible, as Walt Whitman proclaimed in the great literary document of the age, *Democratic Vistas*. But all too soon, in 1877, the nation betrayed the ideals of Reconstruction, withdrew troops from the South, and pushed women along with blacks back into the shadows. With a complete suite of her works on display in the Women's Pavilion, Eliza Greatorex was at the top of her game in 1876. But within two years she was forced to sell off the contents of her New York studio and retreat back to Europe in 1878.

This pattern of a steady rise to success across the '70s and a rapid fall at the decade's end was repeated in the careers of many artists of her generation—men as well as women. A great sea change had occurred. Women and blacks had to wait another century, for the Nineteenth Amendment of 1920 and the civil rights and women's movements of the 1960s and 1970s, to experience the same sense of possibility. In the case of Greatorex, she was able to rally one last time and rise like a phoenix from the ashes to become a leading figure of the Etching Revival of the 1880s.

Never remarrying after her husband Henry Greatorex passed away in 1858, she became the head of her art matriarchy that embraced her sister and daughters. Although attractive and talented, Kathleen and Eleanor seem to have had little romance in their lives. Frequent moves from one location to another and extended stays abroad made it difficult to have sustained relationships with eligible males. But one also suspects that their bonds with their mother were a factor in their single status, perpetuated by a mix of filial duty, guilt, and love of the artistic life the three of them shared. Writer Annie Emaux once recalled, "Even living far from [my mother], as long as I wasn't married, I belonged to her still." The artist's daughters experienced a similar possessive tug.[3]

HER ART

The Greatorex studio functioned as a cooperative where different hands contributed individual skills to the final outcome. The daughters did the decorative work on the title pages and covers, conducted the necessary correspondence in their neat script, and assisted in instructing the many students who passed through their doors over the years. There was a hierarchy of tasks, but also a spirit of collaboration. This was the model upon which this family and their close female friends functioned, supported by her brother, brother-in-law, and her nephew, all of whom contributed to the artwork that bore the Greatorex name. Their modus operandi was a mark of respect for the old ways, an expediency to get the work done, and the practical strategy of a busy mother who needed to care for and educate her children while she tried to earn a living. It eschewed the emphasis of the solitary genius characteristic of male production, and embraced a spirit of community and solidarity characteristic of female creativity.

As a professional artist, Eliza Greatorex repeatedly had to choose between home life and work. Facing what would later be called the dilemma of

the single mother, she juggled competing demands. Twice she went off to Europe leaving her children in the care of her sister, but other times she devised ways to keep them with her: she brought them along on sketching excursions in the Hudson Valley and Colorado, and they set off together for Germany, France, and Morocco. So if their art education was rather hit or miss, their joint travels across Europe, the American West, and North Africa were eye-opening.[4]

Greatorex the elder's style of landscape painting had one foot in the Hudson River School and the other in Barbizon, while her graphic work evolved from pen-and-ink drawings that demonstrated a nervous line and mannerist handling of form to more refined plein air etching. Her daughters belonged to the next generation, trained in a looser and more fluid touch that was somewhere between Tonalism and Impressionism. Both sisters engaged in flower and figure painting, but diverged in their focus and manner. Eleanor Greatorex also painted likenesses, while Kathleen Greatorex steered away from the demands of portraiture and tended more toward the imaginative and decorative. Like many of their contemporaries, they were cosmopolitans who trafficked back and forth between New York and Paris and comfortably negotiated both locales. They were technically better trained than their mother, but lacked her talent and drive. Their innovative flower pieces and figure studies earned them a place in the late nineteenth-century transatlantic art world, which Eleanor helped to chronicle in the popular press. Although this book takes Eliza Pratt Greatorex as its primary subject, the art women of her circle played crucial supporting roles, as did her daughters, whose careers deserve separate study.

FINDING ELIZA GREATOREX

I have been pursuing Greatorex, her family, and her female contemporaries for over two decades. Extensive investigation in newspapers, government records, and manuscripts in New York, Washington, Philadelphia, and beyond has led me to identify her as the leading woman artist of her historic moment. It has also allowed me to fill in the broad outlines of her career and identify three important themes that provide the leitmotifs of this book. First, the story of Greatorex's life and art from the 1850s through the 1880s *is* the story of American art in those decades. Her career provides the lens through which to view the age. Second, she was linked with one of the most important social issues of the day: women's rights. Eliza Greatorex lost no

opportunity to champion the cause of women in the arts: she spearheaded the movement of New York–based women artists to participate in the Centennial, counted as friends suffragists Susan B. Anthony, Mary Louise Booth, and Emily Faithfull, and used her talent and position to help young women entering the artistic ranks. And third, as a participant in the Irish diaspora in America, she experienced that feeling of being between the land of her birth and her adopted homeland. Her imagery, as a result, is redolent with loss and memory. This extends from her early Irish landscape paintings to her major records of the historic landmarks of New York that were being destroyed to make way for the business establishments and mansions of the Gilded Age.

To reconstruct the career of Eliza Greatorex, I have relied almost exclusively on primary research in the United States, Ireland, France, and Germany. Her paintings, three published books, and several portfolios of prints provided my foundation. Aside from published sources, years of searching have yielded a limited number of letters, a modest group of canvases (twenty-five have been identified out of approximately one hundred titles from period records), a series of original drawings, one painted portrait of her, and a handful of photographic and printed likenesses. Writing the lives of such forgotten women is like chasing shadows. Investigation of them usually depends upon private sources: diaries, letters, and the like. In the case of Greatorex, it was just the opposite. The intimate details of her thought processes and day-to-day life were private, for she had no patience for keeping diaries or writing letters, and when a journalist asked for information, she provided only the barest outlines. However, her name frequently appeared in newspapers and journals all over the country, including innumerable articles and notices from the *New York Times, Daily Tribune,* and *Brooklyn Eagle.* I supplemented this material with documents related to her family—especially her sister and two daughters—with whom she formed a unique association, and then expanded this search to embrace the lives of female artists, writers, collectors, and galleries in Britain and America with whom she had direct contact. More and more material was becoming available on the World Wide Web, allowing me to augment my database.

Secondary literature is scanty. Phyllis Peet's doctoral dissertation of 1987 and her catalogue and exhibition *American Women of the Etching Revival* of 1988 discuss her prints.[5] Since the start of the new century, more attention has been paid to nineteenth-century American women, including Laura

Prieto's 2001 book *At Home in the Studio: The Professionalization of Women Artists in America.*[6] In 2008 April F. Masten's *Art Work: Women Artists and Democracy in Mid-Nineteenth-Century New York* devoted several pages to Greatorex as a model of a hardworking professional woman.[7] That Greatorex could be called "a famous woman artist" in 1897 and be largely lost to us a century later is unacceptable. It is fitting therefore that this book goes to press in time for the anniversary of the ratification of the Nineteenth Amendment to the US Constitution granting women the right to vote in August 1920.

PROLOGUE
The Old Church

TELLTALE NOISES FILLED THE AIR. The creaking of the old wooden shingles, the crack of a metal pickax against stone, the muffled thud of worn bricks tumbling to the soft earth, and the voices of the men on the crew shouting to one another in working-class Gaelic. Those sounds were unmistakable. As she stood at the corner of Beekman and Cliff Streets, her worst fears were realized. There was old St. George's chapel, with a makeshift fence erected around it and a crowd assembling just at its edge, trying to get a good look at the happenings (fig. 0.1). People never tired of watching the destruction of the old buildings and construction of new ones that every year rose higher from street level. The workers shouted back and forth to each other in quick phrases, to coordinate what was to them routine work. The accents were so thick and the idioms so distinctive that she could have imagined she was back home in Ireland. She directed her attention to the doorway of the church, where another segment of the crew had been assigned to clear out the interior. They passed back and forth under the archway carrying pews, sections of the staircase that the minister had climbed to address his congregation from the pulpit, and then the pulpit itself. These would be sold and repurposed in

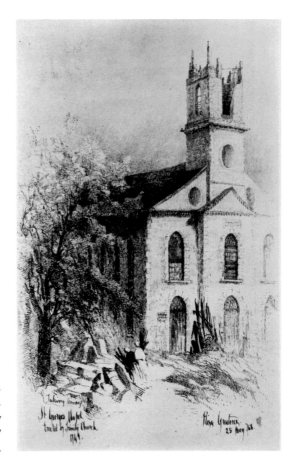

FIGURE O.1
Eliza Greatorex, *Taking Away St. George's Chapel, erected by Trinity Church in 1749*. Inscribed "25 May 68." From *Old New York*, opp. p. 39.

another location, as would the bricks, tiles, shingles, and panels removed from the exterior.

A familiar figure to the wrecking crews who toiled across Manhattan, the striking white-haired woman invariably materialized as they wrought the destruction creating new ruins. She was joined by her younger sister, who had been summoned to assist her (fig. o.2). Together they rescued a few intact panels from the pile of debris the workers had left in front of the church, adding to her growing collection of doleful mementos from these hallowed old structures.[1] St. George's interior woodwork was mahogany, including pulpit, desk, and chancel rails, so likely they salvaged some of that. But then she had to get to work. Selecting a site from which to gain an

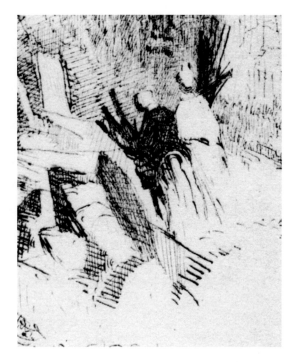

FIGURE O.2
Eliza Greatorex, *Taking Away*
St. George's Chapel, erected by Trinity
Church in 1749 (detail), dated 1868.
From *Old New York,* opp. p. 39.

optimal perspective of the edifice, she set up her folding stool, sat down, and removed from her bag her penner, inkhorn, and sketchpad. Then she set about drawing the church before the demolition would soon render it unrecognizable. When she finished, she dated it "25 May [18]68."

A few days earlier, on May 19, George Templeton Strong had written in his diary: "They are beginning to pull down old St. George's in Beekman Street, a venerable old landmark." Trinity Church opened it in 1752 as its first chapel-of-ease, a dependent church built to accommodate those who lived a distance from the main church on Wall Street. Topped by a complex, multitiered steeple 172 feet high, the handsome Georgian style edifice had occupied the site since before the Revolution. The chancel (92 × 72 feet) was capable of holding about two thousand worshippers, including many of the city's most distinguished families: the Schuylers, Livingstons, Beekmans, Van Rensselaers, and Van Cortlandts.[2]

Witnessing a church demolition would have filled the artist with sorrow for the loss of a structure sacred not only to God but also to history. It was

the container of memories of all the parishioners who had prayed there, listened to ministers' sermons, lifted their voices in song as they followed in their hymnbooks, and were baptized and married there. It must have recalled her father, who as an itinerant Methodist minister in rural Ireland had preached in barns, off the back of carts, and in the modest parlors of his flock. If he had ever had a church as grand as this, then he would have fought to preserve it with his last dying breath. In New York City, by contrast, the old was constantly being destroyed to make way for the new, all in the name of progress. In the span of a week or two, all traces of St. George's would be gone, with her rendering one of the few reminders of its existence. She continued drawing until the setting sun darkened her page, which she paused to assess before packing up her equipment. The workmen too were leaving the grounds for the night. As they filed past, they looked over the shoulder of this curious woman with a pen and stared in amazement at the outlines of the old church, framed by trees and topped by the half-destroyed steeple. She had captured a good likeness.[3]

1

MAEVE'S DAUGHTERS

From Ireland to America, 1819–1848

DAUGHTER OF AN ITINERANT
MINISTER AND HIS WIFE

Eliza Pratt was born on Christmas Day 1819 in Manorhamilton, in the parish of Cloonclare.[1] It was a tiny village in County Leitrim in the northwest of Ireland founded by Sir Frederick Hamilton, one of the many of that family name who brought settlers over from Scotland. In 1630 Charles I granted him five thousand acres of pastureland and ten thousand acres of woodland and bog. Sir Frederick's home had been, according to local tradition, a fine specimen of a seventeenth-century baronial mansion. But by the early nineteenth century, when the Pratt family lived there, the old structure was in a state of decay, with a collapsed roof and ivy covering. The future artist had her roots in this cultivated landscape, dotted with farmhouses and decaying seventeenth-century manor houses.

Manorhamilton is situated east of Sligo town, the largest settlement in the area. The town sits on a plain or "small meadow," as its early Irish name Clooneen translates. "The small town of Manorhamilton is situated at the centre of the most beautiful and interesting part of the county of Leitrim. It is watered by a mountain streamlet called the Owenmore," a traveler noted, "which falls

into the Bonet river a little below the town, and surrounded by lofty hills, many of which display fine outlines, and attain an elevation of 1,500 feet." This was a high elevation for Ireland, but not by the standards of the Rocky Mountains Eliza Pratt would later visit in Colorado. Alpine plants like saxifrage and mountain avens grew on the hillsides, from the midpoint up to the summit.[2] Along with the wildflowers, gardens were a staple of the Irish countryside, the temperate climate and frequent rain being favorable to them. They were everywhere: town gardens, public and cemetery parks, gardens associated with country houses and demesnes (part of the manorial estates). The many species of plants, some native and others imported, inspired her lifelong passion for nature. She spent many springs and summers in such rural settings, although later she became more aware of the political problems between Ireland and England and was troubled by the hard lives of the rural poor—and especially the women—who worked the farms of the often-absent landowners. These social dynamics had endured in the region for centuries.

On her baptismal certificate her mother was identified as Catherine, with no surname, and her father as James Pratt. He was a minister of the Methodist Church, but the religious denomination was officially listed as Church of Ireland.[3] She was the fourth of eight children James and Catherine had together: Ellin (or Eleanor) (1814–18); Deborah (c.1815–44);[4] Adam Scott (1818–1900); Eliza (1819–97); Catherine (1824–43); Henry (b.c. 1824; died "at sea");[5] Matilda (1827–1915); and Walter Scott (b. 1830). As an itinerant minister, Rev. Pratt was obliged to move his family from town to town, preaching the Methodist doctrine to residents rich and poor in the north of Ireland. Before Eliza Pratt was a year old, her family left scenic Manorhamilton to relocate to Killeshandra in 1820, then Castlebar in 1822, Londonderry in 1824, Strabane in 1825, Drogheda in 1826, Dungannon in 1828, Newtownstewart in 1830, Omagh in 1831, Castleblaney in 1832, Killeshandra in 1834, Boyle in 1835, Brookborough in 1837, Monaghan in 1839, Enniskillen in 1840, and finally Pettigo and Ballyshannon in 1841. In each place they "occupied the small house allotted to the residing preacher's family."[6] "No sooner had habitation and friends in one place become home-like and familiar than the preacher's wife must set herself to lift her household goods and move to a new, brief shelter," the youngest daughter explained. "Only to the children was the 'moving' the great event and frolic of their life." The Pratt children were able to transform these potentially troubling dislocations into

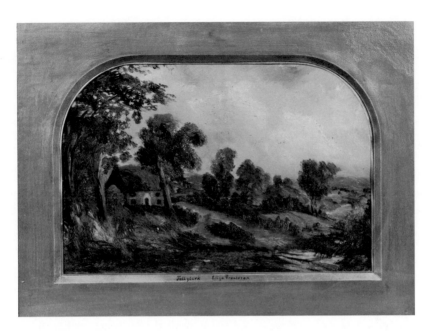

FIGURE 1.1

Eliza Greatorex, *Tullylark, Pettigo, Ireland,* ca. 1858. Oil on paper, 8 ½ × 13 in. in oval frame, surrounded by gold mat 12 ½ × 17 in. Private collection.

adventure. In 1841, when the family arrived back in their mother's hometown of Pettigo, their mode of existence changed forever. After a brief illness, the matriarch died on February 13, 1842, at age fifty-five. She was the glue that had held them all together, and with her passing the family began to break up. Later her artist-daughter would commemorate the place with her painting *Tullylark, Pettigo, Ireland* (fig. 1.1), which she exhibited at New York's National Academy of Design in 1860 as *Homestead in the North of Ireland.*[7] It depicts a two-story home with a thatched roof nestled on the hillside near Pettigo, the old homestead of her maternal grandparents the Reids. A landscape in the picturesque mode painted in rich greens and browns, it was a fitting tribute to her mother.

No longer able to fulfill his duties, Rev. Pratt retired and took up residence in Enniskillen, where his daughter Deborah lived. Catherine the younger died the year after her mother. Several of the other children left no trail. Adam was already in New York by 1840. In 1848 Rev. Pratt emigrated permanently to America, where Matilda and Eliza headed as well. The old

patriarch resided sometimes with Adam, first in upstate New York and by the early 1860s in Washington, DC, and at other times with his daughters. In 1878 the youngest daughter—now Matilda Despard—published *Kilrogan Cottage*, an account of their lives in rural Ireland thinly disguised as a novel. For the young heroine Eleanor—modeled after her sister Eliza—mobility and impermanence became the defining conditions of their existence. "Her earlier life, as the child of an itinerant preacher, had prevented that intense attachment to locality which makes it a pain to many natures to change their home," her text read. "Though her unsettled life had deprived her of the sweet and restful memories . . . of . . . home," she continued insightfully, "it had compensated by leaving her free from the narrow prejudice . . . which, with dwellers in small communities, so often overspread and strangle all mental growth."[8] Frequent moves and an often-absent father were facts of life.

"Preachers were stationed in almost every town, whence they rode over a circuit many miles in extent. Over wild mountain roads, through untracked bogs, in the by-ways and lanes, went the preacher on his sober, strong horse, with well-filled saddle bags," we read in *Kilrogan Cottage*. "From one farm-house to another the tidings went, 'The preacher is coming!' The farmer best able . . . to receive him sent word to friends and neighbors that his house was to be the place of meeting."[9] As a young girl, Eliza Pratt perhaps occasionally accompanied her father on these excursions and experienced both the thrill and the terror of travel through uncharted territory. Certainly she would duplicate his peripatetic existence in her own adult life, when she occupied many different addresses in New York City, trafficked freely back and forth across the Atlantic between America and Europe, steamed up and down the Hudson River, and traveled along the transcontinental railroad to be one of the first women artists to sketch in the West. The itinerant existence of this Methodist minister imprinted itself on the psyche of his daughter, who adapted it to her life as a traveler-artist.

Some appreciation of and talent for the fine arts were also part of his family legacy. As the son of landed gentry, Rev. Pratt had enjoyed access to fine homes and the artwork hanging in them, but his later life on the Methodist circuit would have confined him for the most part to more humble surroundings. As a boy he also observed his mother Deborah Pratt (née Ringwood) painting watercolors. She had some training, to judge by a pair of watercolors dated 1770 that have survived. Painted at Borris-in-Ossory, in

FIGURE 1.2

Deborah Ringwood, *Borris-in-Ossory*, 1770. Watercolor and pencil on paper, 10 × 14 in.
Private collection.

the countryside northwest of the family home in Rathdowney, they depict a
shepherdess resting on a hillside with her flock, with a cityscape in the back-
ground: one done in sepia and the other in color (fig. 1.2). Perhaps she even
instructed her son in the use of the medium especially during his extended
illness when she would have sought occupations for the bedridden patient.
If so, then Rev. Pratt might have passed on what he had learned from his
mother to his daughter Eliza, and she to hers. "The Greatorex sisters have
in their possession—preserved when many others were dispersed and
lost—a sylvan scene of ideal shepherd and ideal flock, painted by their ma-
ternal great-grandmother, the English wife of a Protestant minister in Ire-
land," one writer pointedly explained. Contrary to popular wisdom, it signi-
fied that "the artistic tendency upon the mother's side is exclusively
feminine, manifest in the mothers and grandmothers rather than in the fa-
thers and grandfathers."[10] In spite of their many moves and financial set-
backs, she always maintained possession of her grandmother's pastoral
landscape, an emblem of the art matriarchy she would eventually perpetu-
ate with her daughters.

Catherine Pratt did not enjoy the same cultural advantages available to her husband. As the daughter of a respectable yeoman farmer, she had limited educational opportunities, but would have had some training in music, needlework, and penmanship—the usual accomplishments for a gentlewoman.[11] These skills she would have passed on to her children, during rare moments of quiet between household tasks. Penmanship was especially important, for church doctrine emphasized that a virtuous woman must write. "A quill as well as a distaff was proper to a lady's hand," as the accepted wisdom went.[12] Surely the matriarch nurtured their love of writing beyond the demands of religious practice, for later two of her daughters—Eliza and Matilda—became published authors. With frequent moves making it difficult to form long-term friendships, family relationships would have been especially close knit, and they depended too on such solitary activities as reading and writing to pass the time.

In 1819, the same year Eliza Pratt was born but thousands of sea miles away in New York City, Herman Melville came into the world on August 1. His father was a prosperous importer, his mother the daughter of Peter Gansevoort, a military hero of the American Revolution. Melville was born on Manhattan's Battery overlooking the bay, the starting point for Greatorex's American life and the initiation point of her artist's book *Old New York, from the Battery to Bloomingdale*. Subsequently both she and Melville traveled for their art but selected lower Manhattan as the basis for some of their most memorable works, which they both published with George Putnam. Of all the writers of the American Renaissance save Walt Whitman (also born the same year), only Melville found material in urban life. Analogously, Greatorex was among the few visual artists to depict the city's historic architecture with consistency.

Her star crossed not only with Melville and Whitman but also with fellow landscape painter Martin Johnson Heade. Born the same year on August 11, in Lumberville, Pennsylvania, Heade too lived a restless existence. He rarely stayed at one address for more than a year at a time and traveled widely, across the United States, into Canada, Central and South America, and around Europe. Only in 1884, at age sixty-five, did he marry, settle down, and acquire a home. Along with a love of nature, it was this itinerant life that he and Greatorex shared. When she sailed for New York City in the 1840s, she joined their generation of American artists and writers.

MAEVE, CELTIC WARRIOR QUEEN

Just west of Sligo, the largest town in the region where the Pratt family resided, there stands a terraced limestone hill called Knocknarea, whose north flank is rimmed with forest. It presents a visually striking profile against the low-lying countryside, positioned on the peninsula jutting out into Sligo Bay. Atop it sits a cairn measuring 180 feet in diameter and 32 feet high, said to have been built for the mythical Iron Age Queen Maeve (the Anglicized form of *Medb*), whose father—the king of Ireland—gave her as a gift the province of Connacht, in west-central Ireland. Archaeologists now believe the cairn may actually date to 3000 BC, far earlier than the Iron Age, but that information does not shake the conviction that Queen Maeve was interred there. To this day it is considered bad luck to remove even one stone from Queen Maeve's grave, a curse that effectively inhibits excavation there. Good luck, conversely, comes to the person who carries a stone up the hill and deposits it on the cairn. Perhaps the young Eliza Pratt did just that.

"When an individual's experience of life in a particular locality becomes encoded by a combination of meaningful landmarks and memorable human events particular to that place," folklorists tell us, "that person has achieved a sense of place."[13] The Irish countryside is filled with sites whose names reference the ancient sagas, but none carry more intense associations than those from the *Táin Bó Cúailnge*. Often referred to as Ireland's *Iliad*, it tells a complex of ancient oral tales set down on pages of vellum by anonymous monks during medieval times (some sources say twelfth century; others say eighth century). Landscape is prominent throughout the text of the *Táin*, in which sites were named for an event that took place or a person who was killed there. That volume has helped to provide the Irish people with strong ties to locale, and by extension a sense of identity.

Queen Maeve is one of the leading characters in the *Táin*, the most famous plundering raid of the Irish heroic sagas. The story begins with "pillow talk" between her and her husband King Ailill. He chides her that it is well that she married a wealthy man. She concurs, then becomes suspicious and asks, "What put that in your mind?" Immediately she demands an inventory of all their worldly goods, to prove that her wealth is equal to his. The inventory bears this out, with the exception of one bull: a white bull that had been in Maeve's herd but left it for her husband's, "refusing to follow the rump of a woman." To tip the balance back in her favor, the queen then asks the King

of Ulster to lend her the Brown Bull of Cooley. When her wishes go unfulfilled, she prevails upon Ailill to join her in mobilizing the armies of Connacht against Ulster. After the men of Ulster fall under a debilitating spell, the teenaged Cúchulainn (not yet an adult man and therefore immune to the spell) single-handedly resists the taking of the Brown Bull. Eventually Maeve secures the bull but—as the tale continues—engages in a final combat from which she is forced to withdraw. That tale, however, was set down by monks, who were not about to proclaim a woman victorious in battle.[14]

The warrior queen provides a female archetype, a long tradition of courageous Irish women wielding extensive influence on their communities and enjoying a fair degree of respect for their physical prowess. It lived down through the ages, continuously retold as each generation emphasized the elements most relevant to its historic moment. "The famous warrior-Queen Meave [an alternative spelling], tall and beautiful, with her white face and yellow hair," former president Theodore Roosevelt wrote in 1907, "terrible in her battle chariot, when she drove at full speed into the press of fighting men, and 'fought over the ears of horses.'"[15] In his account she emerged as a modern woman demanding equality of the sexes: "Her virtues were those of a warlike barbarian king, and she claimed the like large liberty in morals. Her husband was Ailill, the Connaught [sic] king, and," he continued, "their marriage was literally a partnership wherein she demanded from her husband an exact equality of treatment according to her own views and on her own terms."[16] Leadership often finds its roots in a pagan ethos. Celtic history and mythology were rich in such ancient queens, goddesses, and female saints, whose stories allowed their women to imagine new possibilities. Their stories were especially important in a country like Ireland, where the political and religious institutions were rigorously patriarchal and therefore limiting to the lives of real women.[17] The Celtic Warrior Queen inspired mortal females, particularly in the difficult times they faced in the nineteenth century with the hardships and deprivation that led to the Famine. Her spirit must have been especially palpable for those who grew up in the Northwest, in the shadow of her tomb.

Maeve was impetuous, brave, and determined to have her way. These same claims could be said for many Irish women who came after her and took strength in her example. Among them were Eliza Pratt Greatorex, her sister Matilda Pratt Despard, her female children Kathleen and Eleanor Greatorex, and the many other women of Celtic descent who people their story and earned the epithet "Maeve's daughters."

REV. JAMES C. PRATT AND THE LEGACY
OF METHODISM

James Calcott Pratt was born about 1780 near Rathdowney in Queens County (later consolidated with King's County into County Laois) to a family of some means and standing (fig. 1.3). He suffered a prolonged childhood illness and "became a subject of regenerating grace in early life," according to church records.[18] In 1808 he was accepted as a candidate for the Methodist ministry, which he served for thirty-four years until he was made a supernumerary and emigrated to America about 1848.[19] Matilda Despard subsequently recalled their New York residence at Third Avenue and Sixteenth Street, where their expanded family included their widowed father. On the corner stood the old Stuyvesant pear tree that had been planted by the settling Dutch. "The grandsire of our household loved to watch the blooming of the old tree and the ripening of its fruit, and a few of the precious pears which were given to him were brought in to the table with much ceremony and state," she fondly recalled. Considered the oldest living thing in New York, the tree's fruit "made a visible link with the past, of which he was himself a living part, for he had stood side by side in the pulpit of John Wesley, the founder of Methodism, and lived to be his oldest successor in the ministry save one."[20] This direct link between the two men is exaggerated, for Wesley's final visit to Ireland took place in 1789—when James Pratt was about ten years of age—making it unlikely that they stood together in the pulpit. But like most family legends, it has some basis in fact, for her father felt such strong ties to Wesley's teaching that he took up the Methodist calling as a young man and served the church for the next half century.

After his Moravian-inspired "conversion" in 1738, Wesley looked upon the world as his parish, and he made twenty-one preaching visits to Ireland between 1747 and 1789. He professed a genuine love for the Irish, but they did not always love him or his traveling band of itinerant preachers, disparagingly nicknamed Black Caps, Swaddlers, and "cavalry preachers." Slowly the Methodists won over the people and put an end to hostility, so that by the end of the eighteenth century their expansion continued relatively unchecked.

When Wesley died in 1791, there were about fifteen thousand Irish men and women enrolled in Methodist societies with twice as many again coming under the influence of Methodists preaching. Before 1770, such growth had taken place mainly in southern Irish cities and market towns. But

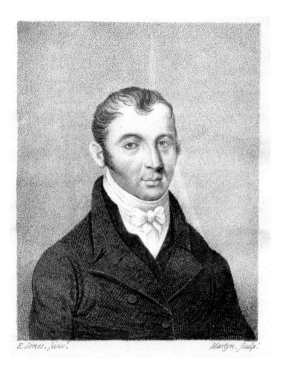

FIGURE 1.3
P. Maguire, engraver, after painting
by E. Jones. *Portrait of James
C. Pratt*, published in *Methodist
Magazine* (1821). Copyright The
Methodist Historical Society
of Ireland.

increasingly from the 1780s, Methodism grew most rapidly within tradition-
ally Anglican populations of the "linen triangle" of south Ulster and the
Fermanagh lake lands where Pratt was assigned. So successful was Method-
ist recruitment in the province of Ulster in the turbulent years at the turn of
the century that by 1815 two-thirds of Irish Methodists lived north of a line
drawn from Sligo to Dundalk, whereas half a century earlier two-thirds had
lived south of that line.[21]

Rev. Pratt contributed to those efforts as he set off on horseback to reach
his congregation in remote parts of the county and delivered his sermons in
a barn or from the back of a cart in the open air, read Wesley's works during
the rare times he was home with his family, and set a constant example of
humility, piousness, and good offices on behalf of the poor. Mirroring the
values of the Methodist Convention, "his sermons were clear, simple, and
practical . . . He always remembered he was an ambassador of Christ . . . and
his Christian and ministerial character was a beautiful combination of gen-
tleness, meekness, and faith." His fellow ministers praised him: "As years

increased, there was a rounding up, a fullness, a maturity, a ripening for heaven, rarely met with." Church records document that "he ended his blameless life in the city of New Jersey, on March 11th, 1870, in the ninetieth year of his age, and sixty-second of his ministry."[22]

Discussions of Methodism have been weighted toward Wesley's defined mission: the poor and neglected of the British Isles. Chiefly associated with evangelization and discipleship efforts, his name has been left out of discussions of the Enlightenment or other aspects of the intellectual history of his time. Recent scholarship sheds needed light on his thought, his appeal for the refined Rev. Pratt, and the lasting significance of that appeal for his daughter. Wesley's influence goes beyond the nature of the future artist's personal faith, which was free of orthodox Christianity. Rather, since Methodism permeated every aspect of her formative life, it exerted a cultural impact that manifested itself in multiple ways.

Wesley's intentions extended beyond the evangelism that is principally linked with his name to effect "reformation not of opinions . . . but of men's tempers and lives; of vice in every kind." A graduate of Oxford and a teaching fellow, he maintained his academic interests after he began preaching to the poor and unlettered of the countryside. Exploring Wesley's ideas in relation to the philosophy of John Locke, Richard Brantley has concluded that the Lockean emphasis on experience as the source of knowledge is a major component of his theology (and subsequently of the romantic revolution in sensibility). "Locke's theory of knowledge formed the intellectual grounding of the Wesleyan movement, lending to it the conviction that true knowledge came from sense perception along with reason." He concludes that Blake, Wordsworth, Coleridge, Shelley, and Keats "owe something of their theory, and much of their practice, to the relation between John Wesley and John Locke. This mix, then, is English Romantic method." Following Brantley's logic, any examination of Wesleyan influence on Anglo-Irish culture must consider subsequent Romantic writers—and by extension, painters.[23] The specific blend of the mundane and the idealized that was foundational to all of Greatorex's work can traced to this lesson she learned at the feet of her minister-father: the Lockean-Wesleyan fusion of experience and ideas. Grounding her imagery in empirical observation of a given motif, she then allowed a degree of idealization in its final realization. These ideas were available through various sources, but in her case, it can be traced to the legacy of Methodism.

A handful of Greatorex's paintings depict Pettigo, a picturesque village straddling Counties Donegal and Fermanagh with few claims on the world's attention but for the fact that it was divided down the middle when the border was drawn between Northern Ireland and the Irish Free State. But that was later, in 1921. In the artist's day it was known as the nearest village to Lough Derg, located approximately four miles from the place of embarkation for pilgrims going to Station Island. This Roman Catholic pilgrimage site had been known for centuries throughout Western Europe, marked on antique maps as prominently as Dublin or Armagh. But it is just a tiny place of a few streets with a population of several hundred. About one hundred miles from Belfast, it feels rather remote even today. Living among low hills, villagers acquired self-sufficient ways.[24]

Rev. Pratt's future wife Catherine Scott was a Pettigo woman, born about 1787 to Walter Scott and Eleanor Reid. As their dutiful daughter, she had an uneventful childhood punctuated by domestic chores, some schooling, religious services, and the cycles of nature and weather to which agrarian communities are attentive. Then "by one of those strange chances which befall even the most tranquil and obscure lives," as Despard narrates, Rev. Pratt "was assigned to . . . the town close to the birthplace" of Scott. There they met and wed in the summer of 1812. She bore him at least eight children and for over thirty years moved with him from town to town on his preaching itinerary throughout the north of Ireland.[25] When she died, she was laid to rest in the Templecarne graveyard on the old road from Pettigo to Lough Derg with generations of her family.[26]

The influential colonial Puritan minister Cotton Mather called women such as her "the hidden ones," virtuous women born in the eighteenth century who questioned neither God nor their husbands and harbored little expectation of being remembered on earth. This fate seemed to befall Catherine Pratt, as for many years researching her artist-daughter I could only establish that she married James Pratt and bore him a family. This is the usual fate of women of her era, when their existence surfaces publicly in only three ways: when they married, gave birth, and died. Death is by far the most frequently recorded activity. Catherine Pratt, her obituary reads, died "On Sunday, the 13th Feb. 1842, in Pettigo . . . in the 55th year of her age, after a tedious illness,

borne with Christian resignation. Her last words were 'Christ is here.'" While this initially appears a rather meager account of an earthly existence, it provides a death date and—extrapolating back—a birth date. The closing line provides further insight: "She leaves behind her an affectionate husband and eight children to lament her loss."[27] At a time and place when death took so many young people, eight of her children survived, which tells us they were of hardy stock. A second, fuller account in the Wesleyan Methodist Church records written by Rev. Pratt provides a few more details.[28]

His words about his wife were far from original, voiced—with slight variations—by other ministers about other women. The eulogy of a good Christian woman was prescribed and adhered to a pattern of godliness basic to the English reformed tradition. But as Laurel Thatcher Ulrich has argued, such funereal commentary can tell us what qualities were publicly praised at a specific time by a specific group of men.[29] From these materials, interpreted in relation to Irish history in those years, a composite portrait begins to emerge.

Around the time of Catherine Scott's birth in the late eighteenth century, the Church of England had long neglected its flock in the northern reaches of the island, leaving it ripe for evangelism. John Wesley had mobilized his followers to become itinerant ministers and travel about converting the local people to Methodism, a practiced captured in Nathaniel Grogan's painting *The Itinerant Preacher* (ca. 1810; Fine Arts Museum of San Francisco).[30] Catherine Scott's parents, as we read in her husband's account, "were an honour to the Wesleyan society, of which they were members." Ministers often praised the education provided by devout parents and the values they instilled in their daughters, and she was no exception: "From early youth her temper was mild, her heart kind, and her manner of life, under religious example and training, very exemplary." Rev. Pratt continued: "In my necessary absence from my family, engaged in the duties of my Circuits, my mind was always calmly confident, knowing her care for our numerous family." Her solid household management freed him to devote himself to his sacred work. "For thirty-four years he prosecuted the work assigned to him with great faithfulness," a colleague reported, "and at the close of that period, broken down in strength and in spirit by his long and earnest service, and by the sorrow consequent on the loss of his beloved wife, he was compelled to become a supernumerary." Most of the details of Catherine's secular life

were omitted, with a brief mention of the illness that took her: "In the latter part of last summer [1841] her health began to decline; and, though many means were tried to restore her, the affliction increased."[31]

A virtuous woman was expected to submit to the will of God, especially in the acceptance of her own death. "In all the time of suffering she united cheerfulness with patience; and confiding in the mercy of God through Christ, expressed herself as free from the fear of death," Rev. Pratt averred. "Some of her last words were, 'Victory, victory, through the blood of the Lamb!' Verses of hymns, such as, 'Strangers and pilgrims here below;' and, 'Now I have found the ground wherein,' &c., were exceedingly refreshing to her; and she sometimes joined in singing them."[32]

It is a rare female obituary that does not contain one reference that departs from the standard tropes to reveal something more personal to its subject, however abbreviated, and in this case we are told: "About twenty-nine years ago, when the late venerable Gideon Ouseley visited this town and neighbourhood, she became experimentally acquainted with the regenerating power of the Holy Spirit."[33]

Ouseley was one of a cast of eccentric characters involved in early Methodism in Ireland, and one of two missionaries who visited Pettigo in 1799.[34] He was a well-educated man from Galway who had lived a reckless life and had lost an eye while trying to separate some of his drunken friends. Converted to Methodism in 1791 through the agency of a quartermaster in the Irish Dragoon Guards stationed in his hometown of Dunmore, his travels took him the length and breadth of the island, preaching to the people in Irish (Gaelic)—often the only language spoken in rural areas, especially by the Catholics—frequently from the back of a horse.[35] It is also recorded that in Pettigo he and another minister named Charles Graham "preached in the street on market day, with great effect on both Roman Catholics and Protestants. Many people followed them afterwards to the house of an eminent townsman called Walter Scott, hoping to hear more."[36] They arranged to have classes taught, and a preaching house was erected on the site of the present church. He and Graham returned several times to Pettigo, where he met Walter Scott's daughter Catherine and catalyzed her spiritual reawakening.

A yeoman farmer who "owned some fields at the town end," Walter Scott and his wife Ellin were civic leaders. They had at least one son, named

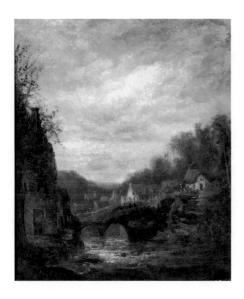

FIGURE 1.4
Eliza Greatorex, *Ivy Bridge at Pettigo*, ca. 1877. Oil on canvas, 20 × 16 in. Ronald Berg Collection.

Adam, who became an apothecary and served the town in that respected profession.[37] Catherine was their only daughter, described as "modest and simple, but with great native force of character," who attracted the attention of the young Rev. Pratt when he—like many Methodist ministers— found "happy accommodation under their roof." His marriage proposal dashed parental hopes for a wealthier suitor, but his gentle upbringing and religious calling were compensation. The couple married on July 23, 1812, and "for thirty years they dwelt in love and peace with each other," sharing a faith that dictated spiritual equality between men and women. Her death left her husband "grey in years, and also eight children, to lament our loss of a most prudent and affectionate wife and mother."[38]

At least three of Catherine's children—Adam, Eliza, and Matilda—went on to establish transatlantic reputations in business and culture. Eliza Pratt returned to Ireland to survey the old place and sketch the local scenery, including *Tullylark, Pettigo, Ireland* (discussed above); *Ivy Bridge at Pettigo* (fig. 1.4), a scene of the old stone bridge that forded the River Termon; and a view of Donegal acquired by her brother (currently unlocated). It was her way of paying homage to her mother Catherine Scott Pratt, who can no longer be counted among "the hidden ones."

CHANGING PERCEPTIONS OF THE COUNTRYSIDE

To state that Ireland is picturesque is to risk cliché. Its signature emerald green vegetation, historic towns, and rocky coastline established it as a tourist destination in the nineteenth century. It also contributed to the formulation of the picturesque aesthetic and exerted a substantial influence on the course of European and American landscape design.[39] The scenery that surrounds a future landscape artist as she grows up bears significance. Also important is the cultural milieu. Since she spent the formative decades of her life among the bucolic hills and vales of Ireland, nurtured in the aesthetic of the picturesque through the paintings she saw and the readings she accessed, it became part of her genetic makeup.

During Eliza Pratt's youth and teenage years in Ireland, the countryside was perceived as an expanse of bogs and meadows and rocky coastlines, lacking firm boundaries or divisional units. Natural landmarks were familiar to the locals and given descriptive names, often in Gaelic, but remained uncharted and unnavigable by outsiders. Then in 1833 a detachment of Royal Engineers arrived and permanently changed perceptions of the landscape. They were engaged on behalf of the British army and government in making the first Ordnance Survey. Work commenced in northwest Ireland, with the initial focus being nearby Sligo, virtually in the Pratts' backyard. The men measured the height of hills and the extent of fields. For cartographic purposes they had to record and translate the local Gaelic placenames into English. In this task they were aided by the residents, who provided knowledge about the terrain and the names given to its features. This information was entered into a book for later insertion into the new maps. Cnoc Ban, for instance, could become Knockban or—directly translated—Fair Hill. It seemed on the surface like a harmless, administrative act, but the countryfolk learned too late that the maps would serve the absentee landlords to their own detriment.[40] Replacing the old estate agents' maps, the new maps were intended to establish legal ownership of property, which meant English ownership. In the short term, however, the curiosity the strangers displayed about the land that its inhabitants had long taken for granted fostered a new awareness among them. It was inevitable that this would help inform the artist's appreciation for its topographical nuances. A map was a geographical tool as well as a mode of visual representation that

aided in picture-making of the surrounding landscape. Beyond establishing spatial coordinates, surveyors inadvertently recorded the Celtic myths and legends that peopled the land through their place-names. The Ordnance maps, therefore, also preserved the Irish past, a lesson that was perhaps not lost on the young woman who would go on to help create a storied past for Old New York.

While few precise details of Eliza Pratt's early schooling have surfaced, it is evident from her subsequent career path as a visual artist and writer that she was the recipient of an education far above that given to most young women in rural Ireland. Almost certainly she attended grade school and secondary school, and was taught needlework, music and drawing: skills considered essential for her gender.[41] Since her parents lived humbly as they moved almost annually from one rural village to another, she likely resided for a time—as suggested by her sister's narrative in *Kilrogan Cottage*—with her paternal relatives, who would have provided the means, stability, and opportunities for her education.

William Ashford's *Mount Kennedy, County Wicklow, Ireland* (fig. 1.5) is representative of the fine art canvas that hung in the great manor houses during her youth. She saw such works most likely on visits to landed gentry she made with her father's people. Ashford represented a high point in the ideal landscape tradition revered across the British Isles. He left Birmingham, England, for Ireland at age eighteen and soon made his name doing topographical views of the country seats with carefully rendered depictions of their houses and surrounding gardens and properties. His ordered representation of architecture in a natural setting was specific enough for recognition and yet sufficiently idealized to encourage nostalgia. The fact that Ashford's *Mount Kennedy* was subsequently published in London by Thomas Milton, as part of the print series titled *Milton's Views* (1787), provided an important precedent for Eliza Greatorex's later practice, when she published her drawings and paintings of New York architectural landmarks as a sequence of prints. Ashford also helped to popularize Irish landscapes sites that she—like many others—painted, including his *Lakes of Killarney* (1778; Fota House, Cork). Whether she saw this particular canvas, a print after it, or other similar works, she must have had access to models of the picturesque landscape tradition that she would carry to America.

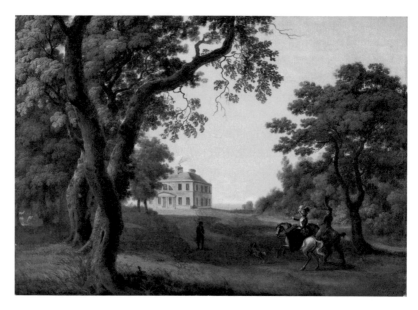

THE BIG WIND

Developments in natural history and the physical sciences were giving humankind a new sense of power over nature. In Ireland wolves had been exterminated, primal forests felled, and vast areas of what had been bog and waste were now surveyed by the Ordnance engineers, ready to be transformed into usable lands. Railroads were opening remote areas to commerce. Ocean travel had been transformed by the invention of the steam engine. People felt a new sense of confidence about their place in the world. This made the events of Sunday, the sixth of January 1839, a night of madness all over Ireland, all the more shocking—and humbling.[42]

The day had started out like any other, with children enjoying the snow and everyone preparing for the festivities of so-called "Little Christmas." But by 3:00 in the afternoon the air became preternaturally calm, the temperature rose, and people had a sense of foreboding. Those who survived remembered it as the most terrifying night of their lives. Along the western seaboard especially, people were convinced they were witnessing the end of the world and prepared to meet their maker. "This town and its

neighbourhood were visited by one of the most tremendous hurricanes that has ever occurred within the recollection of the oldest inhabitants," a Belfast journalist reported. "About eleven o'clock, a violent westerly wind began to blow, which over the course of an hour or two increased into a complete tornado, sweeping everything before it."[43] Children were carried off, never to be seen again; roofs were lifted from churches and houses destroyed. "In many parts of the town the houses rocked as if shaken by an earthquake."[44] On that night—Twelfth Night—the most cataclysmic storm the country had seen in six hundred years hit. It killed residents, destroyed property, and left a path of destruction unequaled in the annals of Irish history.

All the newly acquired scientific knowledge seemed impotent in the face of this cruel, powerful disaster. The Big Wind—as it would go down in legend—was the natural sublime at its most potent, awesome, and fearful. For the future artist it was all the more significant coming on the Epiphany, the feast of revelation when the infant Christ was made known to the world. This Christian celebration overlay the older, pagan festival associated with death and divination, a time when "the living felt the dead very close," as Lady Wilde wrote. Witness to these events, the members of the Pratt family were acutely aware of the pain and destruction wrought on Rev. Pratt's flock. But for a twenty-year-old woman invested in the study of art and nature, the Big Wind of 1839 made not only a physical and emotional impact but an intellectual one as well. Eliza Pratt absorbed the lessons of this potent storm, which informed her treatment of the sublimity of nature in the Alps, in the Colorado Rockies, and on the banks of the Hudson. More people found themselves homeless on that night than were evicted between the years 1850 and 1880. Its horror has therefore been compared to the Famine, which wreaked havoc on human life the way the storm did to property.[45]

FAMINE IRELAND

Lady Jane Francesca Wilde wrote under the pen name Speranza (Hope) in the Irish Nationalist paper *The Nation* in 1847, the worst year of the Famine. Best known today as the mother of celebrated novelist and playwright Oscar Wilde, she was in her own day distinguished as a folklorist, political activist, and advocate for women's rights. She accused the British of deliberately starving the Irish to death and warned that the government officials

and landlords would be answerable at the Last Judgment. More than an accusation, it was a clarion call to Irish nationalists to take action. Lady Wilde shaped the way people would think about the Famine on both sides of the Atlantic. Her poem "The Famine Year" (first titled "The Stricken Land") conveys better than any prose description could the horrors of that avoidable tragedy, and so it is inserted here.

THE FAMINE YEAR

A POEM BY "SPERANZA"

Weary men, what reap ye?—Golden corn for the stranger
What sow ye?—human corpses that wait for the avenger.
Fainting forms, hunger-stricken, what see you in the offing?
Stately ships to bear our food away, amid the stranger's scoffing.
There's a proud array of soldiers—what do they round your door?
They guard our masters' granaries from the thin hands of the poor.
Pale mothers, wherefore weeping—would to God that we were dead;
Our children swoon before us, and we cannot give them bread.

Little children, tears are strange upon your infant faces,
God meant you but to smile within your mother's soft embraces.
Oh! We know not what is smiling, and we know not what is dying;
We're hungry, very hungry, and we cannot stop our crying.
And some of us grow cold and white—we know not what it means;
But, as they lie beside us, we tremble in our dreams.
There's a gaunt crowd on the highway—are ye come to pray to man,
With hollow eyes that cannot weep, and for words your faces wan?

No; the blood is dead within our veins—we care not now for life;
Let us die hid in the ditches, far from children and from wife;
We cannot stay and listen to their raving, famished cries –
Bread! Bread! Bread! and none to still their agonies.
We left our infants playing with their dead mother's hand:
We left our maidens maddened by the fever's scorching brand:
Better, maiden, thou were strangled in thy own dark-twisted tresses –
Better, infant, thou wert smothered in thy mother's first caresses.

We are fainting in our misery, but God will hear our groan:
Yet, if fellow-men desert us, will He hearken from His Throne?

Accursed are we in our own land, yet toil we still and toil;
But stranger reaps our harvest—the alien owns our soil.
O Christ! how have we sinned, that on our native plains
We perish houseless, naked, starved, with branded brow, like Cain's?
Dying, dying wearily, with a torture sure and slow –
Dying, as a dog would die, by the wayside as we go.

One by one they're falling round us, their pale faces to the sky;
We've no strength to dig them graves—there let them lie.
The wild bird, if he's stricken, is mourned by the others.
But we—we die in a Christian land—we die amid our brothers,
In the land which God has given, like a wild beast in his cave,
Without a tear, a prayer, a shroud, a coffin or a grave.
Ha! But think ye the contortions on each livid face ye see,
Will not be read on judgement-day by eyes of Deity?

We are wretches, famished, scorned, human tools to build your pride,
But God will take vengeance for the souls for whom Christ died.
Now is your hour of pleasure—bask ye in the world's caresses;
But our whitening bones against ye will rise as witnesses,
From the cabins and the ditches, in their charred, uncoffin'd masses,
For the Angel of the Trumpet will know them as he passes.
A ghastly, spectral army, before the great God we'll stand,
And arraign ye as our murderers, the spoilers of our land.[46]

"DANCING 'TWEEN DECKS" AND ARRIVING IN NEW YORK CITY, "THE MOST IRISH CITY IN THE UNION"

Among the multitudes who fled Ireland for America was Eliza Pratt. Decades later she commenced her book *Old New York, from the Battery to Bloomingdale* (1875) with her drawing *The Battery and Castle Garden* accompanied by her sister's text: "The stranger is happy if, in coming to New York, his first approach is through the Narrows and up the bay to the Battery. Thirty years have not effaced the recollection of the city seen for the first time in the magical light of an October day, after a voyage of nearly as many weeks as now days, in an unwieldy sailing ship." Evoking their own feelings upon arrival, she continued: "The transition from the dull days of calm and the tossing of contrary

winds to the life and brightness of the Bay was like the opening of the new heavens and the new earth."[47] Her description idealized that long-ago event and omitted all references to the difficulties of the transatlantic passage. Travelers from across Ireland had to make their way to the ports of Dublin, Cork, or Belfast and cross the Irish Sea to their point of embarkation: Waterloo Docks, Liverpool, where they booked passage across the Atlantic. "The road from Liverpool to New York, as they who have traveled it well know," Transcendentalist poet Ralph Waldo Emerson observed, "is very long, crooked, rough, and eminently disagreeable."[48] Like other privileged passengers, Emerson traveled in the relative comfort of a private cabin and was served his meals in a common area for dining and socializing. At age twenty-eight, Eliza Pratt left Liverpool bound for New York on the SS *Speed*. Records indicate that she traveled in steerage, where she slept, took her meals, and wiled away the long days in the dark, damp, and cramped common quarters below deck.[49] Included in the price of the ticket were staple food supplies, but steerage passengers were obliged to prepare them for themselves. "From Liverpool each passenger receives weekly 5 lbs. of oatmeal, 2 ½ lbs. of biscuit, 1 lb. flour, 2 lbs. rice, ½ lb. sugar, ½ lb. molasses, and 2 ounces of tea. He is obliged to cook it the best way he can in a cook shop 12 × 6!," a physician reported. "This is the cause of so many quarrels and many a poor woman with her children can get but one meal done, and sometimes they get nothing warm for days and nights when a gale of wind is blowing and the sea is mountains high and breaking over the ship in all directions." He concluded: "Reform must be made to better the condition of the poorer classes of emigrants."[50] Cutaway ship drawings reveal the constricted quarters and primitive bunks that made up steerage, also called the 'tween deck for its position between the cabins and the hold. These are the conditions she endured to get to America.

Along with physical hardships, passengers had to contend with the psychological dimension of their breaking ties with home, which in most cases they would never see again. The crossing could last more than a month, depending on weather, and was full of emotion. During such great social migrations, which removed people from familiar surroundings and traditions into unfamiliar ones, emigrants relied upon the "mobile arts" for cultural expression and remembrance. Historians have included song, music, and dance in this category, citing evidence in newspaper illustrations that show Irish steerage passengers dancing 'tween decks. Sociologists have suggested that such dance articulates embedded stories and offers a way of

performing memory and confirming their hopes for the future. But "mobile arts" can also refer to physical objects—a picture of a loved one, a statuette, a bit of textile or chinaware. Among her meager possessions, Eliza Pratt carried with her the watercolor by her paternal grandmother, Deborah Ringwood Pratt. It depicted an ideal landscape with a town in the distance, flanked by a shepherdess: an artifact deeply connected to family and motherland. Throughout her peripatetic existence she rarely called one place home for long but always kept this pictorial relic close at hand. Her own art would be driven by a quest for home and hearth. Her books from *The Homes of Oberammergau* to *Old New York* depicted aged domestic structures as containers of history and memory.

This condition of "betweenness"—of being suspended between two worlds—also contributed to the acuity of Greatorex's pictorial observations. Eva Hoffman, in "The New Nomads," describes the condition of exile that "places one at an oblique angle to one's new world and makes every emigrant, willy-nilly, into an anthropologist and relativist; for to have a deep experience of two cultures is to know that no culture is absolute." Hoffman's words speak directly to the artist's situation. She observed closely the domestic life and setting of others and began "to discover that even the most interesting and seemingly natural aspects of our identities and social reality are constructed rather than given and that they could be arranged, shaped, articulated in quite another way."[51] These revelations were all put to the service of her art.

Between 1845 and 1855 more than 1.5 million adults and children departed Ireland to seek refuge in America, landing first in Manhattan. The city's population was estimated at four hundred thousand, more than double what it had been in 1825. It still confined itself to the lower end of the island, but now it reached Fourteenth Street. The Croton reservoir system had been completed to great acclaim, which meant clean and plentiful water for drinking and bathing. Gaslights replaced oil lamps. All this must have seemed a world away from rural Ireland. How were the new arrivees to survive, much less stand out, against such odds? Having reached the United States in advance of other family members, Adam Pratt laid the groundwork. They all seem to have been quickly linked into the extensive network of influential Irish Americans, including close associations with descendants of the famed Irish rebels: the Emmets and the Despards.

Robert Emmet was among the prisoners who had been incarcerated in the dreaded eighteenth-century Kilmainham Gaol. He was the leader of a

political uprising who was hanged, drawn, and quartered in 1803. In his speech from the dock during his trial, he famously requested that his grave go unmarked until Ireland was a sovereign nation. As a result, the whereabouts of his body remain a mystery to this day. But his ghost, it is rumored, is watching out for his enemies in Dublin's oldest pub, The Brazen Head, where Emmet once held resistance meetings. More significant for the Pratts, his spirit extended its hauntings to New York City, where his brother Thomas had relocated.

Thomas Addis Emmet (1764–1827) trained first in medicine and then in law, spent four years in prison for leading the failed Irish uprising of 1798, and then was released on the condition that he go into permanent exile. He lived first on the Continent, primarily Paris. In 1804 (following his brother's execution) he emigrated at age forty to America, where he became "the favorite counselor of New York." There his interest in the Irish cause continued, and he was of invaluable assistance to many of the early Irish immigrants in the United States. Emmet was a close friend and the lawyer of Robert Fulton, and was painted by famed portraitist Gilbert Stuart in his youth and by artist-turned-inventor Samuel F. B. Morse in his late years. Their family has a distinguished history of involvement in culture as well as in politics. His grandson Thomas Addis Emmet (1826–1919) enjoyed a distinguished medical career and assembled an important collection of historic images of New York that was later bequeathed to the New York Public Library. He became a loyal supporter of Eliza Greatorex, and she in turn honored his family with an entry in her book *Old New York*. The obelisk-shaped monument to the old rebel Thomas Addis Emmet stands to this day in the churchyard of St. Paul's Chapel of Trinity Church (fig. 1.6), one of the few structures erected to honor an Irishman in nineteenth-century New York.

Their extensive Celtic American network included not only the Emmets but also another familiar name in Irish history. Matilda Pratt married Clement Despard, a descendant of Colonel Edward M. Despard. The elder Despard, once comrade-in-arms to Admiral Nelson and an Irish-born British colonel turned revolutionary, was executed for high treason in 1803, the same year as Robert Emmet, for plotting to assassinate George III. (In fact, he had the bad luck to be the last person to be hanged, drawn, and quartered in England.) His primary loyalty was to Ireland's separation from England, and his descendants too turned up in New York.[52]

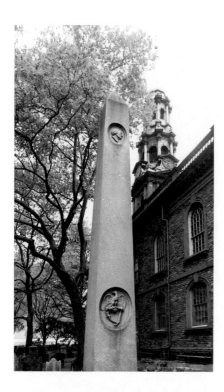

"COME AND SEE ADAM PRATT"

On March 19, 1840, Adam Scott Pratt (fig. 1.7) disembarked from the ship
Frankfurt from Liverpool to set foot for the first time on American soil. After
spending some time in New York City, he headed upstate to settle in Le Roy,
New York (outside Rochester), where other members of the extended Pratt
clan had previously arrived and opened doors for him.[53] He quickly estab-
lished himself in business and acquired a residence in the small town. By 1843
the upstate press reported that he was going back and forth to New York City
to obtain cashmere, shawls, and other merchandise for Pratt's One Price
Cash Store. He must have combined business with pleasure on these trips,
for before long he was engaged. In May 1844 the *Le Roy Gazette* announced his
marriage to Sophia M. Philips, daughter of William Philips, Esq., of Brooklyn.
Rev. Dr. Cutler officiated at the wedding that took place in St. Ann's, a Brook-
lyn institution that goes back to the eighteenth century. As the first and for
many decades the only Episcopal Church in Brooklyn, St. Ann's was the place
of worship for many of the city's founding families.[54] In its broad outlines his

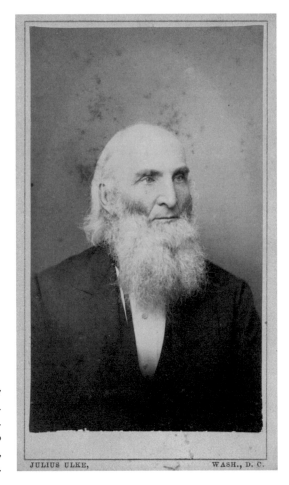

JULIUS ULKE, WASH., D. C.

FIGURE 1.7
Julius Ulke, *Adam Scott Pratt*, 1883.
Carte-de-visite, 4 × 2 ½ in.
Private collection (on verso
"Mr. Pratt, Dec. 3, 1883, Washington,
D.C." written in pencil).

story conforms to patterns of nineteenth-century immigration to America, in which an intrepid individual left his old life to create a new one across the Atlantic where other nuclear family members gravitated. In his case, however, it was marked by more than the usual degree of success.[55]

Possessing a good sense for finance and retail strategies, he kept an eye on metropolitan fashions and collaborated with a well-respected shipping company to ensure that he was the first to introduce them to his regional market. "Adam Pratt would announce in public in general and to the ladies in particular," the press reported, "that he has received at his *One Price Cash Store*

a new and beautiful lot of goods direct from New York via Pomeroy's & Co. Express in the prices and styles of a few which he would beg us to direct attention."[56] After marriage he took an increasingly prominent role in local politics, attending town meetings and serving as vice president of the 4th of July Committee.[57] Up to this point he had been operating with a partner, J. A. Parsons, but on April 1, 1846, it was announced that the partnership had been "dissolved by mutual consent. The business will hereafter be conducted by J. A. Parsons."[58] Pratt then opened an independent establishment and by 1849 was beckoning shoppers with what became his signature call: "Come and see Adam Pratt—Bargains, Staple goods, astonishing low prices, to the Ladies."[59] Since A. J. Stewart had only opened the doors to his pioneering New York City department store on September 14, 1848, Adam was clearly in on the ground floor of the retail business. (John Wanamaker was Stewart's contemporary and competitor in Philadelphia.) By May 1850 Adam Pratt had a "new Cash Store, 10 Main Street, with a lot of superior clothes of the richest colors . . . Also a large lot of ladies' bonnets for sale at his usual low prices." And by fall of that year he offered ready-made garments, the latest boom in clothing that replaced made-to-order clothing with prefabricated items.[60] The 1850 US Census tells us that by then his growing household included his widowed father James C. Pratt as well as Betty Humphrey, most likely the housekeeper.[61] Through the 1850s Adam continued to fulfill his civic and religious duty, serving as village clerk[62] and as superintendent of the Sunday school.[63] The visits of his sisters and their husbands were reported in the local newspaper, including accounts of their joint musical performances in the local church.

With the stock market crash of 1857, the business climate changed and the ever-nimble Adam Pratt changed with it. Two years later he had joined with A. O. Comstock in opening an insurance office, offering insurance "at any hour of the day, with the most reliable Companies in the United States." But his days in upstate New York were numbered. By 1860 his skills had come to the attention of leaders in Washington, DC, where he was offered a position in the government. That June he advertised a sale of the family's household furnishings in the *Le Roy Gazette* and departed soon after.[64]

Throughout the Civil War Pratt served in the Treasury Department, where he became chief of the Redemptive Division. The National Bank Act, enacted during the war, required each national bank to maintain an agent in Washington, in part because the Treasury issued currency on which the

individual banks' names were printed. The amount each bank could legally issue was closely controlled, and the bank's agent personally witnessed the printing of new currency and the destruction of the old so that the Treasury and the bank would always be in accord on the quantity each bank had outstanding. Over time the use of checking accounts largely superseded the practice of banks issuing their own currency, which finally ceased during the Depression of the 1930s. In 1867 Adam departed government service and established his own company, which started as a Washington agent for national banks. It is still operational today, under the name A. S. Pratt & Sons.[65]

Following his Methodist upbringing, Adam mated his business activities to an unfailing social commitment. In Washington during the Civil War, he devoted weekends and free evenings to the sick and wounded who had been brought from the battlefields. In the summer of 1863, shortly after the Battle of Gettysburg, he wrote to his former neighbors in Le Roy: "You have done much already by liberal and timely gifts to alleviate suffering, and no doubt you are still working and will continue to work as long as there is a necessity." He implored them for help: "A good supply of pure Native wine is much needed and would be of the greatest blessing to the suffering men; and it is to *stimulate* you to action on this matter that I now address you." Resuming his old advertising habits, he appealed to the "Ladies . . . the mainspring in all benevolent action" and asked them "to convert a portion of their Raspberries, Currants, Rhubarb, Grapes & Col into Wine for the Hospitals. You cannot tell the benefits that such a gift will . . . be—for many a proud Father, Husband, Son, or Brother."[66] He also provided major backing for the Young Men's Christian Association and the all-black Howard University Medical College. Equally important for our story, he was a staunch supporter of his sister's career and children. He served as mentor to her fatherless son Tom Greatorex, for whom he secured a position as page in the Treasury Department. This allowed his nephew to gain experience, which he applied when he too ventured into the world of business, in his case out west.

After 1860 Adam Pratt made his home in the District of Columbia on Eleventh Street NW, where the artist and her children were frequent visitors. There she expanded her New York network to embrace his associates, many of whom were the capital's business and cultural leaders. This included William H. Corcoran, who had opened his gallery of art across the street from the Executive Office of the White House in 1870. A friend and

business associate of Corcoran's, Adam Pratt made frequent visits to his gallery, accompanied by his sister when she was in town. On several occasions Mr. Corcoran himself guided them on their tour, pointing out his special treasures and pondering the acquisition of works by her as well as Toby Rosenthal's portrait of her.[67]

In these years Adam Pratt also speculated in real estate in Virginia, where he established a health spa at Rock Enon Springs. He was succeeding in business while Greatorex was charting a career in the visual arts and Matilda Despard pursuing her literary ambition. All were enterprising and breaking certain prescribed boundaries, but their pathways were still bounded by gender: the men in business, the women in culture. In typical Irish tradition, they forged strong family ties that endured throughout their lives.

1848: NEGOTIATING THE NEW AMERICA

In 1848 at age twenty-eight Eliza Pratt arrived in New York City.[68] She soon met Henry Greatorex, married him in 1849, bore him three children, and resumed the artistic endeavors she had begun back in Ireland. It was a seminal moment to be taking up a new life in America, when historical events contributed to shaping her multifaceted career.

On all fronts—political, social, artistic, and economic—the year 1848 was tumultuous. On February 26, Karl Marx and Friedrich Engels published their *Communist Manifesto*, in which they declared: "The history of all hitherto existing society is the history of class struggle." They identified this moment as "the epoch of the bourgeoisie," which "has simplified the class antagonism. Society as a whole is more and more splitting up into two hostile camps, into the bourgeoisie and the proletariat." The opening of A. J. Stewart's first department store later that year in New York signaled a new phase of urban, bourgeois capitalism and the site where women would begin to exert their economic power.

Gold was found in California, prompting thousands to head "the plains across, the Horn around, or the Isthmus over" to get from the East to the West Coast. The Irish Potato Famine, which had begun with blight three years earlier, drove thousands out of their homeland and across the Atlantic. Sweeping through Europe in 1848, a wave of revolutions ended the Orleans monarchy (1836–48) in France and brought about the Second French Empire. Uprisings elsewhere triggered the Italian *Risorgiamento* and the rise of Prussia, which led to the unification of Italy and Germany, respectively.

Turmoil on the continent triggered transatlantic immigration, which contributed to a growing foreign population in America. The Fourth of July that year was celebrated with the dedication of the Washington Monument on the National Mall in Washington, DC. President James Polk (1844–48) presided over the ceremony. In 1845 journalist John O'Sullivan coined the term "Manifest Destiny" to denote a general belief in the nation's divine mission to expand its territory across the continent, and with the Treaty of Guadalupe Hidalgo ending the US-Mexican War (1846–48) that mandate was realized. Mexico ceded its northern territories to a United States that thus was extended from sea to shining sea.

On February 14 Polk was photographed by Mathew Brady, making him the first president to be photographed in office and signaling the new importance of the visual arts in American political and cultural life. Effie Gray married John Ruskin, a British art critic whose extensive writings were just beginning to have significant impact in the States. Poet Walt Whitman spent three months in New Orleans, his first time away from New York, in a career-shaping interlude. The Fox sisters from upstate New York gained national attention for their claim that they could communicate with the dead. On February 14, Hudson River School founder Thomas Cole died at his home in Catskill, New York. His Memorial Exhibition held later than year would be an eye-opening experience for the next generation of landscape painters to whom he passed the torch.

Expatriate Hiram Powers's neoclassical marble sculpture *The Greek Slave* (1841–43) was concluding its international multicity tour in 1848. Widely displayed, executed in multiple versions, and covered extensively in the press, this life-sized female figure symbolizing aesthetic purity and grace became the most famous statue of the day. For the more than one hundred thousand viewers who paid to see *The Greek Slave*, it became the "emblem of the trial to which all humanity is subject, and may be regarded as a type of resignation, uncompromising virtue, or sublime patience."[69] Americans at mid-century commonly searched for such didactic and moral messages in fine art.

Eighteen forty-eight saw the American Academy of Arts and Sciences elect to its membership Nantucket Quaker Maria Mitchell, who went on to distinguish herself as the country's first female astronomer. Her discovery of a new comet on an October night the previous year thrust her into the international spotlight. On her extensive lecture tour, she was celebrated by foreign royalty and won many new converts to the field. In 1865 she became

professor of astronomy at the newly founded Vassar College, where she played a significant role in women's education.[70]

In 1848 the female genre painter Lilly Martin Spencer and her husband Benjamin Rush Spencer moved from Ohio to New York City. She quickly began to make her presence felt through the exhibition and distribution of her work by the American Art-Union (1839–51), a subscription-based organization aimed at shaping a public for national art. "Each subscriber of five dollars becomes a member of the Art-Union for the year. The money thus obtained . . . is applied first, to the production of a fine and costly engraving from a choice painting, of which every member receives a copy," a guidebook to New York explained. "Second, to the purchase of paintings and sculpture by native or resident artists, which are publicly distributed by lot amongst the members at the annual meeting in December. The works of art distributed in this manner, in 1844, numbered ninety-two."[71] Yet, though Lily Spencer was the most popular and widely reproduced female artist of the AAU, she remained financially distressed, since she only received profits from the sale of the original paintings and not from the sale of the proliferation of prints after her paintings.[72] Her women and children in domestic interiors done in a realist style were the polar opposite of Powers's idealized figures.

The Seneca Falls Woman's Rights Convention, organized by Elizabeth Cady Stanton and Lucretia Mott on July 19 and 20, 1848, witnessed the first serious proposal of votes for women in the United States. Black abolitionist Frederick Douglass, then editor of the *Rochester North Star*, helped swing the support of the crowd to accept the suffrage resolution. He had only recently returned from an extended lecture tour in Britain and Ireland, where he found a friend in Daniel O'Connell, leader of the crusade for Irish freedom. An eloquent speaker, the fugitive slave was trying to effect a coalition between the Irish immigrant working class and African American slaves.[73] Whether Eliza Greatorex heard Douglass speak back in Ireland or was among the crowd of three hundred people in Seneca Falls—not far from her brother's home in Le Roy—goes unrecorded. We do know that she and her brother were sympathetic to their cause, and that he became a major donor of the all-black Howard University.

At the closing session, Lucretia Mott won approval of a final resolve "for the overthrowing of the monopoly of the pulpit, and for securing to woman equal participation with men in various trades, professions, and commerce." One hundred men and women signed the Seneca Falls Declaration, although

subsequent criticism caused some to remove their names. Editor James Gordon Bennett printed the entire Declaration of Sentiments in his *New York Herald*. Motivated by derision, its publication served the larger purpose of informing its huge readership of the cause of women's rights.[74] For the women involved, it gave them a sense of identity, a confirmation that they were not alone in their feelings of frustration and desire for better social standing. It also conferred a new sense of confidence that collectively they were stronger than they had realized. Greatorex took advantage of the opportunities for women and for artists that this new land offered. Eighteen forty-eight marked a major crossroads in the history of the world and of this woman artist, who was beginning a new phase of her life.

2

ART, DOMESTICITY, AND ENTERPRISE, 1850–1861

BECOMING A LANDSCAPE PAINTER

"Mrs. Eliza Greatorex . . . has been rapidly rising into favor as an artist, and whose landscapes, both in crayon and oil, are now highly appreciated," the *New York Times* reported in March 1855. It referenced her debut at the National Academy of Design, the nation's premier exhibition venue, with a work titled *Moonlight*.[1] The handful of women who had shown at the academy up to this point specialized in figural subjects, foremost among them miniaturist Ann Hall and genre painter Lilly Martin Spencer. By contrast, Greatorex aimed to become a professional landscapist.

In 1848, as Eliza Pratt and Henry Greatorex were courting, Thomas Cole—father of the Hudson River School—passed away. "His death has spread a gloom not only over the immediate circle of arts professors, but it extends far and near," John Falconer wrote to Jasper Cropsey, "and the nation may be said to mourn the loss of so great an artist and so good a man—and the press now teems with eulogistic notices."[2] Given the publicity surrounding not only Cole's death but also his Memorial Exhibition held at the American Art-Union in April, it is likely that the couple were among the audience viewing Cole's paintings. Greatorex had acquaintances in

Hartford, where he had resided in the early 1840s, including Daniel Wadsworth, Aaron Goodman, and others in Cole's circle, which would have provided added incentive for them to attend his retrospective exhibition.[3] Inspired by Cole's example, his wife-to-be began to expand upon the training in drawing and watercolor she had received in Ireland to work with the more challenging medium of oil paint.

As a young artist in New York in 1827, Cole hosted the first meeting of what became the Sketch Club in his rooms at 2 Greene Street. The club provided a gathering place for the city's artists and cultural leaders to work and socialize together. Eliza Greatorex became "one of the two lady members of the Club," as a journalist reported.[4] New York was and is a city of clubs that artists depended upon to make social and professional contacts and potential sales. Since the Sketch Club was one of the few organizations open to female membership, it provided a rare opportunity for her to interact with some of the city's foremost visual artists, to work side by side with them at the homes of the host-members, and to become acquainted with writers, critics, and patrons. By 1855 the press was reporting on the productivity and creativity she displayed at these gatherings.

Between 1854 and 1856, she met and began studying landscape with William Wallace Wotherspoon, a fellow club member who had emigrated from Scotland. Throughout these years she seemed most comfortable with other former residents of the British Isles, as teachers, supporters, and friends. She also sought instruction from William Hart, another member of the Sketch Club and one of a large family who had come from Paisley, Scotland, to settle in the Albany area. Hart's canvases demonstrate his adherence to the Hudson River School principles codified by Cole and Durand that he passed on to his female pupil. Works such as *Bloomingdale Farm* (fig. 2.1) embody lessons she learned from him, including a brushy treatment of sky and clouds. But already she was asserting her independence by inserting what would become her hallmark—a focus on domestic architecture nestled within the terrain—although at this early stage their forms were not yet sufficiently differentiated.[5]

Ambitious for more advanced study, however, she initiated her pattern of leaving her children in the care of family members and heading across the Atlantic. "Went to England and Ireland for drawings of lake scenery in 1856/57," she reported. There she made studies for the scenes she displayed back in New York: *Glen of the Downs, Ireland*, shown in 1856, and *Wicklow*

Castle, in 1857.[6] At the time of the exhibition, *Glen of the Downs, Ireland* was already in the collection of Madame Bailini, wife of the tenor Francesco Bailini, a member of the Astor Place Opera Company who often performed in New York.[7] Living in America less than a decade, Greatorex was already receiving support from the city's musical and cultural elite, and increasingly from other women.

She demonstrated her already distinctive approach to landscape at this formative stage in *Tullylark, Pettigo, Ireland* (see fig. 1.1). Small in scale, it represents a picturesque Irish village on the border between the present-day counties of Donegal and Fermanagh. The artist tended to favor settled over wild nature and rendered the whitewashed façade of the Tullylark homestead surrounded by vegetation. Her compositions were often bifurcated: one half is filled with a screen of trees while the other side, with a lower horizon, features a fuller expanse of sky. She applied the paint in broad strokes of green and brown to suggest rather than detail the foliage and foreground terrain. The scene is contained in an arch-shaped frame, a retrospective format. There is a romantic air about the picture, a striving to capture a feeling about nature and history rather than a portrait of the place. It emits nostalgia for a past time when man and nature were in harmony.

Her deep feelings for nature were expressed not only in pictures but also in poetry, a duality that had been characteristic of Cole. "At a late meeting of *The New-York Sketch Club*," we read in the press, "the subject for illustration being 'Spring,' Mrs. Eliza Greatorex, in addition to a very beautiful drawing, contributed ... exquisite verses, which were read before the Association by Mr. James Cafferty, the host of the evening." Taking up the age-old theme of the passage of the seasons, Greatorex wrote:

> The meadows by the silver stream,
> The hawthorn in the glen,
> Are laughing out again,
> And ragged Robin-run-the-bush
> Is busy with his chain,
> Clasping the blushing briar-rose,
> That seeks escape in vain.[8]

In this single verse that occurs midway through the poem, she conveys a view of animate nature. The emphasis is on the inevitability of its cycles, the impossibility of escaping from its patterns, but at the same time the small joys to be gleaned from each element of its passing phenomenon. For the *Knickerbocker* editor, her poem was "delicate and felicitous,"[9] aligned with a Romantic sensibility that looked to nature as a beneficial force, a source of sensual pleasure, moral instruction, and of course artistic inspiration. She looked not to the crashing waterfalls of the sublime, but rather to the quiet "silver stream" of the picturesque. Although she faced the changes of the modern world, and arguably lived a liberated life, she was at heart a child of the late eighteenth century.

Also like Cole, Greatorex countered her romantic imaginings with direct study of nature. In 1858 she exhibited at the academy a work titled *Sketch from Nature*, followed in 1859 by *Study from Nature* (owned by a Mrs. Owen); *Village in the North Countrie, Ireland—Sketch from Nature*; and *Ross Castle, Killarney, Sketch from Nature*.[10] Her picture-making linked a sensibility steeped in literature and music with close observation of what she saw in front of her, a blending of the ideal with the real. Her contemporaries, after all, wanted neither a totally idealized work nor one that was too literal. She adopted the realist practice of working before the motif and confessed her struggles to balance direct study with the demands for making a pleasing

picture. "I am trying in earnest," she explained, "to make my pictures like the real places."[11] Her efforts soon caught the attention of Elizabeth Ellet.

ELIZABETH ELLET: MOTHER OF THE HISTORY OF WOMEN'S ART

"Mrs. Greatorex is a landscape painter of merit, and is rapidly acquiring distinction," we read in Elizabeth Fries Lummis Ellet's groundbreaking book *Women Artists: In All Ages and Countries* (1859). "She has a deep love of wild mountain and lake scenery, dark woods, and rushing waters; and her productions are marked by the vigor of tone and dashing, impetuous freedom of touch especially adapted to that kind of subjects [sic]."[12] It marked a milestone for the artist, who "has painted many pieces of romantic scenery in Scotland and Ireland" that she had been exhibiting in New York since 1855. Ellet deliberately accentuated traits in her work that were generally regarded as the province of male artists: "This felicitous boldness she has in a remarkable degree, and her works are marked by truthfulness as well as strength."[13] Women artists were rarely credited with being strong, bold, or true.

Ellet's endorsement of Greatorex at this early stage of her career helped to put her on equal footing with the rising male Hudson River painters.[14] The author led the way in awakening readers to the historical roles played by women and insisted on using primary documents in her reconstruction of the past that gave her work authority. Prior to *Women Artists*, she published two popular histories intended for general audiences: *Pioneer Women of the West* (1852) and *The Women of the American Revolution* (1848, two volumes, in its fourth edition by 1850). In her interpretation, undisputable data pointed to the fact that women nurtured and guarded the spirit of liberty so necessary for the nation's founding. Ellet closely identified with colonial Boston historian Mercy Otis Warren, author of *The History of the Rise, Progress, and Termination of the American Revolution* (1805, three volumes) and Massachusetts wife and mother whom John Singleton Copley had sensitively portrayed.[15] Ellet was extremely fortunate in finding a same-sex role model in Warren, who boosted her confidence and helped guide her career.[16]

Continuing her narrative from the Revolution through the westward migrations, Ellet articulated the role of the pioneering women in the settling of the frontier. Like her male counterparts George Bancroft and William Prescott, she viewed history through a romantic lens and located the spirit of America in the heroic actions and shared dreams of its people. A remark

by Lydia Maria Child on the invisible female artist decided her next project, for which she identified literally hundreds of long-forgotten painters and sculptors. In format she followed Giorgio Vasari's *Lives of the Artists* (1550) and provided a series of sketches of individual women intended "to give such impressions of the character of each distinguished artist as may be derived from a faithful record of her personal experiences."[17] She discussed each artist within her cultural context according to the tenets of Hippolyte Taine, with special attention to the condition of women prevailing at each historic juncture.

Ellet was one of a handful of women actively engaged in the recovery of women's history including Lydia Maria Child, Margaret Fuller, and Elizabeth Oakes Smith. She began to collect a usable past for women and to demonstrate that they had a history worthy of telling. Unlike Fuller or Smith, however, she never fashioned her material into an argument for women's rights. Her position within the social terrain of the 1850s was ambiguous, for she was at once "the most industrious historian of the American woman" and a self-professed anti-suffragist. Surveying a broad swath of history, her texts helped insert women into American political and art history. From ancient Greece to the nineteenth century, her narrative culminated in America, where she was convinced that the woman as artist had come of age, a wondrous figure capable of great things. Ellet's assessments of miniaturist Anne Hall, genre painter Lilly Martin Spencer, and sculptor Harriet Hosmer all emphasized the success she regarded as proof positive of feminine artistic power.[18] She explained in her preface the lack of precedents for her study: "I do not know that any work on Female Artists . . . has ever been published, except the little volume issued in Berlin by Ernest Guhl, entitled *Die Frauen in die Kunstgeschichte*."[19] Guhl's work became one of her primary building blocks, to which she added more personal information on "women devoted to the brush and the chisel."[20] While his coverage ended with the eighteenth century, she forged ahead alone to address nineteenth-century, living artists.

One only has to peruse the standard biographical source on American artists, Henry T. Tuckerman's *Book of the Artists* (1867), to appreciate Ellet's efforts. "Among other genre painters who have won more or less credit and manifested certain kinds and degrees of talent," Tuckerman wrote, "are Bingham, Comengys, Pratt, Barrow, Peele, Stearns, Holyoke, C. Jarvis, Street, Woodside, Mrs. Greatorex, Mrs. Spencer, Laurent, Wright, Cogswell,

Carter, Morris, Rutherford ... Edouart, Perry, Irving, Washington, and Colyer."[21] Leaving aside the fact that he misclassified Greatorex as a genre painter—when in fact she rarely delineated figures—he buried the names of the women within a general list. Ellet, by contrast, distinguished Greatorex's emerging style of landscape art and provided a detailed ten-page sketch on Spencer that was—like the text on her contemporaries— "prepared from materials furnished by [the artists] themselves or their friends."[22] Convinced that the female creative impulse was too powerful to be suppressed, Ellet was optimistic about the future of women's art, especially in the United States. Women like Spencer, Hosmer, and Greatorex were her living proof.

"LOVE ME!" PORTRAIT OF AN ARTISTIC MARRIAGE

On May 7, 1849, Eliza Pratt wed Henry Wellington Greatorex, a British-born organist and composer from a distinguished musical lineage.[23] She was approaching her thirtieth birthday, and he was a widower with a four-year-old son. While this might not sound like the ideal recipe for romance, they achieved a loving union that supported not only his creative work but hers as well, a novelty at the time. Some idea of her emotional state is expressed in a poem she wrote to him called "Love Me," which he put to music:

LOVE ME!

Love me forever, though my cheek paleth fast, though from my lip has pass'd
 youth's flush of fever;
Look in my heart and see, Summer and light for thee, shining so constantly,
 shining forever. Love me! Love me!
Love me, me only; Earth no sweet music hath, Life's gentlest, gayest path, Rude
 is and lonely, save when I hear thee sing; Through all our journeying,
 closer, still closer cling, cling to me only. Love me! Love me!"[24]

The words convey her self-consciousness at what was considered her advanced age for marriage, when "youth's flush of fever" already "has pass'd." She reveals that she finds life dark and lonely, save when she hears Henry sing, and beseeches him to love her. To ensure that the testimony to their deep feelings for each other would live on and inspire others, after her husband's death she published the sheet music—complete with her drawings of cupids and hearts—that went on to become a popular Civil War tune

(fig. 2.2). Since her husband's death had left her with four children, no property, and little money, she had to be practical as well as romantic.

Henry Greatorex had been much in demand as a church organist and held distinguished positions in Hartford before moving to New York City. Six months before their nuptials, he had been appointed "organist and leader of the music" at the Church of St. George, just when it was moving from its old building on Beekman Street to the new building and fashionable address on Stuyvesant Square. Called "one of the first and most significant examples of Early Romanesque revival architecture in America," it was yet unfinished when they made their vows in May 1849. But they must have felt especially blessed that their service was performed by Rev. Stephen H. Tyng, a leader in the evangelical wing of the Episcopal Church and one of the most notable preachers of the day.

The newlyweds moved into their quarters at 79 East Sixteenth Street, where the US Census for 1850 recorded them living in a household with

Francis Greatorex (four-year-old male child); Thomas (four-month-old male child); the artist's sister and brother-in-law, Matilda and Clement Despard; and two unrelated females: twenty-five-year-old Mary Morrin and sixteen-year-old Bridget H(?), both from Ireland and likely working as domestics. According to the records at St. George's, Henry was appointed organist and leader of the music, for which he was paid three hundred dollars a year. His services were required three times on Sunday, one evening during the week, and the usual holy days of the Church.[25] While most families gathered on Sundays, it was a workday in the Greatorex household, a familiar routine for a minister's daughter.

Eliza Greatorex's ambitions to become a landscape painter were stirring in the early 1850s, when she was a new wife caring for young Francis Henry (known as Frank), Henry's son from his previous marriage.[26] During this time, too, they had three children together: Thomas Anthony in 1850, Kathleen Honora in 1851, and Eleanor in 1854.[27] This moment coincided with the cult of motherhood, when the mother-and-child relationship was cherished in paintings and photographs where the baby's head rested tenderly on the mother's breast. While most mothers at that time were home tending to their children, this mother was out taking art lessons, sketching in the field, and preparing finished canvases for exhibition—often with the children in tow. She had the support not only of her husband but also of her sister and her brother-in-law, who must have taken turns caring for the growing brood of Greatorex and Despard children.

Highly regarded as both musician and composer, Henry Greatorex "was considered a remarkable player for the times and enjoyed an unusual popularity."[28] He received his training from his father Thomas (fig. 2.3), an exceptionally accomplished man who was an astronomer and mathematician as well as organist of London's Westminster Abbey, where he was later buried. His son introduced his musical style of playing to America.[29] The fifth of seven sons, Henry Greatorex as a young man occupied a position as musician at Marylebone Church, London, when in about 1838 he was hired to go to America and play the new organ at the Center Congregational Church in Hartford, Connecticut. He remained at that church for two years, inexplicably left the city for a short period, and returned to play the organ at St. John's across the street, where he remained for several more years. In September 1846 local newspapers reported his first marriage: "In Hartford—Mr. Henry W. Greatorex, organist of St. John's, to Miss Frances

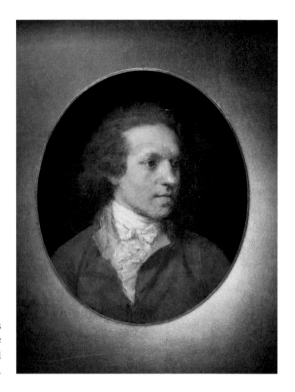

S. Filley, daughter of Horace Filley, Esq. of East Windsor." July 11, 1846, marked the birth of their son, Francis Henry, but the mother died soon after, leaving Henry a widower with an infant son.[30] He then moved to New York City, where he secured a position first as organist at St. Paul's Episcopal Church and then as organist and choirmaster at Calvary Episcopal Church near Gramercy Park.

The composer/musician sometimes traveled with his wife to visit her brother Adam Pratt in Le Roy, just outside Rochester. "Both Mr. and Mrs. Greatorex were fine singers, and their visits to the . . . [family] of the latter were significant events in the life of the little town. Saint Mark's Church in Le Roy, New York, was assured of a good audience when it was known that the musicians from the metropolis would be present," the local press reported. "Mr. Greatorex was a good tenor, his wife was none the less proficient as a contralto, and when members of the local choir joined them an excellent quartet was formed. On some of these occasions a concert was

given, and the visitors appeared in solo parts, winning deserved applause from those who were so fortunate as to hear them."[31] After 1853 their routine shifted, as Henry Greatorex began to perform frequently in Charleston, South Carolina, and according to one source "was organist of St. Phillips Church, the Jewish Synagogue and the Catholic Church."[32] Long before the term "commuter marriage" was coined, they were living the experience, with the artist and her children traveling back and forth between New York and Charleston in the years 1854 to 1858.[33]

Henry Greatorex the man is more difficult to pin down. His acquaintance Professor Thomas Seymour of Yale College provided some idea of his physical appearance: "Greatorex's portrait represents him as a handsome, large-faced Englishman, with bush black beard, a man of thirty-five or forty."[34] He was said to have had a commanding presence, being rather portly in physique.[35] "He (Greatorex) I think the greatest genius I ever met," his Hartford friend Aaron C. Goodman wrote to Frederic Church. "He seems to acquire any language almost at will; his sketches and paintings are generally good, and he is, taken all together, the best and most common-sense musician I ever knew."[36] Goodman's reservations help to explain why his associate was always strained financially and moved from one position to another in a manner that puzzled even those closest to him: "One thing he lacks, and that is application, and a destation of it as regards his profession is a misfortune." But his wife likely forgave him a good deal, for she saw in him what Goodman expressed: "He is one of the most sensitive persons you can find."[37]

To aid his impractical friend, Goodman used his contacts through his bookstore to sponsor the publication in 1851 of what turned out to be a popular compendium titled A *Collection of Psalms and Hymn Tunes . . .*, a compilation of sacred music that came to be known as "Greatorex' Church Music," with arrangements by his grandfather Anthony, his father Thomas, and himself.[38] "Greatorex was in his time one of the best writers of Church music in America" and "his hymn tunes and chants will always find a place in the worship of the sanctuary," one musical authority tells us. "Greatorex's anthem, 'The Lord Is My Shepherd,' and his hymn tune, 'Bemerton,' with the delicate bits of imitation in the third line for the soprano and tenor voices, were among the selections we loved best to sing."[39] The popular volume opened with "A Short Catechism of the Elements of Music" that must have been compiled during his years of teaching music lessons, as it

breaks down complex topics like rhythm, melody, and expression into a sequence of questions and answers illustrated by short bars of music. Goodman's strategy promised to reap some financial benefit for, as one contemporary observed, "the authors of church music have made a repute and a fortune," and while the profits are difficult to track, it was probably true that "there is no surer road to popularity than to become the author of a popular tune that can be sung in church, in Sabbath school, and in the household."[40]

This union between an accomplished musician and an aspiring artist was unconventional by the standards of the day. "She became as famous as her husband, though in a different line of work," one source noted, "for she studied art, and won considerable reputation with her pen and ink sketches."[41] This is a striking observation, one that applied to only a handful of their contemporaries. Eliza and Henry Greatorex were a nineteenth-century power couple, mutually supporting each other's work as they raised their family, attained career success, and socialized with leading figures of the day. They managed on fees from concert performances, the sale of his music, lessons he gave, and an occasional art sale. They seemed to be always struggling financially, yet they were committed to pursuing their artistic passions. At a meeting of the Sketch Club, the members were challenged to do a drawing that would convey the day's theme of "Happiness." Henry Greatorex did not even have to think about his response. He made a quick sketch of a man lost in the joy of his music as he played the cello (fig. 2.4), a surrogate self-portrait. Eliza Greatorex would later claim that she was never happier than when she was at her easel. They understood each other well.

In 1859, the artist exhibited three landscapes at the Washington, DC Art Association, the products of a recent sojourn abroad. There were two paintings—*Ruined Castle in a Cornfield, North of Prelano* [sic] and *Glenwood (from Nature)*—which she offered for sale. The third was a drawing, titled *Sketch from Nature (Burton-on-Trent)*. They were based on sketches she had done in Ireland and the Lake District with her husband in the late spring and summer of 1858. En route to Liverpool and the steamer back to America, they stopped in Burton-on-Trent—located in Staffordshire—the Greatorex family home that Henry's wife had never seen. Then he headed back to America to fulfill his concert engagements while she remained in London, intending to catch a subsequent steamer.[42]

She had no way of knowing that while she was visiting friends and making the rounds of the London art galleries, tragedy struck back home. Her

FIGURE 2.4

Henry W. Greatorex, *Happiness*, 1847. Gray wash, graphite and gouache on brown paper, 9 × 11 ½ in. X.498 Luce Center, New-York Historical Society.

husband had crossed the Atlantic to perform a series of musical engagements in Charleston, South Carolina, where he contracted yellow fever and died on September 10, at age forty-five. "To his absent relatives," the local newspaper reported, "it will be consolation to know that he was surrounded by the kindest friends."[43] But to Eliza, that was cold comfort. The display of the drawing of his birthplace at the exhibition in Washington, DC, was her way of paying homage to her departed husband. Unlike her other work on exhibit, it was not available for purchase.

Now a widow with four young children and no steady income, Eliza Greatorex faced daunting challenges, but none was more pressing that the support of her family. "Drawing and painting had been her gift always," her sister explained, "but not till adverse fortune and her early widowhood had forced her from the dearly loved retirement of domestic life, did she dream of making it her profession and the bread-winner of her four children."[44] These comments must have been prompted by a desire to cloak her sister's

artistic ambitions in the mantle of maternal duty, for, as her exhibition record demonstrates, throughout her marriage she was already working as a professional painter.

LILLY MARTIN SPENCER AND EMILY OSBORN: ANGLO-AMERICAN WOMEN RISING

Never remarried, Eliza was always referred to as "Mrs. Greatorex," an epithet that cloaked her in respectability and allowed her some degree of freedom from the social constraints that hindered younger single women from pursuing career goals. She relentlessly pursued her art, but this took a great deal of determination, given the resistance that enterprising women encountered. Popular artworks of the day dramatized their dilemma. A lithograph by Honoré Daumier depicts a woman concentrating on her art while her child and housework go unattended, a rebuke for neglect of her duty. British Pre-Raphaelite painter Emily Osborn presents an entirely different scenario in her picture *Nameless and Friendless* (fig. 2.5). She depicts an impoverished woman artist who has trudged through the streets of London to present her work to a picture dealer.[45] The only female in the establishment, she receives a chilly reception from the unsympathetic proprietor, who is only interested in artists with established reputations and not in this young woman who lacks a marketable name. Dressed in black, she is accompanied by a boy and has been variously identified as a widow with a young son or a motherless young woman responsible for the care of her little brother. Either way, she is on her own, as Osborn's orchestration of the composition emphasizes, for she is left standing instead of being offered a seat, isolated between a pair of men eyeing her from behind and the judgmental old proprietor.

Emily Osborn was hardly nameless but enjoyed artistic success and was identified along with Rosa Bonheur as being among the leading female artists of the mid-nineteenth century.[46] The daughter of a clergyman, she was by age seventeen exhibiting at the Royal Academy. She counted among her patrons Queen Victoria, who purchased *Nameless and Friendless.* Nor was she friendless, but had many female acquaintances, including the Greatorex women. In 1880 "the family went to London, where Miss Kathleen Greatorex painted in the studio of the distinguished English artist, Miss Emily M. Osborn," a close observer explained. "Miss Osborn, a pupil of Piloty . . . One of her best-known pictures is *God's Acre*, two little girls visiting their

FIGURE 2.5

Emily Mary Osborn, *Nameless and Friendless.* *"The rich man's wealth is his strong city, etc." Proverbs, x, 15.* Oil on canvas, 32 ½ × 40 ⁷⁄₁₀ in. Tate Britain, London, UK.

mother's snow-drifted grave. She has lately painted Madame Bodichon, George Eliot's friend, for Girton College, and her work is widely known through engravings and wood-cuts." A figure study by Eleanor Greatorex (private collection) bears resemblance to Osborn's canvas *A Golden Day Dream* depicting a dreamy woman in a hammock, suggesting that the younger sister Eleanor as well as Kathleen benefited from contact with this English painter.[47]

The climate was changing for the art women at mid-century in the United States as well as in Great Britain. Lilly Martin Spencer's figure painting began to find a market in New York simultaneously with Osborn's in London. Both had decided on their career paths when still in their teens, with the precocious Osborn showing at London's premier Royal Academy while Spencer painted her youthful *Self-Portrait* in Cincinnati. She presents a thoughtful persona, her gaze direct but for the curl that falls over her face: a hint of the sense of humor that would get her through life's challenges.

She was eighteen when she looked in the mirror to portray herself, and by then was gaining local success, which prompted businessman Nicholas Longworth to make his offer. He wanted to send her to the East Coast, to Connecticut to meet John Trumbull and then on to Cambridgeport, Massachusetts, to work with Washington Allston. After that he proposed underwriting European travel to round out her artistic education. He had helped the sculptor Hiram Powers in this way, and now proposed to give her career a similar boost. She turned him down on both counts.[48] At the time she had no desire to train abroad and refused to be obligated to a man she described to her family as ugly and short. By 1849 she had moved her family to New York, where she earned a reputation as the most popular and widely reproduced female genre painter of mid-century America. Official recognition largely eluded her, however, with the National Academy of Design designating her only an "Honorary Member."

For Spencer, participation in the woman's rights movement was a luxury she could ill afford: "My time . . . to enable me to succeed in my painting is so entirely engrossed by it, that I am not at all able to give my attention to any thing else."[49] Her French-born mother Angelique Martin, by contrast, was a vocal proto-feminist and Fourierist. In the mid-1840s she and her husband were among the founders of a Fourierist "phalanx" (commune) near Braceville, Ohio, that was dedicated to socialist principles, including equality for women. She rejected isolated, single-family households, which she regarded as wasteful duplication of domestic labor hampering the development of women and society as a whole. Her daughter's pictures of solitary housewives—tackling their chores in domestic isolation—have been interpreted as a reaction against what Spencer regarded as her mother's impractical views.[50]

Spencer fashioned her kitchen scenes and nursery narratives while perpetually pregnant or nursing (she gave birth to thirteen children, seven of whom survived to maturity). Laughing or frowning, her subjects depart from normative female behavior and directly address their viewers beyond the picture plane. Her canvases grew out of her personal experience as the breadwinner for her children and unemployed husband. By the late '60s, Spencer recognized that her domestic genre had run its course and turned to more monumental figure painting, as in *We Both Must Fade* (*Mrs. Fithian*) (1869; Smithsonian American Art Museum), which conveyed the dilemma of middle-aged American women in a culture that revered youth and beauty.

Osborn, like Spencer, delineated the people around her. Greatorex's turn to nature required different models and sources.

NATURE WRITING AND THE WOMEN'S RENAISSANCE: SUSAN FENIMORE COOPER

Literary inspiration from the English Lake poets to Henry David Thoreau was critical to landscape painters. Susan Fenimore Cooper, the first popular woman nature writer and environmentalist, spoke directly to pictorial artists of her gender. In 1850, four years before Thoreau's *Walden* appeared, Cooper published her *Rural Hours*. The daughter and literary agent of James Fenimore Cooper, America's first internationally recognized novelist, she was well read and worldly. Her evocation of the changing seasons around her country home in Otsego, New York, stirred in her readers a sense of pride in this distinctly American landscape.[51] She advised her female followers to populate their gardens with native plants, and instructed them to imagine history from the perspective of the trees, before exploration and colonization. "In *Rural Hours*, Cooper castigated a rising middle class that cut down its native pine forests in order to raise the money to buy imported embellishments for its homes," Vera Norwood explains. "Americans who truly believed in the republican ideals of the country should not engage in wholesale destruction of their natural heritage. These qualities established her *Rural Hours* as a classic of early American environmental literature."[52]

Compared to the nature narratives usually cited as important to artists, including Asher B. Durand's "Letters on Landscape Painting," Benson Lossing's *The Hudson, from the Wilderness to the Sea*, and the poetry of William Cullen Bryant, her *Rural Hours* provided a narrative more congenial to women's sympathies and concerns. They should avoid overcultivation, she advised, both in themselves and in their gardens. Women who bought foreign or manipulated species instead of preserving the native varieties endangered not only nature, but also American society and the status of women as its moral standard bearers. Like Louisa May Alcott and Emily Dickinson, Cooper contributed to what David Reynolds has termed "the American Women's Renaissance," a moment in the 1850s of intense social and literary activity "when American women's culture came of age."[53] These observations can be extended to their counterparts in the visual arts.

Flower painting had historically been dismissed for its associations with the feminine domain. But writers like Cooper elevated consciousness of

native plants growing close to home, with the result that Maria Oakey Dewing, Ellen Robbins, and Fidelia Bridges all made local specimens their purview. Paralleling *Rural Hours*, Bridges produced her unique combinations of birds and flowers in a series of lithographs for Louis Prang that charted the cycles of nature. Sometimes organized into the four seasons, at other times the twelve months of the year, these sensitive images established her reputation as *the* painter of the birds and wildflowers of the coastal meadows and flats surrounding her Connecticut home.

First published in 1850, *Rural Hours* went through nine editions, with a new preface written for each one (along with a revised, abbreviated version). Her project is comparable to Walt Whitman's *Leaves of Grass*, an organic production evolving as the author responded to a changing America over the decades. Cooper urged her readers to seek a more meaningful relationship with the natural world and instructed them in specific ways to achieve that balance. Landscape and environmental history, as they have been traditionally narrated, emphasize the male-dominated field of wilderness exploration and preservation of distant places. Cooper and contemporary female painters, by contrast, evidence a distinct aesthetic that focused on the local and the native. Through the many editions of Cooper's books and Bridges's lithographs, they extended their network of influence to popular female audiences nationwide.

EXHIBITING AND SELLING ART

In the mid-1850s, opportunities to view art in major cities increased, including the crowd-pleasing big picture exhibitions, where a large-scale painting was displayed as a stand-alone show complete with explanatory pamphlets and take-home reproductions. One of the Hudson River men, Frederic Church, shortly after putting the finishing touches on his *Niagara* (Corcoran Collection, National Gallery of Art), mounted its solo display at one of New York's few commercial galleries in May 1857. "You pass from the bustle of the street into that small back room of the Messrs. Williams & Stevens," a *New York Times* writer explained, "which all lovers of art know so well, and in which they have passed at one time or another so many pleasant hours—and behold! there is the marvel of the Western World before you!"[54] For twenty-five cents spectators viewed the large-scale canvas (3.5 ft. high × 7.5 ft. long), received a pamphlet of critical commentary, and pondered the option of purchasing a chromolithographic reproduction of it. As crowds thrilled at the

illusion that they had been transported to the Canadian side of the sublime cataract, attendance records climbed to one hundred thousand in the first two weeks.[55]

While Church's painting headed eastward across the Atlantic, another even bigger canvas was steaming its way from Europe to America, where it was to be shown in the same venue a few months later. "Arrival of a Famous Art Work," read the headline in the New-York Daily Times, which explained: "The Horse Fair has been purchased by Mr. Wright of Hoboken, but we hope he will allow it to be exhibited to the public." By early October 1857 their hopes were realized when Williams, Stevens, Williams & Co. advertised that "Rosa Bonheur's great picture of the Horse Fair has been open to visitors every day since Wednesday morning at 8½ o'clock, and the hours for exhibition will be for the future, from 8½ A.M. to 6½ P.M."[56] The 8 × 16.5 ft. picture (1852–55; Metropolitan Museum of Art) filled one side of the familiar back room of their establishment, where it remained on view for three months, from October 2, 1857, to January 2, 1858. It was something of a novelty for a female artist to garner so much public attention, but Rosa Bonheur had broken through gender barriers by demonstrating "that wealth of power, the masterly foreshortening."[57] Years later, it was still remembered as "the art event of the day" by decorative arts champion Candace Wheeler. "Everybody went to see it, and the general verdict was that it was 'understandable,' a quality which [Turner's picture] . . . did not possess in the public estimation."[58] "The picture, being only a picture of horses going to a fair," as another critic argued, "does not belong to the region of 'High Art.'" But public enthusiasm could not be dampened by such put-downs, often directed against women, as crowds continued to file into the gallery and purchase the reproductive steel engraving. Rosa Bonheur's success provided a beacon of female accomplishment.[59]

American women artists active in the 1850s tended to produce smaller-scale pictures that lent themselves to group exhibitions rather than dramatic solo displays. But they demonstrated resourcefulness in seeking diverse locations to exhibit and sell work. The National Academy was the standard venue, but competition was stiff for buyers, who often favored fellow members of social clubs from which the women were excluded. A number of New York–based artists looked south to the emerging cultural scene of Washington, DC, where there were fewer resident artists and commissions might also be secured in the Capitol or other government buildings. When the

Washington Art Association was formed in 1856, many New York artists participated with an eye to expanding their markets. The first exhibition opened on March 10, 1857, in a building on H Street provided by William H. Corcoran. Greatorex was off in Europe at the time, but upon her return submitted three works to the 1859 show. Eliza Greatorex was one of a growing number of women exhibitors including the Washington-based portraitist Eunice Makepeace Towle, who counted among her sitters Presidents John Quincy Adams and Martin van Buren.[60] That year Greatorex's work hung alongside that of Anne Gliddon, British crayon-and-pencil artist married to noted archaeologist and expert on Egyptian hieroglyphics George Gliddon. She had provided her Irish American friend with letters of introduction to Leigh Hunt and others on her recent trip.[61] It must have been something of a coup for them to display their work side by side in the nation's capital.

Given the association's agenda to foster the appreciation of art, it sponsored a number of public lectures held in the hall on the ground floor of its building. One of the most popular events was Rembrandt Peale's presentation on his large-scale painting *The Court of Death*. Rev. George Samson's lecture on women in the history of art was another subject deemed to be of sufficient topical interest to attract audiences.[62] As a Baptist minister and president of Columbian College (later George Washington University) from 1859 to 1871, Samson's observations on the subject carried particular authority,[63] and perhaps included reference to the work of Greatorex, Gliddon, and Towle to be seen on the association's walls. Eighteen sixty sadly saw the demise of the Washington Art Association, another casualty of the increasingly divisive politics between North and South leading up to the Civil War. But in its five-year history, it achieved marked success, not only in drawing artists from around the country, but also in opening the doors to women.

Women found an especially welcoming reception in Philadelphia, thanks in part to the Peale legacy. Female members of that family excelled early on and achieved a status that no other women artists in America had previously known. The family's patriarch, artist and scientist Charles Willson Peale, had named his artist-daughter Angelica Kauffmann Peale, in honor of the revered Swiss artist. His brother James had three daughters who were all professionals: Anna Claypoole Peale became a well-known miniature painter, Sarah Miriam Peale supported herself as a portrait painter and teacher, and Margaretta Angelica Peale followed in her father's footsteps as a still-life painter. All three sisters exhibited their work in 1811 at the Penn-

sylvania Academy of Fine Arts. Subsequently, Anna and Miriam were elected academy members. Charles Willson's son Rembrant named his artist-daughter after the Venetian painter Rosalba Carriera, and when later in life he remarried, it was to his art student Harriet Cany, who worked and exhibited from the 1840s through the 1860s. This lineage suggests that the Peales were especially tolerant, if not encouraging, of the female family members. And they in turn helped pave the way for the female art students who came to study at the city's academy.

The Pennsylvania Academy was founded in 1805 by Charles Willson Peale, sculptor William Rush, and other artists and businessmen "to promote the cultivation of the Fine Arts in the United States of America by . . . exciting the efforts of artists, gradually to unfold, enlighten and invigorate the talents of our countrymen."[64] By mid-century women had a significant presence. Twenty-one of the one hundred students signed up for the antique class at the academy in the years 1859 to 1861 were women, including Emily Sartain, Anne Whitney, and Fidelia Bridges. A handful of women were also represented in the annual exhibitions of that time: Mary Smith (after whom an academy prize would be named), Spencer, Bridges, Greatorex, and Ida Waugh, all important names in American art circles for decades. Rosa Bonheur exhibited at the PAFA along with her first partner and fellow artist Nathalie Micas.[65] Both Mary Cassatt and Eliza Haldeman—unabashed feminists when it came to the rights of women in the arts—exerted their influence. Emma Stebbins's sculpture was on view at the gallery of Philadelphia dealer James Earle. The academy had on daily view two paintings from its permanent collection by the Swiss artist Angelica Kauffmann.[66] There Bridges found a mentor in the local landscape painter William Trost Richards, who invited her to join him on nature excursions and trained her to sketch out-of-doors.

WOMEN IN THE FIELD: FROM THE HUDSON RIVER TO BARBIZON

Accepted wisdom would have it that social conventions, combined with pressure on the home front, deterred women from plein air work. Yet we know that increasing numbers of women adopted the patterns of the Hudson River men, spending the months from late spring working as much as possible in the open air and retiring to the studio for the winter. Unmarried, Bridges initially accompanied Richards on his forays, or traveled with her

artist-friend Anne Whitney through the Alps, and later opted for the solitary study of birds and flowers found in the marshes near her Connecticut home. Other women banded together to make joint excursions. Greatorex occasionally took to the field with Julia Hart Beers, a neighbor in the Dodworth Building in these years and sister of her early teacher William Hart. Beers was the tenth child of a family of Scottish immigrants that numbered several artists, including not only William but also James MacDougal Hart. "When her husband died twelve years ago her brothers advised her to turn to painting as an occupation," journalist Lucy Lee Holbrook explained. "Then it was an uncommon thing for a woman to go out sketching in the country, and when she asked permission to go with her brothers they advised against it, saying she could not stand the exposure, and they could not adapt their movements to her weakness." But she took up their challenge. "Where they forded streams I forded them, and I tramped on after them many a weary mile through the mud and wet, when it seemed to me I could go no further."[67] These experiences proved her mettle in fieldwork. In the warmer months, with the help of her daughters, she took parties of women sketching in New England and the Adirondacks. During the summer of 1866 she and Greatorex were together in Bethel, Maine, where they painted local scenery exhibited at the National Academy in 1867.[68]

Throughout the '60s and '70s Beers gained success, which many typically attributed to her brothers' influence. To this she countered: "It is not gained by talent, or from the reputation of my brothers James and William Hart, but by sheer hard work and persistent labor." Her works such as *Hudson River at Croton Point* (fig. 2.6) bear the evidence of outdoor study in its freshly observed delineation of this small peninsula extending into the lower Hudson. Here she added a twist on the convention of inserting staffage into the scene, now a woman and a young child, seen from the rear, a reference to the artist herself and her young daughter.[69]

Like Beers, Greatorex faced the conundrum of how to pursue landscape painting while caring for young children. "When her children were a little older the family moved to Cornwall-on-the-Hudson, where they lived with Mrs. Despard," we learn. "The little girls and their brother, with their cousins of similar age, made a solid body of young recruits in the service of art, for here began their first instruction and experience."[70] Soon "Mrs. Greatorex went daily upon her sketching excursions," it was reported, "accompanied by this guard of youthful enthusiasts."[71] She came to find these

FIGURE 2.6
Julia Hart Beers, *Hudson River at Croton Point*, 1869. Oil on canvas, 12 ¼ × 20 ¼ in. Collection of Nicholas V. Bulzacchelli.

excursions mutually beneficial. "At last these children understand that I am just as young at heart as they, while I am at my out-of-door work," she attested, "and I share their confidences and enter into their plans beautifully."[72] Accustomed to having youngsters around her while she sketched, she developed the ability to focus on her work even while chatting with onlookers or minding her young brood as they ran about or brought her flowers and other specimens they found. Then as now, passersby stopped and stared at the artist at work, but her powers of concentration were such that "it is quite the same to me that there is a storm coming, and that excursionists pass by, curiously peering at me."[73]

After sketching a scene, Greatorex would return to the motif several times over the following days to compare her picture against the original. Had she captured the look of the place? Had she selected the most advantageous point of view? Often, she would revisit a motif under different conditions of light and perspective to rethink her approach. "Coming to the entrance of the cañon this morning, very early, I turned to look at the fountain playing in front of the house, and find I have not taken the best view," she later wrote on her Colorado expedition. "It is lovely now, when the trees make a somber background. . . . I stop to note down this new idea."[74] Sketching was an

FIGURE 2.7
Photographer unidentified, *Fidelia Bridges,* ca. 1864. Photographic print on carte de visite mount, 4 × 2 ½ in. Oliver Ingraham Lay, Charles Downing Lay and Lay family papers Archives of American Art, Smithsonian Institution.

ongoing process requiring constant editing. Throughout her career Eliza maintained her practice of revisiting motifs and revising her pictures.

Likely the portable sketching apparatus carried by Greatorex and Beers resembled that of their associate Fidelia Bridges, who presents herself as an outdoor painter in her carte-de-visite around 1864 (fig. 2.7). She is dressed like a Zouave regiment *Vivandiere,* her skirt extending to just above her ankle, where a dark, geometric pattern reinforces the hemline. Her attire projects a severe, slightly military air: a deliberate contrast to the Second Empire–style dresses then worn by women in the parlor. She holds her field-sketching equipment: a wooden paint box with shoulder strap and folding umbrella. Frederic Church

had a similar wooden sketch box that when open could support the panel on which he was working inside the lid of the box. He had it with him on all his expeditions, including his hunt for icebergs in the cold waters off Newfoundland and Labrador. In *After Icebergs with a Painter* his traveling companion, Rev. Louis Legrand Noble, described him sitting on the deck of a pitching ship, making sketch after sketch, "with his thin, broad box upon his knees, making his easel of the open lid . . . dashing in the colors. . . . Again the painter wipes his brushes, puts away his second picture, and tacks a fresh pasteboard within the cover of the box."[75] So perhaps Greatorex and Beers had equipment of that variety, or maybe it more closely resembled that of Sanford Gifford, who portrayed himself sitting atop Cadillac Mountain with his sketch box, looking south over Seal Harbor. His was different in size and shape: smaller, square, and boxy instead of the broad, slim-profiled rectangle—looking a little like today's laptop computers—carried by Bridges and Church.

The unidentified photographer shot Bridges in the studio, posed against a painted woodland, but the sitter is surely the one who selected the clothing, props, and backdrop. In the mid-1860s this artist explored the places familiar to the Hudson River men, but relative terra incognita for women.[76] This self-presentation stakes her claim to equal standing with her male compatriots and to the challenges of working in the field: tramping to motifs; lugging awkward, heavy equipment; spending long hours exposed to insects and the elements; working alone in remote spots. Women were taking their easels, umbrellas, and paint boxes out into the fields, and were coming home with studies they transformed into finished pictures that held their own with those of their male counterparts.

For clues to the responses of male landscapists to these developments, we must rely on visual evidence. Winslow Homer's *Artists Sketching in the White Mountains* (1868; Portland Museum of Art) provides a commentary on what was becoming an increasingly common practice by the late 1860s: artists heading for favored sites in places like New Hampshire and scrambling for a spot to paint. Gone is any idea of originality or solitary contemplation of nature: artists are packed onto hillsides cheek by jowl, one echoing the next, as we look over their shoulders to detect a series of nearly identical motifs. Tossed on the ground is the telltale bag, in which the outdoor sketcher transports the necessary equipment. But what is wrong with this picture? Women, obviously, are absent. We wonder what would happen if Greatorex or her friend Julia Beers arrived and set up her stool and umbrella

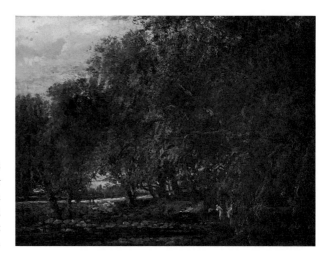

FIGURE 2.8
Eliza Greatorex, *Wash Day at Chevreuse*, ca. 1866. Oil on canvas, 9½ × 12½ in. Ronald Berg Collection. Shown at the NAD, 1866, no. 276.

next to one of these diligent gentlemen. As if to answer our query, Homer created a "sequel" for the cover of *Appleton's Journal*. A lady does in fact appear, but only to gaze lovingly over the shoulder of her male companion, to encourage and inspire his work. There is no suggestion that she would take up the brush and paint the scene before them. But whether the men accepted it or not, the women were asserting their presence in the field, from the banks of the Hudson to Fontainebleau Forest at Barbizon.

Another trip to Europe was in the planning stages. Greatorex was preparing for a trip to France to seek training and acquire the imprimatur of the Barbizon style then coming into fashion. "The facilities for art studies in New York were very few," her sister clarified, "and in the spring of 1861 she went to Paris to study in the atelier of Edouard Lambinet. Here her natural feeling for color found great development."[77] In fact she studied not with Edouard but rather with the landscapist Emile Charles Lambinet. Following his program of working in the field and studying Old Masters paintings, she divided her time between Paris and its outlying countryside. She found an agreeable spot in Chevreuse, southwest of the capital, where she worked on a small scale in oils. *Wash Day in Chevreuse* (fig. 2.8) demonstrates her mastery of richly textured greens in the foliage characteristic of Lambinet as well as the popular Diaz de la Peña. In her treatment of this corner of woods by the stream where two women launder their clothes in a pot of boiling water, her personal touch is unmistakable in the twisting network of brown

tree branches underlying the leaves and in her compositional habit of opening the sky on one side and obscuring it on the other.[78]

Surely Greatorex must have been aware when she boarded the steamer bound for Europe in March 1861 that war at home was imminent. On April 12, Confederate batteries under orders from General P. G. T. Beauregard bombarded Fort Sumter in the harbor of Charleston, South Carolina, not far from where her husband lay buried. Although the artist could not have known at the time, it was an event that plunged her adopted country into four long years of civil war, shifting national interest away from art and culture. Yet she chose to remain abroad for an entire year in pursuit of her art, while her younger sister cared for her children and her affairs in her absence.

3

CIVIL WAR AND ARCHITECTURAL DESTRUCTION

DRAFT RIOTS AND CIVIL WAR

On July 13, 1863, violence broke out in New York City and ran its course over the next five days and nights. President Abraham Lincoln had recently instituted the Conscription Act, which forced men age eighteen to thirty-five to serve in the military for a three-year term, with the proviso that a substitute could be financed for $300, a sum far beyond the means of the working class. Many of their numbers, including the recently arrived Irish, resented the policy that allowed the rich to buy their way out of the draft and exempted African Americans. Catalyzed initially by local Democratic opposition to the federal draft, the unrest was fueled by other, deeper fissures within the Union: resentment over Emancipation, Lincoln's handling of the war, and economic inequalities. Laborers feared the competition for jobs by black freedmen coming from the South, a fear only made more pressing by the likelihood that when they were conscripted and sent off to war, they would have no employment when they returned. Thousands of enraged men, women, and children—primarily poor workers including Irish immigrants—took to the streets to protest with bricks, torches, and clubs.

This upheaval followed closely upon a horrific moment in the Civil War. The Battle of Gettysburg was waged from July 1–3. Overall casualties for those three days exceeded fifty thousand, with more than seven thousand dead, thirty-three thousand wounded, and ten thousand missing. One of the fiercest moments in the battle occurred on July 3, when after an artillery barrage lasting more than an hour, upwards of fifteen thousand Confederate infantrymen advanced in close order across Emmitsburg Road to attack Union forces waiting behind stone walls and breastworks along Cemetery Ridge. Volley after volley of musket fire, grapeshot, and canister tore huge gaps through the Confederate ranks. Those who reached the Union lines were killed or captured, while their comrades withdrew, back across the fields. Following the bloody ordeal, President Lincoln ordered thousands of weary federal troops from the battlefield to restore order to New York City, where military firepower was employed to suppress the mob. The official death total was 105 killed, but historian Barnet Schecter persuasively argues that owing to the use of musketry and artillery, the death toll was probably closer to 500, mostly protesters. Twelve free blacks were lynched. Some thousand others were wounded, and many buildings were destroyed. City residents locked themselves in their homes and waited for help to come and rescue them. The Draft Riots, as they came to be called, constituted the largest civil uprising in American history.[1]

Although the city streets were rarely the sites of direct combat, these events of July 1863 were the exception that brought the terrors of the battlefront to urban front doors. Some residents still remembered the Astor Place Riots of 1849, when twelve lives were lost. But that earlier event had all been acted out between groups of people with the streets as the backdrop. The Draft Riots, by contrast, exhibited a significant departure in that participants targeted the built environment. Architecture associated with the war effort, the Republican Party, and social privilege was under attack. The demonstrators raided weapon stockpiles intended for the Union Army and burned draft offices, police stations, the Colored Orphanage, and a state arsenal. Following that, they moved on to homes and businesses of known Republicans, including Brooks Brothers clothing store, which supplied officers' uniforms. Although this was technically not a battle of the Civil War, the Draft Riots have been characterized as an "urban Appomattox" for their confluence with the war and impact on the American psyche.

The riots lasted five days and nights.[2] The reverberations of fear, however, prevailed far longer for residents. "Men and ladies attacked and plundered

by daylight in the streets," George Templeton Strong recorded in his diary, "private houses suddenly invaded by gangs of a dozen ruffians and sacked, while the women and children run off for their lives." Like many New Yorkers, Strong identified the villain of these events as "this Celtic beast," the recently arrived Irish immigrants who were "burning orphan asylums and conducting a massacre."[3] The fact that blame was being laid at the feet of the Irish could not have been lost on the Irish-born Eliza Greatorex.

Martha Derby Perry provides a female eyewitness account of those terrifying days. She was residing at the time on Lexington Avenue with her husband, assistant surgeon John Perry of the 20th Massachusetts Volunteers, whom she was nursing after he had been wounded. Housebound and terrified, she followed news of conflict in the streets, desperate to protect her husband and herself. "By this time the city was full of troops, and finally the riot was quelled by firing canister into the mob," Perry wrote in her diary on what turned out to be the final day of the siege. "As we heard the heavy reports and responding yells, it seemed to me that I knew something of the horrors of war."[4]

By that time Eliza Greatorex was back in the city after her absence in France. For twelve months she had been taking her easel and brushes out into the woods at Barbizon, studying the great oil canvases in the Louvre in Paris, and honing her skills as a painter of landscape. But returning to New York she was confronted with the events of that terrifying July, probably the most violent and bloody single month in United States history. The illustrated press ran pictures of the lynching of a black man, a horrific scene that took place on West Thirty-Second Street, just blocks from the artist's home. Second Avenue witnessed military intervention (fig. 3.1) while other combatants targeted Pearl Street, where buildings were burned and more people lost their lives. This was a source of personal anxiety for the artist and her family since her brother-in-law's business establishment—Despard & Co.—was located on Pearl Street. These events were not being conducted in some far-off battlefield—which was frightful enough—but on her own doorstep. Not surprisingly, the force and proximity of this violence triggered a rethinking of art. How could one continue painting nature—pristine rivers and lush forests—when her adopted city was under siege? She searched for a way to express her response to the horrors she had witnessed. Abandoning the landscape to which she had devoted herself, she shifted her attention for the first time in her career to the metropolis that had witnessed armed warfare.

FIGURE 3.1

Unidentified artist, *Draft Riots: The Battle in Second Avenue*. Engraving from John Gilmary Shea, *The Story of a Great Nation* (1886).

To express sorrow and outrage over the war and civic uprising required a strong, stark medium. Greatorex abandoned her oil paints and brushes and worked in black and white, making pen-and-ink drawings on the city streets using her portable penner or inkhorn (fig. 3.2). A *penner* is a device that predated self-contained writing instruments. It is sometime called an *inkhorn* because prior to the invention of Gutta-Percha and synthetic plastics, the material commonly used was bovine horn. It was designed to carry powdered ink, quill pens, and fine-grained sand as a blotting agent all compactly assembled with the pieces united by threaded joints. When the artist wanted to make a drawing, she simply unscrewed the joints, laid out the contents, and set to work. The long shape allowed it to be carried upright in the tail pockets of a man's coat, or in this case a lady's skirt. It was made with an economy of form and portability typical of military equipment. The ink drawings she made were then reproduced via a photomechanical process duplicating those contrasts of light and dark. It bears emphasis that monochrome was the palette of chose for expressions of outrage over war, extending from Francisco de Goya's series of eighty-five prints titled *The Disasters of War* (1810–20) to Pablo Picasso's protest over the Spanish Civil War in *Guernica* (1937). Greatorex chose this same graphic language to convey her message.

The events of that summer impressed themselves deeply on people all across the country, but for New York City residents they had a special reso-

FIGURE 3.2

Art DeCamp, Penner and inkhorn, 2008. Reproduction of an eighteenth- or early-nineteenth-century instrument. Private collection.

nance. Surveying conflict and conflagration from his Brooklyn home, Herman Melville wrote the poem "The House-Top: A Night Piece (July, 1863)," which opened with an evocation of the sheer animal terror of those nights:

> No sleep. The sultriness pervades the air
> And binds the brain—a dense oppression, such
> As tawny tigers feel in matted shades,
> Vexing their blood and making apt for ravage.
> Beneath the stars the roofy desert spreads
> Vacant as Libya. All is hushed near by.
> Yet fitfully from far breaks a mixed surf
> Of muffled sound, the Atheist roar of riot . . .

He inserted it into a compendium of seventy haunting poems called *Battle-Pieces* that moved chronologically from "The Portent" (1859) to the fall of Richmond in April 1865. Like most of his fellow New Yorkers, he saw the urban insurrection as contiguous with the war itself. Writing these poems

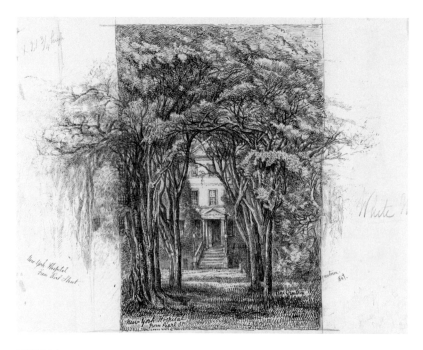

FIGURE 3.3

Eliza Greatorex, *New-York Hospital from Pearl Street*, June 20, 1864. Pen and pencil on paper. Museum of the City of New York.

over the course of seven years as he pondered the momentous events, he published *Battle Pieces* in 1866.

Like Melville's poetry, her project necessitated a long gestation period. As events continued to unfold, the devastation wrought by the Draft Riots of 1863 elided with the razing of older structures and redevelopment continuing into postwar. As order began to be restored, she commenced sketching the architecture in the neighborhood that had witnessed the combat. Her first subject was the old New-York Hospital, which had occupied a site on Broadway between Duane and Worth Streets since 1791.[5] Given its location in the midst of the combat in lower Manhattan, it was the primary hospital to receive the dead and wounded fresh from the urban battle sites. The heroism of the Union cause, Walt Whitman predicted, would be recorded for posterity, and the "real war"—by which he meant the gore of a battle's aftermath and the stench of overcrowded hospital wards—would never make it into the history books.[6] In the wake of the Draft Riots, however, Greatorex turned her

attention to the hospital emblematic of warfare and began work on her rendering of *Old New-York Hospital from Pearl Street* (fig. 3.3). She presented the hospital yet unscathed, seen through a clearing in the trees. She pictured neither the wounded combatants within nor the destruction that continued to threaten it from without, but presented it intact, as she wished it to be remembered. When she finally felt satisfied with it, she inscribed it "June 1864."

Few American artists of the day painted the Civil War directly. Only a handful of them created explicit references, and even a smaller number responded immediately. Not until the 1880s and 1890s, in the wake of the Centennial, were Americans able to revisit those events through the mists of time and make art from them. Scholars have interpreted landscapes by Greatorex's contemporaries Fitz Henry Lane, Martin Heade, and Sanford Gifford as veiled commentaries on war. To this distinguished group must be added the suite of architectural works that commenced with her *Old New-York Hospital from Pearl Street*.[7]

WOMEN AND WARFARE

Matilda Despard called her sister "Old Mortalita," a reference to the loss and death that became the subject of her art. From these tentative beginnings born of the Draft Riots, the artist recorded the demise of *Old New York* via its aged buildings slated for destruction that culminated in the book of that title in 1875. These years extended from the height of the Civil War until the Centennial: the hundredth anniversary of the Revolutionary War and American independence, and the ten-year anniversary of the Civil War's end. In between, she made a two-and-a-half-year sojourn in Europe with extended residence in Bavaria, 1870–72, years that spanned the Paris Commune and brought her into close contact with the Franco-Prussian War and its immediate aftermath: the formation of a united Germany. Given that she lived her life in theaters of major armed conflict, it follows that the pictures of lost urban architectural landmarks contained in *Old New York* lend themselves to interpretation as a metaphor for that warfare and destruction.

Pictures of hospitals, wounded men, and ministrations to the sick expressed an artist's feelings about the war without recourse to battlefield imagery. Eastman Johnson was among the many who painted such scenes, emphasizing women's roles as nurses tending to the wounded soldier in a field hospital. Early in her literary career Louisa May Alcott made her name with a similar subject. Her *Hospital Sketches* (1863) is a compilation of letters

she sent home during the six weeks she volunteered as a nurse for the Union army in Georgetown. Closer to home, Greatorex's brother Adam Pratt was also tending to the fallen soldiers in the hospitals of Washington, DC, where he was living by the outbreak of conflict.[8] In that now infamous summer of 1863, shortly after Gettysburg, he wrote home "in behalf of the sick and wounded soldiers in hospitals," beseeching his family to send food and wine to alleviate suffering and provide them with some home comfort.[9] Acutely aware of his selfless care of the young soldiers, and perhaps even a volunteer herself on her visits to him, she depicted the hospital in lower Manhattan as a visual emblem of war. Significantly, this, her first picture—that of old New-York Hospital—spoke to the woman's efforts in wartime, for as her sister Matilda Despard reported in the accompanying text, "Here many of the devoted and efficient women, who served as nurses in the civil war, went through their preliminary training."[10]

These feminine associations continued as she moved from hospitals to mansions to farmhouses. Depictions of homes were associated with what has been referred to as the "feminine sphere." Yet we need only remind ourselves of the rhetoric Lincoln employed during these years that relied on images of family and the domestic. Among them, one particularly effective motif was "the house divided." Rendering the damaged and soon-to-be-demolished domestic architecture of her adopted city, Greatorex created a subtle vehicle to convey massive loss on a manageable scale. Since the entire history of the nation impressed itself on New York in one way or another, and that history was one of violent warfare, her record of the assaults on New York's built environment provides a meaningful metaphor for armed conflict.

War touched Greatorex even closer to home. As she had a young stepson who went off to battle, her experiences of the Civil War were distinct from those of any of her artist-contemporaries. After her husband's death in 1858, she raised their three children and Henry's son Frank, who as a teenager volunteered for military service and fought in the Union Army. Christened Francis Henry, he inherited the musical instincts of his father and became an admired musician and singer. While still a youth of about fifteen, he enlisted as a drummer in the 84th New York State Militia, perhaps wearing a uniform and adopting the brave bearing seen in images by William Morris Hunt and Eastman Johnson. When he came of age, he joined the 176th New York Infantry "Ironsides" Regiment and was later detailed to instruct the band in one of the "colored" regiments being raised along the Gulf Coast.

The Ironsides Regiment went on to serve under Philip Sheridan in the Shenandoah campaign of 1864, and in North Carolina under Sherman in 1865. Mustered out of the service at Savannah in 1866, Francis Greatorex moved to Florida, where he lived to the respectable age of fifty-nine. During those years his mother must have spent many a troubled night, dreading to find him among the dead in the news from the front.

Before the establishment of the Red Cross, the US Sanitary Commission was directly responsible for the army's medical care. To raise needed funds, female organizers used a variety of strategies, including mounting fairs. In the spring of 1864, New York hosted the Metropolitan Sanitary Fair. Artists were invited to show their works, which were sold in a benefit auction. The subject of Greatorex's submission was telling: *Kate Kearney's Cottage on the Banks of Killarney.*[11] The painting itself remains unlocated, but nineteenth-century photographs record the appearance of the cottage she depicted where this legendary Irish beauty made her famous *poitín*. She flouted the law, dispensing her "fierce and wild" poitín—illegal moonshine—to weary travelers who were in need of hospitality. The artist's loan of this picture constituted her assistance to the war effort, and specifically a form of assistance that referenced the acts of a defiant Irish woman.

The North was left relatively unscathed compared to the devastation of the plantations and cities of the old South. The New York Draft Riots of 1863 were a major exception that destroyed local lives and property, followed by intensified efforts to tear down old neighborhoods to create a more ordered and forward-looking city. Rather than treasuring the surviving historical structures, New York was bent on becoming a modern metropolis and eradicating its past. Greatorex's project expanded as the nation moved from war into Reconstruction, when New York embarked on a major campaign of urban renewal. The examples of domestic architecture she depicted, such as the Van Nest house (dated 1864 on the plate) and others that followed, were arguably casualties of war not unlike the ruins of Richmond, Virginia, poignantly conveyed in photographs by Irish-born Timothy O'Sullivan. These houses were among the many sites where battle scars merged with the purposeful destruction enacted in the name of progress. Born of the Civil War, her pictorial project is not specific to that event, but rather speaks to the violence that punctuated the city's entire history. Turning its pages, readers follow her urban tour, replete with images and references to the American Revolution, the Irish Rebellion of 1798, the War of 1812, the Civil War, and

Lincoln's assassination. This underlying theme might seem to be at odds with the static images of buildings done in picturesque fashion, highlighting their slightly tumbled-down and aged qualities. But they are meant to function as mnemonic devices, triggering memories of the violence that occurred at these sites. Greatorex's *Old New York* records the razing of old Gotham, victim of both military warfare and civic destruction.

FROM FORT SUMTER TO LINCOLN'S ASSASSINATION

The city's streets and neighborhoods were witness to every phase of the war. It was not so much that bullets or swords left scars on a particular old edifice or that a soldier had fallen at a certain intersection. Rather, the streets were the sites of rallies, parades, departures, and returns, whose imprints were left on the busy thoroughfare. Her black-and-white renderings of familiar structures or stretches of road could potentially trigger memories of such events that occurred at a given site even in the absence of physical markers. Like photographs in a family album, they evoke emotions personal to an individual's experience. Alone, these depictions of streets and edifices are mute, but when combined with the book's text they become animated and tell their story. "Sunday the 16th [sic, 14th] of April, 1861, will be the most historically worthy of record. The first note of war had sounded from Fort Sumter, and a silence like death fell on New York; for three days the city was paralyzed," Despard wrote, noting that a few days later "the *people* of New York . . . then thronged Broadway till the long bright avenue was indeed a moving human sea. The churches shortened their services . . . and sent their congregations forth filled with pure ardor of self-sacrifice." Inspired to head to the battlefields, young men then needed to outfit themselves, so "the shops of the gunsmiths were opened, and weapons were bought and various articles for the outfit of the volunteers who determined that day to enlist for the salvation of their country."[12]

April 20 has been described by historian Adam Goodheart as "a day unlike any the city had known before." Half a million people crowded Broadway and other thoroughfares from Battery Park to Fourteenth Street, trying to get as close as they could to the rally at Union Square, where New York's first one thousand volunteers took the oath (as was the custom in the early months of 1861). They were the 11th New York Infantry, also known as the "Fire Zouaves," dressed in their red shirts as they headed off to war.[13]

The same row of buildings and street experienced another "April day four years afterwards, when the news of the fall of Richmond raised the city to an ecstasy of delight."[14] But tragedy struck again all too soon. On the night of April 14, 1865, President Lincoln was shot while attending a play at Ford's Theater. His assassination is usually regarded as one of the last major events of the Civil War. Americans experienced a collective national grief upon hearing the news of Lincoln's death, even as they followed news of the escape of his assassin, John Wilkes Booth. Greatorex again had a personal stake in the tragedy, for her dearest friend was author Mary Louise Booth, first cousin of John Wilkes Booth, whose grief and shame she shared.

A train carried Lincoln's casket from Washington, DC, to its final resting place in Springfield, Illinois, on a circuitous seventeen-hundred-mile journey. On the way, the train made a stop on April 25 in New York, where his body lay in state in City Hall. There, thousands stood in line all day to file by and pay their respects. But for many the passage of the funeral cortege through the streets of the city was even more poignant. "When the funeral car approached the reverent silence was profoundly impressive. Nothing was heard as it passed but the regular footfall of the troops, the dull roll of the muffled drums and the occasional tolling of a bell far away," *Harper's Weekly* reported. "The sober aspect of the people all the day, the wailing peals of minor music from the hundred bands, the houses draped with mourning, the innumerable flags bound with black and hanging at half-mast, the profuse and accumulated signs of true sorrow, have made the day for-ever memorable to all who looked on."[15] Black crepe, wet from rain and decaying over time, clung to the façades of buildings long after Lincoln had been laid in the ground. It reminded citizens of the day his body was borne through the streets, when the city was preternaturally silent and still.

People remember where they stood at the moment of a historic event. An image of that place later triggers profound memories. Greatorex's rendering of the familiar New York buildings recalled for residents a series of wartime events that imprinted themselves there, from the first shot fired at Fort Sumter to their tearful farewell to the slain president.

JANE JACKSON, FORMERLY A SLAVE AT THE NATIONAL ACADEMY OF DESIGN, MAY 1865

Delayed by war, the annual exhibition of the National Academy opened in May rather than March and remained open through June. Visitors on

OUR CONTRIBUTORS. Nº XI.

Yours most faithfully
N. P. Willis.

Engraved expressly for Graham's Magazine.

FIGURE 3.4
Portrait of Nathaniel Parker Willis,
unidentified magazine clipping.
Author's collection.

preview night crowded into the academy's new building, the Venetian-style palazzo on East Twenty-Third Street, only recently dedicated. Lining Fourth Avenue and huddled at the bottom of the double staircase leading to the entrance were the usual street vendors, many of them black, reminders that Emancipation had hardly solved the former slaves' economic problems. Passing them, the well-dressed attendees entered the large show, where hundreds of works hung salon-style, floor to ceiling, in the four main galleries and spilling into the central corridor. The artists who had helped to define the national school of painting were a familiar sight: Albert Bierstadt, Frederic Church, Eastman Johnson, William Sidney Mount, William Brad-

ford, Jasper Cropsey, George Inness, and William Morris Hunt. Reluctant to reveal her new architectural graphics yet, Greatorex submitted a landscape painting of *Moodna, Hudson River* (currently unlocated). It depicted a small tributary of the Hudson above Cornwall that runs below Idlewild, *Home Journal* editor Nathaniel Parker Willis's (fig. 3.4) self-fashioned shrine of American nature.[16]

The previous owners of this rocky promontory on the Hudson Terrace had assumed that it would be forever "idle" and "wild," but N. P. Willis (as he was always known) thought otherwise. He hired the go-to architect Calvert Vaux to design his fourteen-room cottage overlooking a deep gorge and worked with him to ensure that every window, turret, and terrace would have a striking view. The tributary of the Hudson that flowed below had gone by the unsavory name of Murderers Creek after the alleged massacre of colonial settlers by hostile natives, but Willis altered that to Moodna, a corruption of the old Dutch name "Moordenaars," and it stuck. Then Willis proceeded to establish its fame through his book *Out-doors at Idlewild; or The Shaping of a House on the Banks of the Hudson* (1855). He employed as a domestic the former slave Harriet Jacobs (who wrote her memoir with his encouragement) and published work by Julia Ward Howe and their friend Grace Greenwood. Willis was known to encourage female talent and undoubtedly hosted his neighbor Matilda Despard and her sister. A rendering of one of the sacred sites in the Hudson Valley on par with those associated with Washington Irving and his fictional character Rip van Winkle, Greatorex's *Moodna* might be construed as a patriotic gesture in its nod to the national school of landscape art.[17] Perhaps, too, the reference to murder was not unintentional.

Other artworks alluded to the recent conflict, some obvious and others subtle. Camp scenes by Thomas Nast and Winslow Homer depicted the Union troops, while Sanford Gifford's sensitive rendering of a "demon-cloud" and other weather effects in his *A Coming Storm* (1863; Philadelphia Museum of Art) were interpreted as tragic symbolism of the war.[18] Among them, Elihu Vedder stood out for his diverse perspective: dark, highly personal, and original pictures including *The Gloomy Path* and *The Lost Mind*, which both intrigued and puzzled critics. Elaborating on two studies of heads—*The Arab Slave* and *Jane Jackson, Formerly a Slave* (fig. 3.5)—one journalist exclaimed: "But how good these two heads are, and how powerful! Jane Jackson is our favorite, partly because we know her better than the Arab, but mainly because the head itself is wonderfully fine, full of expression and truth."[19] For

the *Harper's Weekly* critic, "It is a head merely, but there is a quaint vigor in the sketch that well befits the strange, dusky, tragical [sic] face. Yet our great romancer, Hawthorne, thought we had no material for romances in this country!"[20] Herman Melville fell under the spell of the picture that inspired his poem "'Formerly a Slave': An Idealized Portrait, by E. Vedder, in the Spring Exhibition of the National Academy, 1865":

> The sufferance of her race is shown,
> And retrospect of life,
> Which now too late deliverance dawns upon;
> Yet is she not at strife.
>
> Her children's children they shall know
> The good withheld from her;
> And so her reverie takes prophetic cheer—
> In spirit she sees the stir
>
> Far down the depth of thousand years
> And marks the revel shine;
> Her dusky face is lit with sober light,
> Sibylline, yet benign.[21]

Although the identities of models who inspire such idealized heads often remain anonymous, in this case Vedder's memoirs provide clues to Jane Jackson's identity. These, along with Melville's observations, allow the subject to step off the canvas and into this realm of art and culture where her humble station in life and ordinary surname would typically have rendered her invisible to all but a few.

"At the time I had my studio in the Gibson Building on Broadway. I used to pass frequently a near corner, where an old negro woman sold peanuts. Her meekly bowed head and a look of patient endurance and resignation touched my heart and we became friends," Vedder recorded in his autobiographical *The Digressions of V.* "She had been a slave down South."[22] The artist tells us first, that this "old negro woman" was a vendor selling peanuts on one of the city's main thoroughfares. The street became the site of employment for many former slaves who tried to eke out a meager livelihood, performing tasks of a casual nature in hopes of a small handout. The men cleared the snow from paths, swept the street crossings, or carried baggage for arriving passengers at the docks while women sold small, portable food items to passersby or sought any sort of domestic chore: laundry, cleaning, or sewing. But in this case the artist offered Jackson a very different type of employment, for he "finally persuaded her to sit for me and made a drawing of her head and also had her photograph taken."[23]

Vedder tells us that he habitually saw Jane Jackson in one place: the near corner of Broadway and Bond Street near the building where he kept a studio (present-day Soho). Her regular appearance there suggests that she likely lived somewhere nearby since the use of rail cars was slow, and all the more vexing for black women to ride in still-segregated cars. In 1860 the city's 12,574 African Americans claimed no territorial base. After the Irish had pushed them out of the Five Points, they scattered about the city in small enclaves. One group of about five thousand gathered in the area bounded by Houston on the north and Canal on the south, concentrating in Greenwich Village streets—Minetta Lane, Bleecker, Thompson, Sullivan, and MacDougal—near to jobs as servants for the Washington Square gentry.[24] City directories might help to locate her. African Americans were identified as "black" in the nineteenth century directories starting in 1820, replaced by "colored" in the 1830s and later by "col'd." This abbreviation and all other terms describing blacks disappeared from New York City directories after 1870.[25] Searching for her name in the New York City directory, one

finds it only once, in 1864–65: "Jackson, Jane (col'd) h. 205 Church." It is likely that this entry refers to the woman in Vedder's picture, although the name Jackson was sufficiently common among African Americans that we cannot be certain. But it is tantalizingly suggestive that, having sat for and been paid by Vedder, she used her earnings to secure a residence at least for a year at number 205 Church Street. It would also identify her as a widow, for if she were married then she would be assumed under her husband's name and would be absent.[26]

Significantly, Jane Jackson's son was also a soldier: "a fine tall fellow, fighting in the Union Army," as she told Vedder. Who was his father, where was he born, and what motivated him to enlist? Our questions go largely unanswered, but we do know that he would have been a member of the United States Colored Troops (USCT), who fought bravely during the last two years of the war. On May 22, 1863, the US War Department created a Bureau of Colored Troops to facilitate recruitment of African American soldiers for the Union Army. Regiments included infantry, cavalry, engineers, and heavy artillery units from all of the states in the Union. In all, 175 regiments composed of 178,000 free blacks and freedmen did service and bolstered the army at a critical time. If young Jackson had come to New York with his mother and enlisted there, he would have been one of 4,000 blacks whom the state sent into battle.[27] His mother must have shared the sense of patriotism that drove his enlistment, given that his military service is one of the few personal details she revealed to Vedder. But the artist's sparse remark affords one additional bit of information: "She had been a slave down South, and had at that time a son, a fine tall fellow she said, fighting in the Union Army."[28] This suggests that mother and son were born into slavery. Both managed to get north, and to freedom, but how? It is possible that they were released from slavery by way of the Emancipation Proclamation, signed by President Lincoln on January 1, 1863, and read to gatherings of African Americans all over the country. Alternatively, they could have escaped at an earlier date and headed north. Paintings of the day including Thomas Moran's *Slave Hunt*, Theodor Kaufmann's *Escape to Liberty*, and Eastman Johnson's *Ride to Freedom* all indicate several paths to freedom, but whether the Jacksons took such a measure remains a matter of conjecture.

Did anyone recognize Jane Jackson from her portrait hanging in the West gallery? Did she ever enter the imposing new academy building and see it for herself? The organization apparently had no policy that would have

prevented her from attending the exhibit, but given that she was a black woman who sold peanuts on the street, she likely would have felt uncomfortable in such an alien situation and had no desire to do so. Jane Jackson is truly the invisible woman. We may never secure more biographical information about her than we now have. Neither the undated pencil drawing (c.1863) nor the photograph of her that Vedder had made as the basis for the oil painting has yet surfaced. But Herman Melville intuited the universal truths about her from Vedder's painting. Although "the sufferance of her race" is plain in her face, he wrote, for her "too late deliverance dawns." Even her son may never be completely free. But "her children's children they shall know / The good withheld from her" as they break free and fulfill the promise of emancipation. Thus, from "down the depth of thousand years" she sees the good that is to come—not to her but to hers—and "her dusky face is lit with sober light."[29] Vedder's canvas provides the gateway between the dual worlds that he, like the Irish American Greatorex, inhabited: the art world of studios, art classes, and exhibitions on the one hand and, on the other, the grittier city streets where Vedder found models in the streets and where Greatorex drew the soon-to-be-demolished buildings one step ahead of the wrecking crews, crews that were often composed of free African Americans and Famine Irish laborers.

PALIMPSEST AND CITIZENSHIP

The United States had a violent history, every stage of which impressed itself on New York City, from the Revolutionary War (1775–83) and War of 1812 to the Civil War (1861–65) and the assassination of President Lincoln (April 14, 1865). The built environment of Manhattan therefore presents a palimpsest of the national military history. *Palimpsest* was originally defined as a manuscript that has been written upon repeatedly, with the earlier writing incompletely erased and often partly legible, but it has come to reference a place that embodies the complex layering of its history. Greatorex became expert in excavating the city's layered history, seeking out sites overlooked by others. "When the walks and avenues of Central Park were laid out, and the road on the extreme north from Eighth to Fifth Avenue was opened," the text explains, "the citizens of New York saw beauties of landscape of . . . abrupt hills and rocks, the wild face of the country, seemed to belong to some unknown and remote region rather than to Manhattan Island." Acknowledging the beauties that others saw, she drew not one of

FIGURE 3.6
Eliza Greatorex, *Old Powder
Magazine Left from the War of
1812*. Inscribed "1875." From *Old
New York*, opp. p. 231.

the park's picturesque vistas favored by her compatriots but those with military associations: "On the wooded height a little south-east of Claremont, about One Hundred and Fifth Street, a square grim building was visible. All who climbed to see it closer, found rude steps leading to an iron door, walls three or four feet thick, and narrow windows in a deep embrasure: it had been evidently a military structure." She referred to the Powder Magazine (fig. 3.6) remaining from the War of 1812.[30]

The Civil War left the South in ruins while New York—the de facto financial capital of the Union—was growing richer. New fortunes amassed from the spoils of war demanded Gilded Age mansions to replace more modest existing domiciles. Historic structures were being leveled in the name of progress, a process that was especially rapacious in the 1860s and early 1870s. Surveying the building boom that was shaping the modern metropolis, Greatorex interpreted the destruction of the old buildings as an extension of war. In her eyes, the attacks on civic and domestic structures during

the Draft Riots found parallels in the actions of city fathers, including most notoriously William Macy "Boss" Tweed, who ordered old churches, hospitals, and venerable Dutch homes demolished to extend Broadway. Greatorex was steadfast in her devotion to the New York landmarks, fueled by her appreciation for the past and her willingness to take up her pen in protest: both instilled in her by her Celtic heritage. She continued her campaign to record the city's disappearing structures and, over the subsequent years, created over one hundred such building portraits, which she published in her folio volume *Old New York* (1875).

As she immersed herself in this process of visual memorializing, she initiated one other act that might also be understood in the wake of war as patriotic. On March 25, 1867, the Irish-born artist applied to become a naturalized citizen of the United States. The country's nationality law transformed hundreds of thousands of northern and western Europeans into its citizens, so this in itself is not so unusual, but it is the timing of her actions that is significant. From 1790 until about 1870, the rules for naturalization established by Congress dictated that applicants meet three basic requirements: have five years' residence in the country, possess "good moral character," and be "free white persons." So Greatorex had been eligible to commence this process for about fifteen years and only did so at this moment in early 1867. This chronology suggests that recent events triggered her decision to self-identify with her adopted country. Signing the document that read that she "intends always to reside in the United States and to become a citizen thereof, as soon as she is naturalized," she was affirming her political and emotional bond with a land and people struggling to heal and reunite after this unprecedented conflict.[31]

4

SUCCESS IN THE NEW YORK ART WORLD, 1865–1870

STUDIO LIFE IN THE DODWORTH BUILDING

Eliza Greatorex occupied Studio 8 in the Dodworth Building at 212 Fifth Avenue on the corner of Twenty-Sixth Street overlooking Madison Square Park from 1865 until she departed for Germany in 1870.[1] "The vicinity of Madison Square is the brightest, prettiest, and liveliest portion of the great city," James McCabe wrote in 1872. It was convenient to transportation and "may almost be considered the heart of upper New York" where "two sets of [street] cars come round the corner and four sets of omnibuses." This location also had its drawbacks, for it got so congested that "at some points of the day it is hardly possible for a lady to pass."[2]

By mid-century the city's burgeoning art community spelled a shortage of desirable workspaces. Most artists rented quarters in commercial buildings or rooming houses, especially in low-rent neighborhoods. When Richard Morris Hunt's Tenth Street Studio Building opened its doors late in 1857, it offered artists for the first time spaces that were constructed to fit their special needs. But it accommodated only twenty-five artists, and although women were not specifically prohibited, records from the early years indicate only one female resident: Anna Mary Freeman, from 1858 to 1860.[3]

Others scrambled for space in multipurpose buildings, the best known of which was the large-scale Gothic-style University Building, which opened in 1835 on Waverly Place. Constructed by New York University (then known as the City University of New York), it was home to artists John Kensett and his companion Louis Lang.

Being at Dodworth's put Greatorex at the center of a lively community of artists who were on the rise, rather than the established names who gravitated to Tenth Street. She liked its constituency, artists who were not so insistent on large-scale oil paintings as the sole vehicle for serious expression and worked in a variety of media including watercolors and printmaking. As a mother, she often had her children with her and required a building that would be welcoming to them.[4] Her daughters Kathleen (fourteen years old in 1865) and Eleanor (eleven) were already demonstrating artistic talent that would thrive best in a nurturing atmosphere. If fellow residents found it something of a double novelty not only to have a female artist in the building but also to have her children around, they showed no signs of it. "Here the children were in their glory," as it turned out, "for they received not only the benefit of their mother's teaching, but the kind though not always flattering criticism of the colony of artists there established."[5] Here she could also make contacts that would help advance her career. James Smillie moved into the building around the same time she did. He had been a skillful banknote engraver who was studying at the academy school to become a painter.[6] Greatorex and her elder daughter became good friends with him, taking advantage of his skill with the burin to learn the basics of printmaking.

John Quincy Adams Ward, "the sculptor of the *Indian Hunter*, the *Freedman*, and numerous other statues which ornament the public places of our large cities, occupies a studio in Dodworth Academy on Fifth avenue," a journalist explained as he described the society behind its walls. "Adjoining the studio of Mr. Ward is that of John Rogers, whose statuette groups have gained for him a high reputation. . . . On the same floor with the sculptors Mr. Hart has his studio, which is filled with elaborate studies." Being a painter of landscape, Greatorex must have been aware of the fact that "the skylight floor of Dodworth's building is almost exclusively occupied by landscapists. Mr. [Samuel] Colman's studio is graced by a number of studies and finished pictures. . . . The two brothers, G. H. and J. D. Smillie occupy the same studio and have made it attractive by the execution of pictures which would have been remarkable had they been the production of men of

years and experience." She would have found her own name and that of her female compatriots at the article's end: "Besides the names we have already mentioned, Kittell, Ferguson, Greatorex, Miss Beers and Mr. Brown have studios in Dodworth's Fifth avenue building. Of the many studios which are thrown open to the public every Saturday, few possess more attractive objects of interest or more attentive hosts than those in Dodworth's."[7]

Greatorex forged relationships there that were key to her success. From the time Ward's statuette of the *Freedman* had created a sensation at the National Academy of Design in 1863, he was on his way to becoming one of the country's most prominent sculptors.[8] He took an interest in this rising woman artist and purchased her *Sketches in Rome*.[9] William Hart dropped in on her from time to time to offer advice, continuing relations that had begun when she studied landscape painting with him a decade earlier. She and her daughters sang in a choral group with Smillie.[10] Most beneficial of all was the opportunity to live and work with other professional women artists, among them H. Wilhelmina Wenzler. She became close friends with Julia Hart Beers, another widow whom she had probably met through her brother William Hart, who had been Greatorex's early instructor.[11] They had much in common, including their efforts to juggle children and a career on their own. But it was their shared love of art that led to their joint sketching tours.

Another attractive feature of the building was the owner himself. A bandmaster and violinist with the New York Philharmonic, Allen Dodworth had been acquainted with Greatorex's late husband, with whom he shared a passion for music. Dodworth opened a dance school at 402 Broadway in 1842. His other studios were located at 681 Fifth Avenue (with its huge dance hall illuminated by skylights, it made an ideal picture gallery when it was the temporary home of the Metropolitan Museum of Art from 1871 to 1874) and at 12 East Forty-Ninth Street.[12] Dodworth believed that proper dance technique and etiquette could help refine society, a position he presented in his dance classes and in his book *Dancing and Its Relation to Education and Social Life*.[13] All of these aspects of his activity would have been congenial to Greatorex, who favored preservation of traditions and social etiquette.

By 1860, the fine arts were sufficiently woven into New York's social fabric that local artists were frequently invited to private parties and receptions where their work was hung. The annual exhibitions at the National Academy were de rigueur, but the number of events was expanding to the extent that it was almost impossible for the artists to keep up. Organizations mounting

art displays included the Artists' Fund Society (instituted in 1859), the Cooper-Union (founded in 1859), and the Brooklyn Art Association (founded 1861). The Century Association and the Athenaeum also featured art exhibits, but participation was often limited to members and therefore men only. Seasonal public receptions were held at the two major artists' studio facilities: the Tenth Street Studio Building and Dodworth, home of the Artists' Reception Association, started in 1858.

Dodworth was convinced from his own experience in the music world that interaction between artists and the public was paramount to success. He planned his building to include a large central hall and encouraged his artist-residents to hold regular receptions, where they mounted group exhibitions and enticed visitors to circulate through the studios, meeting the artists and viewing their work. He could foresee the day when a new breed of picture dealer would intervene between artists and art enthusiasts, but for now the artists needed to have direct contact with potential buyers and also take responsibility for educating the public. "The artists of Dodworth Studio Building gave the fourth and last reception for the season on Saturday afternoon, March 7," a writer for *Harper's Weekly* reported in 1868. "A large number of ladies and gentlemen indicated by their presence their appreciation of art in general, and their interest in these artists in particular." Going from studio to studio, he headed for "Miss Greatorex's room," which he described as "a *study* [emphasis in original] in itself, adorned as it was with all manner of pretty, tasteful ornaments in addition to the oil paintings and pen and ink sketches, which latter are very beautiful, and attracted much attention."[14] Once seduced into her chambers, visitors could talk with her directly about her work.

Dodworth Studios provided cheery corridors and common spaces that allowed easy exchanges with fellow residents, who would leave their doors open when at work. At Tenth Street, Sanford Gifford earned the reputation of being highly accessible, welcoming visitors who stopped by at random, where they could have full access to his working environment, from pictures-in-progress to finished canvases. But there were times, of course, when most artists desired to close out the world and work in solitude. Frederic Church only allowed access to preferred guests, a policy which led to no end of complaint.[15] Winslow Homer famously locked his door and put out a sign reading "Mr. Homer is not at home." He particularly disliked the interruptions by reporters, who asked endless intrusive questions. He took

the position that anything worth knowing about him was evident from his art, and the rest was his business. It was different for women, who often felt the need to be more accessible, to make their presence known. While staying with her brother in Washington, DC, Greatorex likely visited the Capitol Hill studio of Vinnie Ream, who was making a name for herself with her statue of Lincoln. Ream's open-door studio policy was widely known. Dressed in a loose-fitting smock and turban covering her famous long curls, she worked with clay and marble all the while as visitors thronged her studio, chatting with her from morning to night. Greatorex often taught art classes to make ends meet, and therefore had something of a pedagogical bent herself. She felt it was the obligation of the artist to nurture appreciation of art, as a way of fostering broader cultural awareness. But at times she too desired privacy, a coveted commodity for a mother whose daughters were often underfoot in her relatively small space and who managed to devise strategies to block out even the fiercest distractions.

FEMININE ART NETWORKS

William Merritt Chase famously depicted his Tenth Street studio as a workplace that doubled as gallery/salesroom to display pictures to potential clients. But neither he nor his male cohort could just sit back and wait for the city's moneyed elite to stroll through their studio doors. They therefore sought membership in the city's well-established clubs that provided opportunities to socialize with the businessmen and civic leaders who were positioned to purchase artworks, enumerated in Junius Browne's 1869 guidebook to New York.[16] The Century Association was one of the most advantageous clubs for artists. It was formed in 1847 at a meeting of the Sketch Club, which had been organized by Thomas Cole in 1829. Membership had always been made up of writers, artists, and amateurs of the fine arts. It amassed an art collection and held exhibitions, to which women were permitted access one afternoon a year. But even this event was "ladies only," thus denying them that window of opportunity to meet and greet the male patrons who might have taken an interest in their work. The stereotypical image of regular meetings, redolent with cigar smoke and brandy, was not so tempting in itself. But where else could the women hope to mix and mingle and meet potential patrons if access to the metropolitan clubs was barred?

Ever resourceful, they evolved a number of strategies. Those who rented space in predominantly male studio buildings made sure they made their

presence felt. Following Cole's example, they joined forces with writers, musicians, and their networks. And they formulated their own dedicated interest groups, including the Ladies Art Association (LAA) in 1867. Associations for women artists began appearing just after the war, but this one was by far the most successful. It conformed to the pattern of many women's groups: it started out addressing a general constituency and narrowed over time. In the beginning, the LAA offered life classes as well as "instruction . . . in all branches of technical art, including painting on china, furniture decoration, carpet and wall-paper designs." It strove to foster both professional fine artists and commercial workers earning an independent livelihood.[17] Within ten years of its founding, its dual constituencies distilled out and followed their separate paths to either fine or applied arts. It was an organization of its moment, when the art world was heterogeneous and women who were just beginning to establish a presence there saw their best chance in sticking together rather than dividing into small interest groups.[18] It was also multigenerational, with seasoned artists looking out for younger ones. When President Alice Donlevy needed artworks to hang in the association's temporary headquarters for a reception in May 1869, she turned unhesitatingly to Eliza Greatorex, who could deflect charges that the group was made up of "mere lady amateurs" since she was a well-known professional. She donated an autographed copy of her first book, *Relics of Manhattan*, to their growing library and acted as their ambassador abroad, investigating possibilities for women's art training during her residence in Munich.[19] She played the role of "Godmother" of the organization, a position Donlevy acknowledged by hanging a framed photograph of her in their new offices.

Greatorex also provided a link between female visual artists and the literary set hosted by Mary Louise Booth, who every Saturday with the assistance of her partner Anne Wright welcomed a procession of guests to their weekly salon.[20]

Mary Louise Booth was the founding editor of *Harper's Bazar* (later *Bazaar*; fig. 4.1). When she took the position in 1867, she was thirty-six years old and already had a number of accomplishments to her credit: she was the author of a history of New York (first published in 1859), an advocate of woman's rights, and a translator from the French of a number of important works. Harper Bros. publishing house had in mind a periodical that proclaimed itself "a repository of fashion, pleasure, and instruction." The

PORTRAIT OF MISS MARY L. BOOTH.

FIGURE 4.1

Waters & Son, engraver, *Portrait of Mary Louise Booth,* ca. 1860. *American Phrenological Journal* 31 (May 1860): 72. Library Company of Philadelphia.

magazine had begun with a focus on what would come to be called lifestyle, encompassing fashion, etiquette, the arts, gardening, and other domestic issues. It instructed readers on the best gowns of the Newport social season, the subtle art of facial expression, and running a country home. Booth intuitively realized, however, that this editorship was a potentially powerful position for a woman, allowing her a platform to challenge the status quo. She worked hard to make it much more than a fashion magazine, set out to discover new literary talents, and published their essays and short stories. By all accounts Booth exerted complete control over content, and through her selections she subtly advanced her own social agenda. Running articles on everything from women's trousers to Susan B. Anthony's politics, *Harper's Bazar* became a voice for gender reform.[21]

Booth was at the center of several intersecting social and cultural spheres and was acquainted with almost everyone worth knowing in New York. At her home "every Saturday night may be met an assemblage of the beauty

and wit and wisdom, resident or transient, in the city," the press reported. Attendees varied from week to week and included not only her actor-cousin Edwin Booth, but also "authors of note, great singers, players, musicians, statesmen, travelers, publishers, journalists, and pretty women, making the time fly by on the wings of enchantment."[22] Inviting her friend Eliza Greatorex and other creative women to mingle with this company provided unprecedented opportunities for them to make needed professional contacts. Their presence conversely raised awareness of women artists among the guests. Always on the lookout for new talent, she was occasionally able to offer them work at *Harper's*. A salon regular was journalist Grace Greenwood, with whom Greatorex teamed up on her Colorado book, perhaps hatching their plan after meeting here.

Booth's weekly salons, like the LAA, served as bridges between the women artists and the postwar world of commerce and culture in which they were learning to circulate. The organizations grew and changed with their needs. They were proactive, but no longer needed to be as defensive. The associations made while sipping lemonade at Booth's soirees or arguing about the merits of a work of art at an LAA exhibit contributed to the feminine art networks that augmented their professional careers.

UPROOTING BLOOMINGDALE, 1868

The Saturday before Christmas 1868, Eliza Greatorex held her last reception of the year in her "pleasant studio" in the Dodworth Building.[23] At these gatherings, visitors enjoyed the unique opportunity to see the artworks where they had been created and to hear the artist expound upon them. That evening, fifteen of her pen-and-ink drawings hung as an ensemble, "and they represent, for the most part, old and picturesque churches and buildings in the suburbs of New York that will soon be swept away, if they have not already disappeared."[24] Among them was *Church of the Puritans, from Across Union Square* (fig. 4.2), which viewers would have known about from recent coverage in the news. Designed in 1846 by leading architect James Renwick Jr., it featured a striking twin-towered façade inspired by Paris's Abbey Church of Saint-Denis, with one exception: he substituted round-arched windows for the Gothic pointed windows, establishing it as the first Romanesque church in Manhattan. It became famous for the fierce abolitionist campaign its minister, Rev. George B. Cheever, waged from his pulpit. So powerful were his religious antislavery arguments that he was

FIGURE 4.2
Eliza Greatorex, *Church of the Puritans, from Across Union Square*. Inscribed "1868." From *Old New York*, opp. p. 71.

encouraged to publish them in books such as *God against Slavery* (1857). Now, in 1868, his church was being razed to make way for Tiffany & Company's new store.

Some of those who passed through Greatorex's studio that evening must have asked what made her start sketching these old churches and what plans she had to continue this line of work. Like most projects, its beginnings were difficult to pinpoint, but the experience of watching the city change slowly before her eyes certainly crystallized in the destruction of individual, favorite buildings. The loss of the Church of the Puritans was a terrible waste; the building was only twenty years old and already held an important place in both American architecture and history. In a plan to

salvage something of the sacred edifice, materials were numbered and re-used to construct the Fifty-Third Street Baptist Church.[25] Greatorex drew it as it was being torn down and the remains hauled away. Along with the reassembled elements, her pen-and-ink drawing constituted a rare trace of the church's short but distinguished existence.

Arriving in New York after a decade abroad at precisely the same moment when Greatorex sketched this church, Henry Adams famously remarked: "Had they been Tyrian traders of the year B.C.1000, landing from a galley fresh from Gibraltar, they could hardly have been stranger on the shore of a world, so changed from what it had been ten years before." [26] She had reached New York from Ireland in 1848 a few years after Richard Upjohn completed his masterpiece Trinity Church (1846), whose 281-foot steeple made it the tallest building in the city. Church spires were the highest and most prevalent structures in sight (save for the ships masts, if you were close to the docks). Those spires had traditionally dominated the horizon. But now, seemingly overnight, their presence was being dwarfed, or erased. The process seemed to be accelerating as not only historic churches but also eighteenth-century Dutch homes were being demolished to make way for newer, taller, and—yes, it had to be said—less attractive buildings. The city was destroying itself, but nobody yet knew what it was to become. They only knew that it would never be the same. Neither author nor artist fully comprehended the magnitude of this historic transformation, yet both recognized it and felt the necessity to respond.

The more Greatorex saw, the more convinced she became that it was Haussmann's Paris all over again. In Europe during the spring and summer of 1867, she had stopped in Paris to view the Exposition Universelle, but she was as awestruck by the changes in the city since her previous visit in 1861 as she was by anything on the Champs des Mars. The radical modernization of Paris that had been spearheaded by Emperor Napoleon III and his chief urban planner Baron Georges-Eugène Haussmann had made startling progress in the intervening six years. Gone were the dense old quarters of the city with their irregular passageways left over from medieval times, replaced by wide avenues and open spaces organized into a rational design. His efforts were not limited to streets and utilities but extended to building façades, now organized in prescribed horizontal levels to assure continuity along the street. "Cruel demolisher," poet Charles Valette bemoaned in 1856, "what have you done with the past? I search in vain for Paris; I search for myself."[27]

French artists had been among the first to mourn the loss of the ancient city, which they desperately tried to capture in prints and photographs before all signs had been erased. Hippolyte Bayard had taken some haunting photographs of the half-ruined structures. As official photographer of the city of Paris, Charles Marville documented the before and after: the picturesque, medieval streets of old Paris that were slated for destruction and the broad boulevards and imposing structures of the new Paris that were replacing them.[28] The etchers too contributed to the growing catalogue of lost sites: Adolphe Martial Potémont collected 300 etchings in his *L'Ancien Paris* in 1864, and Alfred Delauney created 24 plates for *Eaux-Fortes sure le vieux Paris* (1870–78). But as in New York, the commercial and political interests that increasingly dominated society were virtually unstoppable.

Simultaneously Asher B. Durand, the elder statesman of the Hudson River School, was beginning to weary of the enormous alterations he witnessed during his residence in the city. "He had passed fifty-four years in the metropolis, and thirty-one of these in Amity Street," his son recounted. "When he established himself in 1832 in this street, it was on the outskirts of the city, far above the business tumult and fashion." By the time he was turning seventy-three years of age, "in 1869 it was 'down-town,' fashion had arrived at and long abandoned the vicinity. A retreat became imperative."[29] There are two basic responses to unwelcome change. You can retreat or you can stay and fight. Durand was of an older generation; born in 1796, he had seen his share of conflict. Now he chose to build a house on the family property in Maplewood, New Jersey, and abandoned the city for good in 1869. The disappearance of the Church of the Puritans and other landmarks, by contrast, constituted a turning point for Greatorex. She had witnessed the rise of modern Paris and the concomitant demolition of the picturesque old quarters of the city. Upon her return to New York, she could not help recognizing some of the same forces at work. It is little wonder that the examples of Bayard, Marville, Martial, and Delauney worked their way into her artistic consciousness. Then and there she vowed to find a way to force busy New Yorkers to notice the loss of these historic structures that provided the material link to their past.

In this endeavor, the artist found an ally in Thomas Addis Emmet, a noted physician and grandson of an Irish revolutionary of the same name. When he was not tending his medical practice, Dr. Emmet devoted considerable energy and expense to amassing antiquarian materials relevant to the

history of New York, which he subsequently bequeathed to the New York Public Library. He gave Greatorex full access to his books, including Mary Louise Booth's *History of New York* (1859), which shockingly was the sole synthetic treatment of the subject. With Emmet, the women united in the efforts to preserve New York's past. "It was about this time that Mrs. Greatorex began making the pen-and-ink drawings," Sylvester Koehler later recalled, "a series of pictures of *Old New York*—by which she is, perhaps, most widely known."[30]

Although New Yorkers had seldom demonstrated much respect for their past, never in the city's history had they been so bent on its wholesale destruction. The flood of money into the city during and after the Civil War accounted in part for the unprecedented growth. But now Boss Tweed and his corrupt ring of cronies were accelerating the real estate and construction boom for their own profits. Every week brought news of new projects and scandals. The city had its origins down and around the Battery, which remained its focus for more than a century. Even when Eliza and Henry Greatorex married in 1849, their first residence on Sixteenth Street was considered uptown. In twenty years, the city's population had expanded enormously and was spreading further and further north. Yet the streets did not provide easy access between distant neighborhoods. There was not even a single direct thoroughfare from one end of the island to the other. Boss Tweed wanted a boulevard running north to south, connecting all parts of the island. With teaching, art-making, and the care of the children, Greatorex rarely had time to read the newspaper, but now made it her business to keep abreast of the destruction along the old Bloomingdale road as Tweed transformed it into modern Broadway.[31]

Greatorex headed to Bloomingdale and focused her attention on the Somerindyke House (fig. 4.3). The edifice had stood since the eighteenth century at Seventy-Fourth Street and the Bloomingdale Road. Studying her picture, it is hard to believe that the site that today is near the IRT subway stop at Seventy-Second Street and Broadway looked anything like this 140 years ago. It was here, legend had it, that Louis Philippe (afterwards King of France) and his two brothers taught school while in exile from France. Although historians later debunked the myth, it was oft-repeated in the artist's day. She vividly recalled her first impressions of the Dutch colonial house "rising on this beautiful green knoll, with the trees shading it perfectly from the heat and dust of the road." Then, she emphasized, there was

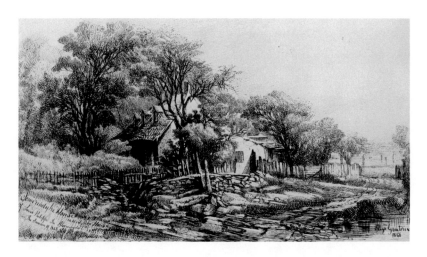

FIGURE 4.3
Eliza Greatorex, *Somerindyke House, the House of Louis Philippe in Bloomingdale, Summer 1868*. From *Old New York*, opp. p. 184.

"no sign of the terrible uprooting which has been making such sad work with the freshness of Bloomingdale since that summer of 1868."[32]

Comparison between her drawing and a rendering of the same site that appeared in *D. T. Valentine's Manual* for 1863 reveals the hallmarks of Greatorex's style and approach to her subject. The lithograph (by Sarony, Major & Knapp, fig. 4.4) features signs of technological progress and urban development, such as telegraph lines and streetlamps. Greatorex, by contrast, positioned herself on the northeast corner, where she could avoid the appearance of these intrusive modern elements. Her picture derives some of its interest from the tension between the reality she confronted and the ideal she wanted to convey. She aimed "to make each picture faithful and literal," but she achieved this "while ignoring . . . their inharmonious surroundings."[33] For her this meant capturing the atmosphere of its former days in a picturesque view of the house sheltered by ample foliage, tumbled down and slightly rustic, often with a glimpse of the river in the distance.

In November she returned to the site, as was her habit, to compare her drawing with the actual motif, and recorded its further dismantling: "Going this morning, with my picture to look once more at the Somerindyke House, I find the last beam of the roof is just being lifted away. The walls are still left, but inside there is only a confusion of brick and plaster, fragments of

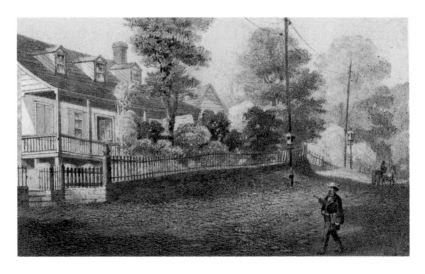

FIGURE 4.4

Sarony, Major & Knapp, *Somerindyke Estate on the Bloomingdale Road, near 75th St.* In *D. T. Valentine's Manual* (1863).

wood, and at the hearth a heap of broken tiles." Wanting to portray the building on a discarded panel, she searched among the rubble but reported: "I cannot find one which approaches the shape and pattern of a complete one, so I lift up some of the pieces to bring away."[34] Her finished sketch conveys her sentiment: "I cannot say how sorry I feel that this old house is gone."[35] Later in 1871 when Vanderbilt's construction of Grand Central Depot obliterated the neighborhood around Forty-Second Street, she redoubled her efforts to record the soon-to-be-lost landmarks. Ultimately, she sketched over eighty buildings that met similar fates, which she then compiled in her showpiece *Old New York* (1875).

REALIZING *RELICS OF MANHATTAN*

Some summers Greatorex left the city with her children to stay with her sister in Cornwall-on-Hudson and used her home as a base from which to sketch along the river and into the Highlands. In this she paralleled the practices of the Hudson River men, making preparatory sketches for paintings she would elaborate during the winter months in her studio. Then she began to realize she could apply the same methods to the urban environment. Come June 1868, she decided to remain in the city and set out every

day to survey northern Manhattan, where Boss Tweed was redoubling efforts to remove its rustic structures and make way for the extension of Broadway. Working in the heat of June, July, and August, she "produced at the end of the season a series of sketches, among which are the following: the Old Village Church at Bloomingdale (in the process of demolition at the time); the Bloomingdale Stage Inn, built in 1792; the ancient Smithy of Joseph Chaudlet; the Harsen Homestead built on the bank of the Hudson in 1754; the Somerindyke House, built in the seventeenth century; and Somerindyke Lane, leading to the old Gassner and Perrit mansions." The old inn and smithy and the residences of the families who once inhabited these residences had helped shape the old city.

"Besides these," the reviewer continued, "Mrs. Greatorex has produced sketches of several old churches—St. Mark's in the Bowery, the North Dutch in William street, St. Johns's, and the last views of the picturesque ruins of St. George's and the Church of the Puritans."[36] These churches were the mainstay of life in their neighborhoods. A passage in Sarah Orne Jewett's *A Country Doctor* (1884) paralleled the spirit of Greatorex's drawing. In the novel an old country church—the "dear and quaint . . . place of worship"—sets the young character Nan on a personal voyage of discovery into her family history: "there were so many antique splendors about the chancel, and many mural tablets on the wall, where she read with sudden delight her own family name and the list of virtues which had belonged to some of her ancestors." Acknowledged for their historic significance, these churches also functioned as repositories of memory. "There had never been and could never be any church like it," as Jewett put it; "it seemed to have been waiting all her life for her to come to say her prayers where so many of her own people had brought their own sins and sorrows in the long years they were gone."[37] Like the artist, the novelist was invested in their culture's cherished notion that churches are themselves containers of multiple histories, of communities and individuals, in their relation to spiritual life. Greatorex's expressive technique matched her message, as reviewers perceived: "Her pen produces the effect of fine etchings, and the historical value of her pictures adds to the interest they excite among lovers of art."[38]

Her pictures were one-of-a-kind drawings that she now needed to duplicate for wider dissemination. Up to this point she had little training in printmaking. To produce multiples of her drawings, she could turn it over to a

wood engraver, who in the process of transferring her rendering to the wood block would lose the subtlety of the original. Just coming into its own, lithography offered another option. Napoleon Sarony's lithography firms had produced the illustrations for *D. T. Valentine's Manual* (used, for example, in the 1863 edition mentioned above), which contained depictions of some of the same old homes and churches that now interested her. Perhaps this led the artist to consult him, but in the end he used not lithography but photography to reproduce her drawings. Two years her junior, Sarony had arrived in New York from his native Canada about 1836. He had worked in printmaking, training under Nathaniel Currier before starting his own lithographic firm: first as Sarony and Major, then as Sarony, Major & Knapp. He then withdrew from that firm to establish a photographic studio. After visiting his older brother Oliver in Scarborough, England, and seeing the enormous financial success Oliver was having in portrait photography, Sarony felt he could do the same. At the end of the Civil War he returned to the States and in 1865 opened his first photography studio in New York City at 630 Broadway, later moving it to 680 Broadway. He always wore a fez—a practical expedient for covering his bald spot—which gave him an exotic air and became his signature. He was the initiator of celebrity photography, in which he made photographs of the rich and famous but kept the exclusive rights to sell them. He was doing so well that by 1871 he moved his studio once more to 37 Union Square, where he occupied several floors above ground level.[39] But in late 1868 he was game to combine his old and new expertise, and employed his camera to reproduce Greatorex's pen-and-ink drawings (fig. 4.5). She arranged them in a volume she titled *Relics of Manhattan*, which she intended to exhibit and promote outside the walls of the academy.[40]

It was something of a coup that she was able to show the photographs of her New York drawings at Schaus's early in December 1868. Along with Goupil's (later Knoedler's), William Schaus was one of the leading picture dealers, where the work was sure to be seen by a wide variety of people, who were frequently convinced by the proprietor to acquire it. Located at 749 Broadway, his galleries were "always open free of charge to the public," the press reported, and "display, from time to time some of the best works of foreign masters, as well as frequently the best productions of our American easels." That establishment, with its mix of European and American work, seemed a good fit for her since her own life and her art bridged the two. Additionally, Schaus demonstrated good business sense. In 1848 he had arrived

FIGURE 4.5
Napoleon Sarony (after Greatorex),
Somerindyke Lane. From *Relics of
Manhattan*, 1869, after drawing
of 1868. 6½ × 4¼ in. Private collection.

in New York as the agent for Goupil & Co, Paris. Within four years, when the firm denied him equity in his publication of American pictures, he opened his own business. It was well known among artists that the Long Island native William Sidney Mount owed his national and international reputation to Schaus, who discovered him and arranged issue of ten of his paintings as large color lithographs done in Paris.[41]

To create a market for art, he adopted the latest retail strategies. His establishment was fitted with a large plate glass window, not as large as those in A. T. Stewart's department store but eye-catching, especially when he displayed a large-scale canvas. If busy New Yorkers did not have time to enter, as *Watson's Weekly* reported, then they could catch a glimpse of works like Oswald Achenbach's *Coming Storm Near Rome* as they passed by: "We are

glad to see this picture in the window of Schaus's store, where the masses who throng Broadway at all hours during the day, will have the opportunity to see and study its fine effects."[42] Many went inside, because they knew that they would be "constantly pleased and surprised by finding, from month to month, excellent additions of pictures or statues." Most of his competitors put up a show once a month and left it intact, taking it down at the end of the run and replacing it with another whole collection. He, by contrast, was constantly substituting, rearranging, and adding new things as they arrived to take the place of those that had sold. People always had a reason to drop in, to see the latest acquisition. Another of his strategies for making art fashionable was the exclusive preview. Many organizations had an initial event to celebrate a new show, but for all intents and purposes admitted *tout le monde* through the doors. But he teased artgoers, making them want to come to his establishment: "The Schaus Collection for the season has not opened yet. To-day such as are favored with invitation will have the privilege of a private view; to-morrow it will be thrown open to the public." The sepia photographs of Greatorex's images were added to the rows of pictures hung from ceiling to floor in his little gallery. He made sure announcements of their arrival were sent to the city's many newspapers, since her name was well known and the old landmarks she depicted were of great interest. Besides, the holidays were drawing near, when people liked to give illustrated books and prints as gifts. Greatorex had high hopes for her prospects, especially working with Schaus.

Some of her colleagues likely disapproved of her initiative to bypass the academy and secure a commercial gallery to show her work. But she was enterprising and wanted to be more vigorous about seeking diverse means to reach a broad public. When she first started exhibiting as a professional artist in the mid-1850s, such opportunities barely existed. The National Academy had something of a monopoly, the only serious place to exhibit work where a significant number of people would see them. Artists heavily depended on the annuals to sell their pictures. "Broadway, which but a few years since knew of but one or two regular dealers in pictures, and they but of an inferior type, has now at least half a dozen first-class galleries, and at least a score of [auction] houses infinitely better than those of ten years back." Now anyone interested in art was familiar with the names of Schaus, Knoedler, Weissmann, and Langenfeldt, establishments whose exhibits were covered regularly in the newspapers. In the days when the city lacked

an art museum, they provided rare opportunities to see fine art. During the times of the year when the doors of the academy galleries were closed, they were the only locales where artists could show new work. In the Friday edition of the *New York Times* they even placed notices under the heading "Amusements This Evening." Following announcements of theater performances, Barnum's museum, and minstrel shows, readers could discover featured single-picture shows at Schaus's and Goupil's: the latest Bouguereau or other crowd pleasers. These picture dealers educated the public, encouraged artists and art students, offered entertainment and a place to socialize, and became integral to the life of the city.

Greatorex had a few sets of the photographs printed and bound in portfolios with a title page that read: *Relics of Manhattan. A Series of Photographs, from Pen and Ink sketches taken on the spot by Eliza Greatorex, Illustrating Historic Scenes and Buildings in and around this City.* Additional sets could be made up as orders arrived. She mounted the sepia-toned photographs, about 3 × 5 inches each, onto standard 8 × 10–inch mounts, one to a page, organized them into two categories—the Old Churches and Bloomingdale neighborhood—and provided dates and a few pertinent details in the table of contents.

THE OLD CHURCHES

1. Taking away Old St. George's, Beekman street	Erected 1759
2. North Dutch Church, William street,	Erected 1763
3. St. Marks, in the Bowery	Erected 1795
4. The Old Dutch Church, Bloomingdale	Erected 1805
5. St. John's Chapel, St. John's square	Erected 1807
6. Taking away the Church of the Puritans, Union Square	[n.d.]

LAST LOOKS AT BLOOMINGDALE

1. The Village Church, and its Surroundings

2. The Old Stage Inn, built in 1792

3. The Ancient Smithy of Joseph Chaudlet

4. The Old Harsen Homestead on the bank of the Hudson, built in 1754

5. The Bogg Mansion said to have been built by a French Marquis, and called by him—Chaudlait.

6. The Somerindyke House, built in the 17th century, where, it is said, Louis Philippe, Ex-King of the French, taught School

7. Somerindyke Lane, opening on the Hudson, and leading on the right to the Gassner Mansion, the residence of an Old French Family; and on the left to the Old Perrit Mansion, where Tallyrand landed, 1794.

With the research assistance of her sister, she had added the dates of building construction and a few identifying points. She wanted only minimal text, to allow the images to speak for themselves. By early January 1869 she had reason to be optimistic about potential sales. "A series of 'Pen-and-Ink Sketches' by the well-known artist Eliza Greatorex, have attracted deserved attention and cannot be too highly praised," one journalist wrote. "The workmanship of these sketches is most exquisite . . . The sketches of the artist have been photographed, and, undoubtedly, will be multiplied to an unlimited extent to meet the demand made for them."[43]

Acutely self-critical, the artist was not entirely satisfied with *Relics of Manhattan*. Compared to the original drawings, the photographs faded off toward the margins. Her ink contours seemed to float on the albumen paper, like boats that had lost their moorings. The image no longer filled the page but lost its measured relation to the edges, something she believed paramount in graphic work. These were the drawbacks of the photographic medium at the time. But she recognized flaws in her own technique as well. Having painted landscape for more than twenty years, she was less versed in architecture and cityscapes. If she wanted to continue with the project, then she would need additional training in architectural draftsmanship and alternate means of duplicating them. Realizing *Relics of Manhattan* made her appreciate the distinction between the creation of a drawing and its reproduction for distribution, between pictorial expression and pictorial communication.

That same year, 1868, Josiah Dwight Whitney published *The Yosemite Book*, what Martha Sandweiss calls "a masterpiece of photographic bookmaking." He acquired twenty-eight photographs to appear in the volume, twenty-four by the well-known photographer Carleton Watkins. His ambitious plans were somewhat stymied by the limitations of photographic printing. To make the designated 250 copies of the book, each featuring twenty-eight albumen prints carefully tipped onto sheets and bound into the text, they would need a staggering seven thousand photographs to be

printed. The demands of producing a book with original photographs hit home, even for an explorer like Whitney whose budget was covered by the California state legislature.[44] As a self-financed project, Greatorex's book of photographically reproduced images was a brave but largely impractical effort.

ELECTION TO THE NATIONAL ACADEMY, 1869

The preview reception of the Forty-fourth Annual Exhibition of the National Academy was held on Tuesday, April 13, 1869. Greatorex must have been among those heading toward Twenty-Third Street and Fourth Avenue, where the Academy's Venetian-style palazzo stood on the corner. When the doors opened at 7:00 p.m., the crowd mounted the stairs and passed inside. The attendees for the opening night academy gala consisted mainly of well-dressed ladies holding the arms of gentlemen, who were there to see and be seen, with only a passing interest in the artworks adorning what everyone still called the new academy building, opened now four years ago. "The rooms and the corridors were thronged with a fashionable and artistic crowd, and the gorgeously dressed and be-diamonded ladies, heaven bless them, blocked up every avenue for locomotion," the press reported. "When they stood still to gossip, everything stood still, but the sight nevertheless was very brilliant, and the occasion was one of interest." Alongside those there only to see and be seen, there were some serious connoisseurs. "Prominent artists had their separate set of admirers," it was observed, "and became involuntary heroes of the hour."[45] Women artists had to learn to negotiate the crowds. While the academy and its membership were gendered male, celebratory events like openings and galas consisted of mixed gender spaces. To be successful commercially as well as artistically, the rising female ranks had to size up the sexual dynamics and find their place in the social echelon, so as to distinguish themselves both from the bejeweled lady art lovers and from the male painters.

To have a work selected by the jury for the annual exhibition was no easy matter. First came the agonizing over what to submit. She had completed *Landscape with Cows* (fig. 4.6) in 1868 and considered submitting it to the jury. It was, as required, a new, previously unexhibited work. With a stream cutting through the flat foreground, mountain peaks behind and rich, full foliage on the near shore, it fit into the Hudson River mode. But there was

always the problem of trying to second-guess the selection committee. They were supposed to choose the "best" artwork, which meant that—aside from the likelihood that the work of academicians and friends was chosen—it should have a high degree of finish, treat an American subject, and be composed according to convention. Well, at least that had been the accepted wisdom. But change was in the air with new members like Winslow Homer and John La Farge, who was already making his presence felt with suggestions for reforming the academy. The inclusion of these men and others of the younger generation trained in Europe insured that the content of the shows was far less homogeneous than it had been fifteen years earlier, when she had debuted at the academy, a wife and mother with four young children. The shifting tides that accompanied the emergence of the younger artists made the dilemma of which work to submit even more difficult.

She decided to send her *Joseph Chaudlet House on the Bloomingdale Road* (fig. 4.7), which combined her early work in landscape with her current interest in the architectural remains of the old city. This canvas appears deceptively simple, a pastoral view of a country road dotted with several domestic structures. But she actually created a complex composition in which the eye of the viewer is drawn in several competing directions: first to follow the path into the depth of the scene, second to move right and left to take in all the architectural detail, and finally to ascend to the glorious treetops and sky above. Left and right are two houses, which could be dismissed as picturesque staffage, but which hold the key to what

FIGURE 4.7

Eliza Greatorex, *Joseph Chaudlait House on the Bloomingdale Road,* ca. 1868. Oil on canvas, 17 × 33 in. Ronald Berg Collection.

was arguably her distinct contribution to American art. Not only had she evolved an individual visual language, but she had also linked it to a particular thematic regime. As New York grew and changed after the Civil War, the old architecture—especially the Dutch farmhouses and early churches—was being torn down to make way for more modern structures. Simultaneously, the city was expanding to areas such as this, where the Joseph Chaudlet house stood in Bloomingdale—now the Upper West Side—that until this moment had been relatively rural. The Chaudlet picture demonstrates that by the end of the 1860s she had found her own voice and the means to express it pictorially. In the end, however, she decided to submit another work that conveyed a similar message: *Somerindyke House, Bloomingdale, at 76th St., in the Spring of 1868* (unlocated). Perhaps the fact that it had already been purchased by printing press manufacturer Robert Hoe would carry weight with the jury. She complemented the painting with a selection of her pen-and-ink drawings, further evidence of her new direction.

Once the artist made her choice, the works had to be framed and delivered to the academy for final selection. Then there was a long wait before the acceptance letters went out. If your work was accepted, then you showed up at the academy on "hanging day," or "varnishing day" as it was also

known, and stood in line until you were admitted, and only then did you find out where your work had been hung. Greatorex's works were usually skied, so that viewers had to strain their necks to look at them high on the wall. "Varnishing day at the Academy," Jervis McEntee observed, "has made me feel a little depressed."[46] But he was known as a curmudgeon. Eliza Greatorex tried to make the best of the situation, adding a touch of color or a light layer of varnish to an oil painting to adjust for its position and available light, and hoping for a sunny day when the critics passed through the show. This year her strategy paid off and she had reason to feel proud, with five accepted works. They included the oil painting *Somerindyke House, Bloomingdale, at 76th St., in the Spring of 1868* and four pen-and-ink drawings: *Somerindyke Lane, at 76th St., Bloomingdale, in the Summer of 1868*; *The Old Dutch Church, Bloomingdale, at 68th St., as It Stood in the Fall of 1868*; *The Old Perrit Mansion, Bloomingdale, at 76th St.*; and *The Old Lawrence Mansion, Bloomingdale, at 76th St.*[47]

A handful of academy members made up the Hanging Committee, which was responsible for arranging the pictures on the walls. They hung some optimally "on the line," meaning that it was at eye level for the average person, while they "skied" others, putting them high up on the wall. Customarily, paintings were hung in the four main galleries while the corridor was used for the display of works on paper, and this year was no exception. Mounting the staircase and pushing past other visitors, Greatorex would have caught a glimpse of her painting *Somerindyke House at Bloomingdale* (no. 10), which received a mixed response. It was deemed "very well composed, and contains a beautiful sky, besides a general pleasing tone of color throughout." But, the reviewer added, "the foreground is not sufficiently made out, and looks unfinished." The review then moved on to the corridor, which, "as usual, is chiefly devoted to drawings and architectural designs. Among the former are several admirable specimens of landscape in pen and ink, by Mrs. Greatorex."[48] Another critic was even more impressed and called her pen-and-ink drawings "remarkable for their clear and decisive touch, surpassing a steel engraving in the amount of spirit expressed, and as artistic compositions are excellent, proving at once, that the artiste is most accomplished in her art, and amongst women artists of America, is entitled to a foremost position." He was especially impressed with a pair of drawings of Bloomingdale: "*Somerindyke Lane, at 76th Street, Bloomingdale, in the Summer of 1868*, and *The Old Dutch Church, Bloomingdale, at 68th Street, as it stood*

in the Fall of 1868. They are superb as artistic compositions, and it is with no little gratification that we make the acknowledgement, knowing that we are paying tribute to a woman's genius."[49]

After a premiere, an artist's natural inclination is to search the newspapers for reactions to her work. Some seize the morning's paper, to satisfy a pressing need to know right away or to get it over with, as some would put it. Others wait a bit, until the memory of the opening starts to fade. Still others have friends read the critics' verdict and deliver a softened summary. Female artists in the nineteenth century faced additional frustrations, since reviewers typically clustered their names together at the end of a review, or if the review was lengthy and printed in several installments, the verdict on their work would not appear until several days later. That year Greatorex fared well with the critics, who even referred to "a woman's genius." These highly positive notices appeared just in advance of the academy's annual business meeting held in early May, where new members were elected if they received a two-thirds majority vote.[50] A few days later she received the news that she was elected an associate, the only female member of the academy.

PORTRAYING THE WOMAN WITH THE PEN

Upon the election to the academy, an artist was required to donate a portrait or self-portrait. Dedicated to landscape, she had never tried her hand at figure painting and had no option but to engage a portraitist. But who was the best candidate for the job? Daniel Huntington was an obvious choice; he could be relied upon for a good likeness. The portrait he had recently done of fellow academician James Suydam (NAD) with the glimpse of shoreline behind him was commendable. But most of his work was a bit severe, and his handling of women somewhat insensitive. Given too that he was president of the academy, he was above suggestion or criticism if she found herself dissatisfied with his efforts. She could have engaged one of the artists in the Dodworth, but no likely prospects came to mind. To have another woman portray her would have made a statement, but options were limited there too. Lilly Martin Spencer was at that moment engaged doing a full-length portrait of Mrs. Fithian, which would occupy her for a while.[51] G. P. A. Healy was a portrait-producing machine (by some accounts he was painting nearly a hundred a year), and had done a seated, reflective *Abraham Lincoln* (1864; Newberry Library) that was admirable.[52] For a country where fifty

years earlier the only paintings people wanted were portraits, the field was limited and wide open for new talent.

William Page was receiving encomiums for the *Portrait of Rev. Henry Ward Beecher* in the current NAD exhibition, although one wondered if the critic for *Putnam's Magazine* went too far with his praise: "Page's portraits of Beecher and Wendell Phillips . . . are among the greatest achievements of the art in modern times."[53] Oddly, for someone with claims as a portraitist, he often avoided flesh-and-blood people in favor of subjects from his imagination—including a portrait of Shakespeare that he said came to him in a vision. Greatorex was acquainted with his wife, who kept a sharp eye on the comings and goings of the art scene even as her husband withdrew further into his own world. Mrs. Page and other friends shared advice with her before she approached anyone with a commission.

The name Ferdinand Thomas Lee Boyle came up. He had just accepted a teaching position at the Brooklyn Institute of Arts and Sciences, where he would begin in the new year. Page had painted his likeness upon his election to the academy, and many colleagues spoke well of him: a dignified, soft-spoken man who exuded an air of competence. The son of the British composer John Boyle, Ferdinand had been born in England and brought to the United States at age eight. This was a profile that appealed to Greatorex, who had come from Ireland and married a British organist and composer of ecclesiastical music. They could talk music and politics as he painted her. Boyle had depicted famous men of the age including General Ulysses S. Grant and Senator Thomas H. Benton of Missouri and was being recognized as a skilled portraitist. Since Boyle had not yet taken up his duties at the Brooklyn Institute, his studio was still conveniently located in Manhattan, at 1227 Broadway, where she sat for him.[54]

Since the lineage of American women artists situates Greatorex between Lilly Martin Spencer and Mary Cassatt, it is useful to compare her likeness to their self-portraits. Spencer had been chosen as an Honorary Member of the NAD in 1850 but was never made an Academician. Her youthful *Self-Portrait* (1841; Ohio Historical Society) was done when her prospects were spread out before her. Seated at a table, she stares directly at the viewer, her dark curls falling in her face. She omits any reference to profession. Just eighteen years old and beginning to gain local success, Spencer portrays herself wary, but open to possibility. Mary Cassatt painted herself in Paris a year after Edgar Degas invited her to exhibit with the Impressionists (1878;

Metropolitan Museum of Art). Done in watercolor, it highlights the many influences she had absorbed abroad. She has composed herself so that her figure cuts a diagonal across the paper, in a daring, asymmetrical pose against an unconventional sage-green background. And strikingly, she displays complete indifference to the viewer as she directs her attention to something outside the picture plane. She presents herself as an independent woman immersed in modern French art.

Although Boyle painted Greatorex's portrait (see fig. 0.01, in the introduction), his artist-subject surely dictated how she wanted to be presented. Her attire is simple, even severe: a dark, loose-fitting dress with long sleeves and a trim lace collar. She is shown in half-length standing erect, with a white column (one of Boyle's studio props) partially visible behind her. She holds her pen in her right hand, which folds over her left, and both rest on a leather-bound portfolio presumably containing her pen-and-ink drawings. As her black dress merges into the dark background, light from the upper left dramatically illuminates her face and hands. She stands before us a gray-haired woman of fifty with no pretense of vanity, but with an intensity of passion and vocation. The white quills of the pen catch the light and call attention to the fact that she has replaced the more traditional artist's prop of the paintbrush with an ink pen, her new personal emblem. As she moved from paint to pen-and-ink drawings, she would henceforth be known—as William Corcoran dubbed her—the "artist with the pen."[55]

Compare Greatorex's likeness also to the French female painter Élisabeth Louise Vigée-LeBrun (1790; Metropolitan Museum of Art), who was known to have painted at least thirty-five self-portraits. Vigee-LeBrun looks fashionable and feminine by contrast with her American counterpart, who in her gravity bears closer analogy to male artists. Nicolas Poussin's well-known self-portrait inscribed "done in Rome during the Jubilee Year of 1650, at age 56 years" demonstrates the point (1650; Musée du Louvre). He wears a dark robe and rests his right hand on a sketchbook, a demeanor she may well have known and emulated. But given that Greatorex sat for her portrait on the eve of her departure for Nuremberg, it is not impossible to imagine that she also had that city's native son Albrecht Dürer's engraving of *Erasmus of Rotterdam* on her mind as she determined her pose and props. She echoes the position of his body convincingly at an angle to the picture plane, tilt of his chin, and prominence of his pen. Erasmus had deep admiration for Dürer, whom he praised: "And is it not more wonderful to

accomplish without the blandishment of colors what Apelles accomplished with their aid?" Reinventing herself as a graphic artist, she naturally revered the man whom Erasmus eulogized as the greatest of graphic artists. It is fitting, then, that she is painted almost entirely in black and white. Once the portrait was complete, Greatorex donated it to the NAD, where it hung in the summer 1870 exhibition.[56] Then she and her children boarded a transatlantic steamer bound for Europe and new adventures.[57]

5

IN THE FOOTSTEPS
OF DÜRER, 1870–1872

━━━━━━━━

NUREMBERG

On May 20, 1870, "just after the National Academy of Design had conferred the almost unique distinction of electing her, *a woman*, a member," Eliza Greatorex sailed from New York harbor on the *Hammonia*, a steamship on the Hamburg America line. She planned to take "her two young daughters to South Germany, and for two and a half years studied in the galleries of Munich, among the wonderful antiquities of Nuremberg and in the beautiful Bavarian Highlands."[1] They crossed the Atlantic and docked in Hamburg, "where everything was too civilized to deserve notice," and quickly proceeded to Nuremberg, where they were arrived by June 24 and spent the next six months. It was the first of several stops on the itinerary, which included Nuremberg (June–December 1870), Munich (February 1871), a side excursion to Italy (March–May 1871), and Oberammergau (July–September 1871). Then it was back to Munich (through the following spring 1872), where she organized the publication of the work she had done in Oberammergau. Once that was completed, they returned for a farewell visit to Oberammergau on May 31, then took a tour through Switzerland before returning to New York by the end of 1872. The size

of the traveling party expanded and contracted over time, with the children sometimes enrolled in school while the artist traveled. Nuremberg provided their first taste of life in Bavaria, where Greatorex, her sister Matilda Despard, ten-year-old nephew Walter, and her two daughters boarded in hotels, took their meals in local establishments, and picnicked on cheese and seasonal cherries as they immersed themselves in the sites of the historic city.

In October 1870, *Littell's Living Age* ran an article on Nuremberg and its most famous native son, Albrecht Dürer, that sheds light on their motivation for heading there. Modernization, the author explained, was destroying many of Europe's hallowed cities: Paris, "whose topography occupies a place in the history of mankind, whose memories are harshly disturbed by wholesale demolition"; or Florence, which is "suffering from the influx of a new population and the erection of suburban villas." Having visited both places, Greatorex concurred: "there is something often inexpressibly sad in the rapid disappearance of the relics of the past."[2] Nuremberg, according to the journalist, had remained relatively unchanged since the Renaissance, when Dürer roamed its streets. Huddled between its fortified walls and the imposing hill surmounted by the castle, the old town's past and present intermingled. Since Greatorex's imagination connected to the past with such intensity, this town would have offered her a rich site for exploration.

The nineteenth century experienced a revival of interest in the Old Masters. Leonardo da Vinci, Raphael, and Michelangelo provided the inspiration for scenes of these artists painting at their easels, consulting with popes and kings, or frolicking with their female models and muses.[3] This hero-worship also took the form of pilgrimages to see not only works of art but also sites associated with the lives of favored figures, such as Eastman Johnson's travels in Holland in search of Rembrandt.[4] But none was as powerful as the cult of Dürer, "the most thoroughly celebrated artist who ever lived. An annual Albrecht Dürer Day, like the feast of a saint, was observed by German artists from 1815 until the end of the nineteenth century," as Jane Campbell Hutchinson explains, "while national and even international centenary festivals have been obligatory since 1828, the three hundredth anniversary of his death."[5] As Greatorex replaced her paintbrushes with pen and ink, it is not surprising that she should find a role model in Dürer, who raised drawing and printmaking to the level of a painted masterpiece. More urgently. 1870–

71 was the Dürer Jubilee, the four hundredth anniversary of his birth. Tourists were flocking to the city, including painters and photographers who were paying him homage while they capitalized on the event by producing souvenir pictures. Greatorex carried a letter of introduction to the contemporary resident of the Dürer family home, where he was born and lived until 1509 (now destroyed). She spent long hours at Dürer's house on Tiergartenplatz, where he had lived from 1509 until his death in 1528 (fig. 5.1).[6] Typical of the half-timbered burghers' houses of the fifteenth century, it had fallen into disrepair over the ages, but in 1828 the city had bought it, with the intent of making it a museum. She sketched its exterior and was allowed access to the home, where she could imagine the life of the Renaissance artist, and made a drawing looking out his east window.

Following in the footsteps of Dürer, Greatorex roamed the steeply inclined cobblestone streets. "Our haunts were chiefly the museum, the churches, and the heights of the Kaiserburg," her sister noted, "toward which our steps were generally turned at very early morning hours." She often stopped to draw its fortified walls and other well-known and picturesque sites, including the *Henker Steg* (Hangman's Way and Bridge). "More peaceful haunts for study were accessible in the wonderfully-beautiful Lorenz-Kirche and the church of St. Sebaldus, the old, old walls and court of the Rathhaus [sic]," her narrator continued. "In the little hostelry called the Glöcklein, the resort of Hans Sachs, the immortal friend and boon companion of Albrecht Dürer, we often sat (the gray hairs of the mother saving us from the too curious glances of the academic students); there we had our lunch of the famous broiled sausages and more famous beer." Dürer's friend Hans Sachs, a poet and leading Meistersinger, sufficiently intrigued the artist that she did a small painting of his home (fig. 5.2). She and her sister would have known of him from their familiarity with Protestant hymn tunes, for which many of his melodies were adapted. Additionally, Richard Wagner's *Die Meistersinger von Nürnberg* (1868) popularized his reputation as the shoemaker-poet, an artist of the people who succeeded best in his humorous Shrovetide plays. Greatorex must have found his ability to straddle high art and vernacular culture appealing as she struggled to achieve a similar balance in her own work. Her rendering of his home emphasized the commonplace over the grand, complete with white hens in the doorway. These were "happy days," her sister concluded, "which even the

remembrance of the cobble-stones and the too-permeating sourcrout [sic]
cannot divest of their charm!"[7]

Greatorex's efforts in Nuremberg resulted in a variety of pictures, includ-
ing a group of oil paintings and fourteen pen-and-ink drawings she sent
back to New York for exhibition. The *New York Times* praised her studies,
"which are of interest from their associations as well as from their merit
as works of art."[8] Beginning in this city and at every stage of her German
travels, she was constantly in search of opportunities to promote and sell
her work. At some point she began to make a selection of her graphics for a
published portfolio titled *Nuremberg* comprised of six prints, three of which
were Dürer-related.[9] Two versions of the portfolio were created, one in
which the images are reproduced one to a page, with no text. In the other
version, the pictures appear in arched frames with a brief literary inscrip-
tion below. The page reproducing her drawing *From the East Window of Al-
brecht Dürer's House* (fig. 5.3) is inscribed with the lines:

> Quaint old town of toil and traffic,
> Quaint old Town of Art and Song,

Memories haunt thy pointed gables,
Like the rocks that round them throng.[10]

Quoting the second stanza of Henry Wadsworth Longfellow's poem "Nuremberg" (1845), she linked her image to America's beloved writer in an effort to boost its audience appeal.

Work proceeded simultaneously on multiple levels. She usually began with a pen-and-ink drawing such as *Albrecht Dürer's House and Street* (Brooklyn Museum). From there she produced oil paintings on canvas as well as suites of prints after the drawings—sold in portfolios or individually, with and without text (perhaps for dual American and German markets). For the portfolio cover, daughter Eleanor Greatorex drew a standing portrait of Dürer in a fur-lined coat with long, flowing hair after Christian Daniel Rauch's sculpture (1840) in the Dürer Platz. Just above his head she inserted "Nüremberg" in script, and just below, "ELIZA GREATOREX" in block letters, establishing her mother's lineage to him. Before their departure, Greatorex also made a pilgrimage to his

FIGURE 5.3
Eliza Greatorex, *From the East Window of
Albrecht Dürer's House*. Print. Private
collection.

grave in St. John's Churchyard, outside the walls of the city, which she recorded in pen and ink (fig. 5.4).[11] Here she was solidifying her career-long pattern to appeal to a wide constituency embracing both highbrow and popular taste.

The first of a series of illustrated publications she produced in the 1870s, *Nuremberg* reveals her evolving approach to the city as a site of cultural exchange via the tangible artifacts associated with the lives of former inhabitants. Spotlighting Dürer, she brought to the fore his favored graphic media over painting, and perhaps inadvertently inserted Germany into an international perspective on art and history that typically privileged Italy and France. Greatorex participated in the nineteenth century's cult of Dürer, but with an individual angle.[12] Playing on the gendered expectations of domesticity, she focused on his home and hearth. A pair of panel paintings depicts the houses of Hans Sachs (see fig. 5.2) and that of the artist in states of picturesque decay. Such was public familiarity with his legend that the site of these pictures would have recalled not only the artist working in his upstairs studio, but also late nights spent in one another's company, much to the distress of the artist's long-suffering wife Agnes Dürer. To access the northern Renaissance

FIGURE 5.4
Eliza Greatorex, *Dürer's Grave*. Print.
Private collection.

master for her American audience, she bypassed reference to his artwork to focus on the more familiar objects of everyday domestic life.

She had departed for Germany in the wake of a long and bloody civil war and the subsequent death of her father at age ninety. Upon arrival, she found herself in the midst of another armed conflict: the Franco-Prussian War. "The whole war," she wrote, "was to me too terrible."[13] Her response suggests a personal investment beyond that of a mere observer: her brother Adam's wife Sophia was from Prussia, and perhaps had a loved one who was somehow caught up in the conflict. Many travelers, including Mary Cassatt, found the situation intolerable and returned to the United States in the fall of 1870 to avoid the effects of war. Greatorex, by contrast, chose to remain for over two years.

ANNA MARY HOWITT, *AN ART-STUDENT IN MUNICH*

In 1850 Anna Mary Howitt headed to Bavaria with a companion to study art. Her account of their experiences was afterwards published as *An Art-Student*

in Munich (London, 1853), which Greatorex credited as her inspiration to visit Oberammergau: "My memory is full of the time when, in my own country, I first read of the Passionsspiel, in Miss Howitt's Art Life in Munich. I remember well how shocked I felt, that any one could witness such a spectacle," she recalled. "Yet there was a fascination in her description of it, which kept that chapter always in my mind! Eighteen years ago that must be; and now I am living with, and loving, the people who were the chief characters in the play of that very time."[14] Anna was the eldest child of William and Mary Howitt, a prolific writing team who authored fiction, poetry, biographies, travel accounts, and books for children. Her upbringing included a special combination of maternal guidance and journalistic apprenticeship that became, as Linda Peterson has argued, an important model for Victorian women artists.[15] From 1840 to 1843 the family resided in Germany, where the parents believed the children could get an education superior to that in Britain. At age fifteen, Anna Howitt illustrated *Hymns and Fireside Verses* (1839), one of her parents' most popular books. She enjoyed the cultural stimulation of her family circle, which included John Ruskin, George Eliot, Dante Gabriel Rossetti, and his wife Elizabeth Siddal, who encouraged the young woman to take up painting professionally.[16]

In 1850 she returned to Germany to enroll at the Munich Academy of Fine Art, but when she was told that it was "impossible for women," she approached the director, Wilhelm von Kaulbach. Following his counsel, she "determined, if we could find no really first-rate master, to have models at our own rooms, and work from them most carefully with our anatomical books and studies beside us; that we would do all as thoroughly as we could, and help and criticize each other." She recalled supplementing her labors with art tours of the city: "We would work out some designs in this way, studying the grand works around us, going daily to the Basilica, to the Glyptothek, to drink in strength, and inspiration, and knowledge; that we would draw also from the antique and would take our drawings to be corrected by [Kaulbach], as he had already offered."[17] She recounted her routine: arriving at the studio at 6:30 a.m. and returning home at 7:00 p.m., when she would catch up on her correspondence to family back in London. Reading the rich detail of her daughter's letters prompted her mother to compile and edit them for publication, initially in the periodical *Household Words*.[18] Back in London in 1853 as her Munich text appeared in book form, she submitted her first large-scale painting, *Gretchen at the Fountain*, to the British Institute, where it was

promptly rejected. Further disappointments effectively terminated her career as a visual artist, but her reputation lived on through her book. By 1858 it was excerpted in the United States in *The Crayon*, where the editor "culled that part of her volume which relates more immediately to the artistic life of the Germans." Moving beyond Kaulbach's studio, they took pleasure in her descriptions of Oberammergau, a visit to the October Volkfest, and the casting of a bronze statue.[19] "Especially in America," he pointed out, "it should be welcome, where we need the very element which makes an atmosphere around our student in Munich—that joyous and reverent love for the beautiful, which makes a religion of Art."[20] When the impressionable sixteen-year-old Eleanor Greatorex traveled with her mother to Bavaria, she too penned an account of her experiences as an art student there, which she subsequently published in *The New Century for Woman* (1876). It provides important counterpoint to the narrative by Howitt, who was "one of the fortunate exceptions," having been advised "by the great *Kaulbach*, painting in his studio." Her successor, by contrast, had to improvise with informal anatomy study and private lessons in a "dingy studio" conducted by lesser-known figures.[21]

When the Greatorex women arrived in 1870, Munich's art and cultural scene had expanded greatly for men but little for women since Howitt's day. At age fifty, the mother faced some of the same challenges her predecessor described in achieving her professional status, but her maturity made her more directed in her goals and less vulnerable to the vicissitudes of male colleagues and professors. She had visited there briefly in 1862, when she took private lessons with Karl von Piloty and copied in the Pinakothek.[22] Now she was back, as she explained, "for lengthened study in Munich, Bavaria, in landscape and architectural drawing."[23] She absorbed the growing public collections as documented by her submission to the National Academy of Design for 1875: *Pen and Ink Drawing from a Painting by Salvator [sic] Rosa in the Munich Gallery* (no. 112). [24] And she spent time exploring the city on foot, leading to *Bit of the Old City Wall by the Market Platz Munich* (unlocated), exhibited at the NAD in 1875, and *Schulden Thuner-Munich* (unlocated), shown at the NAD in 1877.[25]

Other American art students in Munich included a group of Frank Duveneck's students dubbed "the Duveneck Boys." They constituted themselves into a male-only club, with the emphasis on youth and energetic masculinity, which carried over into their muscular application of paint and subject repertoire. Given that Greatorex was worldly, older than most of them, and

traveling with her children, the young men's camaraderie likely held limited attraction for her, but they did form several key relationships. "Here they found many friends, chief among whom, as artistic helpers, were Toby Rosenthal and our former countryman, David Neal."[26] Son of a Jewish Prussian-Polish tailor, Rosenthal headed for study in Munich and remained there for most of his adult life producing historical paintings such as *Elaine* (1874; Art Institute of Chicago).[27] He also painted a likeness of Greatorex (currently unlocated) that she must have taken back to New York, where it was shown at the NAD in 1875: "A portrait of Mrs. Greatorex, by Toby E. Rosenthal, was greatly admired as an example of the famous Piloty school, of Munich."[28] Apparently pleased with the image, Greatorex and her brother Adam Pratt were then in negotiations with William Corcoran to purchase the portrait, but terms were not agreed upon and it was returned to the sitter.[29]

DRIFTING DOWN TO ITALY

In need of a respite from the long winter and winds of war prevailing in Germany, the Greatorex women headed south in March 1871 and "drifted down to Italy, visiting the galleries of Verona, Bologna and Florence," according to a family friend.[30] Their movements were usually described as direct or hurried, and it was rarely said that they "drifted." But now they soaked up the *dolce far niente* that Anglo-Americans found so appealing in Italian life. After their leisurely sojourn through the Alps, the mother decided to pause in Rome and arranged for her daughters to attend art classes while she explored the city. There they "studied where [Mariano] Fortuny made his Italian mark, in the rusty, musty, dusky, smoky, weird, disheveled and strange, but cosmopolitan and effective atelier of the world-famous 'Gigi.'"[31] Luigi Talarici, a former model known as Gigi, ran an informal studio where models posed for life-drawing and costume sessions every evening. Women were welcome at the costume sessions, where many of the attendees created figure studies in both local and historicizing dress that were a popular tourist staple. Although not an overwhelming presence at Gigi's, women were gaining increased visibility. Kathleen and Eleanor Greatorex were among the occasional females who, according to one observer, "would come in quietly, make a sketch, and go away unmolested, and almost unnoticed."[32] The sisters made the most of the opportunity to meet others in this cosmopolitan gathering, and observe studio practices distinct from those at home.[33] This was their first visit to Italy, and they immersed themselves in its pleasures.

This was a return visit for their mother. On her earlier trip, the actress Charlotte Cushman hosted her in her famous quarters on the Spanish Steps and provided a home base as she sketched extensively around the city. She traveled the road from Rome's main port of Civita Veccia to Sorrento and spent time in Milan and Naples. A later etching of Naples (Library of Congress) only hints at the bay's topography and emphasizes the boats with their picturesque sails paralleling the church spires. A beautiful sunset, impossible to convey in black and white, was fondly recalled from her visit.[34] With its deep literary and artistic associations, Florence was a special place for her. She likely sought the same perspective on the city from Maiano that appears in a later image, in which she looked out at the famed Duomo and Giotto's Tower from a cluster of trees so heavily inked that it anchors the composition (see fig. 9.9).[35] Sketching all the while she traveled, she exhibited a substantial group of Italian images in the National Academy in 1868. These were among the most popular of her works to date, and by the time of the exhibition most had found homes with New Yorkers. This included a portfolio of her sketches in the possession of rising sculptor and friend John Quincy Adams Ward, whose *Indian Hunter* (dedicated 1869) was the first American sculpture to be erected in Central Park.[36] Hoping to repeat her success, she arranged with dealer Samuel P. Avery to take a group of works, as reported in the New York press: "The result of her summer study are views of *The Church S. Giovanni in Laterano* with the Coliseum in the distance and S. Clemente on the right; *The Campagna from the Villa Mattei, View from the Spanish Steps at Trinita di Monti, Campagna from the Villa Medici*, and *Arch in the Via Julia*, with its quaint old-time surroundings."[37] Although these pen-and-ink sketches of these requisite sites on the Grand Tour have yet to surface, some idea of her conception of the city is evident in her later etching of the Palatine Hill (Library of Congress), where she envelops the crumbling ancient ruins in a cluster of trees.

While in the eternal city, Greatorex had an audience with Pope Pius IX. Since her visit coincided with the twenty-fifth anniversary of his papacy (his would be the longest in the history of the church up to that point, 1848–78),[38] the celebrations extended over the entire year. "All foreigners desiring to be presented to the Pope must write an application to that effect addressed to Monsignore Maestro di Camera or Grand Chamberlain, to be presented by the representative of their country to the Holy See," one guidebook advised. A papal audience was no last-minute addition to an itinerary but had to be planned well in advance. "Persons soliciting to be presented are informed a

few days before, by a notice from the Maestro di Camera, that they will be received at a certain hour, in general at midday."[39] She would have shown up at the appointed hour, when visitors "can either present themselves in uniform or in evening dress without gloves; ladies in black dresses and veils . . . If the party is numerous and ladies are present, audience is granted in one of the long galleries." Raised a Methodist, the artist would have noted that "it is the etiquette that Protestants show the same mark of respect for His Holiness as they do on being presented to their own sovereign, by kissing his hand, if offered." Guidebooks prepared attendees for the finale of the event: "At the conclusion of the audience the Pope confers his blessing on all present, who are expected to kneel to receive it, and the blessing is declared by His Holiness to extend to the rosaries and other objects of devotion which his visitors may have brought with them for that purpose."[40] It must have been then that she saw her opportunity. "At her presentation to the Pope," New York's *Evening Post* reported, "he conferred on her the rare distinction of accepting one of her drawings from her own hand, and writing for her at the same moment an interesting autograph. The incident, we learn, caused a marked sensation among the assistants at the audience."[41] She had selected a drawing of Dürer's House as the Pope's twenty-fifth anniversary gift, which subsequently entered the collection of the Vatican.

Protestants often experienced ambiguous emotions during their stay in predominantly Catholic Rome. Greatorex's attendance at a papal audience is curious, especially if we compare her response to that of her compatriots. A young George Inness was arrested after an altercation with a French policeman, caused by the artist's refusal to remove his hat in the presence of the Pope.[42] On a visit to the eternal city, Frederic Church complained that he found it as threadbare as the priests' garments. Greatorex seemed to be searching for some guidance in matters of faith during this trip. Upon her return to Germany from Italy, she headed for Oberammergau and lived for a summer among the villagers as they performed the Passion of Christ. Matilda Despard once observed that her sister was not religious in an orthodox way but was spiritually inclined. In Europe she found some solace in the outward trappings of Catholicism.

OBERAMMERGAU AND THE PASSION PLAY

By summer 1871, Eliza Greatorex had been traveling with her children for fifteen months and decided to leave them in Munich—where they witnessed

the return of the Prussian troops from France—while she set off for Oberammergau. A rustic village southwest of Munich in the foothills of the Bavarian Alps, it had been since the seventeenth century the site of the Passion Play, performed once every ten years. Plagued by the ravages of the Thirty Years War and the spread of bubonic plague, the town's people had vowed that if God spared them they would perform a "play of the suffering, death, and resurrection of Our Lord Jesus Christ." As the adult death rate dropped, villagers performed the play for the first time in 1634 and continued every ten years until the present day (in 1680 moving it to the first year of each decade). The dramatic cycle, interrupted by the war in 1870, was to continue with the remaining eighteen performances that summer of 1871. Initially the artist intended a brief visit, just to see the play. Once she arrived in the town and saw the performance, she felt under their spell and resolved to stay for the season and record the events surrounding the holy drama. "Dear Children!" she wrote, "We must give up all idea of our projected summer sojourn at Berchtesgaden, and you must come up here to me at once. I cannot write about what I have seen and felt to-day; but I have decided to live among these people ... this summer, and see how their daily life accords with this marvelous religious service."[43]

Only members of the Oberammergau community can act the roles, which engage almost the entire male population (and a few females) in the huge cast. Although the play has evolved over time, it includes spoken dramatic text, musical and choral accompaniment, and tableaux vivant: motionless scenes from the Old Testament that prefigure dramatization of the events of the life and crucifixion of Christ from the New Testament. Members of the Flunger family, with whom Greatorex and her children boarded from July through September, were among the major actors who transformed themselves before their eyes into the characters of the holy Christian drama. Like their fellow residents, they had to engage in the threefold activity of performing in the sacred drama, keeping up with their work on the farms and in the shops, and playing host to the visitors who rented rooms and took meals in their homes. With an estimated thirty thousand visitors in the tiny village that summer, the work never ended.

Greatorex's experiences to this point in Germany were primarily urban: Nuremberg and Munich. Then she came to this little Alpine village and resided among the rural population. Like any artist, she required a get-acquainted period after her arrival in a new setting to achieve sufficient

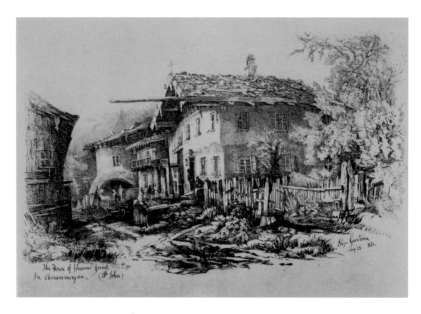

FIGURE 5.5

Eliza Greatorex, *House of Johannes Zwink, Oberammergau*, 1871. Print. Private collection.

familiarity to wrestle with it artistically. She found Oberammergau "odd" at first, "not very picturesque," but gradually she adjusted her aesthetic compass and began to find a way to make it into art. She did not paint or sketch in oils. Seeing a group of artists doing watercolors, she said that she wished she had the skill to record quick colored impressions. Instead, the artist roamed the town with sketchpad and ink pen, delineating the motifs that caught her attention in the open air. *House of Johannes Zwink (St. John)* (fig. 5.5) is typical. Drawn with feathery cross-hatching to indicate form and texture, this picture positions the viewer at street level, looking down the dirt road along which the houses are lined up. She anchored the scene with the edge of the shingled structure in the lower left corner, but its partial, darkened form pushes our eye across the open space of the street to the Zwink house. That perspective allows for a glimpse of the two-story house with rows of windows visible on the side and front façades and other domiciles further down the road receding into the distance. Each one is distinguished with a balcony, a rounded arch and small-scale figures gathered outside. From our low vantage point we look up into the eaves to see the exposed timber supporting the roofs. Everywhere is the feeling of simplic-

ity, hominess, and dilapidation. A cross surmounts the peaks of the Zwinks' pitched roof, with the outline of the mountain peak *Der Kofel* above it in the distance. "I have found many picturesque old houses," Greatorex wrote, "and the church, the Kofel and the Ammer, together, give the village a character peculiarly its own."[44] Here she invoked the aesthetic of the picturesque to convey her perception of these structures as relics of the past.

The vantage point she adopted provides a full view of two sides of the house that are completely blank, devoid of decoration. Yet we know that at the time of her visit the magnificent open-air paintings, or *Lüftlmalerei*, were clearly visible, covering the exterior walls of the town's buildings (as they can still be seen today). It is curious why she omitted them from her picture when in her text she wrote: "The good Matthew tells me, in reply to my inquiries, all about the remarkable frescoes on the houses of the village, many of which were painted by his grandfather, between the years 1780 and 1790. He says that the artist was not always allowed to choose his own subject, this being done by the owner of the house himself, and the results are very odd."[45] Perhaps she wanted to avoid depicting the religious subject matter typical of Catholic Bavaria. But the result is that without them the dwellings look lowlier and more decrepit in her drawings than they do in reality.[46] From this point on she continued to omit distinctive features of a place—such as these frescoes—in favor of the idealized and timeless.

Her picturesque treatment of dilapidated structures certainly owes something to the Dutch masters, including Meindert Hobbema, whose *Landscape with Cottage* she must have recently seen in Munich's Alte Pinakothek (in the collection since 1792). Harking back to these seventeenth- and eighteenth-century pictorial conventions, she sets her rendering of the village further back in time, before the religious paintings were ever applied to the sides of the buildings. For as she states of the town's oldest structure: "I am told that this house is at least six hundred years old, and has been standing ever since the time when Ammergau was one of the stations on the great highway of travel for the merchandise from Venice to Augsburg and the north of Germany . . . Even in the days of the Romans, Ammergau was a known station on their military road."[47] Verbally she links this locale with the days before the plays or the *Lüftlmalerei*, when it was a stop on the Via Claudia Augusta.

Her search for the past to retrieve the look and feel of bygone times also manifested itself in her collecting tangible historic objects and relics from

the sites she visited. An inventory of 1878 enumerates some of the items she had acquired in Ammergau: a very old spinning wheel; a carved figure from the church; small carved figures and frames; and an ancient Streich zither, played with a bow.[48] Two monasteries stood nearby: the Augustinians at Rottenbuch and the Benedictines at Ettal. Her exploration of them included visits to the Benedictine monastery, where she acquired a number of its relics dating from 1721: a coffer from the meal house of the monastery, a pewter beer mug and can, a brass candlestick, a portrait of Josephus Cayetannus by L. B. DeReblong, and a small oil painting.[49] Since none of them were reproduced in her graphic work, it is reasonable to assume these objects were not intended as studio props, but rather as material links to the historic traditions of the place.

Slowly, Greatorex evolved a plan for her summer's work. She had begun to jot down notes that would become the text of the book to accompany her pen-and-ink drawings. Living and sketching in a town crawling with artists who followed the path of the tourists, it was difficult to find a personal theme. So many of her colleagues depicted the theater and surrounding town set amidst the Alps that it was already becoming hackneyed. Living with the Flungers, she began to sense that the homes of the townspeople conveyed a unique spirit of the place. She therefore resolved to depict these aged domiciles, and to animate them with stories of the families who inhabited them and daily transformed themselves into the participants in the sacred drama. These would comprise her first book, *The Homes of Oberammergau.*

Travel literature is often reductive and clichéd, but she was determined to convey the complexities she had begun to discern, including a tension between private spirituality and public performance. Although the town of Oberammergau was just at that moment becoming a site for international tourism and the Passion Play watched by increasingly large audiences, Greatorex never depicted the performance itself.[50] Her book's narration reveals a fascination with the woodcarvers and homemakers who transformed themselves daily into characters from the biblical story. When she depicted their picturesque homes, she identified them not with their family names, but rather with the New Testament characters they played: the house of St. John, Judas, or Joseph and Mary. Her words register her growing affection for the families and the domestic existence they shared, facilitated by her children's knowledge of German and her own growing proficiency with the language. She also acquired a drawing from Tobias Flunger, another mark of their

FIGURE 5.6
Josef Maier, carved wooden cover for
Heimat auf Oberammergau, 1871.
New York Public Library.

growing acquaintance.[51] Yet she recognized that in her position as artist-traveler there would always be a distance between them and her. She never compromised their privacy by delineating their domestic spaces or individual portraits; she published only street scenes and exterior views of the houses. In *The Gossip's Fountain*, as in *Washday under the Kofel*, the townswomen pause momentarily from their domestic chores to exchange confidences. The artist depicts them in a closed circle in the middle distance, which is impossible for her to join. She also delineated *The House of Josef Maier* (*Christus*), the dwelling of the Maier family, who were special friends and collaborators. When not performing the play, the patriarch did intricate woodcarving, for which the region was famous, including at least one pair of carved wooden book covers to encase a set of the artist's Oberammergau prints (fig. 5.6).[52] While it is not certain whether she had them made as a prototype for more

such covers—perhaps for a special gift edition—or if Herr Maier made them as a token of esteem for her, they constitute a handsome and typical piece of workmanship of the sort still produced in the town to this day.

In their emulation of a Bible or prayer book cover, they also helped convey to her audience the interconnectedness of materiality and spirituality she conveyed in her graphics, as in *Washday under the Kofel*. She portrays the villagers doing laundry in the shadow of the prominent cross atop the building, a blending of the modest life of the people and devout Catholic faith of the region. Such an image informs the viewer about Bavaria and Greatorex's quest there. As she gazed out over the village of twelve hundred inhabitants, she confessed that she "silently prayed that the great act of devotion in which I shared might bring me closer to the Christ-life."[53] The village vicar of that time was Joseph Alois Daisenberger, who between 1850 and 1868 revised the Passion Play script. Greatorex came to respect him, portrayed him in front of his church in her picture *Churchyard Gate*, and dedicated her book to him.[54] This act stands out amidst the anti-Catholic prejudice so blatant in the mass of Anglo-American travel literature written primarily by Protestants. She arrived in Oberammergau troubled by war in both the United States and Germany, by illness that afflicted one of her children in Munich, and the loss of her one surviving parent. Her faith was shaky and needed reaffirming. In one of the book's final chapters, she declared, "my questioning is at an end," and that she was departing with "better trust, the surer faith" than when she had arrived.[55] Her pilgrimage to Oberammergau had been a spiritual as well as an artistic success.

THE KING AND THE PLAYERS

Sunday, September 24, 1871, dawned a beautiful day in Oberammergau, where the music of the Passionspiel filled the air for the last time for another ten years. The visitors and villagers alike retired that evening with a mix of sadness to see it end and anticipation for the old life they could resume. Yet Monday morning, people inexplicably awoke to the familiar sounds of the band signaling a performance. King Ludwig had sent a telegram asking if the play could be repeated once more for his benefit, and the Burgermeister immediately agreed. The participants readied themselves, and the entire production took on the air of a reunion as—with the departure of the tourists—the townspeople had the opportunity to experience

the magic of their favorite scenes at this grand if unanticipated finale. Given the young monarch's reputation as a theater enthusiast, it was a great honor to perform for him. Afterwards he returned to his Alpine retreat at Linderhof, and the next day sent an invitation for ten of the major players to dine with him there at his hunting lodge.

Five carriages were dispatched to convey the chosen representatives to Linderhof: Joseph Maier (Christus), Jacob Hett (Petrus), Johannes Zwink (St. John), Johann Lang (Caiaphas), Gregor Stadler (Annas), Gregor Lechner (Judas), Johann Deimer (the Choragus), Josepha Lang (Mary Magdalene), Tobias Flunger (Pilatus), and Franziska Flunger (the Virgin Mary). About 10:00 that night they returned home, full of tales of the time they had had. Afterwards Franziska, nicknamed Francie, told Greatorex and her children—with whom she had grown close after their residence together for the past three months—all about the excitement of the evening. Each of the players, beginning with her, had a ten-minute audience alone with the king. He "praised her for her conception of the difficult part of the 'Virgin,' which, he said, she had acted out with graceful ease and naturalness."[56] Then they enjoyed a sumptuous dinner complete with champagne set with beautiful china and crystal. Afterwards the king saluted his "dear Ammergauers"—as he called them—with cigars for the men and bouquets for the "Magdalene" and "Mary." They were wined and dined handsomely before they were delivered home, with promises that he would attend future performances of their secular plays.

Since this summer marked the end of the Franco-Prussian war and led to the birth of modern Germany under Bismarck, it was amazing that King Ludwig II was mindful of theater. The king's attentions insured not only that the 1870–71 Passion Play was personally memorable for its actors, but also that the Passion Play was fully documented for posterity. Desiring a souvenir of the occasion, the king ordered his court photographer, Joseph Albert of Munich, to go to the town and photograph the scenes and tableaux of the play. When the photographers showed up a few days later, a message was sent out that all the men, women, and children connected with the drama should come to the theater. There the large view cameras were ready to take the photographs, which were assembled into the limited folio edition *Album of the Passion-Play at Ober-Ammergau* (1874), the first edition of the full photographic testimony of these historic performances.

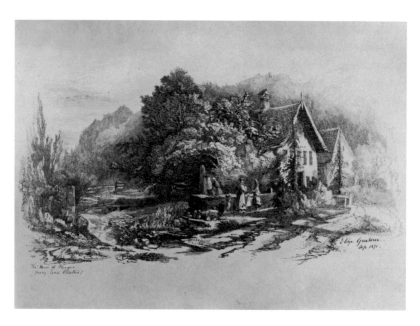

FIGURE 5.7
Eliza Greatorex, *House of Flunger, Oberammergau* (*Mary & Pilatus*), 1871. Print. Private collection.

The pious hospitality of the townspeople that Greatorex described in her text belied their competitive spirits and the intense interpersonal dynamics that occurred behind the scenes. It was no accident that the one household privileged by the king was also the one in which Greatorex and her children resided (fig. 5.7). Two members of one family—Francie and her father Tobias Flunger—were selected not only to play the roles of the Virgin Mary and Pilate in 1870, but also to have the profound honor of being received by the king. The high status of the Flungers in the village was tied to a complicated mix of tradition and politics. All of the players had to be selected from the townspeople; strangers were not permitted to participate in any aspect of the play. The selection of the cast was done by a committee of all the householders, under the presidency of the Holy Rath Daisenberger, with the selection of female players especially competitive since those roles were so limited. Well-established families like the Flungers sought to maintain control of roles that they had held for generations, while other factions in the village contended for the honors.[57] Selection of the players and director

could resemble the struggles of political dynasties. Tobias Flunger had taken part in the play ever since 1820, when he was a child and stood in the tableaux. In 1830 he sang in the chorus; in 1840 he played in the orchestra, on the violin; in 1850 he played the Christus (captured in a photograph from 1850, called the oldest surviving photograph from the play), and in 1860 and 1870–71 the Pilatus.[58] There was no dramatic instruction, except from Daisenberger, and the locals renounced anyone who used the play as a springboard to a professional career (as occasionally happened when townspeople went off to seek their fortune on the commercial stage). "The talent for the apostolic roles seems therefore to be hereditary in the family," Greatorex wrote, repeating the accepted wisdom.[59] These lineages gave the impression of being "natural" but in fact were as dependent on local politics as on dramatic ability.

Every villager had multiple roles to enact. Even as they participated daily for the entire run of the play—if not as performers then as stagehands or musicians—the villagers also had to tend to the hordes of tourists, many of whom were boarding in their homes. "Sefie [Flunger], who is one of the Guardian Angels, looks very modest, and blushes a little as I wonder at the changes I see in her," Kathleen Greatorex observed as she pondered transformations, "for last evening her hair was all tightly coiled round her pretty head; to-day it is in curls, falling down to her waist. Franzisca, the 'Mary,' is quietly getting our coffee, and attending to our comfort."

As Eliza Greatorex's admiration and affection for these people grew, so did her criticism of the social system under which they functioned. In her view, the women bore the brunt of their patriarchal society, all the while conducting themselves with piety and good humor. Although Frau Flunger remained silent on the summer's activities, her neighbor Frau Lechner—whose husband played Judas—"told me, but not complainingly, that these two summers of the Passion Play have been also hard on her. She has had no help but that of her little boy. To be sure, many good people wait on themselves, but others would have even warm baths carried up her little crooked staircase, until her back was weary and her feet would go no more." Coupled with the domestic chores, she experienced a psychological burden since people often conflated her husband with the traitorous role of Judas that he played. The artist asked her "permission for the children to make a drawing of her little kitchen, which is a picture of neatness, and she thought this a

great honor. Her 'man' and her 'boy' are all to her in life, the good women says, and she likes to keep the house bright for them."[60] For Greatorex this humility made their sacred drama so beautiful: "They bring to it working hands held out in love, pious hearts lifted up in faith to meet their Divine Lord, and with their lowly peasant life has mingled the dignity of the life of Christ, whose story they have been born for generations to tell, until their common human nature has become, during the Passion-Time at least, strangely touched by the felling of a Sublime Presence."[61] The Greatorex family were privileged to live with the Flungers that summer, witness these transformations, and experience the life of the townspeople on an extended basis. They had to get back to Munich to organize the details of the book publication, but before they departed for America, they would come back to say their last farewells.

PUBLISHING *HOMES OF OBERAMMERGAU*

"On her return to Munich with her portfolio filled with the rich harvest of her summer's stay in Ammergau, the hard part of her work began," we read: "there was *a book* to be published! And then she did, as hundreds have done, realize the bitter, if covert malice of the desire of old Job: 'Oh, that mine enemy had written a book!'"[62]

Matilda Despard cast her description of the efforts to realize the publication of her book in the language of military warfare: "From etcher to printer, from carvers of the wooden covers to perverse proof-readers, it was a series of skirmishes, almost pitched battles, which she had to encounter and surmount." Greatorex was a novice at book production, as her sister dramatically described: "All her courage, all her irrepressibility, were needed, for she was indeed a very David of inexperience before the Goliath of routine, red tape, and rapacity, without any armor at all, save the stone and sling of simple, direct purpose."[63] Bavaria's rising reputation as an art center was coupled with its growing publishing industry, with Joseph Albert, the most prominent photographer, specializing in art reproduction.[64] With her earlier efforts at reproducing her drawing via photography in *Relics of Manhattan* proving unsatisfactory, she was in need of Albert's advice on a less expensive and more accurate process.

Greatorex and Albert met in Oberammergau in his role as "Photographer to the Court of Munich and St. Petersburg" (a designation he printed on the title page of his productions), when the king had ordered his photographer

to the village to create a souvenir album of the 1871 performance. We can imagine the American artist in Munich calling on the enterprising publisher, carrying a portfolio of drawings that she wanted to reproduce. Albert had just invented the collotype, a modern color printing process. But at the time of their meeting, he was working successfully with another method better suited to her black-and-white work called the heliotype. This was the process they settled on: "A series of twenty etchings in Heliotype, from the original pen-and-ink drawings," as identified in the subtitle of her book. The heliotype is a photo-mechanically produced plate made by exposing a gelatin film under a negative, hardening it with chrome alum, and printing directly from it. "This is obviously a very important addition to the resources of art," reviewers announced in 1871. "From 300 to 400 impressions can be taken in a day . . . and if required, the picture can be printed along with the type in the pages of a book."[65] Her book is a synthetic product of past and present, employing the latest, cutting-edge technology to reproduce her drawings of aged houses made with quill pen and ink. It must have been while they were working together that Albert decided to expand his *Album of the Passion-Play at Ober-Ammergau* to include additional materials enumerated in its final subtitle: "being sixty photographs of the scenes and tableaux of the passion-play, taken by command of his majesty King Ludwig II., of Bavaria, by the court-photographer Albert, of Munich; a series of etchings, in heliotype, from the pen and ink drawings of The Homes of Oberammergau by Eliza Greatorex, and engravings on wood . . . and a full account of the passion-play, with text and songs of the chorus by John P. Jackson." Given the number of visual artists crowded into the village that summer capturing every picturesque detail, it was remarkable that Greatorex's graphics were featured in King Ludwig II's book alongside Albert's photographs.[66] Since these graphics constituted her first book project, this was quite a coup!

"The interest of these graceful sketches," a reviewer noted, "is much enhanced by the notes from a diary kept during a three months' residence there in the summer of 1871."[67] She now had to hone her marketing as well as her artistic skills, to become agent-advertiser as well as artist-author. She arranged for an exhibition of a suite of her Oberammergau images during the late autumn: "These drawings, of which there are about twenty in all, were exhibited in Munich, where they attracted great attention, especially from those who had recently witnessed the Passion Play at Ober-ammer-

gau." Indeed, tourists lingering in the city saw the work as a potential souvenir, as confirmed by the press: "Among these were many cultured English people of rank, who perceived their rare excellence, and subscribed liberally toward their publication."[68] The book was completed later that year, after the exhibit closed and the city's streets empty of visitors. Given that it was published in Munich in English only, the text was not destined to have broad international appeal. Copies had to be sent from Munich to Britain and America, which involved delays in shipping and handling.

A shipment of her books was expected to arrive from Germany in time for Christmas. "Owing, however, to the disturbed state of all postal arrangements throughout Germany [due to the war] these were unfortunately delayed,"[69] as she wrote to the publisher George P. Putnam: "I have had to give up hope of the arrival of my Book in time for the Christmas sale, but as I have received a few albums complete, I [venture?] to ask a place for them in your store, in the hope that they may through your kindly interest find sale at this late hour."[70]

She exhibited a sample portfolio of the heliotype prints at the Goupil gallery in lieu of the completed book, as an incentive for future sales. When copies of the book eventually arrived, it was favorably received, and found an audience beyond the tourists who had actually attended the Passionspiel. "Mrs. Greatorex has pursued a cognate but distinct aim," a writer for the *London Saturday Review* stated, and added that her drawings "will, for different reasons, be interesting both to those who have been and to those who have not visited the spot themselves." Over time, the book found its way into the hands of a variety of different readers. "A copy of the work was presented to the king of Bavaria, whose taste in art is well known." His Majesty reciprocated with "a very complimentary note, accompanied with a handsome collection of works illustrated by Kaulbach in remembrance of the dear happy days spent in Bavaria."[71]

The artist and her entourage had left the Continent for Britain, and from there sailed for America. On October 29, the Steamship *City of Montreal* from Liverpool arrived in New York, carrying passengers including "Mrs. Greatorex and 2 daughters" and "Mrs. Despard and 2 children."[72] They were home, and she settled back into her routine at the studio on East Twenty-Third Street. "Still," Matilda Despard observed with insight gained from years of close contact, "after all she had accomplished, each work is to her active mind only the stepping-stone to the next, which, with the humility of

a true artist, she still aims at making more worthy than the last." The German project had barely been put to bed when she was priming herself for new challenges: "Her thoughts are now turned to the reproduction of American scenery, that which no country affords a finer field for the art student."[73] They were already hatching their plans for the next summer in Colorado.[74]

6

TAMING THE WEST

Summer Etchings in Colorado (1873)

―――――――――

GOING WEST

"Mrs. Greatorex, an artist of considerable note in the east . . . is en route to Colorado on a sketching tour," a Denver newspaper announced in the summer of 1873. She and her daughters were heading west by rail so that she could "procure illustrations for a work on this territory" to appear that December titled *Summer Etchings in Colorado* (fig. 6.1).[1] The publisher George Putnam had contracted her to write a book combining a descriptive text with twenty-one of her pen–and-ink drawings, to appear for the Christmas sales. The project was timely, coinciding with the moment when the West loomed large in the national imagination. Opened in May 1869, the transcontinental railroad was facilitating westward movement, and adventurous women were utilizing it to explore regions that had previously been all but inaccessible to them. With audiences hungry for information and visual imagery of the region, a booming publishing industry was commissioning authors and artists to look west. Frances Flora Bond ("Fanny") Palmer produced lithographs of the Rocky Mountains for Currier & Ives. Mary Hallock Foote's residence in Leadville, Colorado, became the subject of stories and pictures for *Century Magazine*. Thomas Moran

FIGURE 6.1

Eliza Greatorex, *First Glimpse of Manitou.* From *Summer Etchings in Colorado,* 1873, opp. p. 15.

specialized in visual representations of the Yellowstone, earning the nick-
name "Yellowstone Moran."[2] On the heels of completing her first book,
Homes of Oberammergau (1872), Greatorex was ready to employ her dual
abilities as writer and artist to craft her firsthand account of Colorado,
aided by her daughters and her sister.

It was still unusual for women to strike out for the West alone. One of
the few to do so was Isabella Bird, a popular British travel writer. In her first
solo trip abroad in the early 1870s at age forty, she embraced a rugged out-
door life in Colorado. "This is a glorious region, and the air and life are in-
toxicating," she wrote in *A Lady's Life in the Rocky Mountains* (1879). "I live
mainly out of doors on horseback, wearing my threadbare Hawaiian dress,
sleep sometimes under the stars on a bed of pine boughs, ride on a Mexican
saddle, and hear once more the low music of my Mexican spurs."[3] Most of
her countrywomen who went there depended upon male companions. Lady
Howard and Rose Kingsley traveled with their brothers, Theresa Longworth
with her male secretary, and Emily Pfeiffer, Theodora Guest, and Rose Pen-
der with their husbands.[4] The Greatorexes were not the first women travel
writers to set out for the American West, but the fact that they traveled as a
female trio and produced visual as well as written records made theirs a
singular mission.

They hatched their plan to journey to Colorado while still in Germany. They intended to take the train from New York City to Denver, then a coach to Colorado Springs, a nascent European-style health spa. The artist's friendship with Martha Reed Mitchell of Milwaukee opened many doors through her husband Alexander Mitchell, railroad magnate and real estate tycoon who connected them with Colorado developers. They included Governor A. C. Hunt and General William Jackson Palmer, a Pennsylvania-born Civil War veteran who decided to establish a resort community at the base of Pike's Peak in 1871 after seeing it from a railroad car. Journalist Grace Greenwood arrived in 1872 and resided in her Clematis Cottage, extolling the area's virtues in print and hosting notable visitors. With her growing reputation, Greatorex was the ideal candidate to create an illustrated account of its stunning scenery and resources. With Greenwood authoring the introduction, it looked promising. John F. Kensett, Samuel Colman, and Worthington Whittredge painted here, but Eliza Greatorex was the first female artist from the East to spend a summer in the Rockies.

Eighteen seventy-three witnessed the Brunot Agreement, according to which the Ute Indians ceded the San Juan Mountains they called home and moved further west, where they would no longer interfere in the mining of their rich mineral deposits. Reduced conflict between Native- and Euro-Americans opened the way for tourism. Traveling by rail, Greatorex and her daughters observed Native Americans. "At evening we see Indians, Utes. Their eyes, soft, dark, and snaky, attract our attention first," the narrative read, "then their wonderful, composite costume." Station platforms provided contact zones between Native Americans and female passengers who got out to stretch when the train stopped.[5] Filled with curiosity, tourists would praise the men but complain of "dirty squaws" who, "with their dusky papooses slung over their shoulders, begged for a few cents." Greatorex devoted a chapter to Indians and mentioned them frequently throughout the text but did not get the opportunity to sketch them from life. "Yesterday two Ute chiefs, *Chaveneau* and *Little Colorado*, rode up to the Hotel at Manitou to send a dispatch to Washington," she wrote. "We were naturally very desirous of having them to sit to us for a drawing, yet were a little unwilling to ask." A contemporary photograph portrays Chief Ouray, his wife Chipeta, and other tribe members with railroad entrepreneur Otto Mears (fig. 6.2).[6]

"Naturally hot therapeutic mineral pools . . . relieve the tensions of everyday life," reads a twenty-first-century brochure that tempts tourists to

FIGURE 6.2

Photographer unidentified, *Ute Indians, Group Portrait*, [1880?]. History Colorado, Ronzio Collection, Denver Public Library.

one of Colorado's many luxurious spas just outside of Denver. The Manitou and Pike's Peak Railway now advertises year-round service, carrying passengers the 14,110 feet to the summit for breathtaking views. Today tourists in the modern American West can enjoy its hot springs and scenic railroads without realizing that a century and a half ago, Eliza Greatorex was an agent in these developments.

ADVICE TO WOMEN RIDING THE RAILS: SARAH CHAUNCEY WOOLSEY

The Union Pacific–Central Pacific Railroad carried passengers to the West Coast faster and in greater comfort than ever before, and many artists seized their opportunity. When Albert Bierstadt made his first expedition to the Rockies in 1859, he got only as far as St. Louis by train and then switched to wagon and horseback. In 1871 he crossed the country from New York to California in the comfort of his Pullman car. A single woman could neither travel alone by horse or wagon nor accompany a party of male travelers. These restrictions meant that Fanny Palmer, artist of many western scenes

FIGURE 6.3

Frances ("Fanny") Palmer, del., *The Rocky Mountains, Emigrants Crossing the Plains,* 1866. Currier & Ives lith., NY. Library of Congress.

for Currier & Ives including *The Rocky Mountains, Emigrants Crossing the Plains* (fig. 6.3), had to create them sight unseen.[7] The railroad opened the West to women. Much ink has been spilled over the transcontinental railroad, but rarely from a feminine perspective.

In the spring of 1872 Sarah Chauncey Woolsey of New Haven, Connecticut, and her friend Helen Hunt (later Jackson) set off for California by rail. While Hunt chronicled her personal responses, Woolsey compiled practical information for female travelers that she published under the pseudonym of Susan Coolidge in *Scribner's Monthly* in May 1873. Simultaneously, the Greatorexes departed on the same route. The first leg of the journey traversed what is still one of the country's most scenic stretches of rail, north along the Hudson River as far as Albany. From there the train headed west to Suspension Bridge at Niagara Falls, through a heavily populated area made wealthy thanks to earlier access via the Erie Canal. This was familiar territory to the artist from her early days in America staying with her brother in Le Roy, near Rochester. Outside Buffalo they changed to the Lake Shore and Michigan Southern Railway, bound for Chicago. Dismounting from their car

on the New York Central, they were leaving the well-managed domain of Cornelius Vanderbilt and wondered what accommodations awaited them. Travelers were obliged to procure meals at train stops, from canned meats and crackers at smaller stations to fresh rolls and cold roasted chicken in the cities. "Hotel-cars are attached to the train" along some stretches, Woolsey explained. "These are infinitely ingenious in their fitting up, and most beautifully kept and appointed. They have compact kitchens . . . while the dining room attached, with its little tables set out with fresh linen, and pretty plate and china, is so appetizing in its aspect that it would tempt an anchorite to be hungry."[8]

They covered the nine hundred miles from New York to Chicago. On such trips, "dust is the great foe to comfort," Woolsey cautioned. "No brushing, no shaking removes it. It sifts, it penetrates, it pervades everywhere. After two or three days you grow to hate yourself. Some ladies whom we met wore barége caps, which drew tightly with an elastic cord over their hair and kept it free from dust."[9] For the New Yorkers these inconveniences were minor compared to the wonders. "We felt as if we were chasing the sun," Eleanor Greatorex wrote, as they were "whirled over rivers and prairies by the Great Western train."[10] In Chicago they changed trains for Milwaukee and a stopover with the Mitchells.

Once refreshed from their visit, they were off again. "At Omaha, Nebraska," Greatorex continued, "began our experience of real Western traveling. There we took the San Francisco train." For night trains "a large bag or small valise will be needed for use on the cars," Woolsey advised, and continued: "In this bag should be put, beside night-dress, change of linen, etc., plenty of clean collars, cuffs, pocket-handkerchiefs and stockings, a bottle of cologne, a phial of powdered borax, to soften the hard water of the alkali district." Weather also presented challenges, necessitating "a warm flannel sack for the chilly nights—which even in midsummer must, in those high altitudes, be provided against, soap, brushes, combs, a whisk-broom, a pocket pincushion, a brandy flask, and small quantities of two or three of the simplest medicines."[11] The preparations of the New York trio, however, bore little resemblance to this scenario. "What a hot run we had from car to car," they recounted, "cumbered [sic] with bags, baskets, parasols, shawls, and the innumerable articles to the torment of which one always slavishly submits in traveling despite the most cunning skill in packing trunks, and

the sternest resolution against *bundles*."[12] Although seasoned travelers, they suffered from the common malady of poor packing.

Woolsey found that fatigue was surprisingly minimal, "partly due to the great comfort of the Pullman cars, and to their smooth motion, and . . . to the slow running of the railroad trains. And the freedom from jar, the skillful avoidance of shocks in starting and stopping the train, is very noticeable."[13] Here again the Greatorex party diverged. Lacking the luxury of a Pullman sleeping car, they had to sit up all night, with the result that "daylight brings you to a dim consciousness of being in an upside-down condition—somewhere; your head hangs limp over the arm of the seat, your feet are all pins and needles, existence means concentrated misery." For Eleanor, these feelings only lasted "till you shake up the little remains of spirit and courage within you, and face life bravely again."[14]

From Omaha to Cheyenne: "Another day, whirled over the prairies by steam, we were thankful for cool air and lovely skies, but began to long for something to vary the unending stretches of dry blue-green grass," which were relieved only by the prairie dogs. "At last Cheyenne, our changing point, was reached." There they stood "on the rough platform, waiting for the train to Denver, which is behind time." Dark storm clouds rolled in, hail fell, and the passengers were driven into the station, which was already filled with the many emigrants "in sadly tumbled muslin dresses and wonderful headgear." Then "the storm cleared . . . the mountains began to rise up in the soft hazy distance, our train came, and the eighty or one hundred miles to Denver was a ride of joy and delight."[15]

Located on the South Platte River, Denver was settled in 1858 as capital of Colorado Territory and was soon a thriving gateway to the Rockies. "It is a fitting boundary line to this awful earth ocean over which we had been passing for five days and nights of travel since we left New York," our traveling trio observed, "and we descend from the car in this busy, wide-awake, intensely living, new city of Denver, fully convinced that we have indeed crossed the plains, and are really in the Great Far West."[16] "It is a sweet and compensating fact," Woolsey reminded her readers, "that the pleasures of travel survive its pains. . . . The discomforts, the heat and dust, the weariness by the way, the trifling vexations, are soon forgotten; while the novelty and freshness, the beautiful sights, the wider horizon, the increased compass and comprehension, remain to refresh us always."[17]

Reaching the terminus, the Greatorex women would have echoed her parting words: "Go! don't give it up!"

GETTING THE LAY OF THE LAND

Upon arrival, the group was put up in a "little cottage studio and sleeping room—an offshoot of the fine hotel in Manitou."[18] The sisters participated in tableaux vivant and other activities while Eliza Greatorex studied the local terrain.[19] The Rockies consist of a chain of extremely high mountain peaks—many over fourteen thousand feet above sea level—alternating with broad, sunken plains, there called parks. Colorado Springs is about sixty miles due south of Denver, both positioned on the edge of the Plains that ascends into the Ramparts Range (or foothills), offering a secondary gateway to the Rockies. South Park, about seventy-five miles south west of Denver, was the third point of the triangle that bounded their area of exploration. Their base of operations was Manitou Springs, which sits northwest of Colorado Springs in Fountain Creek Canyon in the shadow of Pikes Peak. They hiked extensively in the area and camped out in Bergen Park, close to the present-day town of Evergreen.

Landscape art requires not merely recording the terrain, but imbuing it with a sense of the past. Adhering to this approach, Greatorex absorbed its layered history as she surveyed the scenery. US government–sponsored expeditions to the area included that of Zebulon Pike in 1805–6 and Stephen H. Long in 1819–20, accompanied by the artists T. R. Peale and Samuel Seymour. By the 1840s it had been crossed several times by John C. Frémont and his ill-fated party. The earliest white men in the region were nomadic fur traders who charted a course through the mountains that future colonizers followed. Among familiar names were Ceran St. Vrain and William Bent, who established a chain of trading outposts along the waterways flowing from the Rockies, the best known of which was Bent's Old Fort, positioned where the Arkansas River crossed the Santa Fe Trail. These traders were latecomers compared to the Native Americans, who had inhabited these regions for centuries and were now being expelled.

In Colorado, Greatorex declared that "no landscape in the many countries which I have seen has equaled this."[20] Without her original sketches, only the twenty-one pen-and-inks reproduced in her book reveal her struggles to delineate these vast spaces. Western landscapes by her male contemporaries Bierstadt or Moran wowed audiences with soaring mountains and

FIGURE 6.4
Eliza Greatorex, *Tim Bunker's Pulpit*,
from *Summer Etchings in Colorado*,
1873, opp. p. 55.

vast canyons. Her impulse was to impose a civilizing stamp on the West, to tame it for her readers. Her method meshed with the desires of her hosts to present the Colorado territory as an ideal spot for settlement and prosperity. Her treatment of *Tim Bunker's Pulpit* (fig. 6.4) is a case in point, presenting a steep rocky incline culminating in the "castle rock" formation, named for regional author Bunker (aka Rev. Mr. Clift). Bierstadt or Moran would have emphasized the vertiginous mountainside devoid of people. Greatorex, by contrast, organized the foreground around a serpentine road that counteracts the verticality and fills it with several wagons and a rustic cabin in the composition's center. Although the small structure bears no identifying

mark, her text explains that it was an eatery run by an English family who specialized in antelope pasties: William Iles, his wife, and daughter Annie, recruited from Britain by Dr. Bell to help establish the nascent tourist town.[21]

Increasing numbers of tourists needed food to sustain them, making ranching a mainstay of life in the territory that Governor Hunt was eager for the artist to endorse in her book. He led their camping trip to Bergen Park, which included an overnight stop with "Mr. T.," owner of Thornton's Ranch, which supplied dairy items and vegetables. Another night, they enjoyed the hospitality of Colonel Kittredge's Ranch, where the artist interviewed a man who aimed to establish in Gunnison "one of the largest and finest stock ranches in the United States." These huge complexes were essential to supply food to the towns and resorts. Motivated by the dream of owning their own ranch, the eastern women eagerly engaged with him in "talk round the bright hearth." They "found out so much about . . . the time necessary to live on a homestead or claim, so as to protect it from the wretches, unprincipled and unscrupulous, who would 'jump' your claim and enter your homestead." Governor Hunt took the younger daughter off "searching for *her* ranche" in Colorado, where her brother had relocated.[22]

"GO WEST, YOUNG MAN!" TOM GREATOREX AND COLORADO FRONTIER TOWNS IN TRANSITION

In 1850—the year Eliza Greatorex gave birth to her son Thomas—few realized the enormous mineral potential of the territories the United States had recently wrested in the U.S.-Mexican War (1846–48). Even fewer would have dreamed that southwestern Colorado—with its rugged terrain, severe winters, and hostile Ute Indians—would be settled within three decades. Yet by 1880 Silverton was on its way to becoming an established community where the artist's son was thriving. Many western accounts focus on legendary heroes or villains. His story is instead that of a middle-class easterner of culture and refinement who navigated the boomtown atmosphere of a Colorado mining district and helped to forge its future.

As a young man Thomas Greatorex had gained invaluable experience working with his uncle, Adam Pratt, in the Treasury Department in Washington, DC, implementing changes mandated by the National Banking Act of 1863. Its purpose was to transform the chaos of the country's thousands of issues of bank notes into a new, unified national currency system. This "bright, dashing lad . . . who about 1864 entered the service of the

Government as a messenger in the Note Division of the Secretary of the Treasury" helped identify one of the agents pocketing the old currency he was tasked to destroy. "The result was a confession and trial and the return of some thirty thousand dollars to the Treasury," we learn, and "young Greatorex was afterward promoted to a clerkship."[23] According to the city directory in 1867, he was boarding at 433 Tenth Street N.W., not far from the Treasury Building.[24] Soon he, like many young men, headed westward and about 1870 arrived in Denver, where he worked for several years, associated first with Daniel Witter's abstract office and then with David C. Dodge, working on the Denver and Rio Grande Railway books.[25]

The first Colorado gold rush occurred in 1858–59, when the miners and prospectors who headed for the hills were the only Anglo-Coloradans living there. As time passed and the population failed to grow, the federal government recognized the need for more accurate intelligence to attract people. During the era of the great western expeditions, explorers like Ferdinand V. Hayden and George Wheeler dispelled the image of the Rockies as barriers to progress and promoted them instead as bountiful storehouses of natural resources. During the summer and fall of 1873 the Wheeler party surveyed the San Juan country near Silverton, where they documented thirty-six peaks over thirteen thousand feet high, crossed five thousand miles of roads and streams, and charted east-west lines of travel across the mountains. Hayden and photographer William H. Jackson explored most of southwest Colorado in 1874–75.[26] Information gleaned from their reports helped generate the San Juan mining excitement of the mid-'70s, promoting settlements of Lake City, Silverton, Ouray, Rico, and Del Norte. When Tom Greatorex decided to try his luck in these frontier towns, he was well positioned from his Denver days as an abstractor, one who secures information from public records to validate titles. An abstract consists of a written history of all the recorded documents and proceedings related to a specific property. Between the removal of the Indians from the area, the stakes people made in the mines, and other claims on real estate, there was a crying need for anyone who could sort out issues of ownership. This young man, locals agreed, had "few equals and no superiors as a penman and record clerk."[27]

Like his sisters, the young man heeded the artistic muses of their parents. Local newspapers often praised Tom Greatorex's beautiful bass voice and his participation in Christmas choral events and church services. But "his greatest love," according to his colleagues, "was sketching, and he

FIGURE 6.5

Tom Greatorex, cover illustration, *Williams' Tourist's Guide to the San Juan Mines*, 1877.

scrambled to find time to draw what he found in his mountain surround-ings." From a young age he had accompanied his mother on sketching expe-ditions and now drew many spectacular sites he saw on his extensive treks. Of central importance were the transport routes and passes through the mountains, with which he became intimately familiar as he covered thou-sands of miles by horseback, burro, or skis. Little wonder then that the pub-lishers of *Williams' Tourists Guide to the San Juan Mines* (1877) contracted him to create graphics. Pictures like the cover image (fig. 6.5) of two people by a mountain lake with snow-capped peaks behind convey the dual mes-sage of such guidebooks: both the grandeur of the fourteen-thousand-foot peaks and their accessibility to travelers. His style reflects his mother's work but carries his personal stamp in the immediacy of the mountains and han-dling of human figures.

In 1879 the little town of Silverton, surrounded by snow-crested moun-tain peaks, was enjoying steady growth. Elections were held on April 7, and the civic-minded Tom Greatorex was appointed treasurer and clerk. It was a moment when sidewalks were laid, water irrigation planned, and police and fire departments established. He participated in the shaping of these rough western outposts into towns in the hope that new settlers could live a safe and ordered life.[28]

IN SEARCH OF HEALTH AND HOME

If Tom Greatorex helped establish the infrastructure for Colorado mining towns, then his mother promoted the region as suited to domestic life, rein-forced by her pictures of log cabins and family camp scenes (fig. 6.6). Now that tourists were heading west in increasing numbers, competition grew to attract them to specific destinations. The developers of Colorado Springs laid out the red carpet for the artist with the expectation that her book would give Colorado Springs her stamp of approval. "Such an effort as this should be encouraged by every one," the local press urged, "as, apart from the gratification which cannot fail to be derived from the book, as a work of art, the good it will do for this vicinity will be very great. A subscription list for the work has been opened at the office of Mr. T. C. Parrish, where specimens of Mrs. Greatorex's etchings, and a number of sketches for the forthcoming work can be seen."[29] Relocated from Philadelphia, Thomas C. Parrish and his wife Anne Lodge Parrish (uncle and aunt of Maxfield Parr-ish) were laying the foundations for an art culture and heartily endorsed

Col. Kittredge's Ranch.

Our Camp by Pass Creek.

Greatorex and her book.[30] Its dedication to the "gentlemen of the 'Fountain Colony,' who . . . have achieved already such great success" underscores her obligation to local sponsors General Palmer and financier Dr. William A. Bell.[31] A wilderness when John C. Frémont explored the area in 1842, thirty years later Grace Greenwood declared it "the most fashionable and delightful watering place in Colorado."[32]

The term *spa* is thought to derive from the acronym for the Latin phrase *salus per aquae*, meaning "health through water." Nineteenth-century spas trace their dual roots to ancient towns in Greece and Babylonia and to Native Americans. "We heard from our interpreter many a legend of the Indians, among them the story of the springs," Greatorex wrote. "These medicine waters are looked on with awe as being the abode of a spirit who breathes through the transparent waters, causing the commotion on their

surface." Attempting to distinguish among the tribes, she elaborated: "The Arapahoes, especially, attribute to this water-spirit the power of giving to their undertakings success or failure. Passing by the springs, on the war-trail of their hereditary enemies, the Yutas, through the 'Valley of Salt,' they never fail to offer presents to the 'Manitou.'"[33] Henry Wadsworth Longfellow's epic poem *The Song of Hiawatha* (1855) popularized this theme, which took on new relevance with postwar western expansion. It opens with the appearance of the Master of Life:

> Gitche Manito, the mighty,
> He the master of life, descending
> On the red crags of the quarry
> Stood erect, and called the nations,
> Called the tribes of men together.

Gitche Manito (or Manitou) is a collective name, the common Algonquian term for spirit, mystery, or deity, and by extension the interconnectedness of nature. Manitous exist, not in a hierarchy like classical gods and goddesses, but as part of a collective spirit.[34] Exploiting Longfellow and the Indians, the founding fathers renamed Fountain Colony to become Manitou Springs.[35]

These springs rise naturally from aquifers deep in the ground, where they absorb high concentrations of minerals, exceeding those of better-known watering holes like Saratoga Springs or Baden-Baden. The intense effervescence—the by-product of peak levels of carbonic acid—gives it the character of soda water.[36] Holes were drilled to tap into the underground springs and fountains added from which people could drink. Claims for their healing powers were widely held in the postwar period. Guests drank the mineral waters, bathed in the sulfur springs, and relaxed in a scenic environment, all of which contributed to their sense of well-being and substantiated claims of their health-sustaining qualities. Often visitors came from cities like Charleston, New Orleans, and Washington, DC, that suffered from muggy summers, mosquito infestations, and epidemics of cholera and yellow fever. Visiting the springs, guests removed themselves from the mosquitoes that carried those ailments. Not understanding disease etymology, they credited the springs with preventing illness. Soon the slopes around Manitou were filled with tents and cabins for those suffering with

FIGURE 6.7
Eliza Greatorex, *Monument Park* (Garden of the Gods), from *Summer Etchings in Colorado*, 1873, after p. 74.

tuberculosis and other respiratory ailments. They included Frank La Farge, who had been sent there to recover from tuberculosis. Visiting his brother, artist John La Farge also explored the area and painted watercolors at the Garden of the Gods.[37]

Helen Hunt described the Garden of the Gods as "another of these strange, rock-crowded parks,"[38] purchased by General Palmer as a tourist attraction outside Manitou Springs. Greatorex could not resist delineating a handful of these "remarkable rock formations" (fig. 6.7) with their curious anthropomorphic shapes. She articulated both their geological origins and literary associations, running the gamut from Greek and Roman mythology and Bunyan's *Pilgrim's Progress* to Bryant's poetry, reinforcing her book's leitmotif of Colorado as a natural amphitheater punctuated by human actions.[39] Arranging the images to move from such views of raw nature to community, Greatorex inserted *The New Town* as the final illustration. One reviewer praised its "effect of massed and angry clouds, dark with

foreboding of coming storm, she has produced by pen-and-ink lines in the sketch,"[40] while her rendering of the sturdy houses anchored in the prairie below and the church steeple rising to the heavens above assures us they will withstand nature's forces. In a subtle and slightly sporadic fashion, she narrates the story of settlement and order that human society is imposing on the Colorado territory. Once towns are seeded with homes, businesses, and churches, then the next step in the march of civilization is the introduction of art. She shared this conviction with her friend Martha Mitchell, who worked tirelessly to nurture art appreciation in the West.

CULTIVATION OF ARTISTIC TASTE IN THE WEST: MARTHA REED MITCHELL

On their outbound journey, the artist and her daughters had visited Mitchell, whose Milwaukee mansion was filled with artworks expressive of her taste and cultural mission for the Midwest.[41] With her husband's rising success in Wisconsin banking and insurance, railroads, and Congress, they hired prominent architect Edward Townsend Mix to transform their Italianate-style residence into the French Second Empire mansion that today is home to the Wisconsin Club. When her art treasures were not loaned to some benefit exhibition, they were displayed in the third-floor gallery, illuminated by skylight (fig. 6.8). She assembled the usual assortment of landscapes and figure paintings by domestic and foreign artists, but, in contrast to most collectors, she pursued women's art. Eliza Greatorex contributed to the pictorial ensemble, as did her daughters, who were inspired by Mitchell's love of flowers to paint decorative floral murals and furniture. These complemented the colorful floral still-life paintings the collector acquired from Theresa Maria Hegg.[42]

Mitchell's feminist values were inculcated from an early age. Born in 1818 in Westford, Massachusetts, she received the best possible education for a female child. At age thirteen she was sent to Miss Fiske's School in Keene, New Hampshire.[43] Four years later, she advanced to Miss Emma Willard's Seminary, "where the happiest days of her life were passed"[44] in the first permanent institution offering American women a curriculum equivalent to that of a contemporary men's college. Willard's first generations of students, including women's rights activist Elizabeth Cady Stanton, demonstrated distinct patterns in adulthood that countered prevailing notions of true womanhood: desire for an intellectual life, a seriousness of purpose

beyond the domestic and religious spheres, and a degree of personal aspiration. In 1838 Martha Reed moved with her family to the backwoods of the Wisconsin territory and three years later married Scotsman Alexander Mitchell, whose business acumen helped transform Milwaukee into a major city of the Midwest. Wisconsin archives bulge with materials about Alexander Mitchell, their son John, and especially their grandson William "Billy" Mitchell, known as the father of the US Air Force. Although her dedication to the cultural realm matched her husband's to commerce, there is barely a trace of the cultural trail blazed by this pioneering philanthropist.

An effective ally in these efforts, Greatorex hosted a reception in June 1875 for the press in her New York studio and art gallery at 115 East Twenty-Third Street, featuring Mitchell's latest acquisitions. "Mrs. Greatorex's rooms were also graced by some fine paintings, just unpacked, from Europe, owned by Mrs. Alexander Mitchell of Milwaukee, a lady who has done very

much to cultivate and elevate the taste for art in the West," one journalist reported. "Her pictures from the easels of Staigg, of Rome, Mr. F. Waller (who was of her party in a lengthened tour of Egypt, the Nile, the Bosphorus, & c), Swaine [sic] Gifford, and some of our home-keeping artists, were much admired."[45] They undoubtedly orchestrated these events precisely to garner positive reviews and elevate the status of Mitchell's artworks for, as they knew, taste in provincial locations was easily swayed by opinions in the metropolis.

Mitchell's collection was apparently dispersed without a trace, a pattern all too common with even the most prominent of collectors, male and female. Earl Shinn wrote that by 1879 her gallery boasted about ninety pictures—oils and watercolors—but failed to enumerate them. Exhibition records and reviews help reconstruct her holdings. While many contemporaries collected by what might be called the smorgasbord approach, purchasing a single work from each of a series of fashionable artists, her choices related to two cherished themes: the art of travel and women's art.[46] She acquired works from a cross section of Greatorex's projects: from Bavaria she had *Albrecht Dürer's Home, Nuremberg* and *Falken Thurm, Munich*; from Italy, *Via di San Giovanni, Coliseum in the Distance, St. Clement on the Right*; and from her signature book and series *Old New York*, she chose *Church of the Puritans, New York*. In a sign of support for Greatorex's two aspiring artist-daughters, in London in 1879, "a large figure-piece of Scotch fisher wives, by Miss Eleanor, was bought by [Mrs.] Alexander Mitchell, of Milwaukee."[47] She also acquired landscapes by Julie Hart Beers in the style of her *Hudson River at Croton Point* (1860; see fig. 2.6).[48] Subtly, Mitchell acquired artworks that questioned the era's gendered social relations. Danish/Polish Elisabeth Jerichau-Baumann's *Egyptian Water Carrier* depicts a scantily clad female with breasts bared and a diaphanous miniskirt covering her lower torso,[49] in a degree of nudity that is startling for a woman painter of the 1860s and 1870s.[50] Her collection was proof that she was "a lady who has done very much to cultivate and elevate the taste for art in the West."[51]

TAMING THE WEST

To reveal the full complexities of western scenery, Greatorex alternated between two pictorial modes: the picturesque for the tame, domesticated sites and the sublime for wild places. A camping trip to Bergen Park took them through California Gulch, where "the scenery is very grim," and at a

"particularly disagreeable part of the gulch," their carriage was "overturned on the sharp rocks." They were shaken up but relatively unharmed, save for a few sprained ankles. Here the dangers were not only physical but also emotional. "After recovering from our fright," they reported, "we returned in the carriages with many misgivings at the ominous slides and lurches which we encountered." Traversing Pass Creek, such dread descended on them that they insisted it should be renamed the Valley of the Shadow of Death: "At evening we were in a cañon, the grandest but most gloomy we had yet passed. The little ones cried with fright, and even the elders shivered and quaked at this terrific look into the hiding-places of Nature."[52]

Their trek up Cheyenne Cañon constituted their most intense experience of the western sublime. The night before they departed, they were hit by a storm, perhaps a harbinger of things to come: "Last night we were trembling in our cottage, shut up there from a great storm. Such bellowing of thunder I never heard," Greatorex observed. "When we ventured to raise the curtain and look out, it was enough to make one think that the very last night had come, that the world was surely on fire, and that the flames would be on us in a moment. I little thought I should be here to-day." But then the terror-filled night gave birth to a new day: "Oh! what a new-born, clean-washed earth! What a wondrous sky! What glory and purity, what new life over all, and within myself!"[53] After crossing many creeks and scaling steep paths, they reached their destination with its many stunning waterfalls. "We stood before the beautiful falls at Cheyenne Cañon," she wrote, "and tried to realize all their beauty and the foolishness of the attempt to sketch them with a woman's hand and a steel pen."[54]

However self-effacing their language, these women were no swooning maidens. Their ability to achieve the falls demonstrates courage to face "dreadful precipices" and pluck to overcome obstacles in search of pictorial riches. Imagine her as she describes herself: "[I] stand in the hot sun, tired and brown, in my hand I hold the ink-bottle as well as my sketch-book, while my umbrella is stuck rather shakily in my belt."[55] In this manner she sketched *The Climb, Cheyenne Cañon*, which shows the party of three women on the rocks below the falls. Orienting her image vertically and extending the tree trunk near the left margin beyond the limits of the page, she effectively conveys the precipitous nature of their ascent, here just short of the summit. "It is an ugly, hard climb," Helen Jackson wrote on a similar ascent. "But ah, the reward of ugly, hard climbs in this world! Mentally, morally,

FIGURE 6.9
FIGURE 6.9
Eliza Greatorex, *Looking Out,*
Cheyenne Cañon, from
Summer Etchings in Colorado,
1873, opp. p. 41.

physically, what is worth so much as outlooks from high places? All the beauty, all the mystery, all the grandeur of the canyon as we have seen it below were only the suggestion, the faint prelude of its grandeur as seen from above."[56] Greatorex mustered "a little determination to 'go on,' bringing us to the highest attainable point of the cañon, and from between the rocks we gaze out on the plains. There was, really, not a word to be said, and, with a long-drawn breath, I took refuge in utter silence." An hour later she "found courage to attempt, with my pen, even a feeble remembrance of the scene."[57] The result was *Looking out, Cheyenne Cañon* (fig. 6.9), her most immediate confrontation with the vast heights and spaces of the Rockies.

In 1868 when Timothy O'Sullivan carried his view camera down into the silver mines in Virginia City, Nevada, he took the first flash-lit photographs of mining interiors. Five years later, this woman artist donned a miner's cap and surveyed the coal mines outside Pueblo, what she called "living tombs." Hosted by General Palmer and the Colorado Improvement Company, she traveled from Colorado Springs southeast by private train, resting in an easy chair as they rushed south at forty miles per hour. She had the luxury to stop at will wherever she desired to sketch the scenery distinctive from elsewhere in the territory. "From Pueblo to the coal mines is the wildest bit of country I have yet seen," she observed. Even more startling sights awaited her, when she actually descended into the mines: "By the twinkling lamps carried in the miners' hats we see and wonder at all the dark processes of mining." While conditions prevented her sketching underground, one of the miners told her: "The work is very hard. Often the 'cuts' are made by the miner while lying on his side, the pick used by working it over the shoulder, the hole drilled, filled with powder, and blasted, the daring workmen still in this uncomfortable position." When she "emerged from the black pit into the day, made dazzling by contrast," she felt a newfound sympathy for those who stayed below. "The men whose lives are spent in these sad underground shades," she told her readers, "can have but gloomy and cheerless lives."[58]

Towards the end of their stay, they made a steep and arduous ascent to the region where they mined silver, the most recent magnet to the area. There she described looking down on the Continental Divide, a "a narrow ridge, rising between the mountains, where, should you pour a cup of water, half of it would run on one side to the Pacific, and the other to the Atlantic." Then they arrived at Montezuma—"the highest mine in North America"— where she sketched its entrance in the desolation of the tall peaks. They also saw "some of the wonders of mining . . . drilling, and blasting, and sorting of ore into bags." They were invited to share a meal with the miners, who expressed excitement that the women visitors would "write up" their operation.

MARGARET FULLER, SARAH FREEMAN CLARKE, AND *SUMMER ON THE LAKES, IN 1843*

Many artists in this period took to the road and created bodies of images that responded directly to their travels. Church, Bierstadt, Heade, Moran,

and Kensett all had mobility at the core of their practice. But few of them authored their own published accounts. Many kept travel diaries and wrote letters back home recounting their experiences. But with the exceptions of early figures like Indian painter George Catlin and artist-naturalist John James Audubon, few had the inclination to publish a narrative to accompany their images. In *Summer Etchings in Colorado*, like her earlier *Homes of Oberammergau*, Greatorex created both text and images that communicate with the armchair traveler in complementary fashion. Only a handful of fine artists attempted to bridge the gap between sketching in the field—and therefore in the moment—and writing back in camp, from memory. Even fewer examples of travel art and writing by women were available.

Three decades before Greatorex traveled to Colorado, in the summer of 1843, predecessor Sarah Freeman Clarke embarked on a westward journey. Her companion was Transcendentalist writer Margaret Fuller, with Sarah's brother the Unitarian minister James Freeman Clarke accompanying them partway. A visit to the Clarkes' brothers in Chicago and Milwaukee provided a rationale for the trip. The party traveled for three months, leaving Boston for Buffalo and what was the considered "the West": the Great Lakes, then across the Illinois prairie to Milwaukee and on to Mackinaw Island. In the days before the transcontinental railroad, they traveled by every available conveyance, including regional trains, steamboat, wagon, canoe, and on foot. An exemplar of the woman traveler-artist, Clarke depicted western scenery— in field drawings, book illustrations, and a handful of oil paintings—that demonstrate a personal sensitivity to nature and a marked ability to translate unfamiliar terrain into art. Fuller was a leading feminist who "possessed more influence on the thought of American women than any other woman previous to her time," according to Susan B. Anthony.[59] Upon their return, Fuller authored the book *Summer on the Lakes, in 1843* (1844), illustrated with seven etchings after Clarke's travel sketches.

Male travel writing generally reiterated a chronological sequence: yesterday we did this, today we saw that, etc. Resisting those dominant prescriptions, *Summer on the Lakes* could be characterized as a portfolio of sketches, poems, anecdotes, and self-reflections as they made their leisurely journey to the Great Lakes. Fuller professed her lack of concern with geography or the specifics of their itinerary and instead "aimed to communicate . . . the poetic impressions of the country at large."[60] Sketching throughout their journey, Clarke was moving through artistically uncharted territory and had

to determine for herself which sites were important to delineate. When she made sepia drawings of a log cabin on Rock River or the rolling grasslands of the Midwest, she was not following the example of a predecessor but striking out and fashioning her own sense of place. The product of collaboration between sister-travelers, Fuller and Clarke's book offered women travelers an alternative to conventional travel writing.

The book was unusual for its time and genre and was undoubtedly familiar to Greatorex since Sarah Freeman Clarke belonged to the circle of Martha Mitchell, who could have shared a copy of *Summer on the Lakes* with Greatorex during her visit in Milwaukee on her way to Colorado. This book might have provided Greatorex with an alternative model of travel writing, one that stood in opposition to the direct, chronological approach of male-authored narratives. This allowed for digressions, rambling, and amplification of particular ideas that occurred to her on the road. It also reinforced her conviction that the legibility of her pictures demanded a complementary text. Greatorex traveled further west than her predecessors Fuller and Clarke, but they helped guide her efforts.

REALIZING *SUMMER ETCHINGS IN COLORADO:* MOTHER-DAUGHTERS COLLECTIVE

On the Colorado trip, Greatorex honed her skills as an artist-traveler, while her two daughters trained in expeditionary practice: keeping a journal and sketching outdoors. The trio compared notes, swapped ideas, and made mutual plans together: "We will sit here to-day arranging notes and discussing the long journey which has ended at Manitou for the present."[61] With the fall publication deadline looming, the mother pressed her daughters into service. The three women perused each other's work, decided which elements to incorporate from their individual journals, and assembled them for the final presentation. "Here I am interrupted by Nellie's laugh at the scraps she had written while undergoing the shaking of the cars," the artist explained, "but, after reading her notes, we solemnly pronounce them the best of the three sets, and vote them the place of honor." Eliza Greatorex was the primary author of the twenty-one pictures, but here too she had help. "The title page, which represents a camping scene, gracefully set in a frame of appropriate foliage," one reviewer noted, "was designed by a daughter of the artist, who inherits in no small degree the talent of her accomplished mother."[62] Their

method approximated the ideal of an expedition party, where each member makes discrete contributions. While leaders like Wilkes, Powell, and Hayden did not always orchestrate the findings of their exploring parties successfully, this mother-daughters team created a comprehensive whole. This is likely due in no small part to their silent partner back home: Matilda Despard, who "is to arrange and complete the text for the work I am doing this summer for Mr. Putnam to be called *Summer Etchings in Colorado*."[63]

Finalizing the story of "our summer wanderings in this strange and vast country," Greatorex created a series of thematic chapters that adhered loosely to their itinerary, accompanied by vignettes of the diverse scenes they visited. Travel writers traditionally move the reader from place to place via a first-person narrative. Here the artist/author pushed the authorial "I" to the background and gave voice to pioneers, ranchers, and miners who shared their stories. *Summer Etchings* represents an advance over *Homes of Oberammergau*, demonstrating increased confidence and cohesion. Her descriptive language better evokes scenery and people, while her imagery has expanded from repeating variations on a single theme (town residences) to a variety of images that tell a story: the civilizing of nature for human habitation. It moves from the opening picture of the Colorado wilderness to its transformation at the book's end into the town of Pueblo and the New Town, designated as eighteen months new.

She organized her drawings and, on a sheet of lined paper, while her experiences were still fresh in her mind, wrote the dedication, signed and dated "Colorado Springs, Sept. 26, 1873."[64] The Colorado excursion was at an end. She and her daughters said their goodbyes as they readied for the trip home. Around the same time Winslow Homer was in Gloucester, Massachusetts, packing up his summer's work in watercolors, the first work he had done in the medium during his residence in the lighthouse on Ten Pound Island. Thomas Moran was preparing to head east after terminating work with the geographical survey to the Grand Canyon in northern Arizona. All three entertained great hopes for their new projects: Greatorex with her pen-and-ink drawings of western scenery, Homer with pictures of boys sailing and children playing under the docks, and Moran with his Grand Canyon field sketches, to be elaborated into one of the signature subjects of his career. All three were shifting the foundations of American art from the traditional oil on canvas to works on paper.

The female artist returned to New York from "the Switzerland of America" in early October and set to reproducing her drawings and finalizing the text. "Mrs. Greatorex's book of Etchings in Colorado is in the hands of the publisher," it was reported in November, "and will be out soon."[65] Meanwhile her sister edited and proofed the text, and received an advanced copy dated November 22 with the inscription: "To the dear Proof Reader, or more truly the original first cause and helper of the Summer Etchings in Colorado, With the grateful love of Eliza Greatorex."[66] Completed on schedule, the volume measures only 7 × 9 ½ in., which made it small even when open and allowed the reader to cradle it and study the pictures at close range. Although the book was titled *Summer Etchings*, the images were neither produced nor reproduced as etchings, a term that was loosely applied in the United States. "This work was printed at the Graphic Company's printing works, and the etchings were done by the 'Graphic' process," one source explained. "In this process the design is etched on glass through a thin film of gelatine [sic]. The glass thus becomes a photographic negative, from which a print is taken on prepared paper exposed to the sunlight. The print is then transferred to stone, and from the stone can be printed any number of copies on a steam lithographic press." For *Harper's Magazine*, the etchings "are about a perfect reproduction in general style and effect of pen-and-ink sketches." The process, which is yet almost in its infancy, is destined to work a complete revolution in the art of illustrating books, and to do away entirely with "the mediation of any middleman, draughtsman on wood, or engraver."[67] The pictures were pronounced "vigorous in conception and bold in execution," and "quite worthy of careful study in a purely art point of view."

PRODIGAL DAUGHTER: GRACE GREENWOOD AND WOMEN SETTLERS IN THE WEST

A home on the frontier became a cherished trope in American culture. In this spirit the Colorado Springs Company had given Grace Greenwood a prime lot, where she built her Clematis Cottage, named after the local climbing plant that in the nineteenth century language of flowers symbolized mental prowess.[68] While her written descriptions of the scenic splendors of the Colorado Rockies appeared in the *New York Times*, an illustration of her Clematis Cottage (fig. 6.10)—reproduced widely from *Century Illustrated Monthly Magazine* to stereographs—became a visual icon for women settlers in the west. Laws in

some states still forbade married women to have their own money or property. But under the Homestead Act women were able to claim land in the West. Signed into law by President Lincoln, it went into effect January 1, 1863, and granted 160 acres of free, federally owned land to anyone who had never raised arms against the US government. In return, recipients would build a home, grow crops, and sustain themselves on the land. If they succeeded, then the land was theirs to keep after five years. The Homestead Act embraced diversity and applied not only to white male citizens, but also to immigrants yet to declare citizenship, former slaves, and women. A photograph of a woman standing in front of her house with her horse by her side and labeled "Lillian Wilkinson House on Claim" (Nebraska Homestead National Monument) says it all. Like the renderings of Clematis Cottage and Eleanor Greatorex's log cabin, it proclaims the role of women in the settling of the West.

"One of the liveliest and most characteristic of American writers," Grace Greenwood was a renowned journalist and one of the first women to gain access to Congressional press galleries.[69] After the Civil War she was eager for a change of scenery and struck out for Colorado, which was becoming an increasingly appealing destination for a woman. Her introduction to Greatorex's book lent it authority, and together they led an impressive circle of accomplished women gathering in Colorado.[70]

Hoping that Greenwood would sing the praises of the area to her growing public, town boosters gave her the VIP tour. "General Wm. J. Palmer and party of friends, among them Mrs. Greatorex, Grace Greenwood, and Governor A. C. Hunt, have just returned from an extended tour of the South Park to Twin Lakes, visiting Fairplay and Mt. Lincoln on the return trip," the *Colorado Springs Gazette* reported. "Mrs. Greatorex secured some fine sketches for her new work, titled *Summer Etchings in Colorado*, which is to be published by Messrs. Putnam of New York, and to be ready by the holidays."[71] Just as their male colleagues Bierstadt and Moran socialized with railroad magnates, so these women enjoyed close relations with Colorado's rich and powerful, who provided them with unprecedented access to people and places that would become the material for new work. Greenwood recorded her western experiences in a series of newspaper articles that she collected into a book titled *New Life in New Lands: Notes of Travel* (1873).[72] She became an unabashed promoter and leading citizen of the area, conducting public readings for charities and officiating at events such as the

FIGURE 6.10
Artist unidentified, *Grace
Greenwood's Clematis Cottage*
(Lippincott Cottage), Manitou
Springs. From *Century Illustrated
Monthly Magazine* v. 12 (1876).

opening of the weather station on Pike's Peak. Greatorex too met expectations, with some even complaining that her book did its promotional work too well and that its author was blatantly uncritical. "In short," one reviewer complained, "the book is one long drawn out rhapsody of admiration from preface to finis."

At the Brooklyn Art Association's Winter 1873–74 exhibit, "Mrs. Eliza Greatorex contributed a dozen of the original pen-and-ink sketches which she made last summer in Colorado" in an effort to advertise the book and generate sales.[73] Viewers found the originals "much deeper in feeling and softer in tone than the reproductions recently published in book form." The comparison revealed difficulties with the printing: "The process of etching on glass and printing on hard, smooth paper, robbed them of their beauty."[74] Every critic had an opinion to offer. A columnist for *Harper's* attributed their "peculiar and indescribable charms" to "the fact that such etchings as these introduce us to the mind of the artist, without the mediation of any middle-man; draughtsman on wood, or engraver."[75] Another writer found

the distinct style suitable to the subject: "The sketches which we have seen are not equal in careful finish to her pictures of old New York, but they are perhaps all the better for that, for as they are they are in better keeping with the spirit of the wild and rugged scenery they portray."[76] But "this work is in every respect an American book," they all concurred. "Its theme is the characteristic scenery of the far West, the likes of which is not to be found elsewhere in the world; its treatment is by an American artist, and with the freedom of a true and unconventional art."[77]

These talented eastern women sought some measure of freedom in Colorado and praised its openness and greater opportunities for women. "I understand now," mused Greenwood, "why suffrage was first granted to woman in a territory."[78] Wyoming was the first state to grant women the vote. Colorado followed suit the next year, although at the time it was still a territory and only become the thirty-eighth state on August 1, 1876. These Centennial women earned their status not merely by being among the early artists and writers of their gender to travel west but also by forging new career paths that traversed boundaries between fine and popular art to reach broad audiences for their productions. They opened the doors to women migrating there to make a new life. Greenwood only stayed at her cottage for two summers, but it continued to be associated with her name.[79] Greatorex was unable to return, but her project inspired the dreams of others to acquire a homestead in the Rockies. Here they found the license to tie up their skirts, hike up steep mountain slopes, and allow their properly pale Victorian complexions to sunburn. A spirit of possibility pervaded the region, and they breathed it in like the fresh mountain air.

Back home, a financial thunderbolt struck. With the war's end, railroad construction boomed and resources were diverted into railroad companies, taken to be a sure thing. When the banking firm of Jay Cooke & Co.—one of the most prominent firms in the country, heavily invested in railroad construction—closed its doors on September 18, 1873, a major economic panic swept the country. Six days later, on September 24—a day that would go down in history as Black Friday—the US gold market collapsed. The "Panic of 1873" led to an economic depression. It struck a serious blow to artists, who already had a difficult time making a living while wage workers felt uncertain, even terrified.[80] Such economic crises carry a psychological dimension and shift the mood of the country. Until this point the myth of America as an egalitarian society prevailed, but thereafter it was undeniable

that the country's wealth was in the hands of a few, who could manipulate it at will. The illusion of social equality and fairness was shattered. Out of this unbridled entrepreneurialism of the 1870s, the Robber Baron was born.[81] It remained to be seen how he and his kind would impact the art world and women's place in it.

7

OLD NEW YORK (1875)

Witnessing Urban Transformation

WALKING THE ISLAND CITY

The first installment of *Old New York, from the Battery to Bloomingdale* rolled off the press in April 1875, wrapped in blue paper (fig. 7.1). Over the coming months ten installments appeared, consisting of eighty pictures and accompanying essays. Subscribers typically gathered together the individual installments and bound them in leather to constitute an impressive folio volume. The culmination of ten years' labor, it was the crowning achievement of Greatorex's career and the project on which she staked her reputation. Its original title, *An Artist's Journey from the Battery to Bloomingdale*, underscores its conception as a travel account.[1]

Usually understood as a survey of some faraway and unfamiliar place, "an artist's journey" is here applied to a detailed investigation of her own backyard: the twenty-three-square-mile island of Manhattan, which consisted of a densely packed southern end and a more sparsely populated rural area to the north. Written by her sister Matilda Despard, the text structures the book as an extended walking tour with references to "walks," "rambles," and "strolls," taken up, paused, and then resumed over a number of years. Her

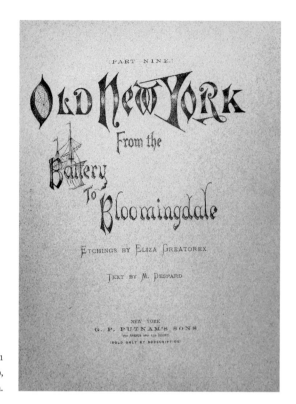

FIGURE 7.1
Wrapper, *Old New York*, v. 9,
1875. David G. Wright Collection.

aims as an antiquarian explorer are symbolized by the cobweb dangling from the initial letter O on the title page (fig. 7.2) This motif signals the reader that this is no dry, objective report but a personal, subjective response to her adopted home. Through these pages, we traverse the length and breadth of Manhattan and see its history through the artist's eyes. We are transferred back in time, to a moment when the city was poised for transformation.

Endorsements printed on the wrappers convey an appreciation for her work. "I want to tell you how much pleasure I find in looking over the First Part of *Old New York*," wrote landscapist James McDougal Hart. "You know I live in that far away country South Brooklyn so every morning I wend my way through the very scenes that you have *so faithfully drawn*." Pondering her opening picture of lower Manhattan—*The Battery and Castle Garden*—he articulated feelings shared by many of her readers: "I have come to love

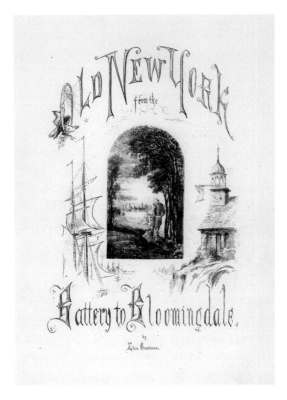

FIGURE 7.2
Eleanor Greatorex, title page,
Old New York, ca. 1875.

the Battery Park and to feel a kind of ownership in it. I am glad you also have loved it enough to thus picture out the grand old trees and the quaint buildings that wall it in." Venerable portraitist Daniel Huntington praised her invaluable series, adding: "As an 'old New Yorker,' I dearly love the places you have saved from oblivion, and as an artist, am charmed by the spirit, the feeling, and the truth with which you have drawn them." It marked an auspicious beginning.[2]

New York in the ten years after the Civil War was well on its way to becoming America's first high-rise city, or the metropolis of the canyon streets. Change was everywhere palpable. In lower and Midtown Manhattan, Revolutionary era architecture was being obliterated while further north the terrain—farmlands and open spaces—was being prepared for development. Contemporary rhetoric touted the positive gains of progress, but Greatorex's book hinted otherwise: "How different from the woodland, the farms and

meadows, the clear waters of the bay and river and sound, which greeted the eyes of these merchants of Old New York."[3] When the artist sketched the *Stuyvesant Pear Tree*, she was painting one of the city's natural icons, a tree said to have been planted by Governor Petrus Stuyvesant during Dutch colonial times on what became the corner of Thirteenth Street and Third Avenue.[4] But between the time she made her sketch and published her book, the tree had been knocked over by a passing carriage. Such incidents only strengthened the artist's resolve to record what she could of the old city that was fast disappearing.

Her project was driven in part by a woman's desire to possess public space. Nineteenth-century urban space had long been designated as the territory of the male, typified by Charles Baudelaire's *flâneur*, perambulating the city streets while the bourgeois female happily presides over the domestic interior. This concept of separate spheres—the narrow rhetoric of "male public" and "female private" spaces—has long provided a comfortable binary for the study of the era. Recently some scholars have begun to cry: "No more separate spheres!" and to search for examples of the "invisible flâneuse," the flâneur's female twin who similarly explored and thereby appropriated the urban environment.[5] The career of Eliza Greatorex supports this new interpretation and interrogates gender divisions. She was constantly wandering the city alone, traversing its busy thoroughfares and lingering in remote lanes. Taking possession of New York's private homes and public thoroughfares through the act of drawing them was a form of emancipation. Making art out of her lived urban experience, she produced her magisterial volume *Old New York* (1875), which claimed the city for herself and for her sex. The metropolis was conventionally seen through masculine eyes until the flâneur became the flâneuse and told an entirely different story.

To encompass what was then a city of villages, she trekked from one village to the next, immersing herself in the distinctive history and architecture of each one. Some of their old names survive today, such as Chelsea, Greenwich Village, Murray Hill, Yorkville, and Bloomingdale. But others— Harsenville, New Utrecht, Gravesend—are nearly obliterated from the collective urban memory. Reconstructing her itinerary around the island city, we recapture a sense of its cartography. In what could be termed her "First Reconnaissance" of 1868–69, she maintained a dual focus on the architectural heritage of Bloomingdale (now the Upper West Side) and of lower Manhattan, where soaring buildings had already replaced their low-level ancestors. Gathering material she had amassed by the late 1860s into her pub-

lished portfolio *Relics of Manhattan* (1869, discussed in Chapter 4) allowed her to develop a preliminary visual schema and consider her next move. After study in Bavaria, the publication of *The Homes of Oberammergau* (1872), and the Colorado interlude, she resumed her New York project with a more intense "Second Reconnaissance" in 1873–75. By this point her overarching schema was taking definite shape, based on a sound understanding of both New York's urban grid and the agenda of postwar developers who were greedily gobbling up old buildings to make way for the new.

She aimed to record the buildings before they disappeared, immersing herself in one neighborhood at a time when possible, although she sometimes had to divert her attention if a key building was unexpectedly targeted for immediate destruction. She worked in Midtown, which was being leveled to make way for Cornelius Vanderbilt's Grand Central Terminal. The land north of the city had long remained largely rural, where long-established farms existed alongside grand country estates of the wealthy. Landed gentry Archibald Gracie and Alexander Hamilton built elegant Federal-style mansions while farmers lived in simple homes, mostly Dutch colonial style. That was before Boss Tweed and his like worked to extend Broadway, destroying all that lay in their path. She wanted to document it all.

Having honed her abilities to chart and measure space as a landscapist, she now applied those skills to the built environment. To paint in oils, she worked *en plein air* with her portable painting equipment: the sketch box, portable easel, panels, umbrella, and an assortment of brushes and pigments that were enormously cumbersome and heavy. Now she replaced those with pen and paper. Finding the change noteworthy, one journalist described her "taking her pen, inkhorn, and table into the open fields."[6] Since her work demanded a minimum of several hours before a single motif, she added a portable stool to her equipment, but even then the change in medium gave her greater mobility and speed of execution, and thus radically altered her perspective on her subjects. She never abandoned painting, but consciously shifted her emphasis to the language of drawing. She was training herself to think like an expeditionary draftsperson: on the move and viewing the world in black and white.

Old New York is composed of chapters that pair an architectural rendering with a brief text explicating its features and history. One chapter, titled "The Hopper House, Farm-House, and Striker's Mansion," bears the subtitle "A Walk with the Artist from Broadway to the Hudson, through Fiftieth

Street."[7] It leads the reader along that single cross-town street from its Broadway intersection to the river's edge, encountering several key landmarks along the way. The contemporary "Sanitary and Topographical Map of the City and Island of New York," known as Viele's Map, reveals Fiftieth Street as a significant line of demarcation between the compact area of the city below and the more open, rural area to the north (then referred to as "suburbs"). It marked the urban frontier and defined the division between civilization and wilderness. Just as the national frontier was moving steadily westward in this era, so the city's frontier marched steadily northward. Establishing this reference point in her travel narrative, she emulated expeditionary protocol and signaled the reader to the changing demographics.

Below Fiftieth Street, as the narrative explained, some of the more interesting buildings had already disappeared before Greatorex began her quest. "In the long stretch from Union Square to the Hopper House . . . even the artist's eyes could discover no subject for a picture," the text stated, conveying to the reader the challenge of identifying subjects that were both historically significant and pictorially pleasing. "The Broadway which has sprung up from Fourteenth to Thirty-fourth Street, and thence to where Seventh Avenue crosses it at Fifty-second Street, was only a succession of farms in the old times, and of market gardens and dwellings of poor squatters in later years," it continued. "The last farm-house to yield to the present state of things, was the Varian homestead on Twenty-ninth Street; but even that was gone before these pictures were commenced."[8]

In spring of 1869 she crossed the Fiftieth Street frontier and headed north to survey the discrete village now known as Yorkville, bounded on the south by East Seventy-Ninth Street, on the north by East Ninety-Sixth Street, on the west by Third Avenue, and on the east by the East River. Her arrival coincided with Yorkville's increasing urbanization, including a middle-class enclave of merchants and bookkeepers living in new tenement buildings several blocks inland. Greatorex's interests lay in the "suburban residences" overlooking the river, where the city's elite families had once led a gracious existence in their country retreats that were now falling into decrepitude. She lingered there sketching the country seats of venerable New Yorkers: Gracie Mansion, built in 1799 for Scotsman Archibald Gracie (which survived to become the official residence of New York City's mayor since 1942); the Riker and Lawrence Houses; and the villa of John Jacob Astor, where

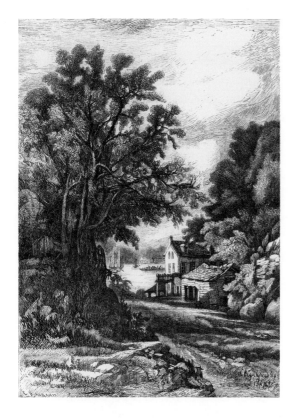

Washington Irving wrote his *Astoria*.[9] There, she and her sister encountered an old Scot who had been a household servant and reminisced about how Mr. Astor had maintained "the good and pleasant fashions of olden times." The artist's drawing was one of the last surviving records of his once-proud house that would be torn down in 1873. She sought to capture the slow decline of these old homesteads. The majority of drawings she penned in the area share one attribute: they feature a house overgrown and literally trapped by the vegetation—what urban historian Michael Nicholas calls "the captivity of the house."[10] Her treatment suggests that if it was not removed, then the house would soon fall and literally became part of the vegetation.

Other nearby subjects included the *Old Hell Gate Ferry House at 86th St.* (fig. 7.3), named for Hell Gate, the narrow hazardous tidal strait first named by the Dutch, where boats would navigate between Flushing Bay and the East River. Travelers who braved that difficult passage could then find

respite at the Ferry House (or Hotel), where they could procure light refreshment, hire a horse and wagon, or catch the stagecoach to City Hall. By the time Greatorex arrived on the scene, the stone structure had fallen to near ruin. In contrast to her usual portraits of homes centered and framed by foliage, here she placed the hotel off-center. Following the rutted, sloping path of Eighty-Sixth Street, she created a natural tunnel formed by arching tree branches and rock walls, providing a rare aperture of light and a view to the river.

Pushing further north, she visited Hamilton Grange, the residence of Alexander Hamilton—founding father and first secretary of the treasury—that stands today on 141st Street today (moved from its original site on 143rd St). The culmination of her journey was the Morris Jumel Mansion at 162nd St. in Harlem, her northernmost landmark (and, along with Gracie Mansion, the only structures that remain standing to this day where she observed them). This property fascinated the artist, who spent many days making multiple drawings and ultimately included two in the publication. Built in 1765 as the summer retreat for British colonel Roger Morris and his American wife Mary Philipse, it is Manhattan's oldest surviving mansion. Nephew of a successful English architect, Morris was greatly influenced by the sixteenth-century Italian architect Palladio. He combined a series of architectural elements to create sophisticated residences: a monumental portico, a pediment supported by grand Tuscan columns, and a large, two-story octagonal addition at the rear, the first of its kind in America. With the outbreak of the Revolutionary War, Morris—a loyalist—left for Great Britain. In his absence, it was occupied by a succession of dignitaries: British lieutenant general Sir Henry Clinton, Hessian commander Baron Wilhelm von Knyphausen, and George Washington, who used it as temporary headquarters from September 14 to October 20, 1776. After the war, the new American government confiscated the property, which became Calumet Hall, a popular tavern along the Albany Post Road. In 1810 the property was purchased by Stephen and Eliza Jumel. When Madame Jumel died in April 1865 at the age of 90, the *New York Times* devoted substantial space to her obituary.[11] From an impoverished Rhode Island family whose mother was probably a prostitute, she married wealthy French wine merchant Stephen Jumel and gained entrance into New York's moneyed elite. They spent several years in France and returned to settle in the mansion, which they redeco-

FIGURE 7.4
Eliza Greatorex, *Madame Jumel's Arbor under the Tree Called Washington's Landmark*, ca. 1870. Pencil and pen wash on paper. Museum of the City of New York.

rated in the Empire style. In 1832, Stephen Jumel died from a carriage accident under questionable circumstance (some suspected his wife had pushed him out of the carriage). Immensely wealthy, his widow married former vice president Aaron Burr the following year, but by 1836 they were divorced. It is uncertain whether Greatorex met Jumel, who lived an increasingly reclusive and eccentric life and died in her home in 1865. The artist did obtain possession of some of the furniture from the house as part of her own collection of antiquities.[12] The house passed through several owners until it was purchased by the city. The Daughters of the American Revolution helped turn it into a museum, a fact that would have delighted the artist, as she longed to have the historic homes she sketched preserved.

In keeping with her practice, Greatorex's published picture of the place is a mix of real and ideal. The best views of the house are to be had standing

directly in front of it, a perspective that accentuates its harmonious Palladian structure and commanding presence on the hill. But the artist chose instead to stand halfway down the hill and behind some trees, where it appears smaller and less impressive, partially obscured by vegetation. She exaggerated its proximity to the river, whose banks are much closer to the house in her drawing than they are in reality, complete with sailboats floating offshore. Conversely, her careful rendering of "Madame Jumel's Arbor under the Tree called Washington's Land Mark," as she inscribed the picture, is straight on and fully realized (fig. 7.4). She was attentive to natural artifacts as witnesses to history, and a further inscription underscores: "Washington used to tie his horse to this tree/ In 1874 the storm broke down the top." She took time to distinguish carefully the character of her subjects, from humble farmhouses to grand mansions, and to embed them in their surrounding terrain. Yet a perusal of her entire oeuvre demonstrates that no matter what pains she took to trek to a remote homestead or church to draw it on site, her compositions unfailingly obstructed the details of the man-made structures by framing them with a leafy curtain.

"RUINS SO SOON!"

In the plates of *Old New York*, this motif of the single stand of trees appears almost without exception, situated between the architectural motif in the middle distance and the picture's edge. On the odd occasion when fellow artists depicted the same motif around the same time (see for example figs. 4.3 and 4.4), no such foliage appears, suggesting that Greatorex inserted them to function as a time portal. Looking through the trees, her viewer is transported metaphorically from the modernized present to a pretechnological past, to a time when her crumbling structures throbbed with life. The conceit of the ancient tree as a symbol of an earlier, idealized time is a staple of American nature writing, which appears in the work of William Bartram, Henry David Thoreau, and William Cullen Bryant. But crafting it as a visual marker between past and present and using it to call attention to their demise more closely parallels the writing of her female contemporary Susan Fenimore Cooper. In 1850, four years before the appearance of Thoreau's *Walden*, Cooper published *Rural Hours*, her popular journal documenting the cyclical changes of the natural world she observed in upstate New York.[13] Daughter of novelist James Fenimore Cooper, she was, as Vera Norwood recognized, "the first American woman to gain a popular reader-

ship as a nature writer."[14] Having trafficked between the Old and New World, and between urban and upstate New York, both women were attentive to the increasingly rapid pace of modern life, its detrimental effects on nature, and its erasure of historic architecture. As Greatorex drew these soon-to-be lost buildings, Cooper was writing a new preface to the 1868 edition of her book. Regarding a cluster of old-growth trees, she pondered history from their perspective. "This aspect of the wood," she wrote, "tells its own history"; she thus argued that the trees ought to be saved as witness to North America prior to European colonization.[15] Looking back in time through this arboreal curtain, Greatorex—like Cooper—called attention to these historic cycles and conserved the past through art.

Thomas Cole famously depicted the classical ruin in the final canvas of his series *Course of Empire: Desolation* (1836; New-York Historical Society) as a warning to his countrymen of the excesses of civilization. But such artifacts in his native land were less hallowed, recognizable, and legible. Nick Yablon calls them *Untimely Ruins*, which he argues were far more prominent in the rise of the American cities than has been recognized. The term derives from Alexis de Tocqueville, whose journeys across America in the 1830s led to his two-volume book *Democracy in America*. When Tocqueville came upon an abandoned log cabin in upstate New York, he exclaimed, "What! Ruins so soon!" In the French author's telling, the untimely ruin contrasts America with the ancient ruins of Europe. Unlike Old World castles and cathedrals that measured their life span in centuries, New World ruins rose and fell within a few decades, or even years. Greatorex and her generation witnessed new steel-framed buildings replace the old wood and stone structures, and she drew those disappearing structures to preserve them for posterity. She regretted their loss, but understood their place in the cycles of history, as symbols of the ambition of her adopted country.

The Old Jersey Ferry House, Corner of Greenwich and Cedar Streets (fig. 7.5) depicts a cluster of tumbledown wooden structures in the foreground in varying states of decay. Porches protrude from the central structure, propped up by rickety vertical supports. Laundry hangs helter-skelter and a stairway twists precariously, leading nowhere. A streetlamp makes a rare appearance in one of her drawings, signaling the encroachment of modern times on a scene that otherwise could have existed a hundred years earlier. Only after taking in all the details of the lower register of the picture do we

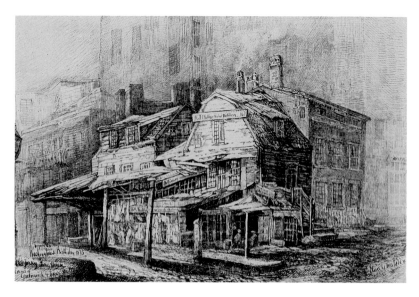

FIGURE 7.5

Eliza Greatorex, *Old Jersey Ferry House, Corner of Greenwich and Cedar Streets,* inscribed "begun on Washington's Birthday 1875." From *Old New York,* opp. p. 32.

realize that above this dilapidated ferry house rise the rectilinear forms of several newer, taller, and more functional buildings. Later modernist photographer Alfred Stieglitz employed a parallel composition in his *Old and New New York* (1910), juxtaposing the free-standing town houses lining Park Avenue with the under-construction Vanderbilt Hotel soaring above them. Both deployed these pictorial strategies to capture a moment of change.

"As we enter the old lane leading to the Harsen House, old Mortalita tries to impart to us a little of her own enthusiasm, and would fain make us see the beauty with which her artist-eyes discern around the place," Matilda Despard explains, referring to her sister with a favored nickname for her ability to recognize with her "artist-eyes" the positive dimension in these ruins that others could not discern. "But we cannot disguise to ourselves that decay holds possession, that the weeds choke the shrubs and flowers, that the few fruit-trees left refuse to wake at the call of spring," she continued, "and look as if they would rather moan and shiver in perpetual winter, dreaming of the lost 'lovely companions' sacrificed to restless, ruthless human progress."[16] "The past is not simply there in memory, it must be articulated to become memory," as literary historian Andreas Huyssen reminds

us.[17] New York City's past had previous articulations, most notably in the writings of Washington Irving. Aware of the strong hold his interpretation of Knickerbocker New York had on the popular imagination, Greatorex referenced him throughout her own narrative of *Old New York* as a means of challenging his authority. Referencing structures like the Emmet Monument (see fig. 1.6), she inserted the Irish into the mix.

THE MEANINGS OF HOME

Old New York scans geographically from one end of Manhattan to the other and includes a range of building types: a post office, hospital, museum, tavern, smithy, ferry house, and the Battery at New York Harbor. A series of churches is evocatively drawn, clustered either in the Village of Bloomingdale or in lower Manhattan. But for the most part she delineated domestic structures, from relatively modest to architecturally grand. She titled her pictures with the words *farm, home, mansion, house, cottage, country seat, estate,* and *homestead,* but regardless of these structural distinctions they were containers of the lives of New York families whose names always appeared in the picture's title. These families were in turn central to the history of New York City and to the United States, but there is one especially curious example.

Louis Philippe, Duc d'Orleans and future king of France (1830–48), spent over three years in exile in America. Many stories were repeated about his New World adventure, but none more improbable than his stint as a schoolteacher in New York City with his fugitive brothers. He was supposed to have lived in the Teunis Somerindyke house on the west side of the Bloomingdale Road (now Broadway) between Seventy-Fifth and Seventy-Sixth Streets, which she delineated in pen-and-inks as well as an oil painting titled *The Louis Philippe House in Bloomingdale* (fig. 7.6). Her book's text repeated the tale of the royal teaching young New Yorkers, a favorite with Americans who liked to believe that he had to support himself just like any other immigrant. Critics sometimes dismissed her domestic subject matter as the inevitable focus of the female artist. If they had dug a little deeper, they might have looked at Greatorex's insistence on the theme of home in biographical and even psychological terms. Not only was she an Irish immigrant seeking a new home in a new land, but she was also the daughter of an itinerant Methodist minister who continually moved his family from one location in the west of Ireland to another, never remaining in one place for more than a year. Her particular interest in the domestic architecture of New York, like her focus

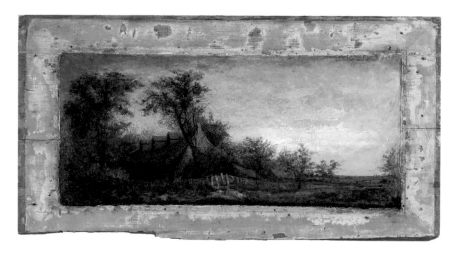

Eliza Greatorex, *The Louis Philippe House in Bloomingdale*, 1876. Oil on canvas, mounted on panel removed from old building, 8¾ × 20 in. (canvas); 13 × 25½ in. (panel). Ronald Berg Collection.

on dwellings of the Bavarian townspeople in *Homes of Oberammergau* (1872) and the settlements, ranches, and mining camps springing up west of the Rocky Mountains she drew for *Summer Etchings in Colorado* (1873), points to a concern that moves beyond the personal. It was an interest her audience across the country shared with her.

A close reading of *The Last of Greenwich Village* (fig. 7.7) from *Old New York* elaborates on this issue of home and guides our understanding of how the book's pairing of text and image can be interpreted on several levels. "The relentless city has spared nothing at all," the text reads, "only this small corner which the picture shows of the lovely rural region, so little . . . known to the dwellers in other parts of the city . . . that part of New York called Greenwich Village."[18] It stirs feelings of nostalgia for a way of life never to be regained, a theme that resonates throughout its pages. More specifically, the image documents the character of a neighborhood while the text provides a census-taking of some of the notable residents and their contribution to life there. Unlike many of the book's pictures that focus on one building, this one depicts a street receding to the horizon and populated by a handful of ramshackle structures. The artist's original study for the final print depicts a single structure with the notation "Tom Paine lived here," probably done about 1870 (Museum of the City of New York, no. 38.408.37).

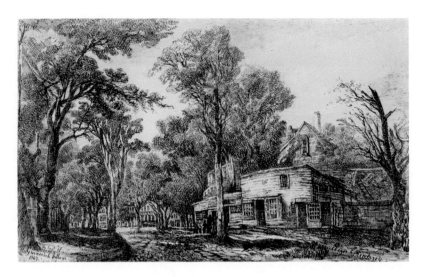

FIGURE 7.7
Eliza Greatorex, *The Last of Greenwich Village*, 1869. Inscribed "1869." From *Old New York*, opp. p. 64.

Despard's somewhat circuitous text opens with the statement "The picture was begun in 1870, finished in 1875," hinting at the process whereby the final illustration evolved from Paine's small wood frame house located "on a street we now call Grove" to become the picture of a now-lost neighborhood that takes its flavor from its distinguished denizen whose pamphlet *Common Sense* laid out why America had to break from England. Despard's words provide context by excavating other residents such as Charles Wright. The nineteenth century fostered a unique interest in the relationship between an individual and his or her home: magazine articles featured homes of artists and writers, residences of leaders such as George Washington's Mount Vernon were set aside early on as sites for visitation and inspiration, and plaques began to be affixed to the sides of buildings informing passersby of those who had lived and worked within. (In 1923 the Greenwich Village Historical Society installed a plaque at 59 Grove Street honoring Paine.) Not only was New York City a cluster of villages that eventually coalesced into a major metropolis, but a single neighborhood was understood as a constellation of dwellings sheltering unique individuals. Each picture by Greatorex, interpreted in light of the accompanying text, moves from microcosm of building and individual to macrocosm of history and country.

Home was a foundational American concept. Abraham Lincoln relied on tropes of family and the domestic, with the biblical reference of "the house divided" speaking poignantly to the tragedy of a nation torn apart by Civil War. The Homestead Act (1862) aimed to provide citizens and foreigners, men and women, with the opportunity to claim land and establish a home in the West. When former slaves cried out for "forty acres and a mule," they were in essence demanding the opportunity to own a home. The Currier & Ives firm produced numerous lithographic variations on the theme, including the sentimental and highly popular *Home Sweet Home*. Greatorex, however, differed from her contemporaries in several telling ways. First, she featured homes located in the city, rather than in the countryside, which constituted the usual locus of idealized domestic imagery. Second, she cast these domestic structures as objects of the past rather than the present. Third, she focused single-mindedly on homes that were, by the very fact of their being slated for destruction, identified as obstacles to progress by at least some faction of the city's population.[19]

An Irish immigrant and a widow, Greatorex was well aware that her status and political rights could disappear if she could not sustain a proper home for her four children. Single working women were designated as "women adrift" because they had literally broken away from the moorings of home and hearth and posed a threat to respectable family life. To be without a home—vagrancy—was classified as a crime. Periodicals featured representations of overcrowded shelters where the lower classes and target ethnic groups—especially Chinese and Irish—took refuge because, according to the press, they were incapable of providing their own housing. In this same vein Native Americans were portrayed in everything from posters for Buffalo Bill's Wild West Show to fine art paintings as lacking permanent homes and preventing Euro-American pioneers from establishing their homesteads. It could function as an instrument for inclusion or exclusion. Picturing nearly seventy homes—telling the stories of their inhabitants and connecting those stories to the larger history of the city—Greatorex contributed to this ongoing, controversial debate over the meanings of home in urban America.

"M. DESPARD" AND SISTER DYADS

The title page of *Old New York, from the Battery to Bloomingdale* (1875) specifies "Etchings by Eliza Greatorex" and "Text by M. Despard," without further elaboration of the author's identity. "The text will be the work of a

writer who has been moved by the like reverence with my own for the beautiful things of the past in this city of our adoption," Greatorex explained of her collaborator in the preface, "and the same earnest wish for their preservation from utter oblivion."[20] Despard had a strong hand in all of Greatorex's project, but as anyone who has ever tried to coorganize a major project with a friend or relative knows, it is not an easy task. The Pratt sisters enjoyed a complex and creative liaison.[21]

Parallels exist between the Pratt sisters and the intricacies of other creative sister dyads. "Behind every great woman there is another woman. Perhaps the only common denominator among nineteenth-century women of outstanding public achievement is their private bond to a female relative, almost always a sister, very often a sister with considerable talent of her own," Anne Higonnet observes. "It remains a subject of fascination that one family produced three exceptional writers: Charlotte, Anne, and Emily Brontë," she continues. "Each sister was the other's most constructive critic, challenging audience, and loyal supporter." Or take the example of Berthe Morisot, who "grew up in an atmosphere infinitely freer and more stimulating than the Brontës': privileged, teeming with new ideas, opportunities, and companions. But in her crucial, formative years, she too depended most of all on her sister. Behind Berthe Morisot was Edma Morisot."[22] And behind Eliza Pratt Greatorex, correspondingly, was Matilda Pratt Despard. But in this case evidence suggests that the converse is also true. In biological terms, their relationship would be termed a symbiosis: interaction between two different organisms living in close physical association, to the advantage of both.

Growing up in a large family in the northwest of Ireland with their father frequently absent, their busy mother had little time to devote to any one of her eight offspring. Eliza and Matilda Pratt became close companions, drawn together over the years by a shared devotion to music, literature, and art. Life in America bound them even more firmly together, and even after marriage, they shared a house at various times with their growing families.[23] When the recently widowed Greatorex decided to go to France, Despard took over the care of her two nieces and two nephews along with her own four children at their home in Cornwall-on-Hudson, New York. Later the two departed with children in tow for Germany, where they lived and worked in Nuremberg and then Munich. After Eliza Greatorex's husband died and her sons left home, mother and daughters functioned largely

within a female sphere that encompassed artists, writers, collectors, gallerists, employers, and fellow members of the women's rights movement. Her closest companions and confidants were her daughters and her sister, who supported them materially and emotionally. Together they fashioned a network that had as its center Greatorex's artistic production.

With little personal documentation, psychology provides insights into these female-female relations. "Either one sister encourages the other to play out some complementary self that she does not or cannot become, or forces around them are such that complementarity becomes the pattern within which both act out their adult lives," Toni McNaron tells us. Adult sisters often repeat behavior patterns ingrained from childhood: "It is as though unconsciously the pairs . . . evolve a system in which they develop only certain parts of themselves in order to cut down or avoid altogether the powerful pulls toward competition found within virtually any family."[24] Following this scenario, Greatorex and Despard strove to establish separate identities and to avoid competition or jealousy. The two were steeped in music, history, and respect for the past. They married the same year, one to a businessman and the other to a musician and composer. While both had abilities and ambitions as authors, Greatorex redirected herself to the visual arts, making way for Despard to continue her literary efforts. Greatorex achieved international recognition and was followed regularly in the press while Despard pursued her writing and assisted in all practical matters. Each sister complemented the other.

Nineteenth-century women authors including Mary Wilkins Freeman offered perceptive analyses of the female psyche. Freeman's New England short stories emphasized that one of the strongest, most intimate and tenacious bonds is that between adult sisters.[25] Scholar Carroll Smith-Rosenberg picked up on this idea and noted the extreme centrality of close-kin relationships, especially sister relationships, in women's lives during the nineteenth century. Unlike most other female-female relationships, she concludes, "sisterly bonds continued across a lifetime."[26] And indeed the links between the Pratt sisters endured.

Despard emerges as the more conventional of the two, who deputized her son to run errands, do favors, and generally indulge the grand schemes of "Aunt Eliza." She was also an individual in her own right, eager to pursue her own literary ambitions. Like many women she made an early foray into publishing by translating the work of another, in this case a children's book

titled *Prince Greenwood and Pearl-of-Price, with Their Good Donkey Kind and Wise*, which she translated from the German of Heinrich Hoffmann, with illustrations by her niece Eleanor.[27] She wrote an extended essay on the music scene in mid-century New York, and occasionally published her poems.[28] Often she adopted the role of her sister's expositor, as in the first article to discuss the full range of Eliza's work insightfully[29] and an account of their stay in Nuremberg.[30] She approached a press about her manuscript that told the story of a family living in Germany during the Franco-Prussian war (unlocated) and published a semiautobiographical novel in 1877 titled *Kilrogan Cottage*, an account of the childhood of a Methodist minister's daughters in the isolated northwest of Ireland. To judge by its few reviews and scanty number of existing copies, it had limited success.[31]

An early article explicated her sister's drawing *The Harsen House* for a new magazine, *The Aldine*, in October 1873.[32] It presaged her essays accompanying the images in *Old New York* and allowed her to conceptualize their methodology. She drew upon published historical material, oral history from local residents, site descriptions, and urban material culture located in the New-York Historical Society to elucidate her sister's picture. Numerous reviewers praised the written exegesis as well as the pictures and saw them in sympathetic harmony. In the decade of the 1870s, Eliza Greatorex and M. Despard were like the early-twentieth-century vaudeville teams, who worked best when they worked together, united in spirit and possessed of complementary talent.

THE URBAN MEMORY OF MARY LOUISE BOOTH: HISTORIAN, EDITOR, FRIEND

Researching Manhattan's past, Eliza and Matilda found an indispensable source in Mary Louise Booth's *History of New York*, first published in 1859 (when the author was twenty-eight years old) and then in its expanded 850-page version in 1867. (She would do a third, enhanced edition in 1880.) Their shared love of history brought the women together, and over time Eliza's relationship with Booth developed into one of the strongest of her life, outside of her family. In a busy career that rarely allowed leisure for letter writing beyond the needs of business affairs, Eliza Greatorex took the time to pen notes to Booth, whom she always referred to with greatest affection. A portrait (see fig. 4.1) conveys the details of Booth's outward appearance enumerated by one of the guests at her weekly salons: "Her gray hair, rolled back over a cushion, becoming her as a crown would have done, her dark-brown eyes, the rose tint

on her dimpled cheek and her beaming smile, all made her beautiful." But further elaboration brings the portrait to life: "Tall and with much majesty of demeanor, she moved among them like a queen . . . and the ready *bon mot*, the witty and good-natured turn upon her tongue, made her charming."[33]

Growing up on Long Island, she dreamed of a career as a writer and, at age eighteen, moved to Manhattan, where she planned to support herself as a seamstress while she broke into publishing. But having little skill with the needle, and an education that included fluency in several languages, she—like many women—began translating French texts into English. She occupied herself with technical manuals and other mundane publications until, as war seemed imminent, she saw an opportunity for something more meaningful in a translation of Count Agénor de Gasparin's *The Uprising of a Great People* (1861). She persuaded Charles Scribner that its strong endorsement of the Union would help its cause and rushed it into print, winning the praise of Senator Charles Sumner and President Lincoln. When peace came, there was a huge surge in periodicals, and Booth was offered the editorship of one of the new ones aimed at the rising female readership. She served as founding editor of *Harper's Bazar* (later *Bazaar*) from its debut issue on November 2, 1867, until her death in March 1889.[34] During two decades in this position, she attained the then handsome $4,000 annual salary. When *Harper's Bazar* began publication, it was a weekly magazine catering to middle- and upper-class women.[35] From its debut as America's first fashion magazine, it showcased styles from Paris and Germany in a newspaper format. Booth significantly used her position as a platform for women's rights and social issues and nurtured the careers of two generations of female authors. She was, in her day, "perhaps more widely known than any other literary woman in the United States."[36]

An important predecessor for Booth was the pioneering editor Sarah J. Hale (1788–1879). When her husband died in 1822, Sarah at age thirty-four found herself with five children and no income. She began to submit stories and poems (the best known being "Mary Had a Little Lamb") and quickly gained attention. When asked by a Boston publisher to edit *Ladies Magazine*, the first ever for women, she moved her family in 1828 from New Hampshire to Boston. In 1837 Louis Godey purchased *Ladies Magazine* to create *Godey's Lady's Book* and invited her to become editor. One of the most influential journals in the nineteenth century, *Godey's* was based in Philadelphia, where Hale and Godey worked together for over forty years.[37] The magazine

spawned Godey's Clubs all over the country, where women pooled their resources to get a subscription and read together. The cost was approximately $3/year. Unlike Booth, Hale was no feminist by modern standards—she opposed suffrage for women (she maintained that politics would corrupt feminine moral sensibility)—but she advocated for women's education, exercise, property rights, and sensible fashion. She coined the term *domestic science* for the housewife's job and promoted that idea in her journal. When she retired in 1877 at age eighty-nine, the magazine was still going strong; it later featured a series of articles by Eleanor Greatorex from Paris.[38]

The print medium was the vehicle whereby Booth and Hale enhanced their authority. "By the 1830s, the written word had long constituted an essential means by which women assured their place in civic life," as Lori Ginsberg points out. "Many women who wanted their views heard in the realm of public discourse wrote tracts, articles, fictional short stories, and novels, as well as authoring and presenting political speeches. Written and read largely by middle-class women, magazines such as *Godey's Lady's Book*—packed with fashion plates and patterns, fiction, domestic advice, and reports by travelers throughout the world—circulated widely."[39] These practices were continued in Booth's *Harper's Bazar*.

The distinct conditions of her domestic life allowed Booth to devote herself to publishing. Her friend Susan B. Anthony never addressed the subject of sexuality head-on, but when she gave a speech in 1877 on the subject of "Homes of Single Women" she drew upon the life of Booth in full knowledge of her relationship with her "romantic friend," Anne W. Wright. Anthony painted a harmonious picture of their partnership, with Booth the breadwinner and Wright tending to the home front.[40] "Perhaps Miss Booth could not have accomplished so much if she had been hampered, as many women are, by conditions demanding exertion in other than her chosen path, and without the comfort about her of a perfect home," another acquaintance observed. "She lives . . . with her sister by adoption, Mrs. Anne W. Wright, between whom and herself there exists one of those life long and tender affections which are too intimate and delicate for public mention, but which are among the friendships of history—a friendship that was begun in childhood and that cannot cease in death."[41]

Booth and Wright held gatherings every Saturday evening during the winter in their home on Fifty-Ninth Street and Park Avenue: "Their house is one particularly adapted to entertaining, with its light and lovely parlors

and connecting rooms; there are always guests within its hospitable walls." The closest thing to a salon America had at the time, these evenings were "an assemblage of the beauty and wit and wisdom, resident or transient, in the city—authors of note, great singers, players, musicians, statesmen, travelers, publishers, journalists, and pretty women, making the time fly by on the wings of enchantment."[42] Anticipating the cultural roles later played by Gertrude Stein and Alice B. Toklas, they hosted a salon that became the unofficial hub of New York's publishers and writers. "These weekly receptions with the simple refreshment of lemonade, ice-cream, and cake, attracted the literary people of the time—Mrs. Mary Mapes Dodge, Stockton, Stedman, Stoddard, Edgar Fawcett," a journalist reported.[43]

"The hostess's cousin, Edwin Booth, came in sometimes; a sad, gloomy man he was then—it was not long since his wild young brother had killed Lincoln. I remember him standing with folded arms in a corner, talking little," one attendee recalled. "He told me that such a party was agony to him, for his hearing was so acute that he could hear even a whisper across the room—and everybody talked at once at Miss Booth's."[44] These occasions allowed the mixing of artists and writers with editors and patrons. It was especially important for her female guests, who were otherwise barred from the New York clubs and therefore from access to opportunities to further their careers.

Among those female guests was Greatorex. She and Booth had shared a romance with New York since childhood, dreaming of it from their respective homes in Long Island and Ireland. In Booth's view New York City had the potential to become "the Athens of America," where a truly national culture could blossom, "the centre of culture and art."[45] But to fulfill its destiny, like the ancient Greek city, it required a sense of history. And that, both artist and writer knew, was largely lacking. "There is certainly too great an indifference prevailing in respect to the memories of our city. But few vestiges of the past remain to us, and even these few are unheeded," Booth lamented. Booth wrote of the city as a great stage on which the historic events were played out, and through her eyes the buildings, parks, and street corners come to life in ways that must have inspired Greatorex and Despard:

> In the hurry of business, our citizens pass and repass the grave of Stuyvesant and the tomb of Montgomery, unconscious of their locality. The busy New Yorkers throng the Post-office, without bestowing a thought upon its eventful

history; [City Hall] Park, the cradle of the Revolution is to them a park, and no more; the Bowling Green, where the Dutch lads and lasses erected their Maypole and danced around it, and where, at a later date, the patriotic citizens kindled bonfires in honor of liberty with stamp acts and royal effigies, is almost forgotten in the upward course of the tide of business; and the Battery, with Castle Garden, has fallen to the Commissioners of Emigration.[46]

In 1874 Thomas Addis Emmet offered to assist Booth in creating an enhanced edition of her *History of New York*, and she jumped at the chance. She always had a lingering wish to include pictures in the book. Emmet had a large collection of New York prints and illuminated books upon which she could draw, which she augmented with other documents and pictures.[47] She appealed to her friend Eliza, who happily supplied some images, testimony to their shared campaign to remember bygone New York.[48] In 1874 a group of friends also threw her a special birthday party and compiled a gift album filled with their photographs that included bust portraits of Eliza and Eleanor in oval prints with gilt edges, and autographed on the mount.[49] Eighteen seventy-four was a year filled with promise as artist and writer pursued their individual projects on New York's history, told from a woman's perspective.

CONTEMPORARIES AND RIVALS DEPICTING THE OLD CITY

Pictorial portrayals of Old New York increased from the 1830s onward, with printmakers and draftsmen trained as artisans churning out images intended for insertion in books and periodicals. When D. T. *Valentine's Manual of the Corporation of New York City* began annual publication in 1841, it offered a range of lithographic scenes of the city's railroad stations, ferries, homes, civic buildings, and waterfront docks. The majority of these images were done in a rudimentary, linear style that conveyed basic information, from the outline of a building to carefully copied signage to identify it. Some of the artists did their work on site and intended it primarily as reportage. Others, like Abram Hosier, made painted copies after pictures in compendia such as Jones and Newman's *Pictorial Directory of New York* (1848).[50] Architects too were beginning to address the subject. "In the mid-1870s, as de facto editor of the *New York Sketch Book of Architecture*, Charles McKim reprinted images of old Manhattan treasures, especially Mangin and McComb's City Hall,

which he called 'the most admirable public building in the city,'" Edwin Burrows and Mike Wallace tell us. "In revaluing the city's built remains, McKim helped fashion a turn toward the past, one that particularly appealed to old Knickerbocker and mercantile families who couldn't muster the financial resources for the social arms race."[51] By the early 1870s, "Centennial fever" was mounting, creating great excitement leading up to 1876 and the hundredth anniversary of the Declaration of Independence to be celebrated in a large international exposition in Philadelphia. History and nostalgia were the order of the day.

Among professional fine artists, the work of Eliza Greatorex's friend Edward Lamson Henry and of London-born Henry Farrer came closest to hers in general conception. Farrer emigrated from Britain to the United States in 1863 and carried with him a respect for the past.[52] His earliest attempts at etching came close in spirit to Greatorex's project when between 1870 and 1877 he produced a succession of etchings of New York street views and buildings, among which at least nine depict scenes similar to hers.[53] Farrer and Greatorex both selected as a subject Old Tom's on Thames Street at the corner of Temple Street, a rustic chophouse that provided a gathering place—like the city's coffeehouses—where commerce and conversation were conducted over food and drink. To render this relatively well-known spot in the city's social and intellectual life, Greatorex executed a rare interior while Farrer created a close-up of the entrance complete with legible sign above and a glimpse of a diner within.[54] Both portrayed the Old Post Office (previously the Middle Dutch Church) and other landmarks.[55] But their treatment of the Somerindyke House is most telling. Here it is evident that Farrer was willing to admit evidence of modern technology such as telegraph wires and paved streets, while Greatorex consistently omitted what she regarded as modern intrusions. Then, too, their visual language and mark-making differ greatly. Farrer worked in a crisp, precise line, while Greatorex's work in pen-and-ink is more feathery and vibrant. "As the old landmarks of New York are every day disappearing under the hand of improvement, the zeal of the artist and antiquarian is exerted to preserve their form and appearance for the purpose of history," one reviewer noted. These words described Greatorex, whom the reviewer then proceeded to compare to her young rival: "It is Mr. Farrer's design at no distant day to embody these etchings in a volume, and it is not too much to

say that the work will have a value beyond that of any of the magnificent gift books of modern engraving."[56] In 1874 he had Franklin Bayard Patterson—a young publisher just starting out—issue nine of these etchings in a portfolio format as *Old New York*. He not only pursed the same subjects as Greatorex, but similarly assembled them in a portfolio. Since she had been exhibiting individual images and published a set of twelve of them as *Relics of Manhattan* in 1869, there is no question that Farrer was aware of her work before he ever made his first preparatory drawing. We cannot know his motivation for following her same path. But perambulating the city and sketching picturesque sites assisted both newcomers in familiarizing themselves with their new surroundings and contributing to a sense of belonging. Her work could have provided a ready model for the young man. For his *Old New York* pictures represented his first attempts in etching, which he later confided to Koehler he did not consider to be of very high quality: "They are some of the plates that I spoke of as being done under very unfavorable conditions but unfortunately they sold when much better work wouldn't." Concern over their quality discouraged his pursuit of Old New York. (A look at his mature landscape etchings confirms his judgment, for these early works are awkward, lacking in nuance, and illustrative by comparison.) The sheer scale of Greatorex's ambition, studying in detail more than eighty structures, was a mark of the depth of her commitment to her subject and made it difficult for any other artist to compete.

Yet Farrer was often credited with pioneering efforts in the medium. "[Farrer's] *Etchings of Old New York*, published perhaps twelve years ago, formed, I believe, the first attempt in this country to preserve in etchings the quaint architectural effects of the olden time," we read in James Hitchcock's *Recent American Etching*. "What he did for New York in his first collection of etchings, Mr. Pennell did some years later for Philadelphia and its suburbs and for New Orleans.[57] He takes no notice of Greatorex. For although she labeled her images as "etchings," we have to remind ourselves, it was used as a generic term for prints, and in fact she only worked consistently in that medium in the 1880s. The images in her *Old New York* were photomechanical reproductions made after her pen-and-ink drawings, and therefore did not fall under Hitchcock's purview. Various writers tried to grapple with the technical subtleties of her craft, but the long and short of it was that they weren't true etchings. This confusion over medium led

some reviewers to draw analogies between her work and contemporary photographic books. Reviewing William James Stillman's *Views of Cambridge, Massachusetts*, a journalist made a direct comparison to Greatorex, his vocabulary typically shifting as he wrote, "What Mrs. Greatorex has been doing for New York so diligently, and with so much sympathy . . . Mr. Stillman has done in a mellower, more artistic way for Cambridge."[58] We cannot discount that sexism was at work. But the omissions and qualifications of these critics underscore a far more significant dimension of her work. Dissatisfied with the quality of images in her *Relics of Manhattan* and with her own preliminary attempts at etching in the late 1860s, she was unceasing in her quest to investigate the various printing and publishing media that were available to her in the early 1870s to get the best results.

THE BUSINESS OF ART: PRODUCING *OLD NEW YORK*

The increasingly rapacious destruction of New York's historic buildings made it more urgent for Greatorex to publish her book. When she first began to draw the soon-to-be-torn-down structures, she had come upon one here and one there—not so unusual for a major urban center. But the pace had intensified so that by the mid-1870s she reported that they were "now almost daily disappearing." Not only had the pace of demolition increased, but she also felt more confident about her contribution. "In the study and accomplishment of the drawings, I have been occupied for the greater part of six years," she wrote. "Many of the sincerest lovers of antiquity have watched their progress, and, recognizing their prospective value, encouraged me in having them reproduced and published."[59] Eliza had published two books featuring her artwork prior to this one, from which she had learned a good deal about publishing media. The first—*The Homes of Oberammergau*—had been done in Munich, where she had the advantage of working with Joseph Albert, one of the pioneers in art publishing. For the second—*Summer Etchings in Colorado* – her publisher was the New York press of George Putnam, who had agreed to do this one as well, so at least she knew what to expect from him.[60] But those volumes had consisted of only twenty images each, accompanied by short texts, and were small enough to be hand-held for close reading. The New York project, by contrast, was far more ambitious. She was envisioning a grand folio volume— 16 × 20 in. at least—with four times the number of drawings. She held

meetings with female artists and friends to study the array of methods and evaluate those that were most correct and promising.[61] Then there was the added pressure of the schedule. For the clock was ticking, driven not only by the escalated pace of architectural destruction but also by the fast-approaching opening of the Centennial Exposition. She wanted to have it available before the first day to capitalize on the interest in history and nostalgia that was currently sweeping the country.

All her energies that year were devoted to the myriad details necessary to realize her grand venture. Having spent six years creating the drawings, she now had to focus on the business of organizing them into publishable form. Following the usual practice for such a large undertaking, the book was to appear in installments containing suites of her pictures accompanied by a narrative text. But she also recognized a possible market for individual images—for display or use in publications by other authors—and offered the option of purchasing single pictures. On March 10, 1875, Eliza prepared a prospectus, to advertise her project and solicit subscribers, which announced: "The work will be issued in ten numbers, quarto size, each containing five original etchings and one reproduction; fine toned paper." She kept prices low and options flexible: "Price $5 per number; and for the use of those wishing illustrations for other works, sets of etchings will be printed upon India paper, size 16 × 20; price without text, $5; with text $6.50."[62]

The dedication set the tone for the project. "To William Cullen Bryant and to Peter Cooper, as representatives of the literature and benevolence of New York, it is my great pleasure, with their kind permission, to dedicate this book, the results of my earnest labor and sincere purpose." They were logical choices: one a noted philanthropist and founder in 1859 of Cooper Union, the other a beloved poet and editor who obligingly penned an "Introductory Note."[63] For her they embodied links between the city's past and present, but equally importantly, they were "devoted . . . to the truest service to women."

Artist and author now poured over the drawings spread out all over the studio, dating from 1864 to 1875. They finally had to settle several questions they had been pondering for some time: which images should be included, how should they be ordered, and what should be the nature of the accompanying text? Like most authors, Greatorex had changed her mind numerous times about the title; an earlier iteration had been "An Artist's Journey from

the Battery to Bloomingdale," emphasizing the subjective nature of her travels across the length and breadth of the island.[64] But as work proceeded, in consultation with her sister, they decided on *Old New York* as simple and direct. Deliberating over the sequence of images, they confirmed that a loosely defined geographic vector moving from lower Manhattan to the Upper West Side (then called Bloomingdale) provided logical structure, and kept the original subtitle. So the series commenced with the drawing *The Battery and Castle Garden* as the first full-page plate, with the opening of the text opposite it.

D. T. *Valentine's Manuals* (1841–70) are the first illustrated histories of the city, one model for integrating prints and maps with text, but they were factual, dry compendia of official records and statistics. Mary Louise Booth's *History of the City of New York* was a masterful synthesis of research into a chronological account; Greatorex and Despard drew upon both, as they freely acknowledged, for their own project. For *Old New York* they crafted a unique voice, redolent with not only the character of the old places but also the artist's individual experiences of them. This narrative should speak to all New Yorkers. And so it began, with a transatlantic steamer heading into the bay, carrying "strangers" to start their new lives in the city. First-person references were scattered and inconsistent, but the individual stamp of their own lives emerged from time to time, as a way of connecting with the shared experiences of their readers. The book consisted of image and accompanying text that included physical descriptions of the old mansions and churches, breezy historic overviews, and anecdotes blended into an idiosyncratic volume that captured the spirit of the city before progress had taken its toll. "The text will be the work of a writer who has been moved by the like reverence with my own for the beautiful things of the past in this city of our adoption," Greatorex explained in the prospectus, "and the same earnest wish for their preservation from utter oblivion." She was referring, of course, to her sister, who was her frequent companion on sketching expeditions and expositor of their shared passions. The title page credits "M. Despard" as the author of the text, but like so much of their work, it was done in collaboration. It was part history and part romance of the life of the old city.

The artist intended to issue the first and second parts in April and May 1875 respectively, comprised of twelve images: *Off the Battery* (frontispiece), *Castle Garden, Through the Trees, No. 1 Broadway, New York (after Robertson)*,

and *Old Jersey Ferry House* in part one; *Interior Old Tom's, Taking Away St. George, North Dutch Church, St. Paul's in Old Times* (Reproduction from H. Reinagle), *New York City Hospital—Gates*, and *New York City Hospital* in part two. "The entire work," she assured readers, "will be completed by December 15, 1875." But delays inevitably occurred, and an edition of only thirty images appeared in time for the Christmas sales. On December 18, New York's *Evening Post* advertised "the first series is now ready":

> OLD New Yorkers should not fail to examine Mrs. Greatorex's artistic and faithful Pen and Ink Etchings of *Old New York, from the Battery to Bloomingdale*.
>
> This first series is now ready, with 30 Etchings and full descriptive letter press.

Quarto, with plates on India paper, bound in full morocco	$40.00
Quarto, with plates on Plain paper, bound in full morocco	$30.00
Quarto, with plates on Plain paper, bound in half morocco	$22.50

> G. P. Putnam's Sons,
> 4th Ave and 23rd St., and 1155 Broadway, near 27th St.[65]

Missed deadlines aside, the early reviews boded well. *Publisher's Weekly* declared: "The finest art book of the year will be the bound volume of Mrs. Greatorex's etchings of *Old New York: From the Battery to Bloomingdale*, 5 parts together, with 30 etchings, $25 to $50."[66]

Behind the scenes, Greatorex had been struggling with the image reproductions, a problem that had dogged her from the outset of her publishing efforts. She had begun the project working with George G. Rockwood, a technician much in demand in New York for his Rockwood Photo-Engraving Process. But as her project proceeded, Boston publisher James R. Osgood acquired the rights to Rockwood's process. She got entangled in a legal battle over the transfer, which slowed down work on her book. Although contracts between artists and publishers rarely survive, in this case a copy of her agreement with Osgood dated May 20, 1875, has been located and reveals that she achieved an arrangement which met her satisfaction. The schedule of the reproductive work, to be done under the supervision of Henry Thatcher, was the first order of business. "The said Mrs. Greatorex agrees to furnish eighty drawings to be reproduced by said process," the

contract read, "said drawings to be placed in the hands of said Henry Thatcher at the rate of eight per month from the date hereof until finished." The remainder of the document spelled out amount and method of payment, mode of delivery, and even the weight and quality of paper to be used. She ordered "five hundred impressions of each" drawing, an indication of her high hopes for sales.

Painfully aware that the city's architecture had been disappearing long before her arrival on the scene, Greatorex sought to supplement her drawings of the 1860s and 1870s with depictions of the city as it appeared in the late eighteenth and early nineteenth centuries. She made copies after Archibald Robertson and others, both from her own collection and those of her friend the "learned antiquarian" Thomas Addis Emmet, as she explained: "Possessing many of Robertson's views of New York in its earliest days, and, by courtesy of a learned antiquarian, having access to many old and rare etchings of the city and vicinity, I shall have the pleasure of including in each number of my work a reproduction of mine of these."[67] Robertson was a Scottish artist who had arrived in New York in 1791 and founded one of the first important art schools in America. Her copies after his pictures constituted an homage to the historical importance of his work, which she also organized for display at the Centennial Exposition.

The title page to *Old New York* reads: "The Etchings are produced by H. Thatcher from the Original Pen-Drawings of the Artist." The term *etching*, however, was loosely applied to a variety of printmaking techniques. "The process by which they are reproduced," Eliza boasted in her prospectus, "excels the finest work of European Heliotype." The heliotype is a variant of the albertype, which was invented in Munich in 1868 by Joseph Albert. It employed a glass plate as the base for a sensitized gelatin emulsion that would harden after exposure to a negative and could retain a greasy printing ink, so that the images could be printed directly on it. It failed to achieve widespread commercial application, however, chiefly because it remained as expensive as using original photographs. The heliotype provided an alternative, which required the operator to strip the hardened gelatin matrix from the glass support (used in the albertype), expose it under a reversed negative, and transfer the resulting film to a stronger metallic support for inking and printing. The Boston publisher James R. Osgood had acquired the exclusive American rights to the heliotype process in 1872, hoping to

attract projects for both scientific and other forms of graphic art. The heliotype would be cheaper than the originals, and more permanent than a photographic copy, for "the ordinary photograph is produced in evanescent materials, and will fade: the Heliotype is printed with permanent ink, and can never fade."[68] The brick-and-mortar buildings were razed, but their memory had been preserved for posterity in Greatorex's *Old New York*.

MEMORY PANELS

"The demolition of old buildings, which is now going on, should excite more than usual interest in the work of Mrs. Greatorex," one reviewer observed in June of 1875, as another installment of her book was ready for sale. He further predicted that the loss of one particular edifice would turn the tide of public opinion: "The pulling down of the North Dutch Church in Fulton street is an event which may well turn the attention of busy New Yorkers to the neglected antiquities of their city."[69] The artist had first drawn the façade of the North Dutch Church in July 1868 "from a window corner of Anne and William Streets," according to her inscription. She had featured it as one of five churches in her 1869 publication *Relics of Manhattan* and inserted it in *Old New York* with an accompanying narrative outlining its historic importance and the changes it had undergone over time. Designed by Andrew Breested Jr. in 1767 and dedicated in 1769, it was one of the oldest churches still standing in the city. During the Revolutionary War the British occupied it and stripped it of its original pews and pulpits. In 1820 an elaborate steeple was added, and in 1842 the interior was remodeled, but by 1866 the church council formed a plan to demolish the building. It must have been this act that spurred Greatorex to draw the building initially, part protest and part documentation. The council delayed action on its decision, but in 1869 the tower and steeple burned, sealing the fate of the church. It was completely demolished in 1875, when the reviewer noted it. Other artists had delineated the storied structure. Edward Lamson Henry painted his scene (fig. 7.8) in 1869, probably to mark the church's dedication that was celebrated on May 25. Since the tower and steeple had been consumed by fire by then, he probably based his picture on a photograph or an engraving in *Valentine's Manual* (1855). Compared to Greatorex's handling of the church form shrouded in vegetation, Henry creates a lively scene with vendors selling their wares and carriages and streetcars nearby.[70]

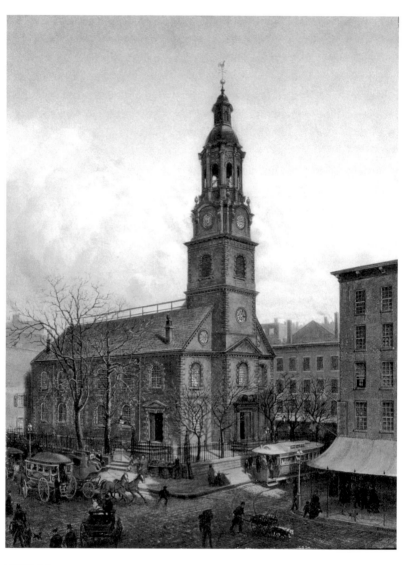

FIGURE 7.8

Edward Lamson Henry, *The North Dutch Church, Fulton and William Streets, New York*, 1869. Oil on academy board, 18 × 14 in. Bequest of Maria DeWitt Jesup, from the collection of her husband, Morris K. Jesup, 1914, Metropolitan Museum of Art.

This multipronged pictorial documentation of drawing, photograph, and print, however, still did not satisfy Greatorex, who determined to make one final, grand effort to commemorate the church. She, her sister, and daughters had made a practice of taking a wood panel, piece of ecclesiastical furniture, or other memento from the sites of demolition and displaying it in their studio. In this Centennial year, she conceived the idea to create what I call a memory panel to preserve a likeness of the church by executing a major painting on a panel that she had removed from the building's site. These memory panels constituted a distinctive homage to a site of sacred importance, and were intended to rouse busy New Yorkers from their historical amnesia and to protest the loss of a precious architectural heritage.

This proposed process presented technical difficulties for the artist, as aged wood panels used for building construction did not necessarily provide the ideal surface for oil painting. Greatorex tried one solution in one of her paintings of domestic architecture, *The Louis Philippe House in Bloomingdale* (see fig. 7.6), where she painted the house and landscape on canvas and then mounted it on a panel removed from the building. The results, however, were not completely satisfactory, as the canvas buckled and refused to lie down flat on the wood. Although a step in the right direction, it did not achieve the effect she desired of a unique memento. The Old North Church, however, triggered a fresh approach (fig. 7.9). Working with a panel from the church's pulpit, she used sepia-toned paint to create the portrait of the church itself in the composition's center. The church reflects the glowing light of a sunset, an effect further enhanced by the raised gold border surrounding the image directly and the broader gold frame surrounding it all. In the tradition of a medieval manuscript or an altarpiece, two text panels flank the image at top and bottom. Below, a larger script identifies the subject: "The Old North Dutch Church / The Fulton Street Meeting House." Above, in old-fashioned script, there appear three related texts separated by a scrolled cartouche. At the top left side of the painting, it reads: "The corner stone of the church was laid by Isaack Roosevelt July 2, 1767 and on the 25th of May 1769 Dr. Laidlie preached the dedication sermon." At top right of the painting is inscribed: "During the Revolution the church was used by the British as a prison, hospital, and storehouse." She signed and dated it "Eliza Greatorex, 1876," but like most of her work she was assisted by her daughters Kathleen and especially Eleanor, who

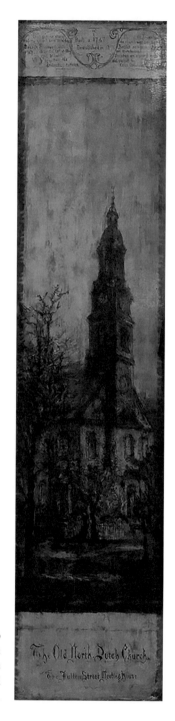

FIGURE 7.9
Eliza Greatorex with Eleanor and Kathleen Greatorex, *The Old North
Dutch Church, the Fulton Street Meeting House,* 1876. Oil in sepia tones
on panel from the pulpit of North Dutch Church, 42 × 13 in. Ronald
Berg Collection. Photograph by Beat Keerl.

sometimes did the lettering and other decorative motifs on her mother's projects. Measuring 42 × 13 in., it was one of her largest works, and meant to attract public attention beyond what a drawing or print could do. Scale and the simple text at the top center, which baldly states "Built in 1767. Demolished in 1875," were meant to work in tandem to generate enormous outrage.

8

CENTENNIAL WOMEN, 1876–1878

THE WOMEN'S PAVILION

During this Centennial year, the emphasis was on founding fathers and great men. In the frenzy to recover the past and celebrate the future, women were largely overlooked. Yet growing numbers of women saw an opportunity to make a stand in Philadelphia. Originally the Centennial Board was made up exclusively of men, but by February 1873—after a year of work—the board was short of its goals. In need of help with fund-raising, they instituted a Women's Centennial Committee to which they appointed thirteen women, one for each of the original colonies. Elizabeth Duane Gillespie, great granddaughter of Benjamin Franklin, was invited to head the committee on the basis of her proven abilities with the Sanitary Fair during the Civil War. She accepted the appointment on the condition that there would be a display of women's work in the main exhibition hall. They were promised "ample space." By the end of 1874 she had set up a Centennial committee in every state that sold stock subscriptions and Martha Washington medals and held Centennial teas to raise money for the exhibition. She presented the proceeds of their work, an impressive $90,000. Then she was informed that there was no space after all for the women's exhibit.

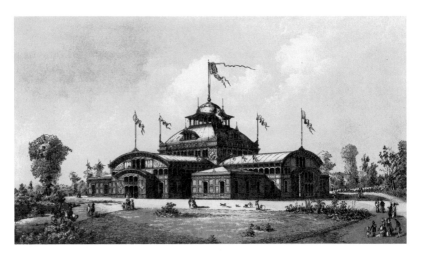

Elizabeth Gillespie confessed that she never forgot "the utter misery of those first moments, for the women of the whole country were working not only from patriotic motives but with the hope that through the Exhibition their own abilities would be recognized and their works carried beyond needle and thread."[1] She resolved then to construct a building of their own for the exclusive display of women's work, even though they had to begin planning and fund-raising from scratch. Against all odds, it was erected in eleven months. First Lady Julia Grant and Empress of Brazil Tereza Cristina Maria de Bourbon opened it to the public on May 10, just after the general opening of the fair. It made the Philadelphia exposition the first to showcase explicitly women's accomplishments.

"We never thought of employing a woman architect," Gillespie later admitted, "and thus made our first *great* mistake."[2] German-born Hermann J. Schwarzmann was only twenty-seven years old and relatively untested when he was chosen to design over thirty of the fair's buildings. Eventually he was also asked to construct the Women's Pavilion, which consisted of a wooden building, 90 feet high to the cupola. It took the form of a Greek cross with wings extended outwards on the four sides, surmounted by arched roofs (fig. 8.1). Painted pale blue-grey with many of the windows framed in elaborate gingerbread trim, it enclosed forty thousand square feet

and housed six hundred exhibits plus a library and kindergarten annex. The first sight that greeted the visitor inside the doors was a woman running a steam engine: symbol of the opportunities opening up for women in modern life. Dressed in formal attire, Emma Allison kept the engine running smoothly and, when queried about her safety, replied that this was far less fatiguing and dangerous than working over a kitchen stove.[3] The engine powered equipment in the pavilion including the Hoe printing press that produced the periodical *The New Century for Woman*.[4] Over the door was a modest sign, "Women's Department." Panels on either side welcomed visitors in six languages with the pavilion's motto: "Her Works Do Praise Her in the Gates," from the thirty-first Proverb.

With women's rights one of the most hotly contested issues of the hour, Gillespie and her committee had to tread carefully. In the nineteenth century many idealists purposefully referred to it as "the woman movement." The use of the singular *woman*—while ungrammatical to the modern ear—symbolized the unity of the female sex and "proposed that all women have one cause, one movement," as Nancy Cott points out.[5] But as the practical Gillespie knew, it was more accurate to refer to women's movements in the plural, given the enormous diversity and discontinuity in the political activities encompassed by the term. Pavilion organizers had to negotiate among these various factions. Gillespie and her coworkers deliberately distanced themselves from what was considered the movement's most radical element led by Susan B. Anthony, who repudiated the pavilion because it failed to address issues of wages and working conditions. But they also wanted to be distinguished from the opposing, antisuffrage faction.

"Let every woman in the country who has made anything, or who can make anything worth exhibiting as a credit to womanhood, send it forward in demonstration of womanly capacity outside the nursery," Rev. Antoinette Brown Blackwell proclaimed. Heeding her call, women worldwide submitted a panorama of objects ranging from needlework and household items to the latest inventions, especially labor-saving devices. Dress reformers caught the attention of visitors with displays that dramatized the harmful effects of restrictive women's undergarments and heavy dresses. A *Statue of Iolanthe* carved in butter by the so-called "Butter Woman" created a minor sensation. To supplement the open-door display, organizers invited representation from the nation's growing number of professional women artists.[6]

A few years earlier sculptor Vinnie Ream had stirred controversy as a young woman awarded the commission for the Lincoln statue in the Capitol. Now she rejected what she regarded as the segregated realm of the Women's Pavilion and competed against the men to show in the sprawling Fine Arts Department in Memorial Hall. In 1873 Gillespie had invited sculptor Harriet Hosmer to create a new work: "I am anxious that in the Fair women shall show that they are behind the stronger sex in *nothing*," and "you stand *first* in your art." She had enjoyed the support of actress Charlotte Cushman and her circle of female sculptors in Rome and enthusiastically promised to show her work exclusively in the Women's Pavilion. Securing her participation was a significant coup, for her statues of *Beatrice Cenci*, *Zenobia in Chains*, and *Thomas Hart Benton* had earned her the title of "most famous of American woman sculptors."[7] In 1859 Elizabeth Ellet, in her book *Women Artists of All Ages and Countries*, held Hosmer up as an exemplar, whose brilliant success offered a lesson for all American women artists. As a young woman from Watertown, Massachusetts, she had pursued her career goals single-mindedly to win fame in art. Her "industry" and "perseverance," according to Ellet, had made her genius flower.[8] She had also mastered management of her press notices, which insured good publicity for her work at the fair.[9]

As art works began to arrive in Philadelphia, the women realized that the architect failed to include a proper space for their display. "'The Art Gallery in the Woman's Pavilion?' said a visitor the other day, 'there is no such thing! There are alcoves to hang pictures in, but you do not call those murderous cross lights, a gallery, in any sense.'" "The Art Gallery in the Woman's Building was an after thought," Eleanor Greatorex wrote regretfully. "The spirit which has induced so many women to send their pictures to these 'alcoves' as an exhibition of the progress reached thus far, is deserving of high praise." She cautioned that "in looking upon the 'oils,' so severely tested here, one must remember the disadvantage of light and position, in praising the good ones and passing by the bad." Even popular pictures by male artists would have been seen at a disadvantage under such conditions: "Take the Leightons and Boughtons from Memorial Hall and hang them here, and see how they would be slaughtered!"[10]

Many artworks won their advocates in spite of gallery limitations. "First among the good pictures that defy even the cross-lights, is a charming

picture by the Italian artist Leopoldina Borrino [i.e., Leopoldina Zanetti Borzino]; a church interior, wherein a group of women and children are at prayers or vespers." Once a member of Margaret Fuller's circle in Boston, Sarah Freeman Clarke had gone on a sketching tour of Egypt, and "from her studio in Rome, sends a powerful picture of the *Temple of Esneh* on the Nile."[11] Along with painting and sculpture, women's contributions ran the gamut from furniture, weaving, laundry, appliances, and embroidery to photography, and prints.[12] Some dismissed the presentation as eclectic, objecting to its lumping together of fine arts, industrial arts, and handicrafts and the interspersing of the work of amateurs and professionals.[13] But others found it stimulating. Candace Wheeler's vocation as America's first woman textile and interior designer was born here. She was forty-nine years old when she visited the fair, a wife, mother, and amateur flower painter. In her memoir she later recalled that the exhibition of embroideries made at London's Royal School of Needlework literally changed her life.[14] Inspired by the school's objective to teach women to create professional-quality needlework as a means of financial support, she returned home in 1877 to found the Society of Decorative Arts, which had a parallel aim in the applied arts. The next year she helped launch the NY Exchange for Women's Work, where they could sell any homemade goods. She became a partner of Louis Comfort Tiffany before she formed her own textile firm.[15]

Having seized the opportunity to display their work before a vast public, these women hoped to capitalize on their momentum and planned follow-up events.[16] "Time went on and in every detail of our work we were prosperous and even at this late hour we are told that through the efforts made by women in 1876," Gillespie recalled in her memoirs, "the women of 1899 are prospering through avenues of labor unknown then to them."[17] Many agreed that it was a milestone in their struggle to achieve visibility in American cultural life.[18] Its conjoining of professional and amateur women and of high and low art, however, implicitly equated the work of all women on the basis of gender alone. Their attainment was a two-edged sword: a measure of their advancement and a reminder of their still separate status. Gillespie's role in organizing this first exposition building planned, funded, managed entirely by women—a model for its successor at Chicago in 1893—has been documented. But Greatorex's efforts to insert fine art into Fairmount Park's Women's Pavilion have been until now obscured.

WOMEN'S ART AT THE EXPOSITION

In 1876 journalist Lucy Lee Holbrook described Eliza Greatorex as "a sweet faced woman of between 50 and 60 years of age, with hair white and curling loosely about her head, slender form and thoughtful earnest manner."[19] A wood engraving from the popular press around 1876 (fig. 8.2) suggests that she had not changed much since she sat for her diploma portrait upon her election to the National Academy of Design seven years earlier. By the opening of the Centennial exposition on the grounds of Fairmount Park in May 1876, friends must have detected an expression of relief mixed with pride on her face. She had spearheaded a committee that worked tirelessly to ensure representation of women artists at the exposition, and after months of what began to look like futile efforts it finally bore fruit. As planning for the Women's Pavilion proceeded on the city and state levels, she marshaled New York women to action, urging them to submit artwork so that they would have a presence at the Centennial. She published a "Call for United Effort," and invited "all the working women artists of New York, Brooklyn, and the surrounding cities" to meet at her East Twenty-Third Street studio. A large group met there on March 14, 1876, mobilized with the help of the landscapist Julia Hart Beers and Mrs. Gray, wife of figure painter and former academy president Henry Peters Gray.[20] To finance their efforts, they then organized a fund-raising exhibition at the only female-owned gallery in the city, the Sallie Gibbons Gallery.[21] With the collaboration of the Ladies Art Association, they strove to make it an all-female effort.

"Mrs. Greatorex . . . appealed to her sister artists to assert their independence and to organize an exhibition of the works which would be creditable to them as a body," a last-minute plea read. "A committee, consisting of Mrs. Eliza Greatorex, Mrs. Richmond Phillips and Miss Mary Cook, was appointed to co-operate with the New York State Centennial Art Committee in making arrangements for the display." Glancing around the Women's Pavilion one could see the work of Alice Donlevy, founder of the Ladies Art Association; Fidelia Bridges, specialist in birds and flowers; and many other familiar colleagues. It was true that a superficial survey would seem to support the stereotypes of feminine art: watercolors were far more numerous than oils, and depictions of children and flowers carried the day.[22] But closer scrutiny revealed that many of them, including a still life by Kathleen Greatorex, evidenced a sophisticated handling of materials and a modern, decorative aesthetic. The time and energy she devoted to this cause paid off, and

MRS. ELIZA GREATOREX.
[DRAWN FOR THE ILLUSTRATED WEEKLY FROM A PHOTOGRAPH.]

FIGURE 8.2
William Steinhaus, *Eliza Greatorex*, "Drawn from the *Illustrated Weekly* from a Photograph," ca. 1876. Wood engraving, signed on the block. Courtesy American Antiquarian Society, Worcester, MA.

the New York women enjoyed a significant presence in the art exhibition thanks to her efforts.

The official art exhibition was organized in Memorial Hall, where Greatorex "with but few sketches sustains the position always granted by her brother artists."[23] The pen-and-ink drawing titled *The North Dutch Church (Fulton Street)* now in the collection of the Museum of the City of New York still bears the sticker on the back that reads "Art Dept. International Exhibition. From New York State Centennial Board," documenting that it hung there.[24] She held her own in that company. "But," as Eleanor Greatorex explained, her mother demonstrated solidarity with her gender: "Her best work is to be found in the Woman's Building, side by side with the work of young beginners, the contrast but showing endeavor and attainment."[25]

Displays were nonhierarchical, with domestic objects adjacent to works by professional female artists from around the globe. Greatorex commanded an alcove, featured in an engraving in the popular press (fig. 8.3). This was a rare opportunity when she was able to stage her oeuvre as a totality of related images and objects. Hudson River landscapes could be seen

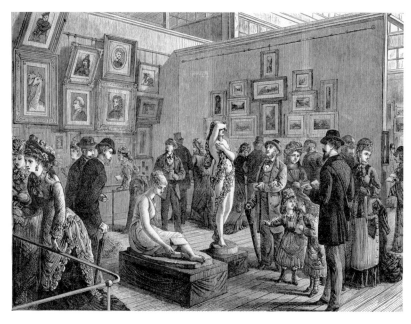

FIGURE 8.3

"Philadelphia, PA—The Centennial Exposition—The Art Department in the Women's Pavilion—From Sketches by Our Special Artist. 1. Crayon Drawings. 2. Statuary. 3. Mrs. Greatorex's Pen and Ink Drawings." From *Frank Leslie's Illustrated Newspaper*, November 25, 1876, 201.

along with the Bavarian studies featured in her first book, *The Homes of Oberammergau* (1872), and the pen-and-ink drawings from Colorado. The star of her display, however, was her pictorial inventory of Manhattan's disappearing buildings that were assembled in her folio volume *Old New York, from the Battery to Bloomingdale* (1875). Emphasizing the integrated character of her projects, she installed the original drawings in proximity to the books and portfolios in which they were published.[26] The ensemble included a group of oil paintings—*The Old Porch*, *The Old Bloomingdale Church*, and *Somerindyke House*—created especially for the Centennial on panels she had removed from the demolition sites.[27] To complement the central image of the building, Eleanor Greatorex decorated the borders and inscribed information about the history of the buildings in the manner of medieval manuscript illumination. This treatment highlighted their standing as architectural relics, the last remaining links to the historic New Amsterdam now replaced by the modern city. Nearby, Greatorex sponsored an exhibi-

tion of Archibald Robertson's late-eighteenth-century drawings of long-lost structures. A Scottish-born emigre to New York, he had started one of the city's first art academies.[28] Establishing a link between them, she helped construct a distinguished lineage for this brand of art.

This alcove embodied her *Gesamtkunstwerk*, the German term for "total work of art," particularly associated with Richard Wagner's aesthetic ideals. It embodied the Romantic ideal, the summation of the arts unified under one theme: here, the attempt to recapture a lost past. Her assembly of these elements—pen-and-ink drawings, landscape paintings, memory panels, books, and a sampling of Roberston's antiquarian drawings—was a pioneering effort that captured the attention of the press.

The mother's work was buttressed by that of her two daughters: a tour de force of artistic energies unusual within a single family. Kathleen Greatorex's large panels of *Corn* and *Thistle* were harbingers of the decorative work that would flourish in the 1880s and 1890s. Adopting the role of historian, Eleanor Greatorex observed all that she could pertaining to women artists and authored a series of articles in *The New Century for Woman*, the only journal continuously published on the fairgrounds. Her articles on the women artists of Britain, Sweden, and the Netherlands echoed the focus of the Women's Pavilion, which highlighted international over American female achievements. Her articles constitute one of the most detailed records of women's art represented in Philadelphia.

DECLARATION OF RIGHTS OF THE WOMEN OF THE UNITED STATES, JULY 4, 1876

The Fourth of July celebration was the crescendo of the Philadelphia Exposition, marking the one hundredth birthday of the nation. According to the Philadelphia press, "the programme of exercises to-day is, without doubt, a more varied one than any ever before carried out in any American city on a single day." There was a military parade, and there were exercises in Independence Square, the dedication of the Catholic Temperance Centennial Fountain, and the unveiling of the statue of Alexander von Humboldt, topped off by fireworks at 8 p.m.[29] Susan B. Anthony, accompanied by Matilda Joslyn Gage and other suffragists, intended to read *A Declaration of Rights of the Women of the United States* into the record at the official ceremony, but they were denied permission to do so. Unwilling to be defeated, Anthony and her colleagues planned an alternate strategy. After the

Declaration of Independence had been read from the speaker's platform, they marched down the aisle and presented a copy of their declaration to acting Vice President Thomas W. Ferry, who was there in President Grant's absence. They then returned to their seats, distributing broadsides and soliciting supporting signatures. Following this event, Anthony headed for Independence Hall in the old city, where a crowd had gathered to hear her articulate their request for just entitlements: trial by a jury of one's peers (meaning women), no taxation without representation, and the removal of the word *male* in state constitutions. "We ask of our rulers, at this hour, no special favors, no special privileges, no special legislation," she concluded. "We ask justice, we ask equality, we ask that all civil and political rights that belong to citizens of the United States, be guaranteed to us and our daughters forever."[30]

The struggle for change by Anthony, Greatorex, and many Euro-American women and men of the middle and upper class was tied to Protestantism. Unlike the Gilded Age reformers of the 1880s and 1890s who signed petitions and engaged lobbyists, the earlier generation were activists. Rev. Sampson's benediction on the fair's opening day had singled out "the women of America, who for the first time in the history of our race take so conspicuous a place in a national celebration." He entreated the crowds to pray that "the light of their intelligence, purity, and enterprise shed its beams afar, until in distant lands their sisters may realize the beauty and glory of Christian freedom and elevation."[31] Arguing that the claim "all men are created equal" must be extended to the legal rights of women, Sampson's certainly would have encouraged the females in the audience, if they could have heard them over the noise of the crowds that day.

As a busy working artist with children to support, Greatorex had limited time for social activism but wielded her professional status to gain visibility for the women's movement. She counted Anthony among her personal friends and attended her fiftieth birthday celebration in 1870, when she presented her with one of her drawings as a gift. January 1873 saw her working as a member of the committee organizing a reception for Emily Faithfull. Seated with the platform party while the renowned English women's rights activist spoke at New York's Steinway Hall on "Women Being Self-Sufficient for Their Own Support," Greatorex was held up as a model for a professional woman achieving success in the cultural realm.[32] Her honorary membership in the Ladies Art Association and close relationship with *Harp-*

er's Bazar editor Mary Louise Booth further reinforced her protofeminist mindset. There is every likelihood that Greatorex and her daughters cheered Anthony's efforts at the fair.

Beginning with the Seneca Falls Convention that launched the American women's movement in 1848, women conjoined their own battle for equal rights with black emancipation and then the Civil War efforts. They had worked hard for the abolitionist movement, which in turn had fueled their own feminist ambitions. Following emancipation and the war's end, with Congress controlled by the Radical Republicans and talk of equality and natural rights ruling the day, serious social change looked possible. Suffragists Susan B. Anthony and Elizabeth Cady Stanton, writers Helen Hunt Jackson and Charlotte Perkins Gilman, and visual artists Mary Hallock Foote and Eliza Greatorex were justifiably expectant that their time had come. Then in May 1870 the Fifteenth Amendment to the Constitution was ratified and enacted, and although praised for equal suffrage, was hardly so. Women were excluded entirely from the right to vote. Promises had been broken, and the women had been sold down the river.

Native Americans were simultaneously misled and mistreated. The precise moment the women were reeling from failed legislation marked a nadir in the history of most western Native Americans. In 1866 Indians were excluded from the category of "citizens" and "voters" defined by the Constitution as male, and many, even after passage of the Citizenship Act of 1924, had to wait until after World War II for suffrage rights to become a reality. Throughout the late nineteenth century, the US government broke treaty after treaty with native tribes and undertook their wholesale removal onto reservations. Land bases were decimated, and dependence on government payments and ration systems was encouraged. Even as fair visitors feted one hundred years of independence, the US Army was waging war with the Indians in the West. Just as the Independence Day celebrations were winding down, the *New York Times* ran an article on July 6 titled "Massacre of Our Troops," which reported on the battle between George Armstrong Custer's Seventh Cavalry and the Sioux Indians on a remote hillside near the Little Bighorn River. The Northern Cheyenne warrior credited with unhorsing Custer during the fight was a woman.[33] When the early pioneers of the women's movement gathered in 1848 in Seneca Falls, they were affirming their debt to the model provided by the Senecas' matriarchal form of governance, in which rights are passed through the women in the family, headed

by a clan mother. These ideas, which fed into the 1848 convention's *Declaration of Sentiments*, were still vital to the women of 1876, when—as a *Puck* cartoon lampooned—feminist liberties enjoyed by the "savages" were denied by "civilization."

SOUVENIR OF 1876

After organizing the women's art display and shepherding *Old New York* into print, Greatorex must have suffered the artistic equivalent of postpartum depression. Once the exposition opened, she found herself idle. To capitalize on what she recognized as the visitors' demand for inexpensive mementoes, she conceived of seven prints depicting national historic sites to be sold as an ensemble titled *Souvenir of 1876*.[34]

During the one hundredth anniversary of American independence, the founding fathers were much celebrated, and none more than George Washington. Books were written about him, poems recited, and songs sung. Statues abounded, including a marble rendering of him perched upon a soaring eagle. The clothes of the Father of His Country, displayed with a placard that read "Coat, Vest, and Pants of George Washington," attracted crowds that recalled those venerating the relics of a saint. Many travelers had visited Washington, DC, on their way to or from Philadelphia. President Grant called them "Centennial pilgrims" and grumbled about the tradition that required him to shake hands with every visitor who requested to meet him.[35] No place had closer associations with the first president than Mount Vernon, his plantation home. It had been acquired in 1859 by the Mount Vernon Ladies Association, which was restoring it and establishing it as a tourist destination via a boat trip up the Potomac from the capital city. Eliza and Eleanor Greatorex took that crowded boat and began to survey the house and grounds for their pictorial vantage point. Like many artists before and after her, the elder Greatorex stood some distance from and at an angle to the house so that the portico seemed longer and grander than it was, and the cupola higher. Foregoing her usual strategy of half-obscuring the building with a profusion of foliage, she opted for a clear view of the home with the trees pushed further to the right (fig. 8.4). Amidst this Washington-mania, such pictures of his home at Mount Vernon became a staple, but Greatorex would frame it with a new perspective.

"As guests of Mt. Vernon we entered with the crowd from the boat," her daughter recalled, but then an extraordinary thing happened "when they

departed, leaving us in the old house, to wander at will through the haunted rooms, or sit beneath the ancient trees on the broad lawn, to live over for the moment the olden time, and people our surroundings with spirits of the past." The unprecedented opportunity to have Mount Vernon to themselves was facilitated by family friend and patron Martha Mitchell. The Mount Vernon Ladies Association that raised money to save the old homestead was made up of regents and vice regents, one from each state, each of whom was responsible for the restoration of a particular room in the house or section of the grounds. As the regent from Wisconsin, Martha Mitchell had overseen the care and furnishing of Martha Washington's bedroom. To counterbalance the widespread emphasis on the founding fathers, the Greatorex women charted their personal pilgrimage in search of Martha Washington's presence at Mount Vernon. Her daughter sketched a variety of scenes, including

Stair-case & Hall Leading to Martha Washington's Room: "At the top of the house a small winding staircase leads to the door of the room Martha died in—directly above that of her husband, which by old Virginia etiquette was closed for two years of deep mourning." She also rendered *The Room in Which Martha Washington Died*, showing the chamber the widow had selected for its view of her husband's tomb. "Musing on her life and death," Eleanor Greatorex wrote, "I slept for the night in her room, the moonlight streaming into the outside hall, and but poorly kept out by the bed-room curtains." This close proximity stirred her admiration: "Though her ghost did not come to me from the sepulcher, her home-life and surroundings were very forcibly brought to me, for what she had done, she had done with all her might."[36] She arranged her ensemble of nine vignettes for the cover of her mother's portfolio (fig. 8.5) announcing its intent to highlight the First Lady and the President.[37]

Mount Vernon was standing thanks to a major national campaign that drew upon the generosity of thousands. But women led this band of

curators of the relics of the American past, spearheaded by Pamela Cunningham of South Carolina, whose pen helped awaken an interest in its rescue, signing her name "the Southern Matron." In the days before the preservation movement established guidelines, Cunningham possessed an intuitive sense of what needed to be done and how to achieve it. "Ladies, the home of Washington is in your charge," she told the association in her farewell address. "See to it that you keep it the home of Washington. Let no irreverent hand change it, no vandal hands desecrate it with the fingers of progress!" Her parting words resonated with the artists: "Those who go to the Home in which he lived and died wish to see in what he lived and died. Let one spot in this grand country of ours be saved from 'change'!"[38]

Along with the canonical view of Mount Vernon, with its columned portico perched on a rise of land, Eliza Greatorex made an additional three drawings in the federal city: *Arlington Heights, Near Washington*; *Christ Church, Alexandria*, where the first president was a regular worshipper; and *The House of Davie Burns, Goose Creek, foot of Seventeenth St., Washington*, where—as she explained in the prospectus—Washington had made "the purchase of a large portion of the land now occupied by the National Capital." She supplemented these with two drawings of hallowed sites in Philadelphia: *Through the Trees of Independence Square*, which "gives us a sunshiny glimpse of the old hall"; and *Old Swedes Church*, "that even Philadelphians need to be reminded of, is here with its clustering graves." Adding a rendering of the Ole Witch House in Salem, Massachusetts (fig. 8.6), they were reproduced and ready.[39] "The Souvenir," the press reported in September, "is for sale at the cheap price of $3. Mrs. Caldwell, the commissionaire of the Woman's Building, . . . will be happy to show it to all who are interested in these quaint bits from the vanishing past."[40] Beyond the fairgrounds, it was available at a shop in Washington, DC, where a journalist dubbed it "a timely gem" and advised readers that "the work may be inspected at Barlow's, where subscriptions are also received."[41] Newspapers as far as Colorado announced its publication.[42] "They exhibit boldness and freedom of touch," wrote another, crediting her with stylistic traits usually identified as male: "We are glad to see in a lady's work the preference of character and strength to prettiness and pettiness." *Souvenir of 1876* fared well with critics, who pronounced it "quite unique in its get-up." [43]

The *Visitors Guide to Mount Vernon* (1876) identified among its chief sources of revenue: entrance fees to the home, fares paid for the boat ride,

FIGURE 8.6

Eliza Greatorex, *The Old Witch House, Salem*, from *Souvenir of 1876*. Photomechanical print after drawing. Private collection.

sale of the Visitor's Guide, copies of the "Will of Washington," and the photographic views of *Mount Vernon Sketches* by Mrs. Greatorex she had donated.[44] When the artist depicted the disappearing landmarks of old New York, she could hardly have cherished any illusions that she could halt the real estate development and commerce transforming the city. But here on the banks of the Potomac a portfolio of her drawings had contributed to the preservation of one significant national monument. She had achieved this acting in unison with her daughter through the spirit of Martha Custis Washington.

RESUMING NEW YORK LIFE

By the time Fairmount Park's fairgrounds closed permanently on November 10, the Greatorex sisters had returned home to New York City, where they rented a quaint old building on East Seventeenth Street to set up their combination work and living space. "Between Union Square and Fifth Avenue, within the shadow of Tiffany's famous establishment, we find a grand square old mansion of the past generation, with a wide hall running through

the center of the house," Fuller-Walker explained. In what was once a private domicile, the Young Men's Christian Association occupied the downstairs while the Greatorex trio occupied the top floor.[45] "Ascending the broad staircase, at the head of which there is a pretty stained-glass window, we enter the studio, a fine square room, with a subdued northern light," he continued. "Hanging over the fire-place, opposite the door, is a large and excellent portrait of Mrs. Greatorex by Tobey Rosenthal, in Munich. The walls of the room are thickly crowded with pictures and panels painted by Mrs. Greatorex and her two daughters." The young women "spent the past summer in studying the flora of America, and have secured many beautiful designs for panels and general decorative purposes. Some of them are painted on [dark?] colored woods, obtained from old churches which are constantly being demolished in the progressive city of New York." He also noted, "One of the most recent pictures painted by Mrs. Greatorex is the quaint old mansion, with overhanging roof, at Bloomingdale, occupied once by Louis Philippe, afterward King of France but only a poor school teacher when a resident of New York."[46]

After all the hustle and bustle of the fair, the matriarch struck out on her own and by All Saints Day—November 1, 1876—she was occupying a temporary studio near Bay Ridge on the Narrows, a tidal straight separating Brooklyn from Staten Island. This South Brooklyn neighborhood was one of the last surviving pockets of agrarian life and Dutch flavor in the orbit of the metropolis and provided a welcome retreat. Accessible from downtown Manhattan by a network of ferries and streetcars—before the Brooklyn Bridge was completed in 1883—it attracted urbanites, whose summer homes and upscale boarding houses lined its avenues. Arriving in the late fall, she occupied several rooms in what was described as an Italianate villa overlooking the water. Shifting gears, she set aside the pen and ink she had been using predominantly for the past seven years, picked up her brushes, and began to work again with paint and color. After all her close linear work in black and white, it would have been a welcome relief to spread strokes of pigment across a broad expanse of canvas. With her daughters set up in a new workspace at the YMCA near Union Square, their mother was enjoying the infrequent luxury of solitude in this country retreat.[47]

With a horse and carriage at her disposal, she took rides into the surrounding countryside including the nearby town of New Utrecht. It was one of the prettiest and most popular towns in the area, with its vestiges of

Dutch architecture in the churches and houses that survived in some form from its settlement in the seventeenth century. The Van Pelt mansion was still standing, albeit with many changes and additions: the kind of place that would have been torn down had it been in Manhattan. At the fruit and vegetable market people could purchase cauliflower and peas fresh off the vine, before they made their way to city tables. Visitors often remarked that it was reminiscent of Holland, where she had traveled a few years before, including a stop in Amsterdam. Here the activities of the boats on the canals and the distinctive shape of the old houses that lined them transported the visitor back in time. The site stood in stark contrast to the modernization going on across the country, mirrored in the recent displays in Fairmount Park: the Corliss engine, the Hoe printing press, and all the other mechanical wonders celebrating American progress. The mood of this place was calm and palliative, reminiscent of the old-world charm of northern Europe.

Martha Mitchell had commissioned four views of Amsterdam for her house in Milwaukee. Having been immersed for so long drawing in pen and ink on the streets of New York, Greatorex must have been apprehensive about taking up the brush again and delineating a European city she had not seen in some time. Most artists keep close at hand their field sketchbooks and drawings that constitute an inventory of motifs jotted down during their travels for future elaboration. Ready to resume painting, Greatorex perused her sketches and located those done in Amsterdam that would serve as aide-de-memoire for a large canvas. Following the age-old practices in which she was trained, she would have identified individual motifs and rearranged them into a pleasing composite picture. She then would have traced the outlines of that scene first in pencil, and only after she was satisfied with the overall composition would she have commenced painting. Slowly the topography of Amsterdam's harborside took shape. Her good friend had been right to encourage her to return to painting, for here in this still-preserved area of old Brooklyn she had found the ideal location to summon up her Dutch reminiscences.

Amsterdam (fig. 8.7) is one of the four pictures that emerged from this rare, peaceful interlude in what had evolved into a hectic life on the move.[48] Surely it was a relief to slow down and invite friends to her bucolic hideaway. When the critic Dr. Fuller-Walker paid a visit to her country studio, he praised the Amsterdam pictures, finding her handling of the windmills and

FIGURE 8.7
Eliza Greatorex, *Amsterdam*, 1876. Oil on canvas, 22 × 39 in. Ronald Berg Collection.

quaint vessels that dotted the water most effective. She portrayed her sub-
ject at various times of day from the midday light of *Amsterdam* to a moonlit
view singled out by the critic. By this moment in late 1876 the Impressionist
inclination to paint *en plein air* under diverse atmospheric conditions was
certainly familiar to Greatorex and her patron Mitchell, and though neither
would embrace the new movement with its broken brushstroke and colored
shadows fully, these progressive women certainly found selected aspects of
its approach appealing.

The artist's residence here functioned not only as a mnemonic device,
jogging her memory to relive her time in Holland. It also prompted new
explorations. For "now that she has exhausted most of the subjects that can
be drawn from old New York," as the press reported, "she is turning her at-
tention to the colonial relics and relics of Revolutionary times which are yet
left in Brooklyn."[49] After spending much of the last ten years exploring the
changing environment of Manhattan Island, she found in Brooklyn a less
trodden pictorial field where she created new pictures like *Bayridge* and
Gowanus, named after the ridge or high spine of land stretching from the
Narrows to Greenwood Cemetery and Prospect Park. She also executed a
scene of an American-built fort that had been used by the British during the
Revolutionary War, adjacent to Bay Ridge at the Narrows.[50] Fort Hamilton
remains in active service today. Even so, these efforts represented little

more than variations on a familiar theme, as the journalist implied. What her career really required was a complete change of direction. Her brother Adam once more came to her rescue and proposed a plan for the entire family to collaborate.

ROCK ENON SPRINGS, VIRGINIA

"Mrs. Greatorex . . . accompanied by her two daughters, who are also very clever artists, is in the city, visiting her brother, Mr. A. S. Pratt, on 11th street," a Washington, DC, newspaper read in June 1877: "They will spend a few days in Washington, during which time Mrs. G. will make studies of some of the picturesque houses in and near the city, and afterwards go to Rock Enon Springs, where they will spend the summer."[51] Rock Enon Springs and Baths is among the many mineral springs found throughout the Blue Ridge and Allegheny Mountains, where the plentiful sandstone and limestone leach their minerals into the water.[52] Straddling Virginia and West Virginia, it was dubbed "America's Sanitarium" for its supposed health-giving properties.[53] After the Civil War many Americans sorely needed rest and relaxation, and none more so than the denizens of the hot and unhealthy cities south of the Mason-Dixon line. Rock Enon offered great potential as a spa: with picturesque scenery and numerous sources of bubbling waters that were reported to improve health and vitality, it was bound to attract crowds of visitors. Adam Pratt bought the property in 1872 with several fellow investors, but they subsequently withdrew, and he became sole proprietor of the grand new hotel. Who better to help promote the site as one suitable for families and respectable women than his well-known sisters and nieces? Her brother's new venture allowed Greatorex the opportunity to immerse herself in the beauties of the local scenery that inspired a new suite of work. Among them was *Rock Enon Springs from Sunset Hill* (fig. 8.8), depicting the hotel buildings tucked into the woods, leaving nature to predominate. She deployed a traditional Claudian composition with the central peak called the Pinnacle flanked by trees to convey a picturesque and restful effect appropriate to a health resort. She also produced a set that "consists of about a dozen sketches taken from the best points of view, and makes a very interesting and pretty portfolio," the press extolled. She "has given to the public a very beautiful souvenir of her summer vacation at Rock Enon Springs last season, in the form of a series of etchings illustrating the charms of that place and its romantic surroundings."

FIGURE 8.8

Eliza Greatorex, *Rock Enon Springs from Sunset Hill,* ca. 1877. Oil on canvas, 33½ × 12 in. Ronald Berg Collection. Photograph by Beat Keerl.

"The etchings are accompanied by a couple of pages of text, furnished by her sister, Mrs. Despard," a journalist elaborated, along with a cover "illustrated by one of Mrs. G's daughters, who gives promise of great excellence in the same lines of art which her mother has so adorned and popularized."[54] Text and images appeared in a prospectus alongside train schedules and fees for the facilities: a mix of practical and poetic. "The studies I brought away

from Rock Enon Springs have still the place of honor in my studio, and many of my artist friends have complimented me on them," Greatorex wrote to her brother later that year from France. "Indeed the remembrances of the fresh, unhackneyed scenery, the delightful 'bits' of forest opening, mossy glade, and fern-clad rock have kept their place in my mind uneclipsed by all I have been seeing here." In a bid to attract artists to the area, Adam Pratt inserted her words into his advertisements: "I hope some day to try again the delightful air of Rock Enon—its truly 'home' atmosphere—its care for the more material wants, as well as to bring to the delineation of its superb scenery all the knowledge and skill which I have come abroad to seek."[55] She exhibited the pair of small vertical panels at the National Academy of Design in the spring of 1878: *Rock Enon Springs from Sunset Hill* and *Old Mill—Rock Enon* (fig. 8.9),[56] presenting complementary views with the twilight sky above contrasting with the darkened forms below.

Winslow Homer, Thomas Moran, and Albert Bierstadt all produced art intended to promote travel and tourism.[57] Greatorex, too, undertook her travels to Colorado in 1873 at the instigation of investors who wanted to see the Rocky Mountains become the latest mecca of recreation and healthy living. Her support of her brother's health spa was certainly similarly intended to stimulate visitorship and hence profits. But the Pratt family's Methodist upbringing dictated that a spiritual and moral dimension was fully integrated into their endeavors. Promotional literature emphasized that liquor was forbidden and visitors could find instead a myriad of options for outdoor activity and good, clean living.

Eighteen seventy-seven has been called "America's year of living violently."[58] But out of conflict and upheaval also comes creativity: cultural and intellectual innovation. Now fifty-seven years old, Eliza Greatorex predicted to a journalist that she had another ten or fifteen years of good productive years left in her.[59] If she was to fulfill her prophecy, then she needed to move beyond the work that made her reputation and find a new direction for her art.

"HARD TIMES IN 17TH ST.": JANUARY TO MAY 1878

Following the economic downturn of 1873, circumstances got tougher for artists. Many of them had barely been able to make ends meet, and when financial disaster struck, the diminishing market in America became even tighter. Matilda Despard had described her sister as being of "limited

FIGURE 8.9

Eliza Greatorex, *Old Mill at Rock Enon Springs*, ca. 1877. Oil on canvas, 33 ½ × 12 in. Ronald Berg Collection. Photograph by Beat Keerl.

means" early in the 1870s, and as the decade continued things only got worse. By June of 1875 Greatorex acted as go-between for her collector-friend Martha Mitchell of Milwaukee, who had taken a "lengthened tour of Egypt, the Nile, Bosporus, etc." for the winter of 1873–74. Among her entourage was the artist Frank Waller, who created a visual record of their travels. In April 1875 Waller held an exhibition of his Egyptian and Roman pictures

in New York, and then took them on to Boston. Two months later, in June, Mrs. Mitchell held her own exhibition in New York at the studio of Mrs. Greatorex of her "fine paintings" from her tour, "just unpacked," and including several works by Waller. This was one of a number of occasions when Greatorex acted as agent and facilitated the exhibition and sale of artworks with an eye to financial remuneration. But it failed to yield the desired results.

Every week during the summer of 1877 the newspapers reported auction sales by artists desperate to sell their work, at prices far lower than they had received a few years earlier. A number of them sold off all the contents of their studios and departed for Europe, where they could live more simply and cheaply. Greatorex must have hoped to avoid that, since with the publication of *Old New York* in 1875 it was important to remain in the city and promote reviews and sales. She had been working on speculation, paying all the publication costs out of her own pocket. She had invested almost everything she had and predictably was not ready to give up and move away yet. She tried a number of strategies to maintain an income stream beyond art sales, including teaching and even dealing in art. Her children did their best to contribute economically, but with only limited success. The options remaining for a respectable widow were limited.

"Mrs. Greatorex, who is well and favorably known to many Washingtonians," the local press reported, "is selling out at private sale all her choice studio properties, rare objects of art, etc., in New York, preparatory to her departure for Europe."[60] The matter-of-fact tone of the notice belies the gravity of the circumstances. When creditors came knocking at the door, her only choice was to sell off the cherished possessions she had acquired over the course of her career to pay off her debts. Even more tragic was the loss of all the artwork that remained in her possession: pen-and-ink drawings for *Old New York*, the sketches she had done on landscape excursions, and her fieldbook of work she had created in Germany.

Artists are inveterate collectors, and Greatorex was no exception. She often picked up pictures, decorative arts, and books on her travels, meant for the enjoyment and education of herself and her children. But that practice trained her eye and awakened her to the commercial value of art. When money was tight, she capitalized on her discerning eye and trustworthy character to act as a private art dealer. Her studio then doubled as a gallery and showroom, where she displayed not only her own work and that of her

daughters but the work of other artists as well. "She has made an art gallery of the first floor of their dwelling, in which her pictures and works will be for exhibition and sale," one observer recalled, "where worshippers of the ancient can admire and buy by piecemeal" artifacts from a range of ancient buildings including "the interior of St. Paul's, the pulpit of the old Fulton-Street Church, a quantity of wood from the old Roger Morris house upon Washington Heights . . . or any other ancient building for which their hearts may hunger."[61]

"The furniture of Mrs. Greatorex's studio . . . is of unusual interest . . . calling up thousands of reminiscences of other days, distant lands and great people," Dr. Fuller Walker enthusiastically explained after a visit to her. "Is it any wonder the appreciative mind finds a studio like Mrs. Greatorex's an excellent place for study and dreams? The very air is filled with historical, political and art influences. The past mingles with the present." The inventory she kept on hand is revealing of her efforts: "The cheerful fire in the open grate is supported by a pair of quaint and highly polished brass andirons, which once performed a similar service in the Washington Heights residence of the celebrated Madame Jumel," a site she had represented in *Old New York*. "A large armed easy chair, upholstered in red plush, resembling the bronze chair which supports the statue of Secretary Seward on Madison Square, New York, once belonged to Daniel Webster. He used to carry it with him from Marshfield to Washington, and used it in the Senate Chamber." Each object possessed historic associations: "Two tall, silent, useless clocks stand in opposite corners of the room . . . One of these clocks, of mahogany and maple, in intricate arabesque patterns, was made on Pall Mall, in London, for the Duke of Orange." In the case of the clock, it possessed special ties with her homeland, as "it afterward became the property of Dean Swift, and thence it fell into the hands of an Irish family of note, by whom it was brought to America." There was china service too that linked to the city's past: "Upon the table there is a lot of rare old [??] china, which was once used in the Carey Ludlow house, in New York, the family for whom the present Ludlow street, well known for its jail, was named." He singled out one item whose association with the occupying British army during the Revolution was destined to rouse the city's anger: "Among this china is a small blue tea-cup from which Lord Howe once drank a cup of tea, while he occupied New York." Each object had its story to tell and brought the past alive, as Fuller-Walker concluded: "We have before us presidents, kings,

generals, saints, statesmen, soldiers, artists, noted women, writers, authors, and they pass by in silent review, every article of furniture in the studio helping to bring them more vividly before the mind's eye."[62]

On Valentine's Day 1878, a private auction was held in Greatorex's studio at 2 East Seventeenth Street, corner of Fifth Avenue, when all her worldly goods were sold off. She and her daughters then made their final preparations to depart for Paris.[63] Competing with hundreds of other studio sales that year, it fetched barely enough to pay off what she owed. In a rare moment of personal revelation, she confessed to a friend, the British artist Elizabeth Heaphy Murray, that were it not for her brother's help she would not be able to stay even one year in Europe. Since few letters survive in which she wrote of her problems, we can only imagine the state of her "poor weary spirit" as she alluded to "all the miserable work" she went through. Her brother provided one of the few rays of hope, and he wrote to her saying that "all [her] goods that were saved were in his house." Although she always lived a peripatetic existence, this is the one time in her life when she was literally homeless and sent her entry to the NAD without the usual identifying address. "When I had gotten through this difficult time," she confided to her friend, her brother "would have a good home ready for me in Washington." After devoting the better part of the past ten years to delineating the residences of the old New York families, Greatorex had been evicted from her own domicile and stripped of her finest possessions. Saddest of all was her resolution that wherever she made a future home, "I shall never seek one in New York again."[64]

9

TRANSATLANTIQUE

From New York City to Paris, from Cragsmoor
to Morocco, 1878–1897

PARIS: AMERICAN ARTIST'S HEAVEN

"Fifty-two American artists in the Paris Salon for 1878. That is almost as good a showing as the National Academy of Design in New York can make with its home talent."[1] This report was just one of many indicators of the substantial transatlantic aesthetic migration from New York to the City of Light in the late 1870s. While the lure Paris held for the global art community in the last quarter of the nineteenth century is widely recognized, the experience of female artists in the French capital demands attention. "After all give me France," Mary Cassatt declared. "Women do not have to fight for recognition here if they do serious work."[2] An expatriate from a wealthy American family who achieved entrée into then-avant-garde Impressionist circles, her career has been charted. Tracking the more conservative Greatorex trio of overlapping generations reveals alternative pathways through the French art world.

Upon arrival in France, the first challenge was to secure housing. One socially acceptable solution for women was to board with a respectable family. Sadly, the distressed circumstances in which the Greatorexes found themselves—having just sold the contents of their studio and life's work to pay off creditors—thwarted that plan.

"All our hopes of finding a house with a good French family were banished," the elder Greatorex wrote to her friend Elizabeth Heaphy Murray, "and we went from hotel to apartment until we found a large room unfurnished and set to work to make it habitable."[3] Finding suitable quarters was problematic, given the influx of foreign artists flooding the real estate market. Accommodations ran the gamut, from full-scale apartments to hotels and pensions. They were forced into the low-budget option: the grim unfurnished room. "To furnish even a small apartment prettily takes time and trouble, as every woman knows," May Alcott Nieriker advised in her book *Studying Abroad and How to Do It Cheaply*, "but if one chooses to spend a few hundred francs at the Hôtel Drouot (the great auction-rooms of Paris), a fine collection of useful and ornamental meubles may be bought for surprisingly little money."[4] Since the Hôtel Drouot was beyond their meager means, we can imagine them scouring second-hand shops for modest fittings. Nieriker's advice extended to meal preparation, but experience had taught Greatorex one solution: "We have the concierge do our buying and cooking," she explained.

Setting up their household and reimmersing themselves in their art improved their spirits, Greatorex explained to Murray: "In this way all the month passed and we were not very strong after our sea voyage and the hard times in 17th St.—that came before we left, but now it is better and I have pleasure in telling you that we do hope for great comfort in our work and some in our lives."[5] Their new address was at 8 rue du Vieux Colombier, in the relatively inexpensive Latin Quarter: "I must tell you we are very happy to be in this quarter the Latin of Paris near the Luxembourg and just by the grand old church St. Sulpice." Having arrived during Easter season, they were able to observe the local holiday rituals: "This is Good Friday and what a sight it was! A great crowd everywhere and the churches you could scarce find standing room. There are great sermons preached in Paris today . . . and the people are very devout—something I did not expect to see." In spite of all the hardships they had faced, they found solace in Paris. "The city is very gay," she concluded, "and indeed lovely."

"Just the last two days I have been at my easel," the artist reported in April, "and the girls are one in the [Académie] Julian and one in Carolus-Duran's studio and begin to live." She started to enjoy again "the quaint delight of the Galleries and the architecture and picturesqueness of the old part of the city" and wanted to get to work sketching them, but did not feel quite ready: "I see many studies but do not feel nerve enough to attack

FIGURE 9.1
Photographer unidentified (Eduardo Fiorillo?), *Eliza Greatorex at Etching Table, Paris*. From
Photographs of Artists in Their Studios Collection, ca. 1885–90. Courtesy of the Frick Collection/
Frick Art Reference Library.

them—but that will come by and by." To catalyze her work, she engaged an
etching instructor: "I am to begin to etch next week and have so much ma-
terial—a young female artist is to give Kate and me lessons twice a week.
She will help me in the biting & etc." But she admitted that "a living will be
difficult even in our simple way this summer." Since July and August were
hot and unpleasant in the city, they followed well-trodden paths to the coast
and across the channel to England, where they stayed with friends: "She
passed most of the past hot summer in London and on the sea coast of
France, at some of the watering places," Fuller-Walker reported.[6] It was on
this trip that she produced the studies for the watercolor *Normandy*.[7]

By November, Fuller-Walker's readers learned, "Mrs. Eliza Greatorex . . .
with her two daughters, Kate and Elenor [sic] are in Paris, earnest students of
art" (fig. 9.1). Greatorex took a new direction: "etching on copper, since she

finds photographic reproductions of her marvelous pen-and-ink drawings will not be acceptable to connoisseurs in Europe." The pragmatic Eleanor Greatorex "is studying book illustration. All three have as many orders as they can fill."[8] They needed to make art that would sell readily. "If reduced to making pot-boilers," Nieriker reminded her readers, "'Live in Paris, but sell in London' was [the adage] long ago adopted by painters of all nations."[9] The younger daughter published magazine articles, and perhaps they sold an occasional picture, but how they earned a living in Paris is uncertain. Working hard, Eliza Greatorex confessed to an occasional diversion: "When we want a sensation and have a longing to hear English spoken—we go over the Bridge to the Quarter of the Louvre where everything is glittering furiously ready to entertain and make merry." They moved multiple times: in 1881 Chez M. Dupont at rue Jacob, 28 in the Latin Quarter and later in the Luxembourg Gardens area at Rue Notre Dame des Champs, 77 in 1887; and then in 1888 at Rue d'Assas, 70. They adopted the migratory habits of urban artists, passing fall to spring in Paris and escaping the city in the warmer months. "During these years they spent the summers at Vesules-en-Caux, at Chevreuse and Cernay, and at Grez (Seine-et-Marne), living in picturesque auberges, and enjoying the companionship of the clever and ambitious artists who frequent them."[10] They traversed Europe searching for new material worthy of Salon pictures.

Paris was alive with activity in the days leading up to the annual Salon exhibition "when artistic excitement reaches its height." Then "pictures literally darken the air, borne on men's shoulders and backs, packed in immense vans, or under an arm of the painter himself, all going to the same destination—the Palais de l'Industrie on the Champs Elysée."[11] The Greatorex women joined the fray and submitted work to the jury, although theirs were often works on paper that typically received less notice than oil paintings.[12] Eighteen eighty-nine witnessed the Exposition Universelle when *tout le monde* surveyed the international displays including the new Eiffel Tower. Eliza Greatorex was one of the few women represented in the Watercolors and Drawings section, where "the American exhibit is small but strong," while her daughters exhibited elsewhere on the grounds.[13] Fleeing New York City, they had arrived a bit shaken in Paris, what became a place of self-imposed exile. But they seized opportunities—in etching, book illustration, pedagogy, and watercolor painting—that firmly entrenched them in the Franco-American scene. They surely concurred with William Merritt Chase's declaration: "My God, I'd rather go to Europe than to heaven."[14]

MARIE BASHKIRTSEFF, ART STUDENT IN PARIS

The eighteen-year-old Marie Bashkirtseff arrived in Paris from Russian and enrolled at the Académie Julian (fig. 9.2) just ahead of the Greatorex sisters. They and twenty-five other young women from the United States, Italy, Sweden, Spain, England, and Turkey were directed to "the studio of the ladies," where female students worked in a classroom segregated from men, assembled in a semicircle around a male model typically draped for the morning session. Women were excluded from studying at the state-supported École des Beaux-Arts until 1896 and forced to seek places in the few private ateliers that accepted them, always—Nieriker qualified—with inferior facilities at a higher tuition rate. When Rudolphe Julian along with Carolus-Duran and Jean-Jacques Henner opened their doors in 1868, men and women assembled together, but after 1874 there were separate studios. Instructors came in several times a week to critique student work, there were weekly classes in perspective and figure study, and on Sunday the École de Médecine hosted an anatomy session. Copying artworks in the galleries was also encouraged.[15] "At last I am working with artists—real artists, who have exhibited in the Salon," Bashkirtseff wrote enthusiastically, "and whose pictures are bought—who even give lessons themselves."[16] She made these observations in a diary she had kept from a young age, eventually filling 104 exercise books totaling 700 pages (now in the Bibliothèque Nationale, Paris), written with an eye to public readership. After her death from tuberculosis about age twenty-six her mother arranged for the journal's publication—albeit with many passages expunged—which stirred controversy over the personal observations she recorded about her self-professed ambition and drive for fame.[17] Bashkirtseff's words negate the myth of the modest, self-effacing female art student to reveal a modern woman every bit as bent on success as her male counterparts.

During her studies the young Russian challenged the boundaries of social convention for women, believed in their equality, and fought for the rights of women art students. Men had access to nude models all day while women worked from models draped in the morning and nude in the afternoon, a policy she helped to overturn. "It is astonishing that there have been great women artists [given] the enormous difficulties they have met," she wrote in 1881 under a pseudonym in the Citoyenne. "Not only are women's studies shackled with gothic procedure, they are excluded from the state schools . . .

FIGURE 9.2

Maria Bashkirtseff, *In the Studio* (Academie Julian), 1881. Oil on canvas, 60⅜ × 74 in. Dnipropetrovsk State Art Museum, Dnipropetrovsk, Ukraine. Courtesy of Bridgeman Images.

Each person should have the liberty to follow the career that suits him."[18] The visual manifesto of her position is arguably her *Académie de Julian* (also called *In the Studio*). There is a long history of depictions of the painters' academy. But she departs from that tradition by conveying a sense of professionalism among the growing number of women who—despite a system that hindered them—managed to acquire training under recognized masters. She organized a group portrait of sixteen of her fellow students variously dressed from sober and practical to expensive and elegant, gathered around a dais in the right middle ground where a young man dressed only in an animal skin posed as the boy John the Baptist. She captured the material culture of the atelier, where nude studies are displayed on the upper walls and the cramped space below is cluttered with easels and chairs. Rodolphe Julian is significantly absent and the scene is presided over by a skeleton. She depicted a tightly knit gathering before the model, with some class-

mates sketching and others critiquing one another: a sympathetic portrait of a community of talented and motivated artists united by a common cause. The irony was that in this assertion of independence they were completely segregated in their labors, located in a less desirable space on the floor below the men. Bashkirtseff's canvas synthesizes the possibilities and limitations that Kathleen and Eleanor Greatorex too faced in trying to obtain an art education in and around 1880.[19]

During Bashkirtseff's pursuit of her artistic endeavors, her closest and most complex relationship was with her mother. (This was probably true as well for the Greatorex sisters, whose situation was complicated by the fact that they born a few years apart, lived in the shadow of a parent who had already achieved professional success, and often functioned as her assistants.) Bashkirtseff retained the maternal ideal of her class and scolded her mother for not keeping up appearances: "Mama was doing housework, which makes me furious. I would like to see her elegant and beautiful instead of looking like a cleaning-woman in an old dress." In Roselle Ruthchild's interpretation, Bashkirtseff revealed here "the deeper story of struggles for self-expression . . . playing with different images of herself—the old ones of society belle and wife of a famous man, the newer, path-breaking ones of scientist, linguist, musician and artist—and with the complexity of fashioning a new identity inside or outside mainstream society."[20] Psychoanalyzing artists from earlier centuries has severe limitations, but we can assert that artmaking brought these women to the brink of emancipation and gave them the means to discover their own independent identities. Kathleen and Eleanor Greatorex may have come to agree with their talented Russian peer: "In the studio all distinctions disappear. One has neither name nor family, one is no longer the daughter of one's mother, one is one's self."[21]

PLEIN AIR ETCHING IN THE VALLEY OF THE CHEVREUSE AND THE ETCHING EXHIBITION OF 1881

In 1881, at age sixty-one, Eliza Greatorex created what is arguably the high point of her graphic work: a small etching, just under 6 × 4 inches, of Chevreuse (fig. 9.3).[22] It is the artist's proof, an initial record of her process at the moment of creation, before subjecting it to editing and amending for public consumption. It depicts a chateau on a hilltop high over the meandering river composed to draw the viewer's eye from the base to the summit

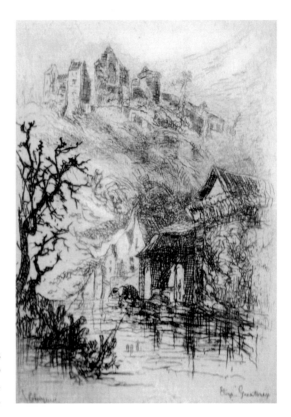

FIGURE 9.3
Eliza Greatorex, *Chevreuse*, 1880
(under mat: "A[rtist's] P[roof]").
Etching, 4 15/16 × 3 1/2. Private collection.

in a vertical sweep. Drawn through a hard ground, etched, then augmented with drypoint, the entire page is filled with varied mark-making, changing from thin line to thick as she shifted pressure from delicate to assertive, creating a complex design in her graphic skein. She probably drew the scene first with pen on paper and then went to the metal plate. From her arrival in Paris in spring 1878 until now, she had been focusing on etching, and this was the outcome.

Dissatisfied with the mechanical processes for reproducing her pen-and-ink drawings, the artist determined to master etching, as it yielded multiples directly. Lacking opportunities to learn the medium at home, Americans headed to Europe for technical training. "Although still working in color [i.e., oil paints]," Sylvester Rosa Koehler reported, she "made etching her chief study." She sought instruction from Charles Henri Toussaint as well as Maxime Lalanne, whom P. G. Hamerton declared "the best etcher of the

present day."[23] He came wholly recommended by Koehler, who had translated his book *Traité de la gravure à l'eau-forte* (1866) into English. Published in 1880, the translated text became the bible of the Etching Revival. Like her, Lalanne was a painter, etcher, and author who created highly refined images of architectural landmarks.[24] His expressive treatment of aging structures in his *Aux Environs de Paris or Vue Prise du Pont Saint-Michel* finds parallels with the Irish-American's conceptions. Comparing her graphics published in 1875 to those of 1880–81 after she came under Lalanne's tutelage reveals that her use of line had become lighter and more suggestive, rather than specific and descriptive. Working on the plate, she scraped and reworked the ink to create evocations of mood that lent an air of character to the buildings she delineated.

She had experimented with printmaking as early as 1868 under James Smillie, a neighbor in the Dodworth Building. She had exhibited the results at the academy but put it aside and was now ready to refine her touch with the etcher's needle. Gradually she gained command of the medium and appreciated its distinct potential. Etching a line into the ground applied to a metal plate is vastly different from drawing a line across a sheet of paper. Laying aside her quill pen, she had to master new skills, including treating the plate, preparing acid-resistant varnishes, composing the acid, timing the bite, selecting the right tools, and using them correctly. She started out conservatively by re-interpreting images from earlier projects in the new medium, prompting print historian Frank Weitenkampf's remark that she "was inclined to transpose to copper the technic of her interesting pen-and-ink sketches of Old New York."[25] Having practiced on familiar motifs, she was ready to take some small plates and head out into the field to etch *en plein air*.[26]

In the summer of 1880 she revisited the Chevreuse Valley she had painted in the 1860s.[27] But now, Koehler related, in "Chevreuse (Seine et Oise), and at Chevreuse and Cernay-la-Ville [she] etched directly from nature."[28] Replacing her paint box with portable metal etching plates and tools, she explored the countryside. Although she originally learned etching to reproduce her pen-and-inks, she discovered it to be an expressive medium that became central to her artistic practice. Cernay-la-Ville, a rural village about forty miles southwest of Paris in Picardy, was a favorite haunt of artists. They were attracted there for scenery, easy access to Paris, and inexpensive and congenial accommodations, including the Léopold Inn where Impressionist Auguste Renoir made a mural sketch that the proprietor accepted in

lieu of payment, and everyone from Camille Corot to Winslow Homer was said to have contributed to its decoration.[29] The town's environs featured a cascade, a church, and a pond, each of which Greatorex featured in individual etchings.[30] Her rural foray yielded six works: three scenes at Chevreuse and three of Cernay-la-Ville, including *The Pond*, a quiet, unassuming view of the water's edge with a glimpse across the marsh grass to the far shore. The picture surface, by contrast, is highly animated, with a varied treatment of line that demonstrates far greater freedom than her drawings of Old New York. She signed in the plate "Eliza Greatorex, Cernay-la-Ville 1880" (fig. 9.4) and exhibited it at the Salon the following spring.[31]

Back home, Sylvester Rosa Koehler initiated several projects intended to elevate the status of etching: editing the journal *American Art Review*, writing and translating relevant books, and organizing exhibitions that "did as much—and in the same way—for American etching as Hamerton did in England."[32] *The American Art Review: A Journal Devoted to the Practice, Theory, History and Archaeology of Art*, published in Boston by Dana Estes and Charles E. Lauriat, ran only two years (1880–81). But during its brief life it disseminated such high-quality reproductions and well-researched arti-

cles and criticism that it exerted a lasting impact on the field. On a visit to her sister in France, Matilda Despard saw the new work and sent a plate home to her son. Acting as her agent, Walter Despard by early December 1880 was negotiating with Koehler to insert his aunt's work into this prestigious publication. "At the kind suggestion of Mr. S. P. Avery, to whom I am indebted for your address," he wrote to Estes and Lauriat, "I have sent you today per Adam Express a pkge containing four etchings by Mrs. Eliza Greatorex, the plates of which are for sale, and may be accepted for your American Art Review." As a precaution, he added: "Should this not be the case please return the etchings at my expense." He must have received a positive response and wrote again: "Feeling assured that your offer for The Pond represents its full commercial value, I take pleasure in accepting it, and shall send the plate tomorrow." The following day he finalized the arrangements: "I now beg to advise you of having sent you the plate of Mrs. Greatorex's etching The Pond, Cernay-la-ville, per Adams Express. Kindly make check to my orders and oblige."[33] Koehler reproduced her etching in the journal in 1881 with an explanation of her pioneering contribution to American printmaking. The image measures approximately $4\frac{3}{8} \times 7$ inches, printed in sepia tones on a sheet 12×17 inches. Five hundred impressions were made in a limited edition, sometimes assumed to be a twentieth-century marketing device but already used in the nineteenth century. To produce her etching, Greatorex went through multiple steps. The etched copper plate is inked. Its flat surface is wiped, leaving ink caught in the grooves and scratches that comprise the image. The plate is then placed onto the bed of an intaglio roller-press. In a process known as *Chine-collé*, a thin sheet of rice-paper is trimmed to the same size as the plate, then laid down on top. The exposed side of the rice-paper is then evenly dusted with powdered paste. A sheet of heavier etching paper, which has been soaked and blotted, is then laid down over the rice paper and plate. Both sheets and the plate are then run through the press, exerting sufficient pressure to transfer ink caught in the lines onto the paper. Residual moisture from the etching-paper activates the paste, causing the rice-paper and image to become adhered to the heavier backing-sheet. The stunning result of this process, *The Pond* became her best-known work.[34]

Koehler also mounted the landmark Exhibition of American Etchings at the Museum of Fine Arts, Boston, where he became its first print curator. The exhibition ran from April 11 to May 9, 1881, with nine works by

Greatorex: five done *en plein air* in the French countryside and four revisions of previous drawings.[35] In his catalogue essay, Koehler argued that "with the decline of interest in the subject," American art entered a new phase in 1876, when "the individuality of the artist gains in importance." He predicted that etching—"the most personal of the multiplying arts"—would play a key role in this next phase of creative expression, as "more attention is paid to the pictorial qualities of art,—to color, and to effects of light and shade. And as etching is such a magician in the expression of these qualities, it stands to reason that it should be most highly valued when they are esteemed of first importance."[36] While many of her Hudson River contemporaries continued painting familiar motifs in the same comfortable style, Greatorex had reinvented herself once more, and this exhibition marked her coming of age as an etcher. "I am very happy to know that the Exhibition of work of American etchers is so successful," Matilda Despard wrote to Koehler, "and greatly indebted to your kind thought in securing my sister's work a representation in it."[37]

MARY NIMMO MORAN AND THE ETCHING REVIVAL

In spring 1881, during the run of Koehler's Boston exhibition, Mary Nimmo Moran submitted her early efforts in etching to London's Royal Society of Painter-Etchers, who then invited her to join them. Only two years earlier her artist-husband Thomas Moran had taught her the technique, and she was already well on her way to becoming an acknowledged leader in American landscape etchings. Her forceful style coupled with her signature of "M. Nimmo" left many guessing about her identity, which many assumed was male. She focused primarily on British and American subjects, especially eastern Long Island where the couple purchased a home in 1884. Works of that year, including *Summer, Suffolk County, New York*, were done primarily outdoors, as suggested by the small scale (plate $5\frac{3}{8} \times 3\frac{3}{4}$ in.) and focus on an intimate corner of nature on eastern Long Island. Back in the studio, she reworked areas of the plate, especially the dark area of vegetation along the water's edge, where she suggested a thicket of trees via a skein of delicate lines made by skillful control of the etching needle and printed it in brown ink on cream paper. A few years later she and her husband mounted a joint exhibition, offering the public the opportunity to compare their efforts. The consensus was that her etchings were superior in vigor and expression to his.[38]

The surge of popularity for prints in the United States in the late nineteenth century inspired an Etching Revival. It had its first stirrings in England and then France, where artists such as Eugene Delacroix and Daubigny tested the possibilities of the medium. In 1866 French etchings made their first significant appearance in New York, where Alfred Cadart mounted two exhibitions, each accompanied by a catalogue promoting etching for the spontaneity of the process. Recognizing their potential, American art dealer Samuel Putnam Avery began promoting them to collectors and amassed a group for himself (bequeathed to the New York Public Library). The increased availability of these small, black-and-white prints often done on an intimate scale in a personalized sketchy technique opened the door for printed works on paper to be appreciated as original works of art.[39]

As this painter-etcher movement gained currency, cities with established artistic and printing centers—New York, Boston, and Philadelphia—facilitated the formation of groups to promote the production, collection, and display of etchings. The New York Etching Club, Philadelphia Society of Etchers, and Society of American Etchers were all active agents in these developments. The original efforts of J.A.M. Whistler were especially admired and stimulated followers, as did those of Peter Moran (one of several painter-etchers in the family into which Mary Nimmo had married). These practitioners and institutions helped facilitate an artist's immersion in the medium.[40]

Mary Nimmo Moran was one of the stars of the 1887– 88 Exhibition of Women Etchers that opened at Boston's Museum of Fine Arts and then moved to New York. She sent "fifty-four etchings varying in size from the tiny proof 'On the Saint Johns River, Florida' . . . to the large 'Landscape' recently published by Mr. Klackner, of this city." The reviewer further noted that "one of the earlier etchings, printed by herself, is the picturesque Bridge over the Delaware at Easton, Pennsylvania and shows the peculiar effect of printing with oil paint, Vandyke brown having been dragged on parts of the surface with a brush."[41] That exhibition helped establish the primacy of women in wresting the medium from the Old Masters and resuscitating it for the modern age. In 1893 her prints earned a medal at the Columbian Exposition in Chicago, where the competition was stiff given the medium's growing popularity that she had helped to foster. Nursing one of her daughters with typhoid fever, Moran contracted it herself and died in 1899 at age 57, at the height of her powers as one of the leaders—male or

female—of the American Etching Revival. Her career, like the movement, was of short duration but left a lasting legacy.

"BRIGHT ALGERIAN DAYS": AUTUMN
1880 TO AUGUST 1881

"In the autumn of 1880 the mother and daughters went to Algiers, where they lived out of the city, on the Mustapha hills," Wright reported on the Greatorex women. The city occupies a beautiful if strategic position on the north coast of Africa. During Ottoman rule (1525–1830) it was a semi-independent province where Arabs, Berbers, black Africans, Jews, Turks, and Kulughi (progeny of Algerian women and Turkish soldiers) lived together. The year 1830 marked the beginning of French occupation, which brought not only French but also southern Italian and Spanish settlers. By the time of the American artists' visit, fifty years of French rule had firmly imposed its system of governance and a physical division onto the space of Algiers. The Arab city on the hillside, known as the Casbah, was demarcated from the "French" or "European" city that encircled and extended below it. The city once known as the "Bulwark of Islam" had been transformed into "Alger la blanche," France's colonial urban showplace.[42] Eliza, Kathleen, and Eleanor Greatorex were the latest in a succession of artists who had arrived from Paris, beginning most famously with Delacroix. Fascinated by the site, they remained almost a year.

Scholars often emphasize women traveler artists' dependence on high-ranking men paving their way. But in Algiers a network of art women helped one another with inspiration, advice, and contacts: Elizabeth Heaphy Murray, a British-born travel artist who published her book *Sixteen Years of an Artist's Life in Morocco, Spain and the Canary Islands* (1859) and produced related watercolors; Emily Osborn, also a visitor to Algiers, where she introduced Barbara Leigh Smith to the Greatorexes; Smith, a British painter and women's rights activist and close friend of Anna Mary Howitt, whose book *An Art Student in Munich* had sparked Eliza Greatorex's desire to see Bavaria. While painting with Howitt on the Isle of Wight in 1856, Smith had written to George Eliot: "I must go to some wilder country to paint—because I believe I shall paint well."[43] She headed for Algiers, where she married Eugène Bodichon, a French anthropologist and physician based there, and divided her time between Britain and North Africa. She produced a steady stream of pictures that enjoyed robust sales, the proceeds of which funded Girton

College, the first women's college at Cambridge University that she co-founded with Emily Davis. Her *Sisters Working in Our Fields* (c. 1858–60) shows the "villa on the green heights of Mustapha Supérieur, commanding glorious views of sea, city, and plain" that the Bodichons purchased upon their marriage.[44] The villa provided a meeting place for her expatriate female circle, where it is easy to imagine their neighbors Eliza, Kathleen, and Eleanor Greatorex visiting.[45]

"The home of the artists in Algiers was a wild place, so lonely that it was considered unsafe to go out of doors after dark. The former occupant had been murdered at his own gate just before our artists took possession," Wright tells us about the quarters of the Greatorex women. "Still, they were never molested, but on the contrary, always politely treated by both Arabs and Spaniards. Once, stopping at a café door to get a certain angle of view, the noise within was instantly hushed, and they were soon left in complete and solitary possession." The place suited them, and "every day they rode into the town, sketching as they could, for, as everybody knows, it is almost impossible there to get models." Each found subjects to interest them: "To the Salon of 1881 Miss Kathleen sent a strong head of an Arab, in oils, also a life-size portrait of a street musician. Mrs. Greatorex and Miss Eleanor occupied themselves with street scenes and flowers in oils, painting banana groves, almond flowers, hedges of aloes and prickly pear, and the wild scenery of the hills." A watercolor of a market scene by the younger daughter (fig. 9.5), richly colored and well composed, treats the vendor as an exotic type. A popular genre at the time, it falls under the rubric of Orientalism, defined by Edward Said as a way of seeing that imagines, exaggerates, and distorts differences of Arab peoples and culture compared to Europe and the United States.[46] Likely it is the work that hung in the New York Water-Color Exhibition of 1882 titled *Street Bread Sellers—Algiers* (no. 417), which she priced at $150.[47]

Greatorex focused on etching, "finishing some half dozen plates of the very striking scenery of Algiers. Some views of interiors, of the street scenes, and of the landscapes around the ancient Arab settlements." Since her sister reported receiving proofs of the etchings, it means that they had some means of printing them on-site. They may have carried a portable printing press, but more likely they had access to a printing shop there, since for decades European and American artists had been depicting local scenes. There "the climate is very [harmful?] to the etchers work," Matilda Despard wrote in April 1881, "the chemicals acting oddly, the ink thickening and

drying. She has forwarded to me a few proofs of these [??] but considering the printing of them imperfect, she does not wish them to be seen."[48] Etching outdoors in the elements is always challenging, but in North Africa it proved to be especially difficult. Eliza Greatorex decided to return temporarily to Paris, "where it is her purpose to go to Lalanne to correct the defects of the printing and avail herself of his counsel in her work." Of the six or more plates made there, one Algerian subject was listed in the Women Etchers catalogue.[49]

"Sickness and sorrow broke in upon the happiness of those bright Algerian days," when Eleanor Greatorex—already in delicate health—contracted a serious illness. "No longer was travel pleasant or the world beautiful, and desolate hearts asked only for home." No sooner was she recovering than tragedy struck again, transforming their world forever. "The invalid sister, Eleanor, scarcely yet won back from death, was brought back to New York in August, 1881. No work was attempted until the opening of the next

year."[50] A letter had arrived from home, informing them that back in Colorado her thirty-one-year-old brother Tom Greatorex had been murdered.

TRAGEDY IN COLORADO

"You may have possibly [learned of] the severe affliction which Mrs. Greatorex has suffered in the death, by a cruel and cowardly murderer, of her only son in Colorado," Despard wrote in a coda of a letter to Koehler. "I have had the most distressing task of sending the sad tidings to her and am now awaiting the answer to my mournful letter."[51] The news of the young man's death, delivered to his mother and sisters by mail long after he was gone, devastated them. It was impossible to believe this tragedy had occurred in Colorado, where he sketched the Rocky Mountain scenery he had begun to think of as home (fig. 9.6). A newspaper account from that Colorado town conveys the strong emotions he provoked among relative strangers, suggesting the depths of grief his mother must have felt:

TOM GREATOREX IS DEAD

In these few words is conveyed the saddest intelligence that has shocked the San Juan country for many years, and as the sorrowful news went from lip to lip, the heart of the hearer was saddened with a heavy weight. Of the population of the San Juan country there are few who did not know the smiling countenance and manly exterior of the form which now lies cold and inanimate upon the banks of the Rio Las Animas, and of those who know him where is one who did not respect and love him? As he was loved in life, so he is mourned in death. And is it any wonder that as friends crowded round the coffins, and looked down into the calm upturned face and the white hands crossed upon his breast and tried to realize that this was all that remained on earth of Tom Greatorex, is it any wonder that they weep bitter, scalding tears and that they feel that revengeful rise within their souls, which rebel, vainly, but rendered more bitter because they are so impotent to avenge this fearful wrong. To think that he, of all men, should be so cruelly, brutally and unprovokedly murdered by a ruffian of the lowest type, is a thought to make men forget themselves and wish for but an opportunity to give his assassin a death such as never existed even in Poe's imaginative brain. The manner in which the deed was done was all-sufficient—the consequences of that deed are more than sufficient to justify any means of retribution.

Tom was, as we have said before, a natural born gentleman. We often see those who endeavor to be gentlemen from force of circumstances and for

appearances' sake, but seldom one who is such in following the dictates of a noble soul. Such a man it was of whom we write today. Generous in spirit, kind of heart, manly in demeanor, strong in mind and jolly in companionship, he was admired in his daily life. An excellent singer, an accomplished dancer, graceful in carriage, handsome in face and figure and engaging in conversation, he was the life of society and an indispensable addition to every gathering. As a penman he was without rival, and his ability as a bookkeeper is attested by the numerous responsible positions he held, as county clerk etc. Thomas A. Greatorex was 29 years of age [sic] at the time of his death, and was born in Charleston, S.C., where he lived for some time. The sad end has been so long delayed that the most sanguine hopes were entertained for his recovery, and the favorable reports which came daily gave grounds for that belief, so that the end was all the more unbearable. All the businesses of Durango closed their

doors during the time of the funeral, which was very largely attended. The remains were deposited in private grounds across the river, pending the wishes of his relatives. His mother and sisters, who are artists not unknown to fame, are now in Algiers, Africa, whither they went for the purposes of sketching. It may be some compensation for their irreparable loss to remember that he died surrounded by hosts of loving friends and theirs are not the only hearts that bleed in this sad hour.[52]

Whether or not family members ever collected his remains goes unrecorded, but other newspaper reports fill in the details of the incident. One March evening Tom Greatorex was out with a group of friends in the frontier town of Durango, when he witnessed a man harassing a local young woman. Jumping to her defense, he was knocked down and shot in the back by a disreputable character named Jack Roberts, who then fled the scene. After the shooting the victim clung to life, and friends hoped for his survival. But his lungs were reportedly punctured and ten days later he succumbed to death. The townspeople got together and collected a reward of $500 to put on Roberts's head. A brief notice in the *La Plata Miner* for March 26, 1881, provides the finale: "A party from Durango went down after him, but came back without him; and reported that he had got lost. He is thought to have gone to another climate via the limb of a tree."

Eleanor's near-fatal illness delayed the women's departure from North Africa, but four months after receiving Matilda's letter, on August 16, Eliza, Kathleen, and Eleanor Greatorex were among the passengers who arrived in New York from Liverpool on the steamship *City of Chester*.[53] Such was their grief that for the next six months they lived in seclusion and hardly picked up a brush or pencil to do any work until after the New Year 1882.[54] From 1882 to 1885 they lived in the Sherwood building at 58 West Fifty-Seventh Street, the first apartment house in New York designed especially for artists, in an elite neighborhood where Cornelius Vanderbilt II resided. A seven-story brick building, it housed forty-four apartments, each of which had a fifteen-foot-high studio and one or two bedrooms. After their years of globe-trotting and living in temporary quarters, they were able to forego the bohemian life and reside in a comfortable residence. Among the amenities in the new building, which opened in 1880, were electrical bell signals, speaking tubes, gas service, and an oversized elevator for large paintings.[55] Living in such a handsome building (presumably with the financial assistance of

family), the sisters could attract a better clientele of paying students while Kathleen Greatorex sold works through the Brooklyn Art Association.[56] In the meantime their mother slowly recovered from the shock of her son's death, made all the more poignant by the fact that her enthusiasm for Colorado had encouraged him to go west and seek his fortune.

Life in New York meanwhile was becoming increasingly noisy and stressful. Buildings rose ever higher, spreading out over the last open spaces of the city as its epicenter moved further uptown. These conditions, coupled with their fragile emotional state, made the need for nature more urgent than ever. When weather permitted, they explored the countryside north and west of the city among the Shawangunk Mountains of Ulster County. With Edward Lamson Henry and other friends, they formulated a plan for an artists' community, where they would all acquire property and live in a mutually supportive enclave.

SEARCH FOR SOLACE AT CRAGSMOOR
AND ART PEDAGOGY

"During these years at the Sherwood the summers have been occupied by sketching principally in the neighborhood of their summer home among the Shawangunk Mountains, in Ulster County," we learn.[57] This modest home was located in what became known as Cragsmoor (originally Evansville until the name changed in 1893), one of a number of art colonies in the Northeast that also included Cos Cob and Old Lyme, Connecticut; Cornish, New Hampshire; and East Hampton, New York. They were gathered under the utopian ideal of a community of like-minded individuals who lived and worked together. Usually these colonies were founded far removed from the distractions of the city, in sites noted for their unspoiled natural beauty, such as Barbizon in France, where Greatorex had firsthand experience.[58] She had been visiting and painting in the Shawangunks since the 1860s and was one of the first to settle in Evansville with the purchase of a dilapidated but charming old structure. "That is a mountain farm-house, upon which the artists came by accident, and which had been too long neglected and deserted to tempt any practical person, but which was attractive beyond description to lovers of the picturesque," a friend reported. "From the piazza of the weather-beaten old house the view extends over a valley more than twenty miles in length, following the windings of the Hudson, until it disappears among the mountains at Cornwall," we read. "The region is fa-

mous for its wild berries, and the gatherers who come from far and near are delightful subjects for the artist's brush, and the wild roads blaze with rhododendrons, azaleas and fields of laurel."[59] An art colony by design provides a support group, and has more to offer followers rather than leaders, where members can work together undisturbed by the activities of the changing art world from which they have felt increasingly isolated. It constitutes not an advance but a retreat, a place of asylum. The natural beauty of the site was undeniable but it is important to consider the motivation for Greatorex to cofound an art colony.

For much of her career the artist had been a pathfinder, traveling through Europe on her own, taking the transcontinental railroad out west, and living in North Africa long before it was considered acceptable for a woman to do so without a male companion. At this point it seems apparent that she needed a refuge. Only a few years earlier she had been so financially strained that she was forced to sell all the contents of her studio—including her own pictures and the antiques she had spent decades acquiring—to satisfy creditors. After such a humiliating experience she had vowed never to live in New York City again. No sooner had her daughter recovered from a near-fatal illness than she received news of her son's murder. Life was made a bit easier by the urban comforts of the Sherwood Building, but they were surrounded by strangers. They took the train to Ellenville and the carriage up the Mount to find sanctuary in the old farmhouse and harmonious community that had begun to gather there in the 1870s and grew over time to include E. L. Henry, Frederick Dellenbaugh, Charles Curran, and Helen Turner.

To meet expenses, Greatorex revived her plein air etching practice and in 1883 created several prints such as *Cherry Trees, Shawangunk Mts* and *The Barn Yard, Shawangunk Mts*, hoping to appeal to residents of the area.[60] Her older daughter, too, researched local subjects and in 1885 painted a multifigural genre scene, *Caning Weaver Girls of the Ellenville Glass Works* (fig. 9.7), based on the industry of the nearby town. The Ellenville Glass Company began production of bottles in 1837, and by 1866—now reorganized as the Ellenville Glass Works—it became one of the largest operations of its kind in the country. Employing over five hundred workers, it produced eighteen thousand carboys and fifty-six thousand demijohns (the names given to glass bottles protected by wicker basketwork), many by skilled glassmakers from Ireland.

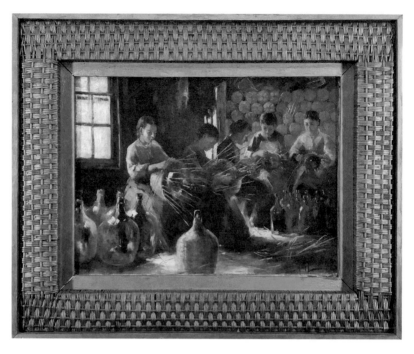

Kathleen Greatorex must have made several visits to the site and sketched the many women and children who worked covering the bottles with woven willow twigs raised on the company's "Willow Lot." For her final painting, she featured five seated women in a sunlit interior weaving their baskets surrounded by a specially designed frame imprinted with their wickerwork pattern.[61]

By this time both sisters had attained proficiency in figure painting as well as in watercolor, as evidenced by Kathleen Greatorex's *Le Jeune Chasseur* (fig. 9.8). These skills became mainstays of their renewed efforts at teaching that provided a reliable income stream. Now artists in their own right, Kathleen and Eleanor Greatorex "formed the class which has sent so much good work to all the New York exhibitions. This class, which averaged last winter [1884–85] sixteen students—the majority exhibitors and professional artists—met three mornings of each week to draw and paint flowers and from the draped model."[62] Among their pupils were Edith Rogers and

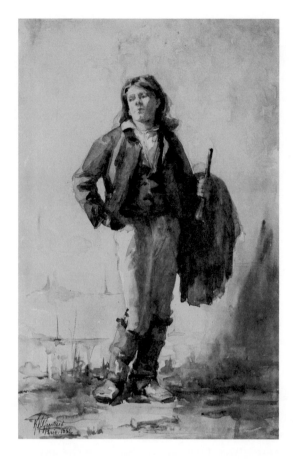

FIGURE 9.8
Kathleen Greatorex, *Le Jeune Chasseur* (*The Young Huntsman*), 1880. Watercolor on paper, 18¼ × 11½ in. Private collection.

John Gellatly, an insurance and real estate broker, who married and subsequently collected art together. In 1929 they donated their significant holdings of American and European painting and decorative arts to (what is now) the Smithsonian American Art Museum, including Eleanor Greatorex's portrait study of Edith Gellatly.[63] Other distinguished students included the family of Mario de Mendonça, member of the Brazilian legation to the United States in the 1880s and 1890s, who sought diversion from his diplomatic duties in their class. "The Brazilian Minister's family will spend the Summer in their cottage in the Adirondacks, where last season a studio was added, as three of the family are fine artists," the *New York Times* reported. "Mr. Mario de Mendonça has made a large number of creditable sketches in water colors, and Miss Amelia and Miss Amalia de Mendonça

studied art for some time under Miss Eliza Greatorex [sic] and Miss Kate Greatorex, who are now in Paris."[64] Mendonça acquired pictures from their mother, including her *Louis Philippe House in 1868, Bloomingdale*, which she showed at the National Academy of Design in spring 1884.[65] These gestures—one student purchasing a signature artwork by the teacher while the instructor created a spontaneous portrait of her vivacious pupil— tells us that a warm and friendly yet professional atmosphere pervaded the Greatorexes' art classes.

"The artists have named their home 'Chetolah,' or 'Sweet Repose.'" Summer after summer they returned here, taking long walks or "lying in hammocks in the old orchard, the purple valley, in its boundlessness and gold-shot mystery of purple haze," which, readers of *The Art Amateur* learned, "reminds them so much of the Algerian sea from the hills of Mustapha, that they often talk of changing the name to 'Tefkira,' the Moors' word for remembrance,"[66] perhaps with memories of their lost son and brother in mind. While E. L. Henry is often credited with spearheading Cragsmoor, Eliza Greatorex and her daughters played a substantial role in scouting out the location, attracting others to move to the area and establishing a spirit of community that held the group together.

MRS. AND THE MISSES GREATOREX AT THE DAKOTA

During the summer of 1882, Kathleen Greatorex journeyed to Milwaukee to paint murals for Martha Mitchell's redesigned mansion.[67] The commission signaled a shift in the lifestyles of the wealthy, who now sought painted decorations on walls and furniture to adorn their lavish residences. This led to another such opportunity closer to home: "During the busy winters at the Sherwood the sisters accomplished, amid their own work, the decoration of the ladies' reception-room at the Dakota, a large apartment house near Central Park," it was reported in the art press. "They executed all the decoration of ceilings, walls and curtains, the latter being done upon huge stretches in their own studio." They were touted as "probably the first women in this country who professionally mounted the painter's scaffolding."[68] Working at what one reporter called "one of the most perfect apartment houses of the world," she predicted: "The ladies' sitting room, adjoining the staircase in the southeast corner, will be decorated by the Misses Greatorex, a guarantee that the work upon it will be artistic and

unconventional."[69] Their work added another dimension of luxury to this innovative real estate project. "The most daring aspect of [Edward] Clark's scheme was the extravagance of his building The largest room was the public dining room on the ground floor, which was fashioned after an example in an English manor house," we learn. "Adjacent . . . was a smaller private dining room, fitted with mahogany and large beveled-glass windows, and a ladies reception room, which . . . featured a frieze of clematis by the famous Greatorex sisters."[70] Clematis was a favorite motif of theirs since their visit to Colorado in the summer of 1873. Each of them had painted that hardy flowering plant in watercolor and oil, in pictures they exhibited around the country, until it became their signature subject. "The scheme of the decoration of the room continues with the draperies, which hang in portières and from the windows. These are of satin, the ground tint of the frieze, and carry the sunlight effect to the floor. On these the vine swings in the abandon of nature with falling shadows," wrote Mary Gay Humphreys. "These draperies are painted and it is to be remarked that they have none of that disagreeable glistening effect of paint on satin," she explained, pronouncing their decorative scheme "most agreeable."[71]

Soon Mary Cassatt and Mary MacMonnies would create famous public murals for the Women's Pavilion at the Chicago Exposition. But in the 1880s, the Greatorex sisters were doing mural decoration for private residences in the United States and in France. Their work in the historic Dakota in 1884 constitutes another chapter in their multifaceted careers while the attendant press notices signaled a sea change in the arena of art. Increasing numbers of periodicals about home decoration began to appear, often citing the work of women as "naturally good decorators," and holding up the Greatorex sisters as exemplars. "Nature has furnished the model, but the effect is purely decorative. The walls have a greenish-gray tone, and have been worked throughout by the palette knife applying the color over the underlying silver. The result is a net work of tints, exquisite in texture as in tone, and altogether novel," Humphreys told her readers of *The Decorator and Furnisher*. "The drawing and the composition follow, one might say, the wantonness of nature. No better idea can be gained of the feeling of the decoration than by imagining the leafy luxuriance of the vine with its delicate blossoms in strong sunlight casting tangled shadows." Rather than being entirely complimentary, authors (often female) were damning them with faint praise. Humphreys peppered her description with asides that

their work was quiet and unpretentious, delicate, "purely decorative," and their compositions followed the "wantonness of nature." These negative aesthetic qualities were being gendered female while women were relegated to the realm of decoration, by implication inferior to fine art.[72]

While her daughters worked inside, the mother explored the neighborhood with an eye to doing some plein air etching. She situated herself across from the building site and with plate and needle delineated its exterior. The resulting etching, *The Dakota, 73rd Street and 8th Avenue, New York, in 1884*, conveys the impression of an isolated structure far away from the congested neighborhoods at the south end of Manhattan. She also looked across the park to depict the adjacent housing of the poor, such as in *Shanties, West of Central Park, 1884* (Library of Congress), then being displaced as developers were constructing high-income properties.

How the commission came about is a matter of informed speculation. The sisters had some experience in interior decoration both at home and abroad and would have been in the running for such work by the early 1880s on the basis of their experience alone. Edward Clark, the builder of the Dakota apartments, died in October of 1882, before the construction was completed. The management of Clark's sizable real estate operation fell to his son, Alfred Corning Clark, who was an associate of the Greatorex family. Five years earlier, when Eliza put the contents of her studio up for sale as she decamped for France, it was the younger Clark who bought the majority of it.[73] Later he willed them to his son Stephen C. Clark, who in turn bequeathed the drawings, prints, and books to the Museum of the City of New York in 1936. In all probability, then, he was behind the choice of the Greatorex sisters to paint the walls of the reception room.

The duo "mounted the painter's scaffolding" and applied pigment directly on the wall. They were likely working in fresco-secco, applying the paint on dry plaster. They had been honing the necessary skills from the early 1870s. During the Philadelphia Centennial, Eleanor Greatorex painted historic architectural remnants that had belonged to Mary Philipse, said to be George Washington's first love: "A shutter from Mary Philipse' window hangs in the Woman's Building, and on it Miss Eleanor Greatorex has painted some delicate flowers, on a background of gold," an observer explained, adding that it could be used "admirably as a chimney piece, or as a cabinet for precious relics, as well as it would adorn a mantel-shelf or wall."[74] She also painted the decorative borders for her mother's architec-

tural paintings done on panels removed from the buildings, most success-
fully in Old North Dutch Church (see fig. 7.9).

One journalist assumed they were candidates to paint the Women's Pavil-
ion at the Columbian Exposition in Chicago organized by Bertha Potter
Palmer: "If Mrs. Palmer should go to Paris she might find profit in the experi-
ence of Eleanor and Kate Greatorex, who themselves decorated one of the
prettiest rooms in town in an entirely original manner."[75] The reference to
"one of the prettiest rooms in town" is again semantically a two-edged sword,
telling us it is superficially attractive but lacking strength. Such critical assess-
ments contributed to the widespread move to push women back into a nar-
row niche, after they had enjoyed a brief interlude in the late 1860s and 1870s
when they were thriving in the open arena. The early 1880s witnessed the
constriction of democracy in American art, with gender roles redefined to
pigeonhole and therefore limit women's options. The sisters were linked with
decorative painting that was increasingly being disassociated from fine art.

ETCHING IN EUROPE, 1886–1887, AND EXHIBITION
OF AMERICAN WOMAN ETCHERS, 1887–1888

For almost two decades Eliza Greatorex's graphic work had been tethered
to a text, in her books or portfolios on Oberammergau, Colorado, Virginia,
and New York. She had long functioned as a traveler artist, capturing a se-
ries of visual and written impressions of far-flung locales that together con-
veyed a sense of place to the consumers of her books. In the spirit of the
Etching Revival, prints existed as expressive vehicles in their own right.
This allowed her to chart a different trajectory and visit well-trodden sites
now reinterpreted through her personal sensibility. From Barbizon to the
Normandy coast, from Florence to Rome, the challenge now was to experi-
ence these established places for oneself as part of an aesthetic and spiritual
quest conveyed via a visual image. On this pilgrimage outward from Paris
across France, Germany, Holland, Italy, and North Africa, she reached an
apogee in her work after age 60: a late style, or *alte stil*.

After vacating the Sherwood building, the Greatorex women never had
another New York City address, but maintained the Cragsmoor residence
and passed a good deal of time in Europe. By December 1885 "Mrs. Greatorex
and her two daughters, Miss Kate and Lizzie . . . have gone to Italy for a year,
most of which time will be spent in Florence, where they will establish their
studios."[76]American artists have always felt a special attraction for the Italian

landscape as the embodiment of a lost Arcadia, coupled with its historied past. Greatorex had extended contact with Germany, the British Isles, and France; she had spent time in Rome on several occasions, when she visited actress Charlotte Cushman at her residence near the Spanish Steps. The promise of a year's residence in Florence, with its rich art treasures and distinctive surrounding countryside, allowed her the leisure to sketch the hallowed sites visited by so many before her. Her frequent forays outdoors with etching plate and needle gave rise to a new body of imagery. "For a period of about eight years I was deeply interested in etching & especially drypoint as it was so easy to carry about in ones [sic] pocket a half a dozen plates, which would fill up at odd moments," American Impressionist J. Alden Weir explained. "I gradually got so interested in a certain charm etching only possesses, [I] had my own press & would often pull prints to the early hours of the morning." [77] His enthusiasm for this mobile process that produced small, intimate etchings surely echoed Greatorex's own.

Perched midway between the ancient Etruscan town of Fiesole and Renaissance Florence, Maiano is a hamlet nestled in the hills from which she etched *View of Florence from Maiano, Italy* (fig. 9.9). Its vantage point allowed the artist to position herself a good distance from the city, with its Duomo and other architectural landmarks just breaking the horizon line. In New York she was of necessity quite close to her subjects in its already dense urban matrix. In Florence her space opens up and extends beyond the confines of the page. The foreground is empty, save for the striations that mark the ascent of the terrain to the plateau that extends towards the city in the distance. A grove of cypress trees in the right middle ground was extensively worked on the plate to pick up the rich, dark black ink, putting the composition slightly off balance. *View of Florence from Maiano, Italy* demonstrates just how far her technique developed from her Old New York days.

Another favored site in the area was Vallombrosa, where the artist etched its famed clock tower. "Probably the first suggestion of desire to visit Vallombrosa comes to all English-speaking travelers from an old association with Milton's comparison, so well known as hardly to need repeating here," a contemporary guidebook read, and went on to quote it anyway:

Thick as autumnal leaves that strew the brooks
In Vallombrosa, where th'Eturian shades
High over-arch'd imbower.

By the time of their visit "something of the primitive charm of Vallombrosa is gone forever," Murray's guide reported, blaming improvements in transportation. But, the author insisted, this did not diminish "the charm of those deep forests, or that wonderful panorama of mountains and valleys, or the sparkling freshness of the pine-scented air."[78] No matter how picturesque the scenery, Italy can be brutally hot in summer. By July 1886 "Miss [Kathleen] Greatorex, her mother, and sister, who passed last winter in Florence, are now in Austrian Tyrol, where they will probably stay till the summer heat is over."[79] Subsequently they spent part of 1887 in Rome and Brittany, where Greatorex mère was especially productive. There was an important show coming up, and she wanted to have new work to submit.[80]

In 1887 Koehler organized a second exhibition titled "Women Etchers of America." Building on his 1881 effort, he compiled "an interesting collection of the work of the women etchers of America . . . to be seen at the Museum of Fine Arts in Boston. Nearly 400 plates are here presented; . . . they are the contribution of only about twenty-three artists."[81] Viewers recognized that "instead of being a meager collection of 'scratches on copper,' [it was] a magnificent display of three hundred and eighty-eight plates, many of them of the highest order as regards both composition and execution." Morris Everett recognized it for the eye-opening event it was—"the first distinctive exhibition of the kind ever given"—and went on to bestow what amounted

to the highest compliment possible to be paid to women's work: they "betrayed a force and skill of execution that compared favorably with the best efforts of men who had won fame with the needle."[82] Pondering gender differences, another critic observed: "there is less 'commercialism' in this exhibition . . . as there would be in a similar collection of plates by men."[83]

Wielding authority as one of a new breed of museum print curators, Koehler succeeded in demonstrating the vital role that women played in the development of etching in the United States. At the instigation of Dr. A. E. M. Purdy, the landmark exhibition moved in the spring of 1888 to New York's Union League Club, now expanded with eleven more printmakers. "Many of the plates are well-known to the public," a journalist explained, "but without seeing an exhibition like this, it is difficult to realize what admirable work with the needle has been done by American women."[84]

"The Old Tavern in Bloomingdale by Mrs. Eliza Greatorex attracts special attention from the fact of its being the first etching so far as known of any American woman," it was proclaimed. "Mrs. Greatorex contributes between thirty and forty fine 'examples' to the exhibition and it is interesting to compare her early work of 1869 with her later productions."[85] She "is represented by a progressive series of plates, showing her evolution from a careful, somewhat mannered pen-and-ink artist, who takes up the needle, into an etcher of the modern school."[86] But times were changing. Although at Boston Mary Nimmo Moran was hailed as the most expert in the medium, new artists were added in New York, leading observers to declare that "the most interesting plates in the way of artistic progressiveness are the drypoint prints of Miss Mary J. Cassatt, the Paris-American impressionist." Her use of aquatint aroused special attention: "Some of her plates are remarkable as examples of the aquatint process, and are strong in individuality as well as in execution."[87]

It was a showdown of two generations of artists. But the changing of the guard also extended to the rising professional critics. Among them was Mariana Van Rensselaer, author of the catalogue's introduction, who might have been expected to be sympathetic to women artists. Alas, Van Rensselaer wrote one of the harshest critiques of their printmaking efforts. In counterpoint Koehler led audiences to recognize the number and range of professional women artists by presenting an impressive panorama of strong works by multiple hands. The press generated first in Boston and then New York

spread word of their success nationally and internationally. Women etchers were finally beginning to get their due.

A "BEAUTIFUL OLD AGE"?

We rarely hear much about the late years of American artists. Like rock stars, they seem never to age and are forever frozen in time at the high point in their careers, when they created the work for which they would be best remembered. F. Scott Fitzgerald's maxim that the working lives of American authors had no second acts was assumed to apply to visual artists as well. These generalizations fail to take into account the female career trajectory that diverged sharply from that of the male counterparts. Accepted clichés still promoted the woman as the ideal mother, as Eleanor Greatorex captured in her watercolor *Mother and Child at Cernay* (fig. 9.10). In reality creative women often bloomed late, after bearing children and burying a spouse, and evolved in several stages. After the death of a husband, the need to support a household and freedom from the routine of married life often motivated them to take up their artistic production with an eye to the marketplace. So while Eliza Greatorex's Hudson River contemporaries like Frederic Church had long disappeared from the public eye and were presumed dead, she was mastering a new artistic medium that earned her fresh encomiums. Study of women like Greatorex forces us to rethink our assumptions about age and creativity. A caricature she sketched of herself in combination with her signature (fig. 9.11) shows her in profile with her mouth slightly open and characteristic coiffure: hair pulled into a bun at the base of her neck with escaped strands in disarray on her forehead. She captured herself in perpetual motion, ready to put new plans into action.

It is useful to revisit the comparison between Greatorex and Durand (twenty-three years her senior), for she played a parallel role for females that Durand had played for males: the dean of women painters, and their guiding spirit. Asher B. and his son John Durand had a close artistic relationship just as she had with her two daughters. John Durand's biography of his father concluded with the words: "Those who loved him have the satisfaction of knowing that his life ended in an honoured, happy, and beautiful old age."[88] We wonder if Greatorex too enjoyed a "beautiful old age," satisfied—as John Durand presumes of his father—that she had achieved all that she had set out to do. She who had recorded New York's old landmarks

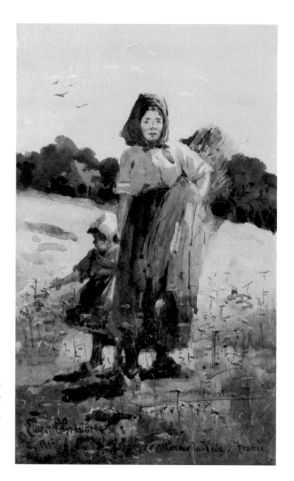

certainly deserved a dignified old age. It would be comforting to think she had one, and yet it is difficult to imagine that this restless, feisty woman would ever find that same tranquility. Little was recorded of her final decade or of her last, unfinished works. Of Durand we read that when he found himself no longer able to paint, he left his studio for good and spent his remaining days wandering in the woods and reading his favorite books in French, which he had learned as a child. Did she, could she, ever resign herself to the loss of her artistic powers, and absent herself from her easel once and for all? She had achieved more than most, as she surely must have realized. Yet the image lingers of a determined woman trying to attend to one more project, to achieve something more while she still had breath in

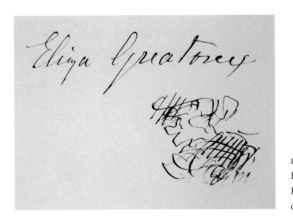

FIGURE 9.11
Eliza Greatorex, signature, 1875.
Pen and ink on paper. Private
collection.

her body. Perhaps her attitude was more in tune with that of another land-scapist of her generation, George Inness, whose son George Inness Jr. re-called in his *Life, Art and Letters of George Inness* that many times his father said to him: "George, my love for art is killing me, and yet it is what keeps me alive. It is my blessing and my curse."[89]

Records indicate that a late etching of the coast of Norway (Library of Congress) was one of the last that Eliza Greatorex exhibited.[90] Her obituary stated that she died on February 9, 1897, in Paris after an illness of long du-ration, but except for that her life in the nineties is something of a blank. A bill exists for transport of her casket to the railway station in Paris, on its way to Moret-sur-Loing, where she was interred. Later Kathleen marked her grave with a memorial stone.

Shortly after her death, an article first published in the *Chicago Tribune* was syndicated in newspapers nationwide. It recorded ongoing debates "running the rounds" of women's clubs across the United States in response to the question: who are the "Americans of the Gentler Sex Who Have Left Records of Considerable Interest"? Initial responses were predictable: Pris-cilla Alden, Pocahontas, Martha Washington, Elizabeth [Mother] Goose, Molly Pitcher, Elizabeth Cady Stanton, and Lucretia Mott. These standard answers "created a storm of protest," and a more nuanced and representa-tive list was compiled of "the greatest women of American history": Mary Washington, Dolly Madison, Susan B. Anthony, Harriet Beecher Stowe, Clara Barton, Frances Willard, Millie Stark, Belle Boyd, Anne Carroll, Er-mine Smith, Nancy Hanks, Eliza Greatorex[91]

EPILOGUE

Kathleen and Eleanor Greatorex Carrying On Alone

LIFE IN AN ART MATRIARCHY

"Mrs. Eliza Greatorex," the press had reported, "is at present teaching her daughters the art of reproducing etchings on plain glass."[1] But such incidents of this mother providing formal study for her children were rare. Instead, "from her they received continual but not systematic instruction, like all children of artists rather imbibing teaching than formally receiving it," a close observer noted. "They had no real lessons, but ran constantly to their wiser and older companion for approbation or criticism. Their ambition was high."[2] They were committed to art and "have received a thorough training in drawing, but as yet do not exhibit," it was reported. "Mrs. Greatorex, with a feeling that does her infinite honor, preferring that they should wait until their works can stand on their own merit, and not through the influence of her name." She was a stern taskmaster, banning the young women from displaying their work until she deemed them ready. In spite of the challenges, "both of these ladies evince a talent of a high order, and are already becoming known in a quiet way in art circles."[3] Referred to as "Mrs. and the Misses Greatorex," they formed a seemingly indivisible unit, making it difficult to distill out the identities

and achievements of the daughters—living and working perpetually in the shadow of their mother—as they struggled to support themselves and hone their craft.

A painting by Lilly Martin Spencer titled *Choose Between* (c. 1857; private collection) thematizes the maternal dilemma.[4] Seated in the parlor, a young mother is flanked by her small son and daughter and holds a litter of four newborn kittens in her lap. Her son points to the kitten he prefers, dooming the others to be drowned, while the daughter is more reluctant to choose. Looking from son to daughter, the mother is at pains to select one over the other but knows that society will do it for her. "Mrs. Greatorex became convinced that one of her daughters possessed striking talent of the spontaneous and impulsive sort that would come to development under any circumstances, favorable or unfavorable, while the other needed the artistic atmosphere in which she was really growing up to bring forth her native ability," a family friend wrote of a time in the 1860s when they were teenagers. "'I know now that I was entirely mistaken,' says the mother, smiling, to-day, 'my mistake was the usual one of supposing a slower growth indicated less talent.' It may be left to the admirers of these gifted daughters of a gifted mother to guess 'which was which.'"[5] Another source put it more bluntly: "Mrs. Greatorex taught her daughters, but they were not considered as good as their mother, Kate being the more talented."[6]

Upon their departure from New York to Europe in the late 1870s, the two sisters began to come into their own as artists and assert their own individuality. So it is at this point that we should try to untangle their respective trajectories. Eleanor Elizabeth (fig. 10.1), although more delicate in health, showed more spunk in seeking income-earning tasks to help support the family. She pursued all kinds of assignments from magazine and book illustration to fabricating wedding albums and painting on porcelain to earn money. Described when she was twenty-five as "a sensible young lady, polished in her manner, and full of artistic promise,"[7] she clearly belonged to the category of an "old-fashioned girl" rather than the more modern "girl of the period." While still a teenager, she created graphics for publications, including John S. C. Abbott's *Kit Carson: The Pioneer of the West* (1873) and *Prince Greenwood and Pearl-of-Price, with their Good Donkey Kind & Wise*, translated from the German of Heinrich Hoffmann by her aunt Matilda Despard (1874).[8] She also created the covers for her mother's portfolios and books. In Bavaria she pursued her studies diligently, seeking opportunities

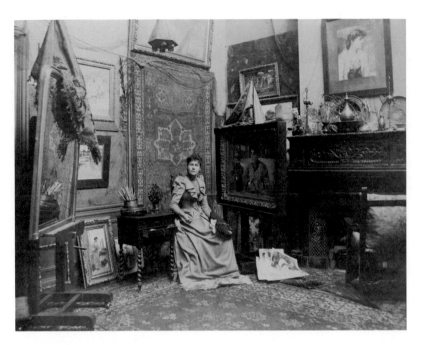

at the art academy and with private teachers, as she recorded in a published
article.[9] She was an observant writer, documenting women's art at the Cen-
tennial for the publication *The New Century for Woman.* Throughout the
1880s and '90s she wrote and illustrated articles on her European experi-
ences and other subjects for journals such as *Godey's Magazine.* She exhib-
ited oil paintings and watercolors of florals and figurative studies at the Sa-
lon and elsewhere. Stylistically she was known for "the glowing magnificence
of [her] color, and the broad, free sweep of her brush."[10] Throughout her life
she also gave private art lessons in New York City and Cragsmoor, New
York. Among her better-known works is *Mrs. John Gellatly* (Smithsonian
American Art Museum), a sensitive portrait of one of her many students.

Her older sister Kathleen (fig. 10.2), by contrast, was considered the fam-
ily beauty, and like all the family was talented in music as well as art. She
pursued her art studies in a desultory manner in New York, Munich, Rome,

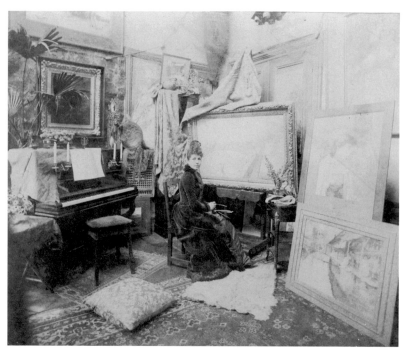

and Paris. She showed artworks at the Centennial and the Columbian Expositions, with the Society of American Artists, and kept up a lively exhibition schedule until the end of the century, both at home and abroad. Her preferred mediums were watercolor and oils. She painted numerous panels of plants and flowers that won favor with audiences, and in 1883 she collaborated with Eleanor on decorative mural painting in the new Dakota luxury apartment building. In later years, living in the French countryside, she took advantage of her close proximity to picturesque canals and painted watercolors of the canal barges and wash boats (*bateaux lavoir*), which she exhibited at the Cotton States and International Exposition in Atlanta, Georgia, in 1895, and elsewhere.[11] In the spring of 1897, critics noted Kathleen's conspicuous absence from the art scene. "The Corridor is fairly aglow with brilliant flower-pieces," the critic for *The Art Amateur* noted. "One recalls the

superbly handled chrysanthemums and peonies the Greatorex sisters used to send, and finds nothing that quite takes their place."[12] With her mother's death in February of that year, Kathleen's public art career was at an end.

MORET-SUR-LOING

A glimpse into the shared life Eleanor and Kathleen carried on after their mother's passing can be gleaned from a series of articles Eleanor wrote for *Godey's Magazine* and other scattered sources. Like Rosa Bonheur and Mary Cassatt, they spent time in Paris but sought respite from its hustle and bustle in nature. Typical of their constant quest for antidotes to modern life, they managed to acquire property in the magnificent medieval town of Moret-sur-Loing on the banks of the river at the edge of the Fontainebleau forest (fig. 10.3). In an article she penned about their quotidian experiences, Eleanor mentions their home nestled against the old walls, punctuated by stone towers. Her description of an outing hints at the simplicity of their lives there: "We had been driving on a very hot day in the shady depths of Fontainebleau forest, and leaving the horse with his soft nose in the grass, we took our trowels and basket to dig some forest loam for our garden."[13] In the amphitheater-like space behind the house, they tended their beloved plants and blossoms that then became the subject of many of their pictures.

Here they did not want for contact with other artists. Along with their house they had a large studio, which at one point they rented out to American sculptor George Grey Barnard, whose private medieval art collection was integral to the formation of the Cloisters of the Metropolitan Museum of Art in New York. When Barnard vacated the space, Kathleen wrote to Auguste Rodin, inquiring if he was interested in leasing their studio, but no record of his response has been located.[14] Rosa Bonheur also lived in the Fontainebleau forest nearby, although she kept to herself and seems to have been only a distant acquaintance. The sculptor Frederick MacMonnies resided there too with his painter-wife Mary Fairchild MacMonnies, Eleanor's close friend and the subject of one of her journal articles.[15] Moret itself was close enough to Paris that artists would come for brief stays, but there was one who called it home. The British-born Impressionist painter Alfred Sisley became the best known of the residents and a close associate of Kathleen's until his death in 1899.

Another important arrival to the town in the 1890s was Sara Tyson Hallowell, an American based in Chicago, where she curated a number of

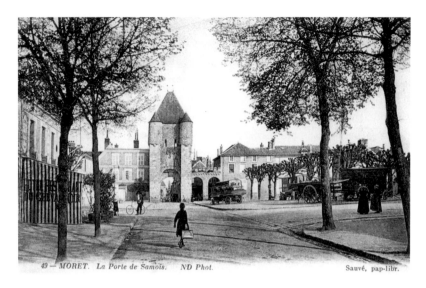

49 — MORET. La Porte de Samois. ND Phot. Sauvé, pap-libr.

FIGURE 10.3

Photographer unidentified, *Place de Samois, Moret-sur-Loing* (location of the Greatorex residence), ca. 1900. Courtesy of the Municipality of Moret-sur-Loing, France.

exhibitions including the loan of French art for the World's Columbian Exposition. She acted as go-between of the Franco-American art worlds and included the Greatorex women in some of the shows she organized. Her cohort embraced many of the leading artists of the day, including Cassatt, Rodin, Whistler, and others. In Moret she lived with her mother and niece Harriet Hallowell, with whom she did humanitarian work during World War I, including running a hospital in Moret. In 1900 Kathleen and Eleanor sold Chetolah—their home in Cragsmoor, New York—to George Inness Jr., who demolished their old quarters, acquired extensive acreage, and built a grand house that survived over a century.[16] With Eleanor's death in 1908 at age 54, Kathleen then carried on alone in France. "Miss Greatorex has chosen a charming suburb of Paris for her home, the little village of Moret, near Fontainebleau, which is set in the most beautiful environment that can be imagined," an unidentified correspondent in Washington, DC—likely one of her nieces or nephews—wrote in 1909. It "is one of those lovely quaint little towns scattered throughout France, of which there is no counterpart in the New World. There, in a charming chateau, surrounded by gardens, she does

her work and dreams her dreams, for all painters dream."[17] In 1909 she began negotiations with the Hallowells to sell part of the property her sister had occupied, and by 1911 she had sold it to Sara and Harriet Hallowell, whose presence provided her with some camaraderie.

THE 1920s

By the 1920s Paris was in the throes of the Jazz Age, with American expatriates Zelda and F. Scott Fitzgerald, Ernest Hemingway, Gertrude Stein, and Gerald and Sarah Murphy all living the fast-paced life that has become synonymous with the era. Just south of the city was a region where some of their compatriots lived a quieter and more conservative existence, as if time had passed them by: "Among American artists residing or visiting the neighborhood of Fontainebleau forest this summer are Walter Gay, Sarah [sic] and Harriet Hallowell, Miss Greatorex and Miss Anna Klumpke, who lives in Rosa Bonheur's Chateau Bly."[18] Then in 1924 Sara Tyson Hallowell passed away. All that was left of the old circle were Harriet Hallowell and Kathleen Greatorex, who even as she grew frail and deaf was still described as beautiful. Harriet was still loyal to her, but grumbled about the tedium of spending holidays and dining with a stone-deaf companion.[19] Kathleen returned to Washington and New York from time to time, in part to renew her US passport so that she could retain American citizenship. The last of these trips seems to have been made in 1921. Although most of her time was now spent in France, on the application she still listed "Ramparts, Moret sur Loing" as her temporary address.

In 1926—the year that witnessed the death of Mary Cassatt at her Château de Beaufresne northeast of Paris—several of Alfred Sisley's descendants made a trip to Moret-sur-Loing to see the statue that had been erected in honor of the British-born Impressionist in the village square.[20] "We heard that there was an old lady still living in the village who had known him well, called Miss Greatorex, whom we visited," Claude Sisley remembered. "She proved to be a good-looking but very fragile old lady—possibly over 80 years of age. It appeared that she was an American. She was amazed to see me. 'I always understood that Alfred had no relation in the world.' From what she said it was clear that she had been the only friend that Alfred had had in the village," he recalled of their meeting with her. "He had always been very poor, and although she did not say so in so many words, it was

evident that she had helped him with money and hospitality," Sisley continued. "She told us that he had married his wife after the two children had been born, and that they had been legitimized. The wife had been a woman of little interest or character." In fact, "Miss Greatorex had had a number of Alfred's pictures, but after his death she had suffered financial reverses and had been obliged to sell them." The arrival of Sisley's relatives a quarter century after she had helped nurse him during his horrible illness before he succumbed to throat cancer was extremely shocking to her, and she displayed great agitation: "Miss Greatorex's friendship with Sisley must have been the abiding interest of her life, and this sudden arrival of someone of the same name, so unexpectedly, moved her very deeply, so much so that we did not like to stay long with her or question her at length."[21]

WORLD WAR II

Kathleen Greatorex continued to live in Moret—with short excursions to Paris or further into the countryside—relatively undisturbed until June 14, 1940, when German troops marched into Paris and occupied it. These times must have recalled her experiences during World War I, when her friends the Hallowells were working with the Red Cross to get food and medical help to those in need, though she had not been directly involved. Now there was little she could do against these invaders, so barbaric and destructive. Around the time of the occupation a gang of looters rampaged in nearby Fontainebleau, where they attacked the synagogue and plundered most of the furnishings. Its eight-branch menorah, made of blue Sèvres porcelain and donated by Napoleon III to the Jewish community, had been smashed.[22] By April 1941 the exterior walls were covered with anti-Semitic graffiti, and a short time after that others set fire to it the building and completely destroyed it. Although no one took responsibility, a cluster of German soldiers were standing in front of the building as it burned to the ground. All that remained of the synagogue were the heavy stone gate and a pillar that had stood to the left of the main door lying on the ground, smashed and broken. Surely she must have read the news and been reminded of her mother, seated before one of the soon-to-be demolished New York churches to record them for posterity with her pen-and-ink drawings. She wished she had thought to record Fontainebleau's fine old synagogue that had been built in 1857 by its small community of Jews, the descendants of the people who had founded and worked in the Sèvres porcelain factories. But she

could never have imagined the events that led to its destruction, and had long ago given up art-making. September 8, 1941—Kathleen Greatorex's ninetieth birthday—was to be her last. On May 6, 1942, at her home in Moret-sur-Loing in German-occupied France, she died, and with her, the bloodline and art dynasty of Eliza Pratt Greatorex.

NOTES

INTRODUCTION

1. Megan Marshall, *The Peabody Sisters: Three Women Who Ignited American Romanticism* (Boston: Houghton Mifflin, 2005); Hayden Herrera, *Frida, A Biography of Frida Kahlo* (New York: Harper & Row, 1983).
2. Margaret Bertha Wright (credited as M. B. W.), "Eleanor and Kathleen Greatorex," *The Art Amateur* 13 (September 1885): 69.
3. Katharine Ann Jensen, "Mirrors, Marriage, and Nostalgia: Mother-Daughter Relations in Writings by Isabelle de Charrière and Elizabeth Vigée-Lebrun," *Tulsa Studies in Women's Literature* 19 (Autumn 2000): 285.
4. Among the few other mother-daughter artistic pairings in nineteenth-century America are decorative artist Candace Wheeler and her daughter Dora Wheeler.
5. Phyllis I. Peet, "The Emergence of American Women Printmakers in the Late Nineteenth Century" (PhD diss., University of California at Los Angeles, 1987); Peet, *American Women of the Etching Revival: Exhibition, February 9–May 9, 1988* (Atlanta: High Museum of Art, 1988).
6. Laura Prieto, *At Home in the Studio: The Professionalization of Women Artists in America* (Cambridge, MA: Harvard University Press, 2001).
7. April F. Masten, *Art Work: Women Artists and Democracy in Mid-Nineteenth-Century New York* (Philadelphia: University of Pennsylvania Press, 2008), esp. 240–41.

PROLOGUE

1. Two women appear in the drawing, removing the panels. Eliza Greatorex, *Old New York, from the Battery to Bloomingdale*, with text by M[atilda] Despard (New York: G. P. Putnam's Sons, 1875), illus. opposite 39.

2. Information from the Trinity Church website, consulted May 7, 2015, www.trinity-wallstreet.org/about/archives/congregrational-office.

3. St. George's Church is discussed in Greatorex, *Old New York*, 39–41.

1. MAEVE'S DAUGHTERS

1. Baptismal Records (no middle name is provided), Irish Family History Foundation, consulted February 15, 2020, www.brsgenealogy.com.

2. James Fraser, *A Handbook for Travellers to Ireland* (Dublin, 1844). The author identifies himself as a "landscape gardener."

3. Irish Family History Foundation, consulted February 2009, www.brsgenealogy.com.

4. "Married: At Enniskillen Church on the 24thy inst. [July 24, 1843], by the Rev. R. P. Cleary A.M., John Purdon West Esq., of Euclid, District of Euclid, county of Coyahoya, state of Ohio, North America, to Miss Deborah Pratt of Enniskillen." *Enniskillen Chronicle and Erne Packet*, July 27, 1843, 1. Deborah died in Le Roy, New York December 19, 1844, and was buried along with her infant daughter in the local St. Mark's Cemetery, where her headstone still stands, according to a family tree assembled by Martinez, a Pratt descendant. Anne Keller Geraci, *Keller-Smith Ancestors: Genealogical Record for George Keller & Mary Barbara Monteith Smith* (Westwood, MA: Neponset River Press, 2013), 55.

5. Geraci, *Keller-Smith Ancestors*, 47–64.

6. M. Despard, *Kilrogan Cottage* (New York: Harper & Sons, 1878), 22.

7. Paper affixed to verso reads: "Tullylark. The old Reid homestead near Pettigo, Ireland was founded about 1611 by a Read from Annandale, Scotland. It was there grandmother McNeely (Catharine Reid) was born (1798–1861)." An asterisk directs the reader's attention to pages 5, 6, and 37 of a book titled *Pettigo* by John Read. The note is signed John McNeely McCrea and dated December 8, 1935. The painting was exhibited at the National Academy of Design in 1860 as *Homestead in the North of Ireland* (owned by John Reed), information from Mary Bartlett Cowdrey, *National Academy of Design Exhibition Record, 1826–1860* (New York: New-York Historical Society, 1943), 1:195.

8. Despard, *Kilrogan Cottage*, 83.

9. Despard, 20.

10. M. B. W., "Eleanor and Kathleen Greatorex," *The Art Amateur* 13 (Sept. 1885): 69.

11. Robert Reid, *History of Pettigo* (1900), 35.

12. Laurel Thatcher Ulrich, "Vertuous Women Found: New England Ministerial Literature, 1668–1735," *American Quarterly* 28 (Spring 1976): 25.

13. Arthur Gribben, "Táin Bó Cuailnge: A Place on the Map, A Place in the Mind," *Western Folklore* 49, no. 3 (July 1990): 277.

14. *The Táin*, translated from the Irish epic *Táin Bó Cúailnge*, trans. Thomas Kinsella Oxford (New York: Oxford University Press, 1970).

15. Theodore Roosevelt, "The Ancient Irish Sagas," *Century Magazine* 73, no. 3 (January 1907): 333.

16. Roosevelt, 333.

17. Bonnie Kime Scott, "Irish Women" (review essay), *NWSA Journal* 7, no. 1 (Spring 1995): 138.

18. Minutes of the 1870 Conference of the Wesleyan Methodist Church (London: Wesleyan Conference Office, 2 Castle-Street, City-Road; Sold at 66, Paternoster-Row. 1870), 38–39. The title page reads as follows: "Minutes of the Several Conversations between The Methodist Ministers In The Connexion established by The late Rev. John Wesley, A. M., at their Hundred and Twenty-Seventh Annual Conference, begun in Burslem on Tuesday July 26th, 1870."

19. Jonathan Crowther, *A True and Complete Portraiture of Methodism; or, the History of Wesleyan Ministers* (published by Daniel Hitt and Thomas Ware, for Methodist Connection in the United States; J. C. Totten, Printer, 1813), 285.

20. Greatorex, *Old New York*, 89.

21. Patrick Loughrey, ed., *The People of Ireland* (New York: New Amsterdam Books, 1988): 159–61.

22. Minutes of the 1870 Conference, 38–39. He was buried in Greenwood Cemetery, Brooklyn, listed as follows: "James C. Pratt, date interment 3/12/1870; lot 16924, section 167." There is no marker; records indicate he was interred with a Betty Humphreys. Records at Greenwood Cemetery, Brooklyn, NY.

23. Brantley's work is discussed in Herbert Schlossberg, "The Cultural Influence of Methodism," in *The Victorian Web*, www.victorianweb.og/religion/herb3.html. See Richard Brantley, *Locke, Wesley, and the Method of English Romanticism* (Gainesville: University of Florida Press, 1984): 1, 13, 25, 201.

24. Neville McElderry, *Methodism in the Pettigo Area* (Pettigo: Privately printed, 1991), 7. Thanks to John Cunningham, Erne Heritage Tours, Ireland, for sharing this source.

25. Eight children lived to maturity, but there may have been others who died in childbirth or shortly afterwards for whom I could not locate records.

26. Despard, *Kilrogan Cottage*, 24–25.

27. Web: Donegal Genealogy Resources: Birth, Marriage and Death Records from four local newspapers, consulted March 2, 2020, http://donegalgenealogy.com/birthdm.htm.

28. James Alcott Pratt (credited as J. C. P.), Obituary of Catherine Pratt, *Wesleyan Methodist Magazine*, April 1842, 332 (discrepancy in initials due to typographical error in original).

29. Ulrich, 20–40. I rely on her interpretation for the compendium of qualities of the virtuous woman I discuss.

30. Museum website, consulted June 3, 2019, https://art.famsf.org/nathaniel-grogan/itinerant-preacher-20021147.

31. Minutes of the 1870 Conference, 38–39.

32. Minutes of the 1870 Conference, 38–39.

33. Minutes of the 1870 Conference, 38–39.

34. Patrick Loughrey, ed., *The People of Ireland* (New York: New Amsterdam Books, 1988): 160–61.

35. Neville McElderry, *Methodism in the Pettigo Area* (Privately published, 1991), 14.

36. McElderry, 14.

37. His profession as apothecary is indicated by the records in Dublin where he had to apply for a license in 1805.

38. Geraci, *Keller-Smith Ancestors*, 47–64.

39. Finola O'Kane, *Ireland and the Picturesque* (New Haven: Yale University Press, 2013) analyzes these developments.

40. Brian Friel, *Translations* (Boston: Faber & Faber, 1981), a play set in 1833 in a Gaelic-speaking community in County Donegal, deals with the effects of the Survey on the population.

41. Thomas J. Curran reports that she attended grade school and secondary school, but does not cite a source. Curran, "Eliza Greatorex," in *European Immigrant Women in the US*, ed. Judy Barrett Litoff and Judith McDonnell (New York: Garland, 1984), 120.

42. Peter Carr, *The Big Wind* (Belfast: White Row Press, 1991) provides a full account of the storm; for the intellectual reaction, see 13–14.

43. *Belfast News Letter*, quoted in Carr, 68–69.

44. Carr, 68–69.

45. Carr, 46.

46. Published in *The Nation*, January 23, 1847.

47. Greatorex, *Old New York*, 9.

48. *Journals of Ralph Waldo Emerson* (Boston: Houghton Mifflin, 1910), 3: 201.

49. Records of Arrivals in the U.S., SS *Speed*, July 5, 1848, US National Archives and Records Administration.

50. "Condition and Care of Emigrants on Board Ship," *New-York Daily Times*, October 15, 1851, quoted on website http://amhistory.si.edu/onthewater/exhibition/2_3.html.

51. Eva Hoffman, "The New Nomads," in *Letters of Transit: Reflections on Exile, Identity, Language, and Loss*, ed. André Aciman (New York: New Press, 2000), 51, quoted in Jillian Elliott Russo, "From the Ground Up: Holger Cahill and the Promotion of American Art" (PhD diss., Graduate Center, City University of New York, 2011), 7.

52. Clifford D. Conner, *Colonel Despard: The Life and Times of an Anglo-Irish Rebel* (Conshohocken, PA: Combined, 2000) provides good background.

53. New York Passenger and Immigration Lists, 1820–50.

54. The clipping in the LeRoy Historical Society archives reads: "Adam Pratt m. May 8, 1844 at St. Ann's Church Brooklyn by Rev. Dr. Cutler. Miss Sophia M. daughter of Wm. Philip Esq of Brooklyn."

55. According to Geraci, he traveled to America with his sister Deborah Pratt (1815–44), who married John Purdon West in Le Roy, New York. She died on December 19, 1844, and was buried along with her infant daughter in the local St. Mark's Cemetery, where her headstone still stands. See Geraci, *Keller-Smith Ancestors*, 51.

56. "First Spring Goods in Western New York," *Le Roy Gazette*, May 1843.

57. *Le Roy Gazette*, July 2, 1845.

58. *Le Roy Gazette*, April 1, 1846.

59. This notice appeared in 1849.

60. *Le Roy Gazette*, October 9, 1850.

61. Records indicate that Rev. Pratt was interred with a Betty Humphreys. Records at Greenwood Cemetery, Brooklyn, NY. A character in *Kilrogan Cottage* is Nanny Humphreys, who is not just a servant but a member of the family. This suggests that Betty Humphreys began in the Pratts' employ in Ireland, joined them in America, and became a close friend.

62. *History of Le Roy, NY* (Boston: Boston History Co., 1899).

63. Frederick C. Kelsey, "Out of the Past," *Le Roy Gazette*, October 17, 1934 (first published in 1916).

64. "Auction Sale of Household Furniture," *Le Roy Gazette*, June 23, 1860.

65. Obituary of Adam S. Pratt, *Le Roy Gazette*, July 11, 1900.

66. Letter dated Washington, July 23, 1863, published in the *Le Roy Gazette*; it is difficult to read in places, but this is the gist of it.

67. See chapter 5, where their relations with William Corcoran and the portrait by Rosenthal are documented in detail.

68. Her father arrived in New York City on September 23, 1848, but on the ship *New World*; Record of Cabin Passengers Arrivals, New York, NY.

69. Minor K. Kellogg, Pamphlet to accompany *The Greek Slave*, in *Scrapbook of Hiram Powers publicity, between 1847 and 1876*, Hiram Powers papers, 1819-1953, Archives of American Art, Smithsonian Institution, Washington, DC.

70. Renée Bergland, *Maria Mitchell and the Sexing of Science: An Astronomer among the American Romantics* (Boston: Beacon Press, 2008).

71. Edward Ruggles, *A Picture of New York in 1848: With a Short Account of Places in Its Vicinity; Designed as a Guide to Citizens and Strangers* (New York: C. S. Francis & Co., 1848): 59.

72. On Spencer, see Elizabeth Johns, *American Genre Painting: The Politics of Everyday Life* (London: Yale University Press, 1991), and David Lubin, *Picturing a Nation: Art and Social Change in Nineteenth-Century America* (London: Yale University Press, 1994).

73. For a fascinating fictionalized account of Douglass's experiences in Ireland, see Colum McCann, *TransAtlantic* (New York: Random House, 2014): 40–99.

74. Aside from producing the Seneca Falls Declaration of Sentiments, the conference conferred upon women a new sense of collective confidence.

2. ART, DOMESTICITY, AND ENTERPRISE, 1850–1862

1. Mary Bartlett Cowdrey, *National Academy of Design Exhibition Record, 1826–1860* (New York: New-York Historical Society, 1943), 1:194; "New-York City: New-York Sketch Club," *New-York Daily Times*, March 20, 1855, 3.

2. John Falconer to Jasper Cropsey, February 24, 1848, Newington Cropsey Foundation, Hastings-on-Hudson, NY.

3. *Exhibition of the Paintings of the Late Thomas Cole at the Gallery of the American Art-Union* (New York: Snowden & Prall, 1848).

4. "New-York City: New-York Sketch Club."

5. "A Famous Woman Artist" (obituary of Eliza Greatorex), *Boston Evening Transcript,* February 11, 1897, 7.

6. Cowdrey, *National Academy of Design Exhibition Record,* 1:194.

7. Vera Brodsky Lawrence, *Strong on Music: The New York Music Scene in the Days of George Strong,* vol. 1: *Resonances, 1836–1849* (Chicago: University of Chicago Press, 1995), 484.

8. "Editor's Table," *The Knickerbocker; or New York Monthly Magazine* 45, no. 4 (April 1855): 425.

9. "Editor's Table," 425.

10. Cowdrey *National Academy of Design Exhibition Record,* 1:194–95.

11. Eliza Greatorex, *Homes of Ober-Ammergau* (Munich: Joseph Albert, 1872), 13–14.

12. Elizabeth Fries Lummis Ellet, *Women Artists: In All Ages and Countries* (New York: Harper & Bros, 1859), 316.

13. Ellet, 316.

14. Ellet, 316.

15. John Singleton Copley, *Portrait of Mercy Otis Warren* (1763) is in the Museum of Fine Arts, Boston.

16. Susan P. Conrad, *Perish the Thought: Intellectual Women in Romantic America, 1830–1860* (Secaucus, NJ: Citadel Press, 1978), 116–22, provides a good overview.

17. Ellet, Preface to *Women Artists,* v.

18. Harriet Hosmer is discussed in Ellet, 322–41.

19. Ellet, Preface to *Women Artists,* v; Ernst Guhl, *Die Frauen in die Kunstgeschichte* (Berlin: Verlag von J. Guttentag, 1858).

20. The phrase appears in Ellet, Preface to *Women Artists,* v.

21. Henry T. Tuckerman, *The Book of the Artists* (New York: G. P. Putnam & Son, 1867), 494.

22. Ellet, Preface to *Women Artists,* v.

23. Five months later, on October 4, 1849, her sister Matilda Pratt married Clement Johnson Despard at St. Marks Church in New York.

24. "Love Me!," words by Eliza, music by H. W. Greatorex (Richmond, VA: Geo. Dunn & Co., ca. 1861–65), private collection.

25. Henry Anstice, *History of St. George's Church in the City of New York, 1752–1811–1911* (New York: Harper & Bros., 1911), 169.

26. She instructed Frank in drawing. Later, while he was living in St. Augustine, Florida, he was invited to Fort Marion by Captain Richard Henry Pratt—later superintendent of the Carlisle Indian School—to teach drawing to the Indians being detained in Florida. See Pratt, *Battlefield and Classroom: Four Decades with the American Indian, 1867–1904* (Norman: University of Oklahoma Press, 1964), 134.

27. Sources vary on the life dates of her children, but my research with these corrected dates is based on the following records: the Federal Census, New York, 1850, states that Thomas Anthony was four months old in August 1850; on her passport application in 1921, Kathleen Honora states that she was born on September 8, 1851, in Hoboken, New Jersey.

28. One of the few biographical accounts of his life is "Henry Wellington Greatorex," in Frank J. Metcalf, *American Writers and Composers of Sacred Music* (New York: Abingdon Press, 1925), 256–62, with an engraved portrait facing p. 256.

29. A sample of Thomas Greatorex's music, "This Is the Day the Lord Hath Made," can be found on the CD *Vital Spark of Heav'nly Flame*, Hyperion Records, 1998, track 1.

30. Francis Henry Wellington ("Frank") Greatorex was born on July 11, 1846, in Hartford, Connecticut, died on November 27, 1905, and was buried in St. Augustine, Florida.

31. Metcalf, *American Writers and Composers*, 260–61. Correspondence with the archivist at St. Mark's revealed no relevant records.

32. Henry Siegling, June 28, 1899, quoted in Phil Adams Otis, *The First Presbyterian Church, 1833–1913* (Chicago: Revell Co., 1913), 212.

33. Shipping notices document these travels up and down the East Coast.

34. This testimony was authored by Professor Thomas Seymour of Yale College, according to whom Greatorex's tune "Seymour" "was named for an uncle of mine who was a bass singer in Greatorex's Choir." Otis, *First Presbyterian Church*, 213.

35. Metcalf, *American Writers and Composers*, 260–61.

36. Charles Dudley Warner, "An Unfinished Biography of the Artist," in Franklin Kelly, *Frederic Edwin Church* (Washington, DC: National Gallery of Art, 1989), 199.

37. Warner, 199.

38. Henry Wellington Greatorex, *Collection of Psalms and Hymn Tunes, Chants, Anthems and Sentences* (Hartford, CT: A. C. Goodman, 1851). It went through numerous editions, with a copyright that passed to his widow in 1879; see Metcalf, *American Writers and Composers*, 262.

39. Otis, *First Presbyterian Church*, 214.

40. It is difficult to ascertain figures for what would be the equivalent of royalties. Quotation is from Matthew Hale Smith, *Sunshine and Shadow in New York* (Hartford, CT: J. B. Burr, 1869), 291.

41. Metcalf, *American Writers and Composers*, 259.

42. Josephine Cobb, "The Washington Art Association: An Exhibition Record, 1856–1860," *Records of the Columbia Historical Society* 63/65 (1963/1965): 173–74.

43. Obituary of Henry Greatorex, *Charleston Daily Courier*, September 10, 1858.

44. M. Despard, "Eliza Greatorex," *The Aldine* 7 (February 1874): 46.

45. It was bought by the Art Fund, Britain, which "rescues" works of art for public collections.

46. Matilda Despard reports that Piloty named Greatorex along with Osborn and Rosa Bonheur as the three great living female artists. Despard, "Eliza Greatorex," 46.

47. Information on Osborn's art can be found on www.victorianweb.org/painting/osborn.

48. David M. Lubin, *Picturing a Nation: Art and Social Change in Nineteenth-Century America* (New Haven, CT: Yale University Press, 1994), 201.

49. Letters, Archives of American Art, quoted in Lubin, 166.

50. Lubin interprets some of the motifs in Spencer's art as a response to her mother's convictions. Lubin, 166–67.

51. Vera Norwood, "Women's Roles in Nature Study and of History of Environmental Protection," *OAH Magazine of History* 10, no. 3 (Spring 1996): 12.

52. Norwood, 12.

53. David S. Reynolds, *Beneath the American Renaissance: The Subversive Imagination in the Age of Emerson and Melville* (New York: Knopf, 1988), 387.

54. "Church's Niagara," *New-York Daily Times*, May 21, 1857, 4.

55. Details summarized in Sarah Cash et al., *Corcoran Gallery of Art: American Paintings to 1945* (Washington, DC: Board of Trustees of the National Gallery of Art, 2016), 112–15; National Gallery of Art website, consulted February 2, 2019, www.nga.gov/collection/art-object-page.166436.html.

56. "Rosa Bonheur's Horse Fair," *New-York Daily Times*, October 5, 1857, 4. There was no catalogue, according to the MMA website, but they based their information on the *Times*.

57. "Rosa Bonheur's Horse Fair," *New York Daily Times*, October 1, 1857, 4.

58. Candace Wheeler, *Yesterdays in a Busy Life* (New York: Harper & Brothers, 1918), 98.

59. Eleanor E. Greatorex article, originally in *Godey's Magazine*, was reproduced as "Where Rosa Bonheur Lives," *Current Opinion* 12 (January 1893): 72–73.

60. Cobb, *Washington Art Association*, 122–90; Andrew Oliver, *Portraits of John Quincy Adams and His Wife* (Cambridge, MA: Belknap Press of Harvard University Press, 1970), 190–92 on Eunice Towle.

61. Letter Leigh Hunt to Eliza Greatorex, July 27, 1858, and Jacintha Hunt Cheltnam to Eliza Greatorex, July 28, 1858, Leigh Hunt Letters, University of Iowa Libraries.

62. Cobb, "Washington Art Association," 130.

63. On Rev. George W. Samson, see the George Washington University website, consulted February 10, 2015, https://library.gwu.edu/scrc/university-archives/gw-history/presidents-of-the-university.

64. Academy Charter, December 26, 1805, quoted on the academy website, consulted March 12, 2017, www.pafa.org/museum/history-pafa.

65. After Micas's death in 1889, Bonheur met the young American portraitist Anna Klumpke, with whom she formed a strong bond.

66. Nancy Mowll Mathews, *Mary Cassatt: A Life* (New Haven, CT: Yale University Press, 1998), 20.

67. Lucy Lee Holbrook. "What Women Can Do—Art Work," *Herald of Health* (new series) 27 (February 1876): 75–76.

68. "Among the Studios," *The American Art Journal* 5 (October 1866): 378.

69. For background on Julie Hart Beers, see entry by Shannon Vittoria in my *Home on the Hudson: Women and Men Painting Landscape, 1825–1875* (Garrison, NY: Boscobel House & Garden, 2009), 7–8.

70. Margaret Bertha Wright (credited as M. B. W.), "Eleanor and Kathleen Greatorex," *The Art Amateur* 13 (September 1885): 69–70.

71. M. B. W., 69.

72. Eliza Greatorex, *Summer Etchings in Colorado* (New York: G. P. Putnam's Sons, 1873), 51.

73. Greatorex, 57.

74. Greatorex, 57.

75. Louis Legrand Noble, *After Icebergs with a Painter: A Summer Voyage to Labrador and around Newfoundland* (New York: Appleton & Co., 1861; reprint, New York: Olana Gallery, 1979), 255, 258, quoted in Eleanor Jones Harvey, *The Painted Sketch: American Impressions from Nature, 1830–1880* (Dallas: Dallas Museum of Art, 1998): 173.

76. See my article "'The Voice of Nature': The Art of Fidelia Bridges in the 1870s," *American Arts Quarterly* (Winter 2012): 27–34. For an overview of the artist's career, consult Frederic A. Sharf, "Fidelia Bridges (1834–1923): Painter of Birds and Flowers," *Essex Institute Historical Collections* 104, no.3 (1968): 217–38.

77. M. Despard, "Eliza Greatorex," *The Aldine* 7, no. 2 (February 1874): 46.

78. Since she exhibited other works from Chevreuse back in New York in 1863 and does not seem to have returned to the area until around 1880, this likely dates from 1862–63, which coordinates stylistically with dated works.

3. CIVIL WAR AND ARCHITECTURAL DESTRUCTION

1. Barnet Schecter, *The Devil's Own Work: The Civil War Draft Riots and the Fight to Reconstruct America* (New York: Walker, 2005).

2. The riots awakened prosperous New Yorkers to the huge rift between black and white, rich and poor, and to how little they understood about the underclass of the city.

3. Allan Nevins and Milton Halsey Thomas, eds., *The Diary of George Templeton Strong* (New York: Octagon Books, 1974), 3:335–440, covers the Draft Riots; quotations are from Sunday, July 19, 1863.

4. Diary quoted in Stephen D. Lut, "Martha Derby Perry, Eyewitness to the 1863 New York Draft Riots," *American Civil War* (May 2000), consulted May 4, 2013, www.historynet.com/martha-derby-perry-eyewitness-to-the-1863-new-york-city-draft-riots.htm.

5. It was chartered in 1771, but construction was delayed during the Revolutionary War. It was replaced in 1877 by a new hospital on Fifth Avenue between Fifteenth and Sixteenth Streets.

6. This famous remark is discussed in Adam Goodheart, *1861: The Civil War Awakening* (New York: Alfred A. Knopf, 2011), 19.

7. Eleanor Jones Harvey, *The Civil War and American Art* (Washington, DC: Smithsonian American Art Museum, 2012).

8. William Richard Cutler, "Fred W. Pratt," in *American Biography*, 128–29, contains information on Adam S. Pratt, father of Fred. W. Pratt.

9. Letter dated Washington, July 23, 1863, published in the *Le Roy [NY] Gazette*.

10. Greatorex, *Old New York*, 50.

11. It was exhibited as Eliza Greatorex, no. 246: *Kate Kearney's Cottage on the Banks of Killarney*. See *Catalogue of Paintings and Other Works of Art, Presented at the Metropolitan Fair in Aid of the U.S. Sanitary Commission, Sold at Auction . . .* (New York: George Nesbitt, 1864).

12. Greatorex, *Old New York*, 128–29.

13. Goodheart, *1861*, 184–215, discusses the rally.

14. Greatorex, *Old New York*, 129.

15. "Lincoln's Funeral in New York," *Harper's Weekly*, May 6, 1865, 275 (reporting on events of April 25).

16. NAD records indicate that in 1862, she exhibited *Cascade at Idlewild on the Hudson* (no. 476); in 1863, *Moodna, Hudson River* (no. 343); and in 1864, *Moodna Bridge at Idlewild* (no. 67) and *Hudson River below West Point* (no. 123); Maria Naylor, *National Academy of Design Exhibition Record, 1861–1900* (New York: Kennedy Galleries, 1973), 1:360.

17. Benson J. Lossing, *The Hudson: From the Wilderness to the Sea* (New York: Virtue and Yorston, 1866), 203–7; N. P. Willis, *Out-doors at Idlewild; or The Shaping of a House on the Banks of the Hudson* (New York: Charles Scribner, 1855).

18. The phrase "demon-cloud" is from a poem by Melville, quoted from the Philadelphia Museum of Art website, consulted October 9, 2019, www.philamuseum.org/collections /permanent/94025.html.

19. "National Academy of Design—Fortieth Annual Exhibition," *The New Path* 2 (June 1865): 97.

20. "Exhibition of the National Academy," *Harper's Weekly*, May 20, 1865, 307.

21. Herman Melville, "'Formerly a Slave,'" from *Battle Pieces*, in *Tales, Poems, and Other Writing*, ed. John Bryant (New York: The Modern Library, 2002): 357–58.

22. Quoted in Joshua C. Taylor et al., *Perceptions and Evocations: The Art of Elihu Vedder* (Washington, DC: National Collection of Fine Art, 1979), 126.

23. Taylor et al., 126.

24. Edwin G. Burrows and Mike Wallace, *Gotham: A History of New York City to 1898* (New York: Oxford University Press, 1999), 854–55.

25. Ira Berlin and Leslie Harris, eds., *Slavery in New York: The African American Experience* (New York: New Press, 2005).

26. Compare Vedder's attitude towards his black sitter with that of Augustus Saint Gaudens. See Albert Boime, *The Art of Exclusion: Representing Blacks in the Nineteenth Century* (Washington, DC: Smithsonian Institution Press, 1990), 207–8.

27. Website of the United States Colored Troops, Civil War Trust,www.civilwar.org /learn/collections/united-states-colored-troops.

28. Quoted in Taylor et al., *Perceptions and Evocations*, 126.

29. The poem is discussed in Stanton Garner, *The Civil War World of Herman Melville* (Lawrence: University of Kansas Press, 1993), 400–401.

30. Greatorex, *Old New York*, 231.

31. Naturalization Records, March 25, 1867, National Archives at New York City.

4. SUCCESS IN THE NEW YORK ART WORLD, 1865–1870

1. She inscribed a visiting card with an embossed G at the top: "Eliza Greatorex. Studio 8, 212 Fifth Ave., 6 December 1866," Theodore Dwight Papers, Massachusetts Historical Society. Her next residence, through 1877, was at 115 East Twenty Third Street.

Trow's New York City Directory (New York: Trow City Directory Company), vols. 1870–77. In a letter to Mrs. William Page dated September 11, 1877, she explained that she had already engaged a studio at Seventeenth Street and Fifth Avenue. William Page Papers, roll 22, Archives of American Art, Smithsonian Institution, Washington, DC.

2. James D. McCabe, *Lights and Shadows of New York Life* (Philadelphia, 1872): 128. "More about Buildings," *New York Times*, August 3, 1869, 2.

3. Anna Mary Freeman, active 1842–59; Annette Blaugrund, "The Tenth Street Studio Building: A Roster, 1857–1895," *American Art Journal* 14 (1982): 64–71.

4. Martha Bertha Wright (credited as M. B. W.), "Eleanor and Kathleen Greatorex," *The Art Amateur* 13 (September 1885): 69, states: "During some months Mrs. Greatorex studied in Paris with Émile Lambinet, the landscapist, the children remaining in America. At her return, during the sixties, she took a studio in what was then called the New Dodworth Building, at Twenty-sixth Street and Fifth Avenue."

5. Wright, 69.

6. "James David Smillie Dead," *New York Times*, September 15, 1909, 9; Rona Schneider, "The Career of James David Smillie as Revealed in His Diaries," *American Art Journal* 16 (Winter 1984): 4–33.

7. "Fine Arts: The Studios on Tenth Street and Broadway," *Evening Post* (New York), February 7, 1868, 2.

8. Lewis I. Sharp, *John Quincy Adams Ward: Dean of American Sculptors* (Newark: University of Delaware Press, 1985), 40–42, discusses these years but makes no mention of Greatorex.

9. 10. *Sketches in Rome.* Maria Naylor, *National Academy of Design Exhibition Record, 1861–1900* (New York: Kennedy Galleries, 1973), 1:360.

10. Smillie's diary mentions interactions with the Greatorex women including shared musical evenings. James D. Smillie Diaries, James D. Smillie and Smillie Family Papers, 1853–1957, Archives of American Art, Smithsonian Institution, Washington, DC.

11. "Mrs. Greatorex, Mrs. Julia Beers and Miss Wenzler are at Dodworth's building in Fifth avenue," quotation from "The Women Artists of New York and Its Vicinity," *Evening Post* (New York), February 24, 1868, 2.

12. In 1876 Delmonico's, the most fashionable restaurant in New York, moved here. The women's Sorosis Club met in an upstairs room.

13. Allen Dodworth, *Dancing and Its Relation to Education and Social Life* (New York: Harper, 1885).

14. "Home and Foreign Gossip," *Harper's Weekly*, March 28, 1868, 220.

15. Gerald L. Carr, "Sanford Robinson Gifford's Gorge in the Mountains Revived," *Metropolitan Museum Journal* (2003): 215–16, provides useful background.

16. Junius Henri Browne, *The Great Metropolis: A Mirror of New York* (Hartford, CT: American Publishing Co., 1869), 442–43.

17. Records of the Ladies Art Association (New York), 1871–1914. Historical Library, Swarthmore College, Swarthmore, PA.

18. Kirsten Swinth, *Painting Professionals: Women Artists and the Development of Modern American Art, 1870–1930* (Durham: University of North Carolina Press, 2001), 117–18, provides background on the LAA.

19. Alice Donlevy Papers, New York Public Library, includes the records of the Ladies Art Association. Among them were materials Greatorex sent from Munich on women's art training in Germany.

20. For further elaboration of her salons, see chapter 7.

21. See Paula Bernat Bennet, "Subtle Subversion: Mary Louise Booth and *Harper's Bazar* (1867–1889), in *Blue Pencils & Hidden Hands: Women Editing Periodicals, 1830–1910*, ed. Sharon Harris with Ellen Gruber Garvey (Boston: Northeastern University Press, 2004), 225–43.

22. *Our Famous Women: An Authorized Record of the Lives and Deeds of Distinguished American Women of Our Times* (Hartford, CT: A. D. Worthington & Co., 1884): 132.

23. "Fine Arts," *Evening Post* (New York), December 22, 1868, 2. "Mrs. Eliza Greatorex held an art reception at her pleasant studio, No. 212 Fifth avenue, on Saturday last, which was well attended."

24. "Fine Arts," *Evening Post* (New York) January 9, 1869, 2.

25. David W. Dunlap, *From Abyssinian to Zion: A Guide to Manhattan's Houses of Worship* (New York: Columbia University Press, 2004), 177.

26. Henry Adams, *The Education of Henry Adams* (New York: Modern Library, 1931), chap. 16.

27. Robert Herbert, *Impressionism: Art, Leisure & Parisian Society* (New Haven, CT: Yale University Press, 1988), 3.

28. Sarah Kennel, *Charles Marville: Photographer of Paris* (Washington, DC: National Gallery of Art, 2013).

29. John Durand, *The Life and Times of A. B. Durand* (New York: Charles Scribner's Sons, 1894), 198.

30. Sylvester R. Koehler, "The Works of the American Etchers: XXII.—Mrs. Eliza Greatorex," *American Art Review* 2, no. 7 (May 1881): 12. Koehler was referring to her election as associate of the National Academy (ANA) in 1869.

31. Hilary Ballon, ed., *The Greatest Grid: The Master Plan of Manhattan, 1811–2011* (New York: Columbia University Press, 2012) provides background.

32. Greatorex, *Old New York*, 184.

33. Greatorex, Prospectus for *Old New York*, March 10, 1875, New-York Historical Society Library.

34. Greatorex, *Old New York*, 184.

35. Greatorex, 184.

36. "Fine Arts," *Evening Post* (New York), December 2, 1868, 2.

37. Sarah Orne Jewett, *A Country Doctor* (Boston: Houghton Mifflin, 1884), 294–95.

38. "Fine Arts," *The Evening Post* (New York), December 2, 1868, 2.

39. Erin Kristl Pauwels, "Napoleon Sarony's Living Pictures: Photography, Performance & American Art, 1865–1900" (PhD diss., Indiana University, 2015) provides background on him.

40. *Relics of Manhattan: A Series of Photographs from Pen and Ink Sketches Taken on the Spot in 1869* (New York 1869); bound, quarto (10 in. × 7⅞ in.), 15 plates. The date 1869 indicates the date when the book was actually bound together, but the works had been photographed and exhibited in late 1868 (as documented in the press).

41. Alfred V. Frankenstein, *Painter of Rural America: William Sidney Mount* (Washington, DC: H.K. Press, 1968) includes "Autobiographical Press Release by William Schaus."

42. "Art Notes," *Watson's Weekly Art Journal*, December 12, 1868, 227.

43. "Fine Arts," *The Evening Post* (New York), January 9, 1869, 2.

44. On western photography and the illustrated book, see Martha A. Sandweiss, *Print the Legend: Photography and the American West* (New Haven, CT: Yale University Press, 2002): 275–324, quotation from 276.

45. "Exhibition of the National Academy of Design," *Watson's Art Journal*, April 17, 1869, 299.

46. Jervis McEntee Diaries, April 7, 1874, Archives of American Art, Smithsonian Institution, Washington, DC. For full entry see www.aaa.si.edu/collection-features/jervis-mcentee-diaries/diary-entry?date=18740407.

47. Naylor, *National Academy of Design Exhibition Record*, 1:360–61.

48. "Fine Arts: The National Academy of Design," *The Albion*, May 1, 1869, 243–44.

49. "National Academy of Design. I," *Watson's Art Journal*, April 24, 1869, 307.

50. Thomas Seir Cummings, *Historic Annals of the National Academy of Design* (Philadelphia: G.W. Childs, 1865), provides minutes of the annual meetings including results of membership votes every year in May; for the two-thirds vote rule mentioned, see 228. Archival records of the NAD provide no further information about her election.

51. Her efforts culminated in the painting *We Both Must Fade* (1869; Smithsonian American Art Museum).

52. Later Healy did a portrait of Vinnie Ream (1870; Smithsonian American Art Museum) when they were both in Rome.

53. "Fine Arts," *Putnam's Magazine*, May 1869, 637.

54. David Dearinger, *Paintings and Sculpture in the Collection of the National Academy of Design* (New York: Hudson Hills Press, 2004) 1:62.

55. A number of images throughout the history of art show learned men/scholars identified by pen. Her pen functions as an implement for writing as well as drawing and as an emblem of her erudition. Journal of William MacLeod, curator for William Corcoran, June 6, 1876, Corcoran Gallery of Art Archives, George Washington University, Washington, DC.

56. Exhibited at the NAD: Winter, 1869–70, no. 231 and Annual Exhibition, 1870, no. 538. See David Dearinger, *Paintings and Sculpture in the Collection of the National Academy of Design* (New York: Hudson Hills Press, 2004) 1:62.

57. See my "Bavarian Beginnings of Eliza Greatorex," in *American Artists in Munich: Artistic Migration and Cultural Exchange Processes*, ed. Christian Fuhrmeister (Berlin: Deutscher Kunstverlag, 2009), 153–66.

5. IN THE FOOTSTEPS OF DÜRER, 1870–1872

1. M. Despard, "Eliza Greatorex," *The Aldine* 7 (February 1874): 46.

2. Despard, 46.

3. See my chapter "Leonardo's Legacy to the American Artist, 1820–1860," in *The Italian Presence in American Art* (New York: Enciclopedia Italiana and Fordham University Press, 1990), 56–65.

4. Teresa Carbone and Patricia Hills, *Eastman Johnson: Painting America* (Brooklyn, NY: Brooklyn Museum, 1999), 19–32.

5. Jane Campbell Hutchison, *Albrecht Dürer: A Biography* (Princeton, NJ: Princeton University Press, 1990), 187.

6. During World War II, a highly explosive bomb landed nearby and caused serious damage, but the site was extensively restored. The city bought the structure in 1828 and it is now a museum.

7. M. Despard, "Nuremberg Cobble-Stones," *Appleton's Journal*, May 13, 1876, 625–26.

8. "Fine Arts," *New York Times*, June 4, 1871, 3.

9. Putnam printed it in 1874.

10. "Nuremberg" first appeared in Longfellow's *The Belfry of Bruges and Other Poems* of 1845; oddly, he is not credited as the author of the poem on Greatorex's print.

11. "Despite the fact that after 1550 Dürer's grave was cleared and re-used for the burial of a succession of clergymen from the Heilig-Geist-Spital, his last resting place has continued to exert a morbid fascination. His tombe was renovated in 1681 at the personal expense of the art historian Joachim von Sandart, who purchased the grave plot and deeded it to the newly-founded Nuremberg Academy—the first German academy of art." Hutchison, *Albrecht Dürer*, 189.

12. Hutchison, 187.

13. Eliza Greatorex, *The Homes of Ober-Ammergau: A series of twenty etchings in heliotype, from the original pen-and-ink drawings, together with notes from a diary kept during a three months' residence in Ober-Ammergau, in the summer of 1871* (Munich: Jos. Albert, 1872), 1. The writer for *Harper's* states that the book was published by Albert in Munich and Putnam's in New York.

14. Greatorex, *Homes of Ober-ammergau*, 12.

15. Linda H. Peterson, "Mother-Daughter Productions: Mary Howitt and Anna Mary Howitt in 'Howitt's Journal,'" *Victorian Periodicals* 31 (Spring 1998): 31–54.

16. For her background in London, see John Hanners, "A Tale of Two Artists: Anna Mary Howitt's Portrait of John Banvard," *Minnesota History* (Spring 1987): 204–8.

17. *Anna Mary Howitt, An Art-Student in Munich* (London, 1853), 5.

18. Peterson, "Mother-Daughter Productions."

19. "Glimpses of Munich: From 'An Art-Student in Munich,'" *The Crayon* 5 (January 1858): 15–18; (April 1858): 105–6; (June 1858): 162–65; (July 1858): 193–96; quotation from 196.

20. "Glimpses of Munich," 196.

21. Eleanor Elizabeth Greatorex (credited as E. E. G.), "Student Life in Munich," *The New Century for Woman*, September 2, 1876, 131.

22. Attendance records at the academy give no evidence of her presence there.

23. Greatorex to Champlain, February 13, 1874, private collection.

24. Maria Naylor, *National Academy of Design Exhibition Record, 1861–1900* (New York: Kennedy Galleries, 1973), 1:360–61.

25. Naylor 1:360–61.

26. Margaret Bertha Wright (credited as M. B. W.), "Eleanor and Kathleen Greatorex," *Art Amateur* 13 (September 1885): 69.

27. See William M. Kramer and Norton B. Stern, *San Francisco's Artist Toby E. Rosenthal* with *Rosenthal's Memoir of a Painter*, trans. Marlene Rainman (Northridge, CA: Santa Susana Press, 1978).

28. "National Academy of Design. Reception Last Evening," *Evening Post* (New York), April 8, 1875, 3.

29. William MacLeod, William Corcoran's curator, made entries in his journal related to Toby Rosenthal's portrait of Eliza Greatorex on the following dates: March 27, 1878; March 29, 1878; October 15, 1880; March 14, 1881; and February 22, 1882; transcriptions of the journals of William MacLeod, Corcoran Gallery of Art Archives.

30. Wright, "Eleanor and Kathleen Greatorex," 69.

31. Wright, 69.

32. Ellen Creathorne Clayton, *English Female Artists* (London: Tinsley Brothers, 1876), 2:160–61, quoted in Jacqueline Marie Musacchio, "Infesting the Galleries of Europe: The Copyist Emma Conant Church in Paris and Rome," *NCAW* 10 (Autumn 2011): 4, where Musacchio postulates that Conant must have attended Gigi's.

33. Margaret Bertha Wright, "Gigi's: A Cosmopolitan Art-School," *Lippincott's Magazine of Popular Literature and Science*, January 1881, 9–16.

34. She exhibited pictures of these subjects at the NAD in 1868; in *Summer* Etchings, 35–36, she compares the western sky to a sunrise she saw on the Bay of Naples.

35. Her etchings of the 1880s repeat motifs she had visited earlier.

36. Naylor, *National Academy of Design Exhibition Record*, 1:360–61.

37. "Art Notes," *Evening Post* (New York), January 4, 1872, 1. The report concluded: "The collection, we learn, is at present in the possession of Mr. S. P. Avery."

38. His papacy coincided with an incredibly tumultuous time, with the unification of Italy and Germany and many other significant changes across Europe.

39. "81. Presentation to the Pope," in John Murray, *A Handbook of Rome and Its Environs* (London: John Murray, 1881), 40–41.

40. Murray, 40–41.

41. "Mrs. Greatorex in Europe," *Evening Post* (New York), May 24, 1871, 1.

42. Alfred Werner, *Inness: Landscapes* (New York: Watson-Guptill Publications, 1999): 13.

43. Eliza Greatorex, *Homes of Ober-Ammergau*, 5.

44. Greatorex, 5.

45. Greatorex, 18.

46. Without the original drawings, it is impossible to know if they contained more details than the published illustrations.

47. Greatorex, *Homes of Ober-Ammergau*, 17.

48. *Catalogue Sale of Private Collection of Paintings, Old Engravings, Old China, Properties and Furniture Belonging to Mrs. Eliza Greatorex* (New York: Privately printed, 1878), nos. 9, 10, 11, and 14, respectively. 86 lots. Auctioneer unknown. Sale held at Mrs. Greatorex's studio, 2 East 17th St., New York, February 14, 1878. New York Public Library, New York, NY.

49. *Catalogue Sale*, nos. 3–8.

50. She owned a copy of the *Album of the Passion Play in Oberammergau, Bavarian Tyrol, containing Sixty Photographs from the Scenes of the Play*—1870-'71, a tourist's souvenir that could have served as aide-mémoire in her delineation of its theatrics, but chose not to. See *Catalogue Sale*, no. 1.

51. A "Drawing by Tobias Flunger (Christus of 'Quits.')" in *Catalogue Sale*, no. 18.

52. *Catalogue Sale*, no. 13: "*Homes of Ober-Ammergau*, cover carved by Joseph Maier (Christus of Play 1870–71)." This carved book cover, containing a set of Oberammergau heliotypes, has been preserved in the New York Public Library.

53. Greatorex, *Homes of Ober-Ammergau*, 6.

54. "Dedicated to the Geistlicher Rath Daisenberger." Greatorex, *Homes of Ober-Ammergau*, frontispiece; the leather cover is adorned with a cross.

55. Greatorex, *Homes of Ober-Ammergau*, 33, 40.

56. Greatorex, 29–30.

57. This continues to the present day; Otto Huber, Afterward, *The Homes of Oberammergau* by Eliza Greatorex (repr., West Lafayette, IN: NotaBell Books, 2000), 53n.

58. She noted of another family that Johannes played the part of John and that his father (the present Matthew) had taken the part of St. John in the year 1840, that of Peter in 1850, of St. James the elder in 1860, and that of Matthew in 1870–71. His grandfather had taken the part of the Christus in the year 1800 and of Peter in 1820.

59. Greatorex, *Homes of Ober-Ammergau*, 20.

60. Greatorex, 23.

61. Greatorex, 8.

62. Despard, "Eliza Greatorex," 46.

63. Despard, 46.

64. Thanks to Helmut Hess for sharing his knowledge of Albert's publishing enterprises. See also Winfried Ranke, *Joseph Albert, Hofphotograph der Bayerischen Könige* (München: Schirmer/Mosel, 1977).

65. "Photography without Light," *New York Times*, May 14, 1871, 2.

66. John P. Jackson, *Album of the Passion-Play at Ober-Ammergau* (Munich: Joseph Albert, 1874).

67. *London Saturday Review*, May 17, 1873, quoted in Lucy Lee Holbrook, "What Women Can Do—Art Work," *Herald of Health* 27 (February 1876): 75. Positive reviews appeared in *Harper's Weekly* and in other American periodicals. No diary has been located to my knowledge.

68. "Eliza Greatorex," *The Aldine* 6, no. 2 (February 1873): 48.

69. "Mrs. Greatorex in Europe," *Evening Post* (New York), May 24, 1871, 1.

70. Eliza Greatorex to George P. Putnam, December 17, 1872, Theodore Dwight Papers, Massachusetts Historical Society.

71. *London Saturday Review*, May 17, 1873, quoted in Holbrook, "What Women Can Do," 75.

72. "Passengers Arrived," *New York Times*, October 29, 1872, 8.

73. Despard, "Eliza Greatorex," 46.

74. Eliza Greatorex, *Summer Etchings in Colorado*, with introduction by Grace Greenwood (New York: G. P. Putnam's Sons, 1873).

6. TAMING THE WEST

1. *Rocky Mountain News* (Denver), July 1, 1873, 4.

2. Nathaniel Langford, "The Wonders of the Yellowstone," *Scribner's Monthly* 2 (May 1871): 1–17; (June 1871): 113–28.

3. Isabella Bird, *A Lady's Life in the Rocky Mountains* (New York: G. P. Putnam's Sons, 1879), 102.

4. Karin M. Morin, "Peak Practices: Englishwomen's 'Heroic' Adventures in the Nineteenth-Century American West," *Annals of the Association of American Geographers* 88 (September 1999): 496.

5. See, for example, illustrations in Henry T. Williams, *The Pacific Tourist* (New York: H. T. Williams, 1876).

6. Eliza Greatorex, *Summer Etchings in Colorado* (New York: G. P. Putnam's Sons, 1873), 18–19, quotes on Indians seen from train; 31–34, focuses on Indians in Manitou. In this group portrait Ouray is at center wearing a beaded buckskin shirt, his wife Chipeta is at his left, and Otto Mears is at his right, holding a top hat and cane. It is likely that Chaveneau is among the group.

7. Her well-known scenes also included *Across the Continent: Westward the Course of Empire Takes Its Way* (1868).

8. Susan Coolidge (a.k.a. Sarah Chauncey Woolsey), "A Few Hints on the California Journey," *Scribner's Monthly*, May 1873, http://cprr.org/Museum/Calif_Journey_1873/index.html.

9. Coolidge, "A Few Hints."

10. Greatorex, *Summer Etchings*, 17.

11. Coolidge, "A Few Hints."

12. Greatorex, 17.

13. Coolidge, "A Few Hints."

14. Greatorex, 19–20.

15. Greatorex, 20–21.

16. Greatorex, 22.

17. Coolidge, "A Few Hints."

18. Greatorex, *Summer Etchings*, 13.

19. "Tableaux at Manitou," *Colorado Springs Gazette*, July 12, 1873, 2.

20. Greatorex, *Summer Etchings*, 93.

21. Greatorex, 55–56. Iles was brought to Colorado Springs by Dr. Bell to manage the hotel but was fired by Palmer for serving liquor in what Palmer wanted to be a dry

town. He then moved to the outskirts of Manitou and started his own establishment. See Scrapbook page for William Bennett Iles on Ancestry.com, accessed August 26, 2011.

22. Greatorex, *Summer Etchings*, 94.

23. "A Colorado Tragedy: The Murder of Mr. Thomas A. Greatorex, a Former Resident of Washington," *National Republican*, March 29, 1881.

24. *Boyd's Directory of Washington & Georgetown* (Washington, DC, 1867), 288.

25. In 1874 he was listed in the Denver directory as a clerk, boarding at the Grand Central and working for the Denver & Rio Grande Railroad; *Denver Colorado City Directory* (Denver, CO: 1874): 120. One of the few secondary sources to take any note of Tom Greatorex is Allen Nossaman, *Many More Mountains*, vol. 3: *Rails into Silverton* (Sundance Books), 47, 243, 255, 277, 279, 290, 292, 299, 319, 336. I am grateful to Freda Peterson Nichols Hills for kindly sharing references in the San Juan County Newspaper Index.

26. One website with a useful overview: www.nps.gov/history/history/online_books/blm/co/10/chap6.htm.

27. "Shooting Thos. Greatorex," from the *Durango Record*, reprinted in *Fremont County Record*, March 26, 1881, 1.

28. State directories provide the following information: in 1880 and 1881 he was living in Silverton, doing abstracts. See *Colorado State Business Directory* (Denver, 1880), 125; *Colorado State Business Directory* (Denver, 1881), 288.

29. *Colorado Springs Gazette*, July 19, 1873, 2.

30. Information on Thomas and Anne Parrish from Kirkland Museum, Denver, Colorado, website, consulted March 8, 2018, www.kirklandmuseum.org/collections/colorado-regional-art/about-colorado-regional-art.

31. Eleanor J. Harvey, "Thomas Moran and the Spirit of Place," Dallas Museum of Art, 2001; online pamphlet, consulted March 24, 2019, www.tfaoi.com/aa/2aa/2aa543.htm.

32. Grace Greenwood, "Then and Now," introduction to Greatorex, *Summer Etchings*, 8.

33. Greaterex, *Summer Etchings*, 30. Here she is quoting from early resident Colonel Steen.

34. Maine Historical Society Website: Henry Wadsworth Longfellow, consulted May 22, 2014, www.hwlongfellow.org/poems_poem.php?pid = 296.

35. It still had its former name in 1873, when Greatorex dedicated her book "To the gentlemen of the Fountain Colony."

36. Manitou Springs website, consulted June 12, 2019, www.manitouspringsgov.com/.

37. Henry Adams et al., *John La Farge* (Pittsburgh: Carnegie Museum of Art, 1987), 241. John La Farge visited there in 1868.

38. Helen Hunt Jackson, "Colorado: A Symphony in Yellow and Red," in *Bits of Travel at Home* (Boston: Roberts Brothers, 1878), 217. She said it was more aptly named "Fortress of the Gods, or Tombs of the Giants."

39. Greaterex, *Summer Etchings*, 75–76. She further developed these ideas in "The Garden of the Gods," *St. Nicholas Magazine*, December 1874, 64–69.

40. "Editor's Literary Record: Christmas Books" (review of *Summer Etchings in Colorado*), *Harper's New Monthly Magazine*, January 1874, 296.
41. Greatorex, *Summer Etchings*, 15.
42. "Alexander Mitchell's Home: A Visit to the Residence of the Wisconsin Railroad King," *New York Times*, November 15, 1884, 3, provides one of the most complete accounts of the mansion, including the art gallery.
43. Gardner C. Hill, MD, "A Famous Institution: Miss Catherine Fiske's Boarding School of the Early Days," *The Granite Monthly: A New Hampshire Magazine* 39 (1907): 337.
44. Mary A. Livermore and Frances E. Willard, eds., *A Women of the Century: Fourteen Hundred-Seventy Biographical Sketches* (Buffalo, NY: Charles Wells Moulton, 1893), 510–11, provides the most complete biography of Martha Reed Mitchell I have found to date.
45. "An Artistic Reunion," *Evening Post* (New York), June 28, 1875, 4.
46. See my "Eliza Greatorex and Her Artistic Sisterhood in the Collection of Martha Reed Mitchell, 1863–1877," *Women's Studies* 39, no. 6 (2010): 518–35.
47. Margaret Bertha Wright (credited as M. B. W.), "Eleanor and Kathleen Greatorex," *The Art Amateur* 13 (September 1885): 69.
48. Biographical information was provided by Hawthorne Fine Art, New York, based on interviews with a family descendant. My thanks to Jennifer Krieger for sharing information.
49. Elisabeth Jerichau-Baumann, *Brogede Rejsebilleder* (Copenhagen: Thieles Bogtrykkeri, 1881). See also Nicholaj Bøgh, *Elisabeth Jerichau-Baumann: En Karakteristik* (Copenhagen: Trykt hos. J. Jørgenson and Co., 1886).
50. *The Art Journal*, June 1866, 194, quoted in Reina Lewis, *Gendering Orientalism: Race, Femininity and Representation* (London: Routledge, 1996), 119, which provides the most complete account of this artist. For illustrations of the works mentioned, see Lewis, plates 24 and 26.
51. Mrs. Charles LeNoir, "Villa Alexandria, Mrs. Alexander Mitchell, South Jacksonville," *American Life Histories: Manuscripts from the Federal Writers Project, 1936–1940*, www.loc.gov/resource/wpalh1.11090418.
52. Greatorex, *Summer Etchings*, 84–85.
53. Greatorex, *Summer Etchings*, 35.
54. Greatorex, 36.
55. Greatorex, 24.
56. Helen Hunt Jackson, *The Helen Jackson Year-Book*, selected by Harriet T. Perry (Boston: Roberts Bros., 1895), 112, entry for July 17 (no year), Cheyenne Canyon.
57. Greatorex, *Summer Etchings*, 41–42.
58. Greatorex, 71–73.
59. Susan B. Anthony, Elizabeth Cady Stanton, and Matilda Joslyn Gage, eds., *History of Woman Suffrage*, vol. 1 (New York: Fowler & Wells, 1881).
60. Margaret Fuller, *Summer on the Lakes, in 1843* (Boston: C. C. Little, 1844), 42.
61. Greatorex, *Summer Etchings*, 15.
62. "Art Notes," *The Evening Star* (Washington, DC), November 19, 1873, 1.

63. Letter from Eliza Greatorex to Fuller-Walker, Manitou House, Manitou, CO, July 22, 1873, private collection.

64. This date September 26, 1873 (a Sunday), appears on the dedication page of the book. Her handwritten draft of the dedication is in the Massachusetts Historical Society, Theodore Dwight Papers. (Theodore Dwight worked for George Putnam, publisher of her book.)

65. "Art Notes," *The Evening Star* (Washington, DC), November 19, 1873, 1.

66. This copy of the book is in a private collection.

67. "'Graphic' Etchings," *The Daily Graphic* (New York), December 26, 1873, 370.

68. Deborah Harrison, *Manitou Springs* (Images of America series, Charleston, SC: Arcadia, 2012), 24.

69. "Christmas Books," *Harper's New Monthly Magazine*, January 1874, 296.

70. Greatorex and Greenwood shared many mutual acquaintances back east, including not only Cushman and Helena de Kay, but also famous suffragist Susan B. Anthony and journalist Mary Louise Booth.

71. *Colorado Springs Gazette*, September 6, 1873, 4.

72. Grace Greenwood, *New Life in New Lands: Notes of Travel* (New York: J. B. Ford, 1873).

73. As the catalogue explained, "269–280 are the original Pen and Ink Drawings forming part of the illustrations in *Summer Etchings* by Grace Greenwood and Mrs. Greatorex, published by Putnams." These included: #269, *Col. Steen's Camp*; #270, *First Glimpse of Manitou*; #271. *Tim Bunker's Pulpit*; #272, *The Client*; #273, *Looking Out*; #274, *The New Town*; #275, *The Lodge*; #276, *The Home*; #277, *Monuments of the Park*; #278, *The Gods of the Garden*; #279, *Lady Ellen's Bower*; and #280, *The Bath*.

74. "Art: Brooklyn Art Association," *The Aldine* 7, no. 2 (February 1874): 48.

75. "Christmas Books," 296.

76. "Art Notes," *The Evening Star* (Washington, DC), November 19, 1873, 1.

77. "Christmas Books," 296.

78. Greenwood, *New Life in New Lands*, 126–27.

79. By the late 1870s her Clematis Cottage was being rented to summer visitors in the absence of the owner, and it floated away in the 1894 flood of Fountain Creek. Harrison, *Manitou Springs*, 25.

80. The phrase comes from a newspaper headline: "A Financial Thunderbolt," *New York Tribune*, September 19, 1873, 1.

81. Charles R. Morris, "Freakoutonomics" (op-ed), *New York Times*, June 2, 2006, A21.

7. OLD NEW YORK (1875)

1. Eliza Greatorex to John Champlain, February 1874, private collection.

2. Wrappers are in the collection of David G. Wright, whose assistance with these and other details is gratefully acknowledged.

3. Eliza Greatorex, *Old New York, from the Battery to Bloomingdale*, with text by M.[atilda] Despard (New York: G. P. Putnam's Sons), 96.

4. Greatorex, 89.

5. Cathy N. Davidson and Jessamyn Hatcher, eds., *No More Separate Spheres! A Next Wave American Studies Reader* (Durham, NC: Duke University Press, 2002).

6. Journalists mentioned that she carried pen and ink into the field.

7. Greatorex, *Old New York*, 115.

8. Greatorex, 131.

9. These appear in *Old New York*, 222, 218, and 153.

10. Michael Nicholas, *Hell Gate: A Nexus of New York City's East River* (Albany: State University of New York Press, 2018), 29–30, discusses Greatorex's visit to the area; quotation is from 30.

11. Obituary of Madam Eliza Jumel, *New York Times*, July 18, 1865, 4.

12. Later she was forced to sell them; see *Catalogue Sale of Private Collection of Paintings, Old Engravings, Old China, Properties, and Furniture, Belonging to Mrs. Eliza Greatorex* (New York: Privately printed, 1878), 86 lots, auctioneer unknown, sale held at Mrs. Greatorex's studio, 2 East 17th St., New York, February 14, 1878, copy in New York Public Library, New York, NY.

13. Susan Fenimore Cooper, *Rural Hours* (New York: George P. Putnam, 1850).

14. Vera Norwood, "Women's Roles in Nature Study and of History of Environmental Protection," *OAH Magazine of History* 10, no. 3 (Spring 1996): 12.

15. Rochelle Johnson, "James Fenimore Cooper, Susan Fenimore Cooper, and the Work on History," paper presented at the 1999 Cooper Seminar (no. 12), SUNY Oneonta.

16. M. Despard, "The Harsen House," *The Aldine* 6 (October 1873): 198.

17. Andreas Huyssen, *Twilight Memories: Marking Time in a Culture of Amnesia* (New York: Routledge, 1995), 3.

18. Greatorex, *Old New York*, 67.

19. Richard White, "When the Idea of Home Was Key to American Identity," *Smithsonian*, September 18, 2017, provided insights for this discussion. www.smithsonianmag .com/history/when-idea-home-was-key-american-identity-180964892/.

20. Eliza Greatorex, Prospectus for *Old New York*, signed March 10, 1875, New-York Historical Society Library.

21. Letter from Eliza Greatorex to Fuller-Walker, Manitou House, Manitou, Colorado, July 22, 1873; *Summer Etchings in Colorado*; both private collection. Fuller-Walker was a columnist who signed his name only with this hyphenated surname and no first name. To date, no portrait of Matilda Pratt Despard has been located. I have not found a specific mention of her involvement in *The Homes of Oberammergau*, but we know that she was side by side with her in Munich, as she arranged for the reproduction of the drawings and the publication of the book.

22. Anne Higonnet, *Berthe Morisot* (New York: Harper Perennial, 1991), 10.

23. According to the New York City Directory, in 1850–51 Henry W. Greatorex was a teacher with a music studio at 609 Broadway and residence at 79 East 16th Street. The US Census for 1850 lists Henry and Eliza living in a household with Francis Greatorex (four-year-old male child) and Thomas (four-month-old male child), two other females—Mary and Bridget (likely servants)—and Matilda and Clement Despard.

24. Toni McNaron, *The Sister Bond: A Feminist View of a Timeless Connection* (London: Pergamon Press, 1985), introduction.

25. Mary R. Reichardt, "'Friends of My Heart': Women as Friends and Rivals in the Short Stories of Mary Wilkins Freeman," *American Literary Realism 1870–1910* 22 (Winter 1990): 54–68.

26. Carroll Smith-Rosenberg, *Disorderly Conduct: Visions of Gender in Victorian America* (New York: Knopf, 1985), 62.

27. H[einrich] Hoffmann, *Prince Greenwood and Pearl-of-Price, with their Good Donkey Kind and Wise*, trans. M. Despard, illus. Eleanor Greatorex (Washington, 1874).

28. M. Despard, "Music in New York Thirty Years Ago," *Harper's New Monthly Magazine* 57 (1878): 113–21.

29. M. Despard, "Eliza Greatorex," *The Aldine* 7 (February 1874): 46.

30. M. Despard, "Nuremberg Cobble-Stones," *Appleton's Journal*, May 13, 1876: 625–26.

31. *Kilrogan Cottage: A Novel* (New York: Harper & Bros, 1878). This is one of the Harpers Library of Select Novels.

32. M. Despard, "The Harsen House," *The Aldine* 6 (October 1873): 198.

33. Harriet Prescott Spofford, *A Little Book of Friends* (Boston: Little Brown,1916), 25, 117–30. As my book was going to press, I discovered that a biography of her had just been published: Tricia Foley, *Mary L. Booth: The Story of an Extraordinary 19th-Century Woman* (CreateSpace Independent Publishing Platform, December 2018).

34. Susan P. Conrad, *Perish the Thought: Intellectual Women in Romantic America, 1830–1860* (New York: Oxford University Press, 1976), 187–89, provides background on Booth's literary career.

35. It was not until 1901 that it moved to a monthly issued magazine, which it maintains today. Since Hearst purchased it in 1913, it has been owned and operated by Hearst Corp. in the United States and National Magazine Company in the United Kingdom.

36. Mary Louise Booth obituary, *American Stationer*, March 7, 1889, 587.

37. Information from text panels at Interpretive Center, Fort Ward, VA, visited May 24, 2011.

38. In October 1863, Lincoln adopted her idea for a national Thanksgiving Day, for which she had campaigned for twenty years.

39. Lori D. Ginzberg, *Untidy Origins: A Story of Woman's Rights in Antebellum New York* (Chapel Hill: University of North Carolina Press, 2005), 13–14.

40. "Portrait of a Female Couple," www.glbtg.com/social-sciences.anthony.

41. Elizabeth Stuart Phelps et al., *Our Famous Women: An Authorized Record of the Lives and Deeds of Distinguished American Women of Our Times* (Hartford, CT: A. D. Worthington, 1884, accessed via Google Books), 131–32. The author concludes: "To Mrs. Wright, more than any other woman I have known, do Wordsworth's lines apply—

"A perfect woman, nobly planned
"To warn, to comfort, and command."

42. Phelps et al., 131–32.

43. William Webster Ellsworth, "Some Literary Reminiscences: Second Paper," *The Bookman* 49 (1919): 670.
44. Ellsworth, 670.
45. Mary Louise Booth, *History of the City of New York: From Its Earliest Settlement to the Present Time* (New York: W. R. C. Clark, 1867; 1st pub. 1859), 2:881.
46. Booth, 1:16–17.
47. Letter: Mary Louise Booth to Thomas Addis Emmet, September 17, 1874, Thomas Addis Emmet Collection, Manuscripts and Archives Division, New York Public Library, New York, NY.
48. This third edition appeared in 1880.
49. Miscellaneous Sale, Nadeau Auction Gallery, Windsor, Connecticut, Sept. 26, 1996, p. 44, nos. 156 and 157 (photographs of Eliza and Eleanor Greatorex that had been removed from an album). Thanks to Helena Wright, Curator of Prints, Smithsonian American History Museum, Washington, DC.
50. Hosier did some of the same subjects as Greatorex, including the Stuyvesant Pear Tree and Beekman mansion. See New-York Historical Society website, accessed January 4, 2014, www.nyhistory.org/exhibit/city-hotel-broadway-new-york-city.
51. Edwin G. Burrows and Mike Wallace, *Gotham: A History of New York City to 1898* (New York: Oxford University Press, 1999), 1083.
52. Stephanie Wiles, "Between England and America: The Art of Thomas Charles Farrer and Henry Farrer" (PhD diss., Graduate Center, City University of New York, 2001), 184–92.
53. The six small etchings of New York civic buildings that date to 1870 are Farrer's earliest known efforts in the medium: *The Old Revenue Office, The Post Office, Old Tom's, Somerindyke House, Old House Cor. Peck Slip and Water Street,* and *Old House in Rector Street.* Hitchcock was among the critics who recognized his intention to record buildings that had been or were about to be destroyed. From 1871 through 1876, Farrer made at least five more etchings he considered part of his "Old New York" plates: *Old House in the "Five Points"; The Old Beach House Cor. Cedar & Greenwich Streets, New York; The Harsen Homestead; The Cooke Monument;* and *St. Paul's Church.* Two additional etchings are known—*Old House on the Hopper Farm* and *The Stryker Mansion, View from the River*—both dated 1871, suggesting that in subject matter, style, and chronology they belong to his "Old New York" series. Matthew S. Marks considers two 1877 etchings to be part of the group.
54. Henry Farrer's *Old Tom's (The Crooked Stoop)* drawing is in the New-York Historical Society, and the etching is in the Metropolitan Museum of Art.
55. The Middle Dutch Church—repurposed as the New York Post Office from 1845 to 1875– was slated for demolition once the new post office was completed. In 1870 Farrer drew the building, which was torn down in 1882. Greatorex, by contrast, chose to show the building more or less as it appeared in the mid-1850s via a copy she made after a painting of 1856 by her early teacher William Wallace Wotherspoon (etchings to be part of the group as well: *Fort Haight (Battle of Harlem Plains)* and *Powder Magazine in Central Park.* But since Farrer did not mention them to Koehler, we don't

know if they were intended to be part of the group. See Wiles, "Between England and America," and Matthew S. Marks, "Henry Farrer's Early Etchings of New York," *Imprint* 7, no. 1 (Spring 1982): 3, now unlocated, 11 ½ × 9 ½ in., SIRIS control no. IAP 61070663).

56. "Old New York–Farrer's Etchings," *Evening Post* (New York), March 24, 1870, 1; quoted in Wiles, "Between England and America," 187.

57. James Ripley Wellman Hitchcok, *Recent American Etchings* (New York: White, Stokes, & Allen, 1885).

58. "Culture and Progress: Stillman's 'Poetic Localities of Cambridge,'" *Century Illustrated Monthly Magazine* 11, no. 1 (November 1875): 448.

59. Greatorex, Prospectus for *Old New York*.

60. It would be interesting to know more about her contracts with George Putnam, publisher of her books, and how those arrangements were negotiated. Mary Hallock Foote wrote of A. V. S. Anthony as a primary contact between her and publishers. See Sue Rainey, *Creating "Picturesque America": Monument to the Natural and Cultural Landscape* (Nashville, TN: Vanderbilt University Press, 1999) for more details on these transactions.

61. My thanks to David G. Wright for sharing these and so many other insights about the ins and outs of print production in this era.

62. Greatorex, Prospectus for *Old New York*.

63. Bryant's original manuscript is in the Morgan Library. See William Cullen Bryant, Introduction to Greatorex's *Old New York*, autographed manuscript, ca. 1875. Morgan Library and Museum, Dept. of Literary and Historical Manuscripts, New York, NY (MA, 653.2).

64. "At present I am engaged in a book entitled An Artist's Journey from The Battery to Bloomingdale comprising views of all old mansions, churches, etc. of historical and romantic interest in old life of New York." Eliza Greatorex to John Champlain, February 1874, private collection.

65. Book notice column, *Evening Post* (New York), December 18, 1875, 2. Two of this group were copied after earlier artists, and two had appeared in an earlier iteration of the project titled *Relics of Manhattan*.

66. *Publisher's Weekly* 8 (December 1875): 798.

67. Greatorex, Prospectus for *Old New York*.

68. Contract between Eliza Greatorex and James R. Osgood, May 20, 1875, Houghton Library, Harvard University; Martha Sandweiss, *Print the Legend: Photography and the American West* (New Haven, CT: Yale University Press, 2002), 291–92.

69. "An Artist-Historian of Old New York," *Evening Post* (New York), June 16, 1875, 2.

70. Kathleen Luhrs et al., *American Paintings in the Metropolitan Museum of Art*, vol. 2 (Princeton, NJ: Princeton University Press, 1985), 561.

8. CENTENNIAL WOMEN, 1876–1878

1. Elizabeth Duane Gillespie, *A Book of Remembrance* (Philadelphia: J. B. Lippincott, 1901), 313.

2. Gillespie, 315.

3. Library Company of Philadelphia, consulted June 5, 2018, https://librarycompany
.org/portfolio-item/2008-centennial-exhibition/.

4. It is sometimes claimed that *The New Century for Woman* bombarded visitors with
feminist and women's rights materials in its weekly reporting, but I would argue that
close study reveals a wide range of topics covered in an objective manner.

5. Nancy F. Cott, *The Grounding of Modern Feminism* (New Haven, CT: Yale University
Press, 1987), 3.

6. Pamela H. Simpson, "Caroline Shawk Brooks: The 'Centennial Butter Sculptress,'"
Woman's Art Journal 28 (2007): 29.

7. Obituary, *Boston Globe*, 1908, quoted in Kate Culkin, *Harriet Hosmer: A Cultural Bi-
ography* (Amherst: University of Massachusetts Press, 2010), 1.

8. Susan P. Conrad, *Perish the Thought: Intellectual Women in Romantic America, 1830–
1860* (Secaucus, N.J.: Citadel Press, 1978), 121, discusses Ellet's treatment of Hosmer.

9. Elizabeth Fries Lummis Ellet, *Women Artists: In All Ages and Countries* (New York:
Harper & Bros., 1859), 316.

10. Eleanor Greatorex, "Among the Oils," *The New Century for Woman*, July 29, 1876, 91.

11. Eleanor Elizabeth Greatorex (credited as E. E. G.), "Among the Oils," *The New Cen-
tury for Woman*, July 29, 1876, 91, 94.

12. For a description of the pavilion by a self-identified female author, see E. B. D., "The
Great Centennial Exhibition: The Women's Department," *Arthur's Illustrated Home
Magazine* 44 (1876): 450–53, where the work of Greatorex is praised.

13. Whitney Chadwick, *Women, Art and Society* (New York: Thames and Hudson, 1990),
210.

14. This display was in the Main Building.

15. Harvard University's Women Working 1800–1930 website provides documentation;
see http://ocp.hul.harvard.edu/ww/wheeler.html.

16. Untitled notice, *The New Century for Woman*, October 21, 1876, 185.

17. Gillespie, *Book of Remembrance*, 330.

18. Chadwick, *Women, Art and Society*, 210.

19. Lucy Lee Holbrook, "What Women Can Do—Art Work," *Herald of Health* (new se-
ries) 27 (February 1876): 74–75.

20. "The Women Artists and the 'Centennial,'" *Evening Post* (New York), March 11, 1876,
4. H. P. Gray was president of the NAD, 1870–71.

21. "Women Artists and 'Centennial.'" The notice read: "The women artists of New York
desire to make a united effort to assist in the Centennial celebration. The Ladies Art
Association have organized an exhibition to be opened in the Art Gallery conducted
by Miss Gibbons, which shall be for the benefit of a Centennial fund to defray the
necessary expenses of the works exhibited by them. It will be opened on Wednesday,
the 15th of March."

22. This observation is gleaned from the Connecticut state guide, which followed the
pattern of other state buildings. See *Souvenir of the Centennial Exhibition: or, Con-
necticut's Representation at Philadelphia, 1876* (Hartford, CT: George D. Curtis, 1877),

131, where an overview of Connecticut women in the art section of the Women's Pavilion can be found.

23. Eleanor Elizabeth Greatorex (credited as E. E. G.), "Memorial Hall: Pictures by American Women," *The New Century for Woman*, May 27, 1876, 1–2.

24. The official catalogue does not cite this work, but many works were submitted late, after the catalogue went to press, and therefore missing from the list. The sticker on the verso of the drawing is definitive.

25. Greatorex, "Memorial Hall."

26. U.S. Centennial Commission, *Official Catalogue. Part III. Machinery Hall, Annexes, and Special Buildings (including the Women's Pavilion)*, 2nd rev. ed. (Philadelphia: Published for the Centennial Catalogue Company by John R. Nagle, 1876), 93, 96, 97, https://catalog.hathitrust.org/Record/100339994.

27. U.S. Centennial Commission, 96.

28. Megan Holloway, "Archibald and Alexander Robertson and Their Schools, the Columbian Academy of Painting, and the Academy of Painting and Drawing, New York, 1791–1835" (PhD diss., Graduate Center, City University of New York, 2006) is the most complete source.

29. "Local Affairs," *Philadelphia Public Ledger*, July 4, 1876.

30. *Declaration of Rights of Women of the United States Presented at the Centennial Celebration in Philadelphia, July 4, 1876*, copy in Special Collections, University of Rochester Library, Rochester, NY.

31. Bishop Simpson's prayer was published in the Pittsburgh *Catholic*, May 20, 1876, and reprinted in Arlene Swidler, "Catholics and the 1876 Centennial," *Catholic Historical Review* 62 (July 1876): 349–50.

32. Emily Faithfull, *Three Visits to America* (Edinburgh: D. Douglas, 1884): 13–17, Greatorex mentioned on 15.

33. Rosemary and Joseph Agonito, "Resurrecting History's Forgotten Women: A Case Study from the Cheyenne Indians," *Frontiers: A Journal of Women Studies* 6 (1981): 8–16.

34. *Souvenir of 1876: Reproductions from Pen and Ink Drawings by Mrs. Eliza Greatorex* (New York, 1876). Copies are located in the Harvard College Library and Boston Public Library, as listed in *Monthly Bulletin Books Added* 12 (1907): 242. Individual prints can be found in various collections.

35. Dee Brown, *Year of the Century, 1876* (New York: Scribner's, 1975).

36. "A Night at Mount Vernon," *The New Century for Woman*, June 24, 1876, 51–52.

37. She inscribed it "Souvenier," the alternative spelling to "Souvenir," which her mother had used on her version of the cover, illustrating the Women's Pavilion.

38. Background provided on the Mount Vernon website, consulted August 12, 2018, www .mountvernon.org.

39. *Souvenir of 1876*.

40. Untitled notice, *The New Century for Woman*, September 16, 1876, 148.

41. "A Timely Gem," *Evening Star* (Washington, DC), September 15, 1876, 1.

42. "Literary and Artistic," *Colorado Springs Gazette*, November 11, 1876, 1.

43. "Recent Art Publications," *Art Journal* 3 (1877): 31.

44. Elizabeth B. Johnston, *Visitors Guide to Mount Vernon*, 7th ed. (Washington, DC: Gibson Brothers, Printers, 1876), sec. 42.

45. Since Adam Pratt was actively involved in the YMCA, it is likely that he played some part in securing these quarters for them.

46. Fuller-Walker, "Mrs. Greatorex: Interesting Glance into a Lady Artist's Studio," *National Republican*, December 21, 1876.

47. Martha Bertha Wright (credited as M. B. W.), "Eleanor and Kathleen Greatorex," *The Art Amateur* 13 (September. 1885): 69.

48. "Women's Work in Art: Pictures at the Academy . . . Mrs. Greatorex's Landscapes," *Daily Evening Transcript* (Boston), May 4, 1877, 6.

49. "The Association Exhibition: A Glance at Some of the Pictures by Brooklyn Artists," *Brooklyn Eagle*, December 10, 1877, 3.

50. Records of December 1876 and December 1877 exhibitions, in Clark S. Marlor, *A History of the Brooklyn Art Association* (New York: James F. Carr, 1970), 208.

51. "Washington News and Gossip," *Evening Star* (Washington, DC), June 14, 1877.

52. Eighteen miles west of Winchester, it was originally called Capper Springs, after its early settler John Capper. In 1856, William Marker bought the property and built a hotel. It contained six types of springs on 942 acres. The spa survived the Civil War and became a place for the Virginia elite.

53. Edward Pollard, *The Virginia Tourist* (Philadelphia: J. B. Lippincott, 1870).

54. "Art Notes," *Evening Star* (Washington, DC), January 5, 1878, 1.

55. A. S. Pratt, proprietor, *The Rock Enon Springs and Baths, Great North Mountain, Virginia* (Judd & Detweiler, 1883 season), 9. Letter from Eliza Greatorex to Adam Pratt inscribed "57 Boul'd D'Enfers, Paris" is reproduced there; original unlocated.

56. 1878, NAD (no address given): no. 8: *Old Mill—Rock Enon*; no. 17: *Rock Enon Springs from Sunset Hill*.

57. See Gail S. Davidson et al., *Frederic Church, Winslow Homer, and Thomas Moran: Tourism and the American Landscape* (New York: Bulfinch Press, 2006) for background.

58. Michael A. Bellesiles, *1877: America's Year of Living Violently* (New York: The New Press, 2010).

59. Fuller-Walker, *Evening Star*, September 15, 1876.

60. "Art Notes," *Evening Star* (Washington, DC), February 23, 1878, 1.

61. Phebe Ann Hanaford, *Daughters of America* (Augusta, ME: True, 1882), 297, quoting from a writer of "Centennial Art Work."

62. Fuller-Walker, "Mrs. Greatorex."

63. *Catalogue Sale of Private Collection of Paintings, Old Engravings, Old China, Properties, and Furniture, Belonging to Mrs. Eliza Greatorex* (New York: Privately printed, 1878), 86 lots, auctioneer unknown, sale held at Mrs. Greatorex's studio, 2 East 17th St., New York, February 14, 1878, copy in New York Public Library, New York, NY.

64. Eliza Greatorex to Miss [Elizabeth Heaphy] Murray, Good Friday, 1878, Paris. Wainwright Collection, Manuscript Division, Princeton University Library. My thanks to Mary Helen Burnham for help locating this precious letter.

9. TRANSATLANTIQUE

1. Fuller-Walker, "Art Notes," *Daily Evening Transcript* (Boston), November 6, 1878.
2. Quoted in Stephen F. Eisenman et al., *Nineteenth Century Art: A Critical History* (New York: Thames & Hudson, 2007), 272.
3. Eliza Greatorex to Miss [Elizabeth Heaphy] Murray, Good Friday, 1878, Paris, Wainwright Collection, Manuscript Division, Princeton University Library, Princeton, NJ.
4. May Alcott Nieriker, *Studying Art Abroad, and How to do it Cheaply* (Boston, 1879), 44.
5. Greatorex to Murray, Good Friday, 1878.
6. Fuller-Walker, "Art Notes."
7. Caption: "*In Normandy* drawn by the late Eliza Greatorex from her water-color painting." *The Art Amateur* 36, no. 4 (April 1897): 103 (illustrated).
8. Fuller-Walker, "Art Notes."
9. Nieriker, *Studying Art Abroad*, 8.
10. Margaret Bertha Wright (credited as M. B. W.), "Eleanor and Kathleen Greatorex," *The Art Amateur* 13 (September 1885): 69.
11. Nieriker, *Studying Art Abroad*, 43.
12. Eliza Greatorex, for example, exhibited etchings at the Salons of 1881 and 1888.
13. *Reports of the United States Commissioners to the Universal Exposition of 1889 at Paris* (Washington, DC: Government Printing Office, 1891), 72.
14. "William Merritt Chase (1849–1916)." In *Heilbrunn Timeline of Art History*. New York: The Metropolitan Museum of Art, 2000–, consulted July 14, 2018, www.metmuseum.org/toah/hd/chas/hd_chas.htm.
15. Enid Zimmerman, "The Mirror of Marie Bashkirtseff: Reflections about the Education of Women Art Students in the Nineteenth Century," *Studies in Art Education* 30 (1989): 164–75, provides a well-rounded assessment.
16. M. Bashkirtseff, *Marie Bashkirtseff: The Journal of a Young Artist, 1860–1884*, trans. Mary J. Serrano (New York: E. P. Dutton, 1919), consulted Jan. 23, 2018, https://archive.org/details/mariebashkirtsefoobashiala/page/n5/mode/2up. This 1877 entry is on 141.
17. The first published transcription of the journal was published in 1887 by Theuriet, with many omissions and changes. It was widely discussed, including a review in *The Art Amateur* 22 (January 1890): 34–36. For a more recent and comprehensive version, see *I Am the Most Interesting Book of All: The Diary of Marie Bashkirtseff*, vol. 1, trans. Phyllis Howard Kernberger with Katherine Kernberger (San Francisco: Chronicle Books, 1997).
18. Zimmerman, *Mirror of Marie Bashkirtseff*, 169 (her footnote: "Cited in Cosnier, 1985, pp. 220–221").
19. Christine Havice, "In a Class by Herself: 19th Century Images of the Woman Artist as Student," *Woman's Art Journal* 2 (Spring–Summer 1981): 38 (article runs 35–40; her painting of Atelier is on 38).
20. Rochelle Goldberg Ruthchild, "Review: On the Edge of Emancipation," *The Women's Review of Books* 15 (November 1997): 21.

21. Bashkirtseff, *Marie Bashkirtseff*, 141 (1877 entry).
22. The Baedeker guide dismissed Chevreuse and the historic importance of its ruined chateau occupying a plateau 260 feet above. Its value for the author was that "it lends picturesqueness to the distant views of the town and valley," just as Eliza captured it in her etching.
23. "Etching," *New York Times*, February 23, 1881, 6.
24. Maxime Lalanne, *A Treatise on Etching*, trans. Sylvester Rosa Koehler (Boston: Estes and Lauriat, 1880).
25. Frank Weitenkampf, "Some Women Etchers," *Scribner's*, December 1909, 732.
26. *Near the Theater, Oberammergau* (163); *Church of Oberammergau* (164); *Old Dutch Church, Long the Post Office, New York* (165), and *The Battery, New York, in Winter* (166) were shown in the exhibition, Boston, April–May 1881.
27. In spring 1862 she exhibited at the NAD *La Madelaine Chevreuse—France* (2) and *Study in the Valley of Chevreuse* (381), both for sale.
28. Sylvester R. Koehler, "The Works of the American Etchers: XXII.— Mrs. Eliza Greatorex," *American Art Review* 2, part 1 (1881): 12.
29. Jean Gould, *Winslow Homer: A Portrait* (New York, 1962), 93.
30. Old postcards provide a good idea of these picturesque sites.
31. *Cernay-la-Ville (Seine-et-Oise): une gravure* shown at the 1881 Paris Salon, no. G4696. See Lois Marie Fink, *American Art at the Nineteenth-Century Paris Salons* (Washington, DC: National Museum of American Art, Smithsonian Institution, 1990): 348.
32. Joseph Pennell, *Etchers and Etchings* (New York: Macmillan Co., 1919), 190.
33. Walter and Matilda Despard's letters, Sylvester R. Koehler Papers, Archives of American Art, Smithsonian Institution, Washington, DC.
34. Sylvester R. Koehler, "The Works of the American Etchers: XXII.— Mrs. Eliza Greatorex," *American Art Review* 2, part 1 (1881): 12.
35. They included: *Near the Theater, Oberammergau* (163); *Church of Oberammergau* (164); *Old Dutch Church, Long the Post Office, New York* (165); *The Battery, New York, in Winter* (166); *Chevreuse, Seine et Oise* (167); *Chevreuse, Seine et Oise* (168); *Church, Cernay-la-Ville* (169); *The Cascade, Cernay-la-Ville* (170); *The Pond, Cernay-la-Ville* (171). *Exhibition of American Etchings, Museum of Fine Arts, April 11th to May 9th, 1881* (Boston: Alfred Mudge & Son, Printer, 1881), Sylvester R. Koehler, Curator. Koehler bequeathed his entire library and collection, including these works, to Boston's Museum of Fine Arts, where they still reside.
36. *Exhibition of American Etchings*, 2nd ed., with introduction by S. R. Koehler (Boston: Alfred Mudge, 1881), 13.
37. Matilda Despard to Koehler, April 16, 1881, Archives of American Art.
38. Morris T. Everett, "The Etchings of Mary Nimmo Moran," *Brush and Pencil* 8 (April 1901): 3–16. The definitive study is Shannon Vittoria, "Nature and Nostalgia in the Art of Mary Nimmo Moran (1842–1899)" (PhD diss., Graduate Center, City University of New York, written under the author's direction).
39. For a useful overview, see Rona Schneider, "The American Etching Revival: Its French Sources and Early Years," *American Art Journal* (1982): 40–65.

40. Schneider, 45.

41. "Art Notes," *The Critic*, November 5, 1887, 233.

42. *Walls of Algiers: Narratives of the City*, J. Paul Getty Museum, 2009, consulted June 8, 2015, www.getty.edu/art/exhibitions/algiers/.

43. Barbara Leigh Smith Bodichon to George Eliot, 1856, George Eliot and George Henry Lewes Collection, Beinecke Rare Book & Manuscript Library, Yale University Library, New Haven, CT.

44. Jan Marsh and Pamela Gerrish Nunn, *Pre-Raphaelite Women Artists* (London: Thames and Hudson, 1998), 104; quotation is from Ellen Creathorne Clayton, *English Female Artists* (London: Tinsley Brothers, 1876), 2:172.

45. Marsh and Nunn, 104.

46. Edward Said, *Orientalism* (New York: Pantheon, 1978).

47. Wright, "Eleanor and Kathleen Greatorex," 69; *Annual Exhibition Record of the American Watercolor Society*, Philadelphia Museum of Art, consulted June 2, 2019, https://philamuseum.github.io/AmericanWatercolors/.

48. Letter from Matilda Despard to Koehler, April 16, 1881, Koehler papers, Archives of American Art.

49. Neither Peet nor I have found evidence of other Algerian etchings in our extensive research.

50. Wright, "Eleanor and Kathleen Greatorex," 69.

51. Matilda Desparad to Koehler, April 16, 1881, Koehler Papers, Archives of American Art. She added: "Excuse me thus adding a personal item to this business note, but your kindly interest in Mrs. Greatorex has led me to do so."

52. "Tom Greatorex Is Dead," *Dolores News* (Colorado), March 26, 1881, 2.

53. "Passengers Arrived," *New York Times*, August 16, 1881, 8.

54. Wright, "Eleanor and Kathleen Greatorex," 69.

55. John Davis, "Our United Happy Family: Artists in the Sherwood Building, 1880–1900," *Archives of American Art Journal* 36 (1996): 2–19.

56. Gordon Lester Ford Papers, New York Public Library, Manuscript Division. Four letters from Kathleen Honora Greatorex to Gordon Lester Ford, April 20, 1882; April 22, 1882; and two undated letters, ca. 1884.

57. Wright, "Eleanor and Kathleen Greatorex," 69.

58. Steve Shipp. *American Art Colonies, 1850–1930* (Westport, CT: Greenwood Press, 1996).

59. Wright, "Eleanor and Kathleen Greatorex," 69.

60. *Women's Etchers* exhibition of 1888, nos. 190 and 191, respectively.

61. Bill Lockhart et al., "Ellenville Glass Works," *Society for Historical Archaeology* (2015): 279–87, https://sha.org/bottle/pdffiles/EllenvilleGW.pdf.

62. Wright, "Eleanor and Kathleen Greatorex," 69.

63. Information found on the museum website, www.americanart.si.edu.

64. "Washington," *New York Times*, June 19, 1892, 10.

65. NAD, 1883, no. 629: *Louis Philippe House in 1868, Bloomingdale*. M. de Mundonca [sic].

66. Wright, "Eleanor and Kathleen Greatorex," 70.

67. "Fine Arts," *New York Herald*, October 2, 1882, 4.

68. Wright, "Eleanor and Kathleen Greatorex," 69–70.

69. "The Dakota: A Description of One of the Most Perfect Apartment Houses of the World," *The New York Times*, October 22, 1884, 5.

70. Elizabeth Hawes, *New York, New York: How the Apartment House Transformed the Life of the City (1869–1930)* (New York: Alfred A. Knopf, 1993), 94–96.

71. Mary Gay Humphreys, "Three Rooms and a Hall," *The Decorator and Furnisher* 5 (February 1885): 178.

72. Humphreys, 178.

73. *Catalogue Sale of Private Collection of Paintings, Old Engravings, Old China, Properties, and Furniture, Belonging to Mrs. Eliza Greatorex* (New York: Privately printed, 1878), 86 lots, auctioneer unknown, sale held at Mrs. Greatorex's studio, 2 East 17th St., New York, February 14, 1878, copy in New York Public Library, New York, NY.

74. Untitled notice, *The New Century for Woman*, October 14, 1876, 176.

75. Article on Mrs. Potter Palmer, *Columbus Daily Enquirer*, April 30, 1892, 2. To which room the author refers is uncertain.

76. *Evening Star* (Washington, DC), December 12, 1885, 8.

77. Letter from J. Alden Weir to Walter Pach, November 25, 1910, in *American Artists, Authors, and Collectors: The Walter Pach Letters, 1906–1958*, ed. Bennard B. Perlman (Albany: State University of New York Press, 2002), 395.

78. John Murray, *Murray's Handbook Florence and Its Environs* (London: John Murray, 1863).

79. *Evening Star* (Washington, D.C.), July 10, 1886, 5.

80. The recent European works she exhibited included:

> 152. (27) *View of Florence from Maiano, Italy* – 1886;
> 153. (28) *Villa Panatooni, Maiano, Italy* – 1886;
> 154. (29) *Clock Tower, Vallombrosa, Italy* – 1886;
> 155. (30) *Palace of the Caesars, Rome, Italy* – 1887;
> 156. (31) *St. Peter's, Rome, Italy* – 1887;
> 157. (32) *San Carlo, Rome, Italy* – 1887;
> 158. (33) *Cornice Road, Italy* – 1887;
> 159. (34) *Mont St. Michel, Brittany, France* – 1887;
> 160. (35) *Crypt, Mont St. Michel, Brittany, France* – 1887;
> 161. (36) *Rue de la Ville, Mont St. Michel, Brittany, France* – 1887; and
> 162. (37) *St. Malo from Paramé, Brittany, France* – 1887.

81. "Art Notes," *The Critic*, November 5, 1887, 233.

82. Morris T. Everett, "The Etchings of Mrs. Mary Nimmo Moran," *Brush and Pencil* 8 (April 1901): 3.

83. "The Fine Arts: Women Etchers at the Union League," *The Critic*, April 21, 1888, 197.

84. "The Fine Arts: Women Etchers at the Union League," 195.

85. "Art Notes," *The Critic*, November 5, 1887, 233.

86. "The Fine Arts: Women Etchers at the Union League," 195. The work of her daughter also hung in the show: "Miss Eleanor E. Greatorex . . . carries her methods on into impressionism in her three Cadore plates, which are marred by a certain fragmentariness."

87. "The Fine Arts: Women Etchers at the Union League," 195.

88. Durand, *Life and Times*, 207–8.

89. George Inness Jr., *Life, Art and Letters of George Inness* (New York: Century, 1917), 101.

90. She exhibited it at several international exhibitions including Berlin, 1891.

91. "Our Women in History," *Naugatuck Daily News* (reprinted from *Chicago Tribune*), May 12, 1897.

EPILOGUE

1. Phebe Ann Hanaford, *Daughters of America* (Augusta, ME: True, 1892), 297, quoting an unidentified New York newspaper.

2. Margaret Bertha Wright (credited as M. B. W.), "Eleanor and Kathleen Greatorex," *The Art Amateur* 13 (September 1885): 69.

3. Hanaford, *Daughters of America*, 297.

4. David Lubin, *Picturing a Nation: Art and Social Change in Nineteenth-Century America* (New Haven: Yale University Press, 1994): 199.

5. Wright, "Eleanor and Kathleen Greatorex," 69.

6. Letter from Mrs. Mott, 1940s, Smithsonian American Art Museum, Washington, DC.

7. Fuller-Walker, "Letter from New York," *Daily Evening Transcript* (Boston), December 28, 1874, 6.

8. John S. C. Abbott, *Kit Carson: The Pioneer of the West* (New York: Dodd, Mead, 1873); H[einrich] Hoffmann, *Prince Greenwood and Pearl-of-Price, with their Good Donkey Kind & Wise*, trans. M. Despard, illus. Eleanor Greatorex (Washington, DC, 1874).

9. See chapter 5 on their Bavarian experiences.

10. Wright, "Eleanor and Kathleen Greatorex," 69.

11. *Official Catalogue of the Cotton States and International Exposition*, Atlanta, Georgia (Atlanta: Claflin & Mellichamp, Publishers, 1895), 259. The exhibition ran from September 18–December 31, 1895.

12. "The Water-Color Society Exhibition," *The Art Amateur* 16, no. 3 (March 1897): 60.

13. Eleanor E. Greatorex, "Where Rosa Bonheur Lives," first published in *Godey's* and reprinted in *Current Literature* 12, no. 1 (1893): 72.

14. Susan Grant, *Paris: A Guide to Archival Sources for American Art History* (Washington, DC: Archives of American Art, Smithsonian Institution, 1997): 22.

15. Eleanor E. Greatorex, "Mary Fairchild MacMonnies," *Godey's Magazine* 126 (May 1893): 624–32.

16. In 1936 Chetolah, or the George Inness Jr. Estate, was purchased by the missionary order of the Daughters of Mary, Health of the Sick, and served as the motherhouse and novitiate until 1970.

17. The Spectator, "Washington Chat," *Washington Herald*, January 23, 1909, 6.

18. "Americans in France," *American Art News*, September 16, 1922, 6.

19. Kirsten M. Jensen, "Her Sex Was an Insuperable Objection: Sara Tyson Hallowell and the Art Institute of Chicago, 1873–1914" (MA thesis, Southern Connecticut State University, 2000). Thanks to Carolyn Carr for providing the references to Greatorex among the Hallowell papers.

20. Alfred Sisley (1839–99) died of throat cancer in January 1899 in Moret-sur-Loing, at age 59, a few years after his wife's death. He was buried beside Eliza Greatorex in the Moret-sur-Loing cemetery.

21. Claude Sisley, "The Ancestry of Alfred Sisley," *The Burlington Magazine* 91, no. 558 (September 1949): 248–52.

22. There are six-branch menorahs and eight-branch menorahs. Those with six branches are used in temples; those with eight reference the eight days of Hanukkah and are only used during the holiday.

BIBLIOGRAPHY

BOOK PROJECTS BY ELIZA GREATOREX

1869: *Relics of Manhattan: A Series of Photographs, from Pen and Ink Sketches Taken on the Spot Illustrating Historic Scenes and Buildings in and around This City.* New York (no publisher; photographer Napoleon Sarony, not identified in volume).

1871: *Die Heimath von Oberamergau.* Oberammergau.

1872: *Homes of Ober-Ammergau.* Munich: Jos. Albert.

1873: *Summer Etchings in Colorado.* New York: G. P. Putnam's Sons.

1874: *Nuremberg* (album of six etchings). New York: G. P. Putnam's Sons.

1875: *Old New York, from the Battery to Bloomingdale.* With text by M[atilda] Despard. New York: G. P. Putnam's Sons.

1876: *Souvenir of 1876. Reproductions from Pen and Ink Drawings by Mrs. Eliza Greatorex.* New York (no publisher).

1877: *Rock Enon Springs, Virginia.* Illustrated by Eliza Greatorex. Washington, DC: Pratt?

ARCHIVES

Harvard University, Houghton Library, Cambridge, MA
 Contract between Eliza Greatorex and James R. Osgood, dated May 20, 1875.
Massachusetts Historical Society, Boston, MA
 Dwight, Theodore F., Papers (Dwight worked for George Putnam's, where he gathered autograph letters, including four letters from Eliza Greatorex, 1866–73).

National Archives and Records Administration (US)

Famine Irish Passenger Record Data File: Eliza Pratt, arrived from Liverpool to New York, July 5, 1848 aboard the SS *Speed*.

New York Public Library, Manuscripts and Archives Division, New York, NY

Donlevy, Alice Heighes, Papers, 1860–1911

Box 1-Letters to Donlevy as Secretary of the Ladies' Art Association.

Box 4-Papers of the Ladies' Art Association (1867–1900).

Ford, Gordon Lester, Collection (Rolls N13–N17, microfilm; originals in Archives of American Art, Smithsonian Institution, Washington, DC).

Greatorex, Eliza, to Governor Samuel J. Tilden, January 28. 1876. Samuel J. Tilden Papers.

Princeton University, Princeton, NJ

Greatorex, Eliza, to Elizabeth Heaphy Murray, Good Friday, 1878, Paris. Wainwright Collection.

Greatorex, Eliza, to Members of the Arcadian Club, December 22, 1875, New York. Laurence Hutton Collection.

Private Collection

Greatorex, Eliza, to Fuller-Walker, July 22, 1873. Manitou House, Manitou, CO.

Greatorex, Eliza, to John Champlain, February 13, 1874.

Smithsonian Institution, Archives of American Art, Washington, DC

Cummings, Thomas Seir, to Prosper Wetmore, December 20, 1847. Prosper Wetmore letters (1834–47).

Despard, Matilda (and other Despard family members) to Sylvester R. Koehler. A group of letters 1880–81, Box 2, Folder 2, Sylvester Rosa Koehler Papers.

Greatorex, Eliza, to Mary Louise Booth, July 20 (no year); Albert Duveen Collection of artists letters and ephemera. Reel DDU1, frames 224–25.

James D. Smillie Diaries, James D. Smillie and Smillie Family Papers, 1853–1957.

University of Iowa Library

Cheltnam, Jacintha Hunt, to Eliza Greatorex, July 27, 1858; Leigh Hunt to Eliza Greatorex, July 28, 1858. Brewer–Leigh Hunt Collection.

PRIMARY PRINTED SOURCES

Catalogue Sale of Private Collection of Paintings, Old Engravings, Old China, Properties, and Furniture, Belonging to Mrs. Eliza Greatorex. 4 pages, 86 lots. Auctioneer unknown. Sale held at Mrs. Greatorex's studio, 2 East 17th Street, New York, February 14, 1878. Copy in New York Public Library, New York, NY.

Despard, M. "The Harsen House," *The Aldine* 6, no. 10 (October 1873): 198–99.

Despard, M. "Eliza Greatorex," *The Aldine* 7, no. 2 (February 1874): 46.

Despard, M. "Nuremberg Cobble-Stones," *Appleton's Journal of Literature, Science and Art* 15 (May 13, 1876): 625–26.

Despard, M. "Music in New York Thirty Years Ago," *Harper's New Monthly Magazine* 57 (1878): 113–21.

Despard, M. *Kilrogan Cottage. New York:* Harper & Sons, 1878.

"Editor's Literary Record: Christmas Books" (Review of *Summer Etchings in Colorado*), *Harper's New Monthly Magazine* (January 1874): 296.

"Eliza Greatorex." *Aldine* 6, no. 2 (February 1873): 48.

Ellet, Elizabeth Fries Lummis. *Women Artists in All Ages and Countries.* New York: Harper & Bros., 1859.

Exhibition of American Etchings, Museum of Fine Arts, April 11th to May 9th, 1881. Sylvester R. Koehler, Curator. Boston: Alfred Mudge & Son, 1881.

Exhibition of the Work of the Women Etchers of America, Boston, Museum of Fine Arts Print Dept., Nov. 1 to Dec. 31, 1887. Sylvester R. Koehler, Curator. Boston: Albert Mudge & Son, 1887.

"A Famous Woman Artist" (obituary of Eliza Greatorex), *Boston Evening Transcript*, February 11, 1897, 7.

Fuller-Walker. "Letter from New York." *Daily Evening Transcript*, Boston, December 28, 1874, 6.

Fuller-Walker. "Letter from New York: Artists' Receptions: Mrs. Greatorex's Summer Work . . ." *Daily Evening Transcript*, Boston, October 12, 1876, 4.

Hanaford, Phebe A. *Daughters of America; or, Women of the Century.* Augusta, ME: True & Co., 1882: 276–78.

Hind, A. M. *A Short History of Engraving & Etching, for the Use of Collectors and Students.* London: A. Constable, 1908.

Hoffmann, Heinrich. *Prince Greenwood and Pearl-of-Price.* Translated by M. Despard, illustrations by Eleanor Greatorex. Washington, DC: N. Peters, 1874.

Holbrook, Lucy Lee. "What Women Can Do—Art Work." *Herald of Health* (new series) 27 (February 1876): 71–76..

Koehler, Sylvester R. "The Works of the American Etchers: XXII.—Mrs. Eliza Greatorex," *American Art Review* 2, no. 7 (May 1881): 12.

Metcalf, Frank J. "Henry Wellington Greatorex." In *American Writers and Compilers of Sacred Music*, 256–62. New York: Abington Press, 1925.

"Obituary—Eliza Greatorex." *The Art Amateur* 36, no. 4 (April 1897): 103.

Obituary of Eliza Greatorex. *New York Tribune*, February 11, 1897.

U.S. Centennial Commission. *Official Catalogue, Part III: Machinery Hall, Annexes, and Special Buildings (including the Women's Pavilion).* 2nd rev. ed. Philadelphia: Published for the Centennial Catalogue Company by John R. Nagle, 1876.

Willard, Frances E., and Mary A. Livermore, eds. *A Woman of the Century: Fourteen Hundred-Seventy Biographical Sketches Accompanied by Portraits of Leading Women in All Walks of Life.* Buffalo, NY: Moulton, 1893.

Wright, Margaret Bertha (credited as M. B. W.). "Eleanor and Kathleen Greatorex." *The Art Amateur* 13 (September 1885): 69–70.

WRITINGS AND ILLUSTRATIONS BY FAMILY MEMBERS

Abbott, John S. C. *Christopher Carson: Familiarly Known as Kit Carson.* Illustrated by Eleanor Greatorex. New York: Dodd & Mead, 1874.

Art for Young Folk: The Art Researches of Two New York Boys, with Biographies of Twenty-Four Prominent American Artists. Illustrated by Eleanor E. Greatorex and others. Boston:

D. Lothrop & Co, 1885 (each story in the book appears to have a different author). Copy at Huntington Library, San Marino, CA.

Greatorex, Eleanor Elizabeth (credited as E. E. G.). "Among the Pictures." *The New Century for Woman*, May 20, 1876, 1.

———. "Memorial Hall: Pictures by American Women." *The New Century for Woman*, May 27, 1876, 1–2.

———. "Memorial Hall: Among the Pictures, English." *The New Century for Woman*, June 3, 1876, 9.

———. "Memorial Hall: Pictures by Swedish Women." *The New Century for Woman*, June 17, 1876, 41–42.

———. "A Night at Mount Vernon." *The New Century for Woman*, June 24, 1876, 51–52.

———. "Memorial Hall: Among the Pictures [French Women]." *The New Century for Woman*, July 8, 1876, 68.

———. "Memorial Hall: The Netherlands." *The New Century for Woman*, July 15, 1876, 74–75.

———. "Among the Oils." *The New Century for Woman*, July 29, 1876, 91, 94.

———. "Student Life in Munich." *The New Century for Woman*, September 2, 1876, 131.

———. "Womans Student Life in New York." *The New Century for Woman*, October 14, 1876, 179.

Greatorex, Eleanor E. (same person as above). "Paris Wet." *Godey's Magazine*, April 1893, 126, 754, pp. 462–68 (written and illustrated by her).

———. "Mont Saint Michel." *Godey's Magazine, February* 1893, 219–25.

———. "Where Rosa Bonheur Lives." *Godey's Magazine*, 1893. First published in *Godey's* and reprinted in *Current Literature* 12, no. 1 (1893): 72.

———. "Mary Fairchild MacMonnies." *Godey's Magazine*, May 1893, 624–32.

———. "The Clocks of Paris." *Godey's Magazine*, October 1893, 469–476.

———. "Citizens of the Air." *Godey's Magazine*, July 1894, 73–81.

Greatorex, Eliza. "The Garden of the Gods." *St. Nicholas Magazine*, December 1874, 64–69.

Greatorex, Henry W. *A Collection of Psalm and Hymn Tunes, Chants, Anthems, and Sentences.* Boston: Ditson, 1851.

Pratt, A. S., proprietor. *The Rock Enon Springs and Baths, Great North Mountain, Virginia.* Judd & Detweiler, 1883.

The Rock Enon Springs and Baths: Great North Mountains, Virginia, Season 1889 (a prospectus issued annually that expanded to include more letters of appreciation, ca. 1877–89).

SECONDARY LITERATURE

Cowdrey, Mary Bartlett. *National Academy of Design Exhibition Records, 1826–1860.* New York: New-York Historical Society, 1943.

Driscoll, John P. *All That Is Glorious Around Us: Paintings of the Hudson River School.* Ithaca, NY: Cornell University Press, 1997.

Manthorne, Katherine. "Bavarian Beginnings of Eliza Greatorex." In *American Artists in Munich: Artistic Migration and Cultural Exchange Processes,* edited by Christian Fuhrmeister., 153–66. Berlin: Deutscher Kunstverlag, 2009. English and German editions.

———. "Eliza Greatorex and Old New York, 1869." *The Magazine Antiques*, November 2009.

———. "Eliza Greatorex and Her Artistic Sisterhood in the Collection of Martha Reed Mitchell, 1863–1877." *Women's Studies* 39, no. 6 (2010): 518–35.

———. "Eliza Pratt Greatorex: Becoming a Landscape Painter." In *The Cultured Canvas: New Perspectives on American Landscape Painting*, edited by Nancy J. Siegel., 217–40. Durham, NH: University Press of New England, 2011.

———. "'The Lady with the Pen': The Graphic Art of Eliza Greatorex." *American Arts Quarterly* 29 (Fall 2012): 11–20.

Manthorne, Katherine, et al. *Home on the Hudson: Women and Men Painting Landscape, 1825–1875*. Garrison, NY: Boscobel House & Garden, 2009.

Masten, April F. *Art Work: Women Artists and Democracy in Mid-Nineteenth-Century New York*. Philadelphia: University of Pennsylvania Press, 2008.

National Gallery of Ireland. *Irish Women Artists: From the Eighteenth Century to the Present Day*. Dublin: National Gallery of Ireland, 1987.

Peet, Phyllis. "The Emergence of American Women Printmakers in the Late Nineteenth Century." PhD diss., University of California at Los Angeles, 1987.

———. *American Women of the Etching Revival: Exhibition, February 9–May 9, 1988*. Atlanta: High Museum of Art, 1988.

Prieto, Laura R. *At Home in the Studio: The Professionalization of Women Artists in America*. Cambridge, MA: Harvard University Press, 2001.

Shively, Charles. "Eliza Pratt Greatorex." in *Notable American Women, 1607–1950: A Biographical Dictionary*, edited by Edward T. James, 76–77. Cambridge, MA: Belknap Press of Harvard University Press, 1971.

Siegel, Nancy, and Jennifer Krieger. *Remember the Ladies: Women of the Hudson River School*. Catskill, NY: Thomas Cole Historic Site, 2010.

Swinth, Kirsten. *Painting Professionals: Women Artists and the Development of Modern American Art, 1870–1930*. Durham: University of North Carolina Press, 2001.

Yablon, Nick. *Untimely Ruins: An Archaeology of Urban Modernity, 1819–1919*. Chicago: University of Chicago Press, 2009.

ILLUSTRATIONS

INDEX

Maier, Josef, carved wooden cover for
Heimat auf Oberammergau, 137 *fig.*
Manitou Springs, Colorado, 160–62, 300n35
Manorhamilton, Ireland, 13–14
Marshall, Megan, *The Peabody Sisters:
Three Women Who Ignited American
Romanticism*, 2
Marville, Charles, 103
Masten, April F., *Art Work: Women Artists and
Democracy in Mid-Nineteenth Century New
York*, 7
McKim, Charles (editor), *New York Sketch
Book of Architecture*, 199–200
Mears, Otto, 149, 299n6
Melville, Herman, 18; *Battle Pieces*, 77–78;
"'Formerly a Slave': An Idealized Portrait,
by E. Vedder, in the Spring Exhibition of
the National Academy, 1865," 86–87, 89;
"The House-Top: A Night Piece (July,
1863)," 77
memory panels, 209, 220
Mendonça, Mario de, family, 261–62
Methodist Church, 14, 15–16, 25; growth in
Ireland, 21–22; itinerant preaching, 16
Micas, Nathalie, 65, 290n65
Middle Dutch Church, 305n55
Mitchell, Maria, 42–43
Mitchell, Martha Reed, 149, 163–65, 230,
235–36; Mount Vernon, 225
Milton, John, 266
Milton, Thomas, *Milton's Views*, 29
Mix, Edward Townsend, 163
Monument to Thomas Addis Emmet (unidenti-
fied photographer), 37 *fig.*, 189
Moran, Mary Nimmo, 250–52, 268;
exhibition with Thomas Moran, 250;
Summer, Suffolk County, New York, 250
Moran, Peter, 251
Moran, Thomas, 147–48, 154, 155, 168–69, 171,
173, 234, 250; exhibition with Mary
Moran, 250; *Slave Hunt*, 88
Moret-sur-Loing, 277–79, 315n20
Morris Jumel Mansion, 184–86, 237
mother-daughter artists, 4, 283n4
motherhood, cult of, 53
Mott, Lucretia, 43
Mount Vernon, 191, 224–28

Mount Vernon Ladies Association, 224–25
Mount, William Sidney, 84, 109
Munich, cultural scene, 129
Murray, Elizabeth Heaphy, 238, 240; *Sixteen
Years of an Artist's Life in Morocco, Spain
and the Canary Islands*, 252

Nast, Thomas, 85
The Nation (Ireland), 31
National Academy of Design, 1, 15, 45, 48, 60,
66, 83–84, 95, 110, 234, 262; "hanging
day"/"varnishing day," 115–16; venue for
women group exhibits, 63
National Bank Act, 39–40, 156
Native Americans, 149, 154, 160–61, 192,
223–24
nature writing, 186
New Century for Woman, The, 129, 215, 221,
275, 307n4
New Utrecht, New York, 229–30
New York Etching Club, 251
New York Exchange for Women's Work,
217
New York Hospital, aka Old New York
Hospital, 78, 291n5
New York University (City University of
New York), 94
New York Water-Color Exhibition, 253
Nicholas, Michael, 183
Nieriker, May Alcott, 242, 243; *Studying
Abroad and How to Do It Cheaply*, 240
Noble, Louis Legrand, *After Icebergs with a
Painter*, 69
North Dutch Church (New York City), 207,
209–11
Norwood, Vera, 61, 186
Nuremberg, 121–127

Oberammergau, 128, 132–38, 140, 142; Eliza
Pratt Greatorex, critique of patriarchy,
141
O'Connell, Daniel, 43
Old Masters revival, 122
Old North Dutch Church (New York City),
207, 209–11
Ordnance Survey (Ireland), 28–29
Orientalism, 253

Founded in 1893,
UNIVERSITY OF CALIFORNIA PRESS
publishes bold, progressive books and journals
on topics in the arts, humanities, social sciences,
and natural sciences—with a focus on social
justice issues—that inspire thought and action
among readers worldwide.

The UC PRESS FOUNDATION
raises funds to uphold the press's vital role
as an independent, nonprofit publisher, and
receives philanthropic support from a wide
range of individuals and institutions—and from
committed readers like you. To learn more, visit
ucpress.edu/supportus.